THE GENIUS OF GILBERT STUART

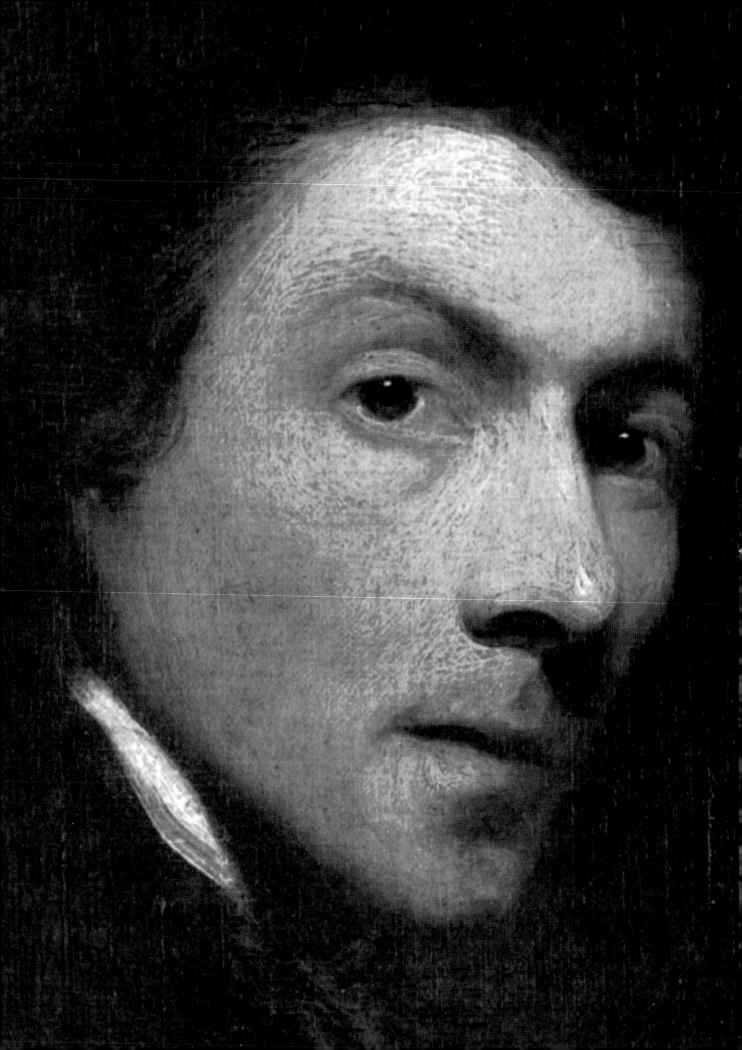

The Genius of

GILBERT

STUART

Dorinda Evans

PRINCETON UNIVERSITY PRESS

PRINCETON, NEW JERSEY

Frontispiece: *Self-Portrait,* ca. 1778 (detail of fig. 12)

Published by Princeton University Press
41 William Street
Princeton, New Jersey 08540

In the United Kingdom:
Princeton University Press
Chichester, West Sussex

Designed by Mike Burton
Composed in ITC New Baskerville typefaces with Castellar display
by Duke & Company, Devon, Pennsylvania
Printed by Paramount Printing, Inc., Hong Kong

LIBRARY OF CONGRESS CATALOGING-IN-PUBLICATION DATA
Evans, Dorinda.
 The genius of Gilbert Stuart / Dorinda Evans.
 p. cm.
 Includes bibliographical references and index.
 ISBN 0-691-05945-4 (cl : alk. paper)
 1. Stuart, Gilbert, 1755–1828. 2. Portrait-painters—
 United States—Biography. I. Title.
 ND1329.S7E94 1999
 759.13—dc21
 [b] 98-30706
 CIP

Printed and bound in Hong Kong

10 9 8 7 6 5 4 3 2 1

FOR TAMSEN

Contents

List of Illustrations

Unless otherwise noted, all works are by Gilbert Stuart. Black-and-white illustrations that also appear in color are noted in brackets at the end of the corresponding entry.

Acknowledgments

I am much indebted to the Smithsonian Institution for a 1986–87 Senior Post-Doctoral Fellowship, to begin work on this book, at the National Portrait Gallery in Washington. The Smithsonian later extended its support of my effort with a Joshua C. Taylor Research Fellowship and a Smithsonian Visitor's Grant at the National Museum of American Art in 1991. For this help and for the unfailing encouragement of the staffs at the Smithsonian's two museums where I worked, I am most grateful.

In addition, this research was supported in part by the University Research Committee of Emory University. I want to thank Emory for granting several research-related leaves of absence from the Art History Department and for faculty research awards in 1987 and 1997 that enabled me to complete the book. After its completion, Emory again contributed with a generous subsidy for which I am grateful. It was used to obtain most of the photographs and permissions and to pay for the publication of half of the color plates.

While preparing the text, I had the pleasure of working, at different times, with art-history graduate students who brought books to me from across the Emory campus and helped track down sources. For their aid, my heartfelt thanks go to Katrina Dickson, Lacey Taylor Jordan, Robert Spiotta, and—especially for her work in computerizing the bibliography—Jessica Taplin. I am indebted, as well, to their fellow student Martina Millá Bernad, who added book publishers to the bibliography.

In a period of over ten years, I have often been assisted on this project by the same people—especially the reference librarians at Emory University's Woodruff Library and at the National Museum of American Art/ National Portrait Gallery Library. Greta G. Boers, Eric R. Nitschke, Marie M. Nitschke, David Vidor, and Marie M. Hansen (at Emory) and Martin R. Kalfatovic, Patricia Lynagh, and Stephanie Moye (at the National Museum) have my deep gratitude. Others, employed in archives, were able to give special help and went out

of their way more than once to do so. Consequently, I have very much benefited from the assistance of Julia I. Armstrong at the Provenance Index of the Getty Art History Information Program, Arthur Breton at the Archives of American Art, Catherine Gordon at the Courtauld Institute of Art's Witt Library, Donica Haraburda at the Inventory of American Painting and Sculpture, Claire Lloyd-Jacob at the Paul Mellon Centre for Studies in British Art, Martha W. Rowe at the Museum of Early Southern Decorative Arts, and Sarah Wimbush at the Heinz Archive and Library of the National Portrait Gallery in London.

For various contributions, involving research questions, I want to thank David Alexander; Brian Allen; Carol Damon Andrews; Barbara C. Batson; Betty Beesley; Shelley M. Bennett; David Bjelajac; Ruth M. Blair; Francis M. Blodget, Jr.; Gladys Bolhouse; Virginia Anne Bonito; Nathaniel Bowditch; Elizabeth Carroll-Horrocks; Richard L. Champlin; Deborah Chotner; Margie Christian; Kelly Peterson Cobble; Lorna Condon; Anne Crookshank; Ulysse Desportes; Stephen Deuchar; Gina Douglas; Peter Drummey; Judy Egerton; David Ellis-Jones; Lindsey M. Errington; Stuart P. Feld; Lee W. Findlay; Eileen Finnegan; Desmond FitzGerald, Knight of Glin; James Fowler; Burton B. Fredericksen; Holly Goetz; John D. Gordan III; Kellee Green; Katherine H. Griffin; Tammis Groft; John Gurnett; Maya Hambly; Robin Hamlyn; Michael Hammer; John Hayes; Margaret D. Hrabe; Kay R. Jamison; Thomas Knoles; Judy Larson; Stuart W. Lehman; Kate Macdonald-Buchanan; Anthony Malcolmson; E. Richard McKinstry; Colm McLaughlin; Christine Meadows; Melissa De Medeiros; Ellen G. Miles; James Miller; David Moore-Gwynn; David Morgan; Milo Naeve; Christine Nelson; Evelyn Newby; Patrick Noon; the Marquess of Normanby; Sir John Nugent, Bt.; Richard Nylander; Marilyn K. Parr; Kelly Peterson; Daphne Phillips; Faith Ponsonby; Martin Postle; Wendy Wick Reaves; Carrie Rebora; Sue Welsh Reed; Aileen Ribeiro; Lady Rosebery; the Viscount St. Vincent; John W. Sears; Peter H.

Sellers; Francesca Sherwood; Nathaniel N. Shipton; Colin Shrimpton; Jayne Shrimpton; Marc Simpson; Ene Sirvet; Lynn Smith; Margaret Smith; Allen Staley; Linda Stanley; Susan R. Stein; Erik B. Stocker; Lydia S. Tederick; Linda A. Thrift; Carol Troyen; William H. Truettner; Nadia Tscherny; Robert C. Vose, Jr.; Philip Ward-Jackson; Michael N. Webb; Shearer West; Gregory M. Wittkopp; Nathalia Wright; Michael Wynn; and Georgianna Ziegler.

One of my greatest debts is to Sally Pickering, who, while answering my letter about an ancestral portrait, told me of the existence of Henry Pickering's recorded interviews with Stuart. I am also indebted to Robert S. Cox of the William L. Clements Library at the University of Michigan, who first told me of Horace Holley's letter; to Elizabeth Kornhauser of the Wadsworth Athenaeum, who showed me a copy of Mrs. Samuel Farmer Jarvis's letter; to Ellen G. Miles of the National Portrait Gallery, who wrote to me about the references in the Wolcott Papers; to Lauren Suber of the Colonial Williamsburg Foundation, who sent me a copy of William Aitchison's letter concerning Cosmo Alexander; and to Peter H. Sellers, who called me when he discovered that he had notes by Jonathan Mason, Jr., titled "Recollections of an Octogenarian."

With regard to other primary references, Merl M. Moore, Jr., was especially generous in sharing pertinent information that he had gleaned, as an archival source, from nineteenth-century American newspaper articles on art. The 1846 article on portrait painting and the 1852 article on Stuart in Boston's *Daily Evening Transcript* made particularly significant contributions.

Of the many stages to a book, perhaps the most difficult is the final writing. In this respect, I want to express my deepest appreciation to Lillian B. Miller of the National Portrait Gallery for her careful perusal of the text in manuscript form. Her valuable suggestions were numerous—particularly on passages where I should expand—and they made the manuscript better than it might have been. I am grateful as well to Paul Staiti for his reactions after reading the text for Princeton University Press; and to James Meyer, my colleague in the Art History Department at Emory, for his discerning comments after going through a late version. Judy Spear, as copy editor, and the diligent staff at Princeton also helped immeasurably in turning the manuscript into a book. I owe the completion of the index to the professional help of Reiko Tomii and Kathleen M. Friello.

The support of my family, scattered near Boston, and of a long-time friend in London, Lady Arthur, helped to make many of my research trips more enjoyable than they would otherwise have been. I would like especially to thank my mother, Priscilla White Evans, and, not least, my patient daughter, Tamsen.

Introduction

This book is a new consideration of the life and work of the American artist Gilbert Stuart (1755–1828), in which the primary focus is on his ultimate achievement in portraiture. Among contemporaries, he excelled in the depiction of a moral intelligence. Like many other portraits produced at the end of the eighteenth century and the beginning of the nineteenth, Stuart's likenesses convey an uplifting sense of human dignity and personal virtue—the content usually associated with Neoclassicism. But he alone created what was acknowledged as a culmination of the moral type in his Athenaeum portrait of George Washington.[1]

As the dominant artist during the Federal period in the United States, Stuart is perhaps most interesting historically as a portraitist who operated at the juncture of present-day constructions of Neoclassicism and Romanticism. Yet, despite his prominence, historians have never examined his work, his stated views, and the public response so as to arrive at a clear understanding of his role within a time of changing pictorial traditions. As his contemporaries seem to have recognized, he acted knowingly within the context of the new intellectualism and historical self-consciousness that shaped artistic discussion in his day. He was an influential artist, schooled in artistic theory and practice, who fashioned his own, quite individual, creative response to contemporary European and American ideas about portraiture. Of all the early American artists, he was perhaps the most esteemed, in his own time, as a knowledgeable man with an original mind.[2]

—Stuart is the artist who, more than any other, helped to effect a shift in the orientation of American portraitists away from the sheer mimeticism of his predecessor John Singleton Copley to a greater recognition of the importance of a controlled content and of abstract aesthetic values. In doing so, he assisted in driving a wedge, as one historian put it, between the American artist and the American artisan. Indeed, in 1818, an admirer of Stuart made a telling contrast, as if in support of this, between his portraits and those by Copley and John Vanderlyn. Pleased with Stuart's fresh colors and lofty content, he observed: "The value of a picture is [in] the expression, and not the mechanical execution, you know."[3]

American born and trained abroad, Stuart had become relatively well versed in current European (especially English) art theory before he returned to the United States from England and Ireland in 1793. He had worked in at least three different, successive styles, as exemplified by the Banister, Waterhouse, and *Skater* portraits. In New York Stuart increased the lifelike quality of his work in *Richard Yates*, which might be considered a harbinger of portraits in a fourth, late style. The ability to assume more than one style at will was a gift he shared with his mentor Benjamin West in England; and in fact, the decorative color and visible brushwork of his English manner seem to have found special appeal as part of a great European tradition. He did not return consistently to the more corporeal and more sentient Yates-type portrait until his final years in Boston.[4]

Stuart's originality is evident early in his exploration of the concept of the sublime, particularly in his famous Athenaeum portrait of George Washington. Although merely a head, it is a landmark within the context of intercontinental ideas about the morally sublime. Yet for more than a quarter of a century after painting it, the artist developed in a different direction. He had long claimed that living, human flesh is "like no other substance under Heaven," but he pursued this otherworldly effect only sporadically before his last years. Not until then did he succeed in capturing the sublime effect of a spiritual, animating presence—a contemporaneous concept of the sublime that stems ultimately from the ancient philosopher Longinus—as opposed to the sublime character of extraordinary moral strength that is present in the portrait of Washington. A key example of Stuart's development, a likeness that radiates an indwelling energy, is Stuart's replica of his last portrait of the aging second president, John

Adams. In this case the effect of the sublime comes from the drama of the contrast between the animation (the energy and sentience) of the subject's expression and the physical decay of old age; notwithstanding its power, the subtleties of Stuart's attempt were understood only by close associates like Washington Allston. In their disparity, the Athenaeum portrait and the late Adams replica encompass what is arguably Stuart's chief historical contribution to the portraiture of his period.[5]

From about 1795 on, Stuart offered in his painted flesh—as in the Athenaeum portrait—what might be called a metaphysical incandescence. Responding to his pictures, a number of his American contemporaries equated the luminous, inspirited quality of this flesh and the "animate expression" of his heads with the depiction of the presence of a soul. The notion that a portrait expressed the sitter's soul involved highly subjective judgments, seeming typically to deal with questions of appropriate dignity. But in the case of Stuart's American work, it depended also on the conveyance of an inner animation and sentience. In his late concern with inwardness and an associative use of animation, Stuart went beyond his earlier imitation of the spirit of the antique and redefined himself in ways that remind us that he lived in the Romantic period.[6]

Some of Stuart's younger American contemporaries, notably Washington Allston and Rembrandt Peale, also tried to suggest the presence of a soul in their portraits. The attempt by these artists to include a metaphysical reference as a means of idealizing the sitter is a discrete phenomenon that separates their relevant work from most portraits by their predecessors and their successors. In fact, their effort draws them into fellowship with some seemingly dissimilar counterparts abroad, such as Joseph Mallord William Turner and Caspar David Friedrich, who produced landscapes suffused with light and the apparent message of God's imprimatur on all of creation. As a Boston art critic wrote in 1846, probably influenced by the precedent of Stuart's Boston portraits: "Under the homeliest, commonest countenance, there is an inner lamp of unrevealed beauty, casting up at times into the features gleams of its light. These translucent moments—its truest and best states—the artist must seize in order to effect a full likeness. This is the genuine idealization."[7]

While still relatively young, Stuart developed, as so many successful artists do, into a formulaic painter who sometimes did little more than meet the demand for a picture he had commodified as a "Stuart." He was an uneven portraitist who was inclined to lose interest in a likeness after completing the head. From at least the late 1780s on, but especially at the end of his life, he repeatedly allowed others to complete the secondary areas of his portraits. He used assistants such as Vanderlyn to do the preliminary blocking in of his replicas, and—as if to stress the importance of his autographic touch—in at least one instance, he seems to have added a few strokes to an assistant's copy of his *Washington* and sold it as his own. Yet he instigated and won the first known United States lawsuit against an entrepreneur who was selling unauthorized copies of an artist's work, in this case the Athenaeum portrait of Washington.

Stuart's own image as an irreverent punster and eventually an unrepentant rogue has prevented a number of historians from seeing his pictures as idealizations, much less subtle referents to the divine origin of creation. The historical bias is clear in one biographer's conclusion: "Stuart's work is no more flattering than we should expect from a study of his character." Unquestionably he is an artist with a damaged reputation that is not all of his own making. Stuart's daughter Anne wrote in 1843: "It has been [Stuart's] misfortune to be handed down to posterity by his enemies. [William] Dunlap has been his most conspicuous biographer. . . . Sometime since I had a conversation with Colonel [John] Trumbull, who was one of my father's old and intimate friends. I asked him what he thought of Dunlap's account of him,—if he should have identified him with that. 'No,' said the Colonel. 'Your father was a gentleman, not the tavern jester, he has represented.'" But beyond this false characterization, Anne and her sister Jane deplored the impression given by their father's "extraordinary stories" that he was dishonest. In particular, they objected to this implication in Dunlap's narrative, arguing that Stuart "was a man but little skilled in fraud," but Dunlap—who had known Stuart and who later served as a conduit for stories about him—actually defended Stuart's honesty repeatedly. He described the artist as amusingly careless about truth but not a man of deceit.[8]

Stuart—it is true—deliberately led the public astray at times with humorously fictitious accounts about himself, but his fictions are characteristically outrageous; the highly plausible embellishments that he seemed to invite and that were provided long after his death are more misleading. What strikes the scholar today, in reviewing the literature on Stuart, is not just that the

three most influential biographies progressively emphasize the more negative as well as the more humorous sides of his character. The last two also have in common the fact that they—along with a third conceived for children—can be considered historical novels. The earliest biography, written by Dunlap and published in 1834, is undeniably a primary source of information in that it includes reminiscences of many who knew Stuart. Important though it is, the book enters the realm of fiction with numerous quotations from the artist that were supplied long after the fact. The ring of truth in the extensive use of dialogue is deceptive; as Stuart's friend Allston pointed out, in a criticism of Dunlap, it is impossible for anyone to recall conversations accurately thirty or fifty years later. While the gist of what was said is probably preserved—and Stuart is brought into the present with an unusual immediacy—Dunlap's history is fundamentally flawed. Extending this approach with some knowledge of psychoanalysis, James Thomas Flexner (in 1955) and Charles Merrill Mount (in 1964) built on Dunlap, telling us repeatedly, without supporting evidence, what Stuart actually thought and felt. Their suppositions, which are in general agreement, offer an entertaining caricature of the artist. For both, he is "a little too clever": a shifty-eyed, tortured, social outcast in Flexner's estimation, and a confidence trickster in the elaboration provided by Mount. The character traits that Stuart's contemporaries remark upon as distorted in Dunlap—and this has some significance for the present book—are the very traits that the imaginings of Flexner and Mount further undermine: Stuart's sense of personal dignity and his moral consciousness.[9]

One other point concerning distortion and a historiographical perspective: Some historians appear to have embraced a chauvinistic need to make Stuart either essentially English or essentially American. Those who would have him be English stress that his mature pictures are consistently in the coloristically decorative English mode. Those who would have him be American—the far majority—stress a thumb-the-nose independence in his character and an unusual truthfulness in his portraits. In an instance of the latter, Stuart's Athenaeum portrait of Washington has even been called "a marvel of simple direct reportage." Rather than trying to fit Stuart into either scheme, we can define him more convincingly in the context in which we view his contemporaries Benjamin West, John Trumbull, and Washington Allston. All these American artists were molded by their many experiences abroad and their extensive knowledge of English and European precedent. What links the four most tellingly, however, is that they incorporated the internationally formulated, uplifting content of history painting into their works.[10]

The reader who wants to refer to a scholarly earlier biography of Stuart should turn to William T. Whitley's painstaking but unfootnoted effort of 1932. Lawrence Park's four-volume catalogue raisonné of Stuart's pictures (1926) is especially useful for information on the sitters. The present study argues against Whitley's conclusion that Stuart's powers waned in his late work, and it departs from the biographical approach of both Whitley and Park to address the artist's creative intellect. In doing so, attention is paid to Stuart's unevenness of effort and its probable cause. Plotting his stylistic development at crucial points is a way of following his creativity as well as providing a foundation for dating his work. Stuart rarely dated (or signed) his pictures, and he destroyed many, which has led to a great deal of controversy, especially with regard to the various portraits of Washington and Thomas Jefferson. The probable chronology of these and other portraits and the basis for that chronology are important issues that are discussed, as required, in the text or endnotes.

The late Boston portraits have been generally neglected by historians, and yet Stuart himself, and such knowledgeable observers as Allston and Dunlap, considered a number of them (those in which Stuart made a special effort) to be the culmination of his career. As if to support this assessment, one visitor to Stuart's studio in 1825, expecting him not to live much longer, reported: "It is said that he paints better now than he ever did." Unfortunately, the current literature on Stuart does not help us to understand this response.[11]

By way of exploring such reactions, this book introduces newly discovered documentation on the artist—the most important sources on him since Dunlap's 1834 biography, J. D. Herbert's 1836 sketch of Stuart's life in Ireland, and the 1939 publication, in their entirety, of Matthew Harris Jouett's 1816 notes on conversations with Stuart. What has come to light leads to historically based reinterpretations of previously known primary material and to a general reassessment of Stuart as more concerned than once thought with interpretative or imaginary, rather than descriptive, effects. The richest new sources on Stuart are Benjamin Waterhouse's "Autobiography" and "Memoirs"; John Cogdell's discussions with Stuart recorded in his diary; Jonathan Ma-

son's account of Stuart's painting procedure in his diary; Henry Pickering's "Interviews with Mr. Stuart in 1810 and 1817"; Horace Holley's 1818 report on the views of President James Monroe, and Monroe's guests, on the subject of Stuart's portraits; the unused portions of recollections of Stuart in letters (1876–79) addressed to George C. Mason; and other scattered letters and journal accounts that mention the artist. Of all these, the largest and perhaps the most crucial addition is the series of seven interviews with Stuart recorded by the Salem poet Henry Pickering.[12]

THE GENIUS OF GILBERT STUART

The Formation of an Artist

GILBERT STUART REMAINED REMARK-ably consistent in his specialization as an artist, having shown a preference for portraits in his earliest attempts at drawing. An African slave, Neptune Thurston of Newport, Rhode Island, first taught him to draw heads by demonstrating, on the top of a barrel, his own ability to capture various facial expressions with chalk. Thereafter, despite the occasional temptation to broaden himself, Stuart rarely strayed far from the human being, or, more precisely, the human face, as his preferred subject. A hitherto-unpublished account in the reminiscences of a boyhood friend, Benjamin Waterhouse, recalls Stuart's adolescent artistic efforts and confirms this early specialization.[1]

In the late 1760s in Newport, Stuart, at about age thirteen, entered into an artistic competition with Waterhouse, who shared his passion for painting and drawing. The agreed-upon criterion was absolute verisimilitude. While Waterhouse proved his ability by carefully transcribing numerous subjects (his favorites being trees and ships), Stuart depicted human heads with such single-mindedness that his competitor, who was almost two years older, assumed he had won the contest. Then an outsider—a well-trained professional artist from abroad—intervened, changing the outcome of the friendly rivalry and the course of Stuart's life.[2]

The Scottish portrait painter Cosmo Alexander was on a painting trip to Newport when one of his sitters —Dr. William Hunter, who admired Stuart's artistic skill—introduced the boy to the older artist. Recognizing Stuart's potential, Alexander took him under his tutelage and "let him copy some of his pictures." Thus both encouraged and challenged, the budding artist produced a careful imitation of Alexander's painting of a pointer dog lying on a carpet (both versions lost)—a work "so well done and so much admired" that Waterhouse reluctantly surrendered any pretensions to an artistic career.[3]

The artist's father—a Presbyterian clergyman's son from Perth, Scotland, and an able inventor—had come to the American colonies in 1751. He built a snuff mill at North Kingstown, near Newport, and ran a snuff-making business under the direction of a local Scottish physician-friend, Dr. Thomas Moffatt, until the enterprise failed. He then moved to a small property that his American wife, Elizabeth Anthony (daughter of a farmer, Albro Anthony), had inherited in Newport and, if hearsay is correct, he kept a shop, selling imported snuff, in the town. Their son Gilbert, named after his father, was born in the mill house on December 3, 1755, the youngest of three children.[4]

After early instruction from his mother at home, young Stuart attended a small, select Anglican grammar school connected with Newport's Trinity Church, which provided free tuition for those who could not afford it. His most memorable teacher there was a

learned and once-wealthy German aristocrat, a strict disciplinarian who had assumed his teaching position and the surname "Knotchel" after losing his fortune through American land speculation. As a schoolboy, Stuart was very capable, high-spirited, and self-willed. Despite his compulsion to punish Stuart for any prank —and there were many—the German schoolmaster always remembered him as outstanding. At home Stuart held the status of an only son, his elder brother having died in infancy. He was handsome and forward, according to Waterhouse, "and habituated . . . to have his own way in every thing, with little or no control from the easy, good-natured father." Along with a facility for drawing and reading, he developed an early love of music before he met Alexander, at about age thirteen or fourteen, late in 1769.[5]

Not long after their meeting, Stuart became Alexander's pupil and assistant, learning, as Waterhouse described it, "the grammar of the art" from him. When Alexander left Newport, probably in the fall of 1770, he took the young artist with him and traveled south. From a surviving letter we know that Alexander subsequently painted pictures in Philadelphia, Williamsburg, and Norfolk, having arrived at the last destination by May 21, 1771. Stuart continued with Alexander as far south as South Carolina and then accompanied him on a return voyage to Scotland, where Alexander, who had been in frail health, died in Edinburgh on August 25, 1772, at age forty-eight.[6]

At this point in historical accounts of his career, Stuart's early biographers differ over whether he attended the University of Glasgow. His two daughters stated that he had studied there, and both a student, Matthew Jouett, and an acquaintance, Henry Pickering, recorded the same claim in Stuart's own words. William Dunlap, who had known him, also thought this was the case. Waterhouse, however, did not mention it but instead focused on Stuart's poverty in Scotland, which had caused him great distress. Later biographers followed Waterhouse's narrative and found no record that Stuart had ever been a university student. But in the 1770s most of the students at Glasgow took classes without ever matriculating. Since Stuart became comparatively well educated—such that others would even think him a scholar—and since he emphasized his education there, we might differ from the later biographers and accept his statement that he, at least in some fashion, did attend the university. Alexander is reported to have left his young charge in the care of his debt-

ridden brother-in-law, Sir George Chalmers, a baronet who was also an Edinburgh artist. If Stuart's daughter Jane is correct, Sir George carried out Stuart's father's original plan for his son by placing him at the University of Glasgow, but he then abandoned him with little money. As if to support this interpretation, a well-educated observer in 1818 called Stuart well read: "He must have studied books attentively at one period of life, and he retains his latin very well." About a decade later, another learned acquaintance wrote of Stuart: "His literary acquirements were of a high order, for a professional man." Arguably a university experience must have laid the foundation that would lead to such an estimation. After struggling financially for a time, Stuart worked for his passage back to America aboard a collier bound for Nova Scotia, according to Waterhouse, and then proceeded farther to Rhode Island, where he arrived "without suitable clothing to appear in the streets."[7]

During the time Stuart spent in Glasgow—probably more than a year—he is likely to have painted some portraits; none, however, is known to be extant. He reappeared in his father's household possibly by the fall of 1773 and certainly in time for the Newport town census that was taken on June 1, 1774. Stuart was counted as a nineteen-year-old male with his parents and one black slave—his older sister, Ann, having married and left the household. During this second Newport period, Stuart pursued his dual interests in music and art, both so strong that, according to Waterhouse, it was difficult to say which was the "ruling passion." Performing on both keyboard and flute (and possibly other instruments as well), he composed original music; and with Waterhouse he hired a muscular blacksmith to pose while he made careful anatomical drawings. The young artist debated questions of artistic import with Waterhouse, who now aspired to study abroad and become a physician, and he also painted his earliest surviving oil portraits.[8]

So little is known about this beginning period that the few Newport pictures assume considerable importance as the only indicators of Stuart's early artistic development. What appears stylistically to be the first is an ambitious double portrait, *Christian Banister and Her Son* (fig. 1), that Stuart painted of the wife and four-year-old son of a wealthy, Harvard-educated Newport merchant, John Banister. Stuart completed a companion portrait of Banister himself, shown to just below the waist, with one hand inside his waistcoat and

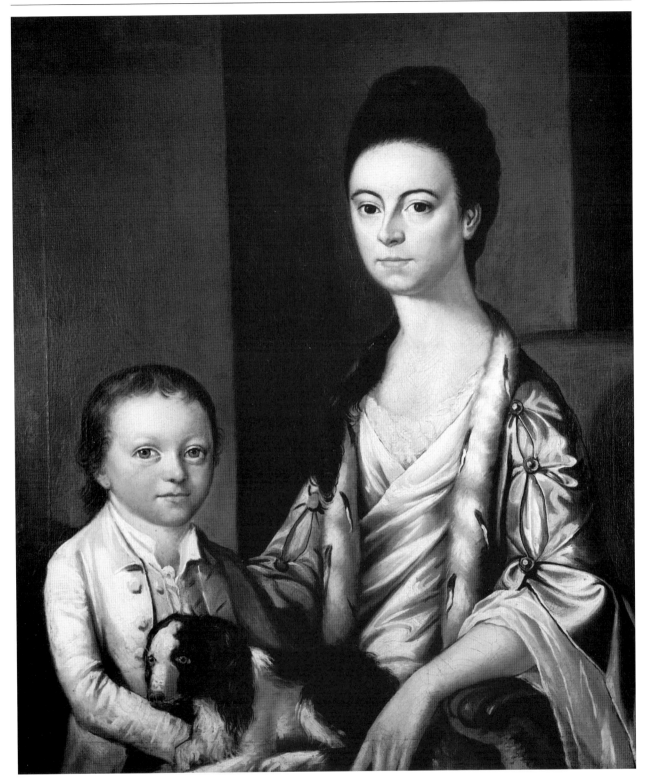

FIG. 1. *Christian Banister and Her Son,* ca. 1773

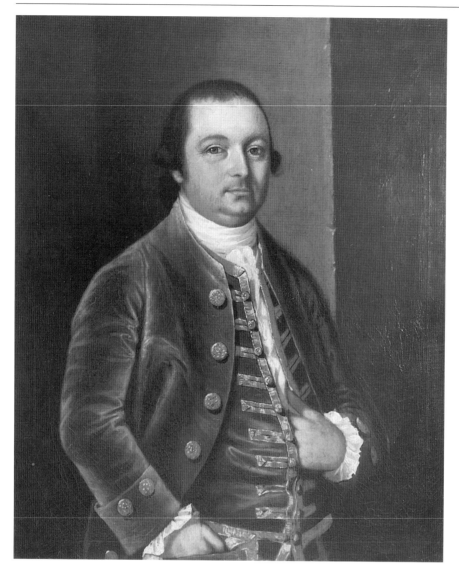

FIG. 2. *John Banister,* ca. 1773

the other in his coat pocket (fig. 2). The two portraits reveal the strong influence of Stuart's Italian-trained instructor, Cosmo Alexander. Indeed, Stuart may well have been hired, shortly after his return, as Alexander's heir and substitute. Comparison with an earlier Newport picture by Alexander, *Deborah Malbone Hunter and Her Daughter Eliza* (fig. 3), is instructive. Although Alexander's modeling is more subtle, and his mouths and eyes are more expressive, his portrait of a woman and child is especially similar to Stuart's in the way the facial features are drawn and then modeled so as to integrate them with the head. The two artists share commonality in flesh coloring as well. For instance, Mrs. Banister's flesh, like Mrs. Hunter's, is quite pale, except for a slight tinge of pink in the cheeks, and is modeled in gradations of the light gray underpaint. The

same three-dimensional effect is created in both women by the device of a reflected light within the shadow under the chin. Stuart's work becomes more awkward and amateurish below the neck, including Mrs. Banister's extraordinarily sloped shoulders, following a fashion that, in this case, has become an anatomically impossible extreme. Her ermine-trimmed attire strongly suggests that the costume details, and probably the body, were painted not from life but, instead, from the artist's imagination and under the general inspiration of English portrait engravings.

It was fairly common at the time to use an aristocratic prototype as a role model for a portrait of an upper-middle-class or middle-class American; the colonial artist borrowed not infrequently from imported prints to supply impressive backgrounds, a dignified

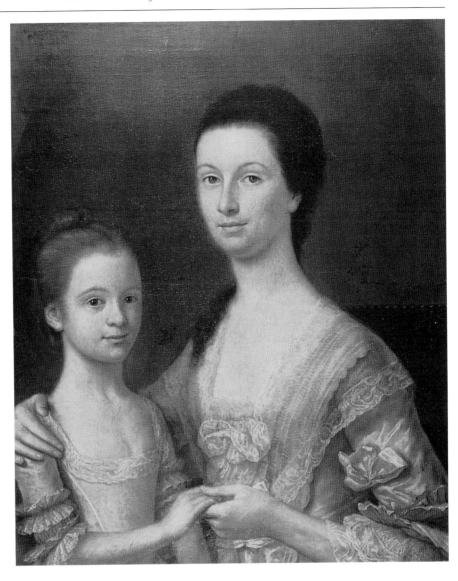

FIG. 3. Cosmo Alexander,
*Deborah Malbone Hunter and
Her Daughter Eliza*, 1769

pose, and highly fashionable costuming. Mrs. Banister's luxuriously trimmed robe is, on the one hand, quite pretentious and more suitable for a peeress; on the other hand, it is not entirely unexpected, given that the Boston artist John Singleton Copley incorporated ermine into some of his pictures of elegant ladies from the late 1760s and early 1770s. With the addition of her son and her lapdog, Mrs. Banister displays the desirable traits of being both genteel and nurturing as a mother. As pentimenti reveal, the boy's right arm, now under the dog, originally folded across his chest so that his hand rested inside his coat. This "hand-in" pose, meant to express gentility, was especially popular in English portraits of gentlemen. Stuart used it habitually with his early standing male figures.[9]

There is a greater emphasis on achieving plasticity

in the somewhat later portrait of William Redwood (fig. 4), a director of the Redwood Library in Newport. Certain mannerisms that can be found in Alexander's work are seen again here—for example, the use of two curved lines to define the upper eyelid and some modeling to suggest a slightly puffy lower lid. Although the three-quarter view of the head, facing toward the right while looking outward toward the spectator, is identical to Banister's portrait, the shading of the shadowed side of the face is darker and conceived more as a whole, the area around the mouth being partially covered by a blanket shadow. As in Stuart's other early pictures, the lighting is not entirely consistent, but the figure helps to define a surrounding space by casting a shadow against a background wall.[10]

In 1773 and 1774, if not before, Stuart had to have

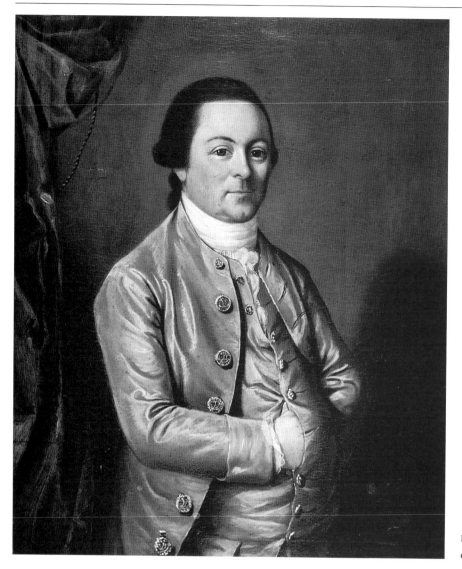

FIG. 4. *William Redwood,* ca. 1774

been aware of the presence of Copley, then the most capable artist in the American colonies, in nearby Boston. Seventeen years his senior, Copley had never studied abroad but had enormous natural talent for producing a strikingly realistic likeness.[11]

Stuart's increased interest in trompe l'oeil effects and his use of almost black shading on the faces in a dual portrait of Francis Malbone and his brother Saunders (fig. 5) appear to be the result of looking more closely at Copley's portraits, which he could have seen in either Boston or Newport. The projecting table edge, the shiny inkstand, the foreshortened book, and the arched hand casting a shadow across the writing paper all signal an apparent effort to rival or emulate Copley, who excelled beyond all other American artists in illusionistic effects. As in some of Copley's pictures too,

there is a new mid-eighteenth-century informality in the poses, the sitters being shown engaged in what might be considered everyday activities. On the whole, this Newport picture represents a step away from Alexander's formulaic precedent and an increased reliance on careful observation, as in the more convincing modeling of the boys' eyelids and eye sockets, and in a more sophisticated use of lighting for three-dimensional effect. For instance, to create the sensation of a rounded head in space, Stuart modeled Saunders's face with shadow that becomes lighter with reflected light from behind as it curves back in space. Also the figures are deliberately separated from the background by light and dark contrasts, such as in the shafts of light behind them both.

The developmental gap between surviving pictures

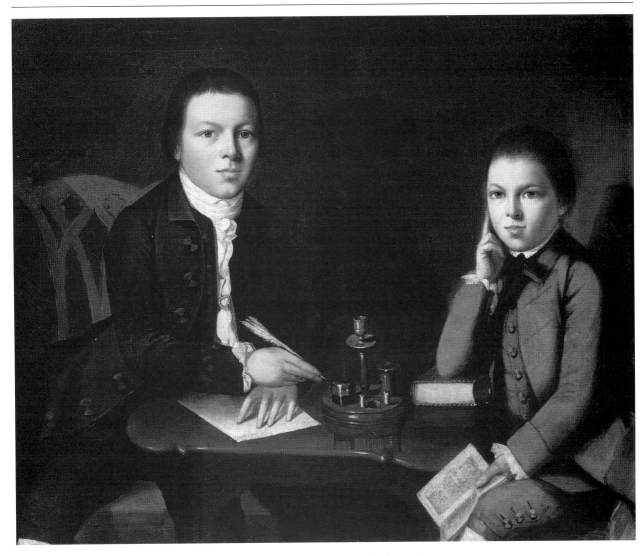

FIG. 5. *Francis Malbone and His Brother Saunders*, ca. 1774

becomes particularly pronounced with Stuart's extraordinary portrait of Benjamin Waterhouse (fig. 6, pl. 1). Being more than a mere borrowing from Copley's signature effects, as in the inkstand reflection on the table in the Malbone portrait, Stuart's *Waterhouse* shows a much deeper understanding of how Copley actually worked, with painstaking observation of minute detail. Perhaps, too, Stuart's friend was willing to sit more patiently than most sitters and have his face studied in the manner of the blacksmith's anatomy. This was likely to have been not a commissioned portrait but rather a gift to Waterhouse or to Waterhouse's family, possibly because the student-physician, shown in a meditative posture, intended to depart soon to be educated in Europe. As in Copley's 1768 portrait of Paul Revere (fig.

7), the right side of the face is almost covered by a large and simplifying dark shadow, which is relieved by the light hitting the center of the far cheekbone. Following Copley further, Stuart incorporated illusionistic tricks such as the shadow of the projecting edge of the coat against the neck cloth, the receding shadow on the book lock, and the projecting angle of the open book, now somewhat cropped by the frame. This same illusionism defines the figure of Waterhouse, who, unlike the Malbone brothers, has eyelashes (original) on both lids, messed eyebrows, a delicately modeled forehead that is slightly furrowed, and a clearly suggested ear behind his hair. There is, in general, more modeling throughout his face, but perhaps the most striking departure from the Malbone portrait is that Water-

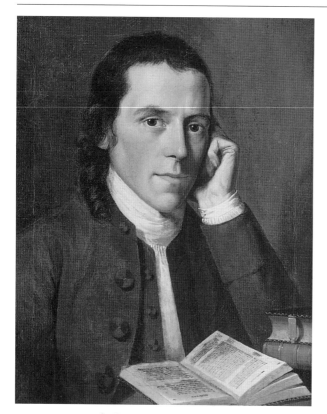

FIG. 6. *Benjamin Waterhouse*, 1775

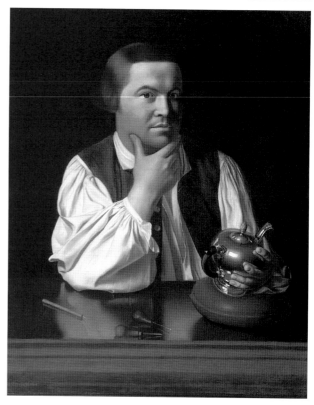

FIG. 7. John Singleton Copley, *Paul Revere*, 1768

house's more focused eyes, like Revere's, convey the impression of actual sentience.

Stuart may well have visited Boston sometime during the spring, summer, or early fall of 1774. The evidence is a statement made by his fellow artist Mather Brown, who recalled that Stuart was the first to teach him to draw at about age twelve in Boston (Brown turned thirteen in October of 1774). The argument for yet a later date is Waterhouse's more precise recollection that "Stuart was shut up in Boston, when the first blood was spilt at Lexington, in our contest with Great Britain, April the 19th, 1775, and escaped from it about ten days before the Battle of Bunker-hill," which would be June 7, 1775. Waterhouse is also the authority for giving the time and place for his own portrait as January 1775 in Newport. It is of course possible that Stuart made more than one trip to Boston, giving lessons to Brown during a longer stay, while living "near Mr. Whiting's, a print-seller near Mill Bridge." Copley sailed from Boston for England in June of 1774, leaving his family behind for a year, during which time Stuart could have seen his studio and met his half-brother Henry Pelham, also an artist.[12]

While Copley seems to have been torn between his wife's loyalist family and his own sympathy for clients who were rebels, Stuart wholeheartedly embraced the cause of the Americans. Waterhouse gave a lengthy account of an occasion before the war, when he and Stuart were sailing in Newport Harbor and got their boat caught between the bow of a British frigate and the buoy that floated over its anchor, whereupon a sentinel on the forecastle ordered them to tack and appeared to threaten to shoot. They obeyed the order, but Stuart became incensed. "'What is all this,' he cried, 'it is our harbor and our land.'" Waterhouse, a self-proclaimed loyalist who was used to arguing with Stuart over the growing conflict, replied that most sailors would keep the king's ship "at an awful distance." "'Hang the King,' exclaimed Stuart, 'what is he to us? He lives too far off to do us any good. . . . [W]hen they want sailors, they steal our people out of our own ships and carry them away from their families like so many African negroes.'" As the situation worsened Stuart found himself in heated disagreement with his loyalist father.[13]

Years later he told Pickering (and also Jouett): "'My father did not espouse the patriot cause, and so to get me out of harm's way, sent me abroad.'" Having bought farmland in Nova Scotia in 1761, the year that the snuff-

making business failed, his father planned to move there in the summer of 1775, his wife and daughter to join him in a few months. Given the alternative of Nova Scotia, Stuart decided to follow Waterhouse and pursue his talent in London, then the artistic capital of the English-speaking world. When he finally set sail from Newport on September 8, 1775, the harbor had become so dangerous that a British man-of-war confronted his ship and held it near the entrance for almost a week before allowing it to leave. Meanwhile, Waterhouse had not only preceded him to London but had also, by the time of Stuart's arrival, gone on to Edinburgh in pursuit of his long-desired medical training.[14]

In choosing London, Stuart had one very attractive precedent, aside from Copley, that probably influenced his decision. The Pennsylvania-born painter Benjamin West had been so successful there that he achieved fame on both sides of the Atlantic. The war for colonial independence, as West and others found, did not generally constitute a career obstacle. Most Americans in the English capital were assumed to be loyalists, but such was the division among Londoners over the mother country's treatment of her colonies that sympathy for the American cause was also widespread. West, who was a generation older than Stuart, had benefited from three years of study in Italy before arriving in London in 1763. Almost at once he attracted considerable attention as a painter of mythology and of ancient and contemporary history, his most famous work being his large and dramatic painting *The Death of General Wolfe* (fig. 8), which showed a relatively recent British hero dying in Canada in the midst of his own victory during the French and Indian War. Stuart would not achieve such instantaneous recognition in London; in fact, he struggled for more than a year there before his fortune began to change. When the shift occurred, it would be through the agency of West, who had been one of the founders of the Royal Academy of Arts in 1768, and

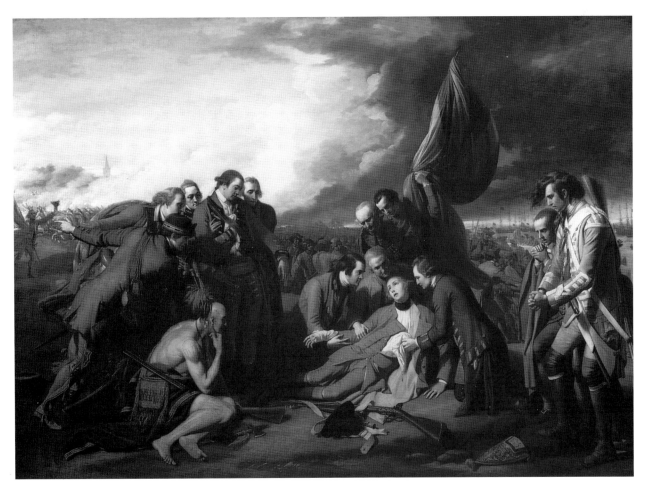

FIG. 8. Benjamin West, *The Death of General Wolfe*, 1770

who after winning the patronage of George III in 1772, carried the title "Historical Painter to the King."

Although Stuart had been helped financially by his mother's brother, Joseph Anthony, a thriving merchant who visited Newport from Philadelphia, he had little money left after he reached London. His daughter reported years later that he "went into cheap lodgings, now and then painting a portrait at prices so low as scarcely to give him bread." As he grew more desperate, he reverted to his old love of music, visiting every concert hall in London and eventually—probably in 1777—auditioning successfully as a church organist. He was still genuinely split between the two careers; when he earned more money, he hired a German musician—a member of the king's band—to give him advanced lessons on the flute.[15]

Upon returning to his London relatives in the summer of 1776 after nine months as a medical student in Edinburgh, Waterhouse found Stuart dejected, on his easel an unfinished group portrait that remained there for a long time and may never have been completed. Stuart was strong willed—stronger, Waterhouse thought, than himself—but he was also capricious and prone to procrastination. "With Stuart," Waterhouse recalled, "it was either high tide or low tide. In London he would sometimes lay a bed for weeks, waiting for the tide to lead him on to fortune." Yet Waterhouse admired the young artist, as did so many others, for his exceptional intelligence and for his "aptitude to excel in every thing to which he chose to direct his strong faculties." The two friends agreed to devote one day a week to viewing pictures, wherever they could gain admittance.[16]

Stuart's earliest known English portrait, *William Curtis* (fig. 9), published here as his work for the first time, can be linked to the artist through both style and documentation. Waterhouse mentioned Curtis as one of the

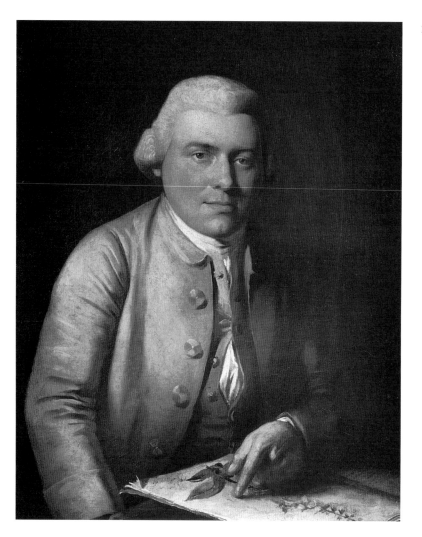

FIG. 9. *William Curtis*, 1776/77

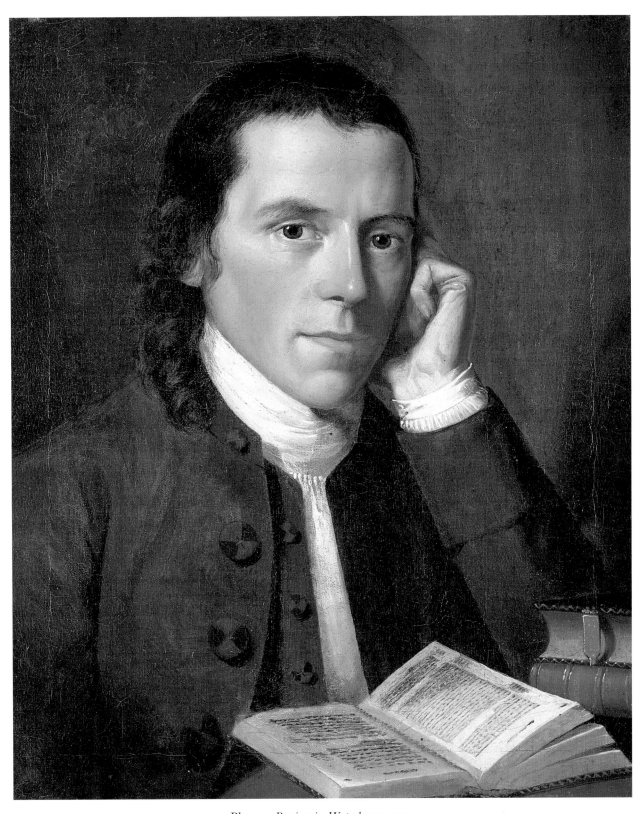

Plate 1. *Benjamin Waterhouse*, 1775

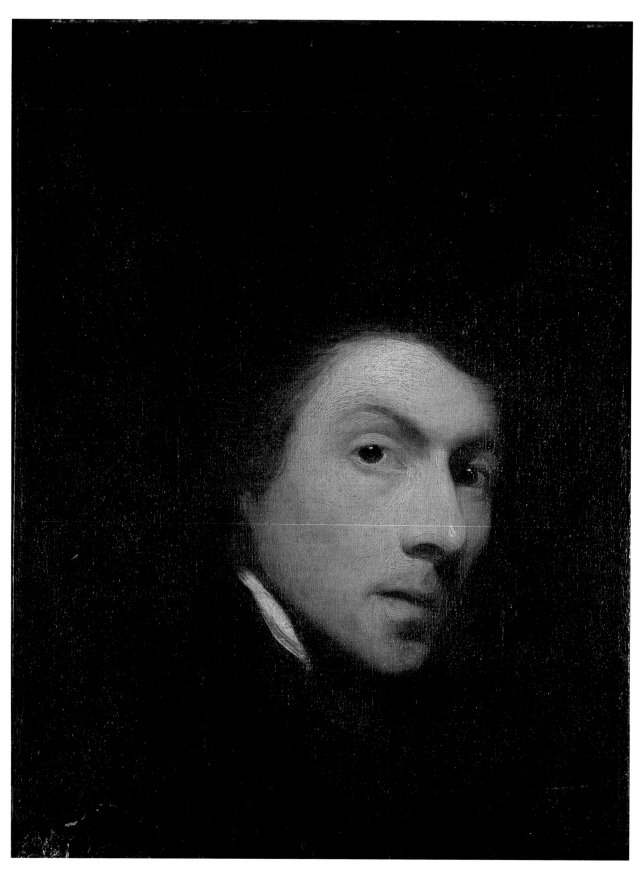

Plate 2. *Self-Portrait*, ca. 1778

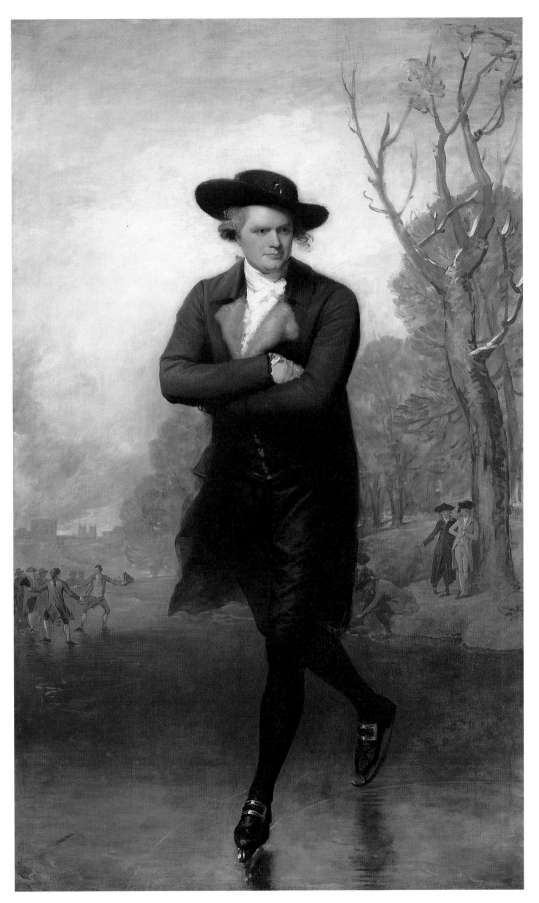

Plate 3.
The Skater
(Portrait of
William Grant),
1782

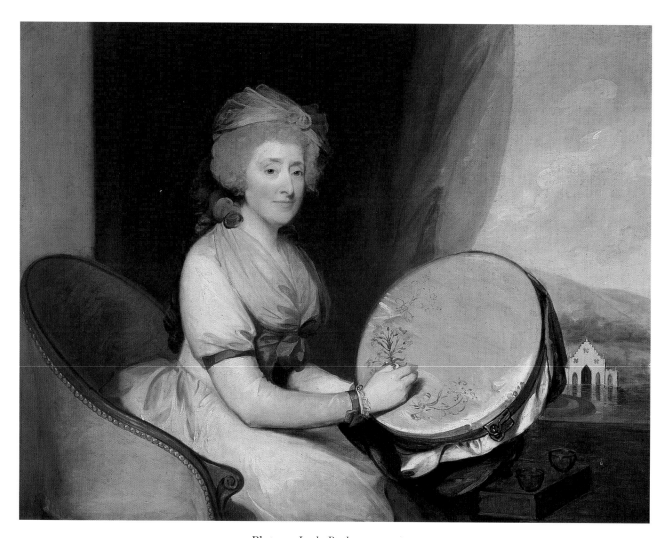

Plate 4. *Lady Barker*, ca. 1790

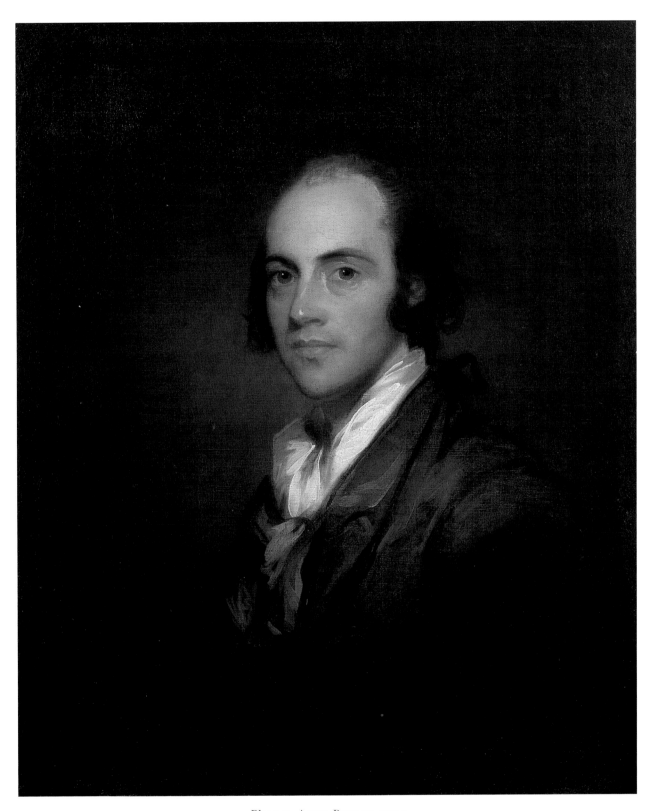

Plate 5. *Aaron Burr,* ca. 1794

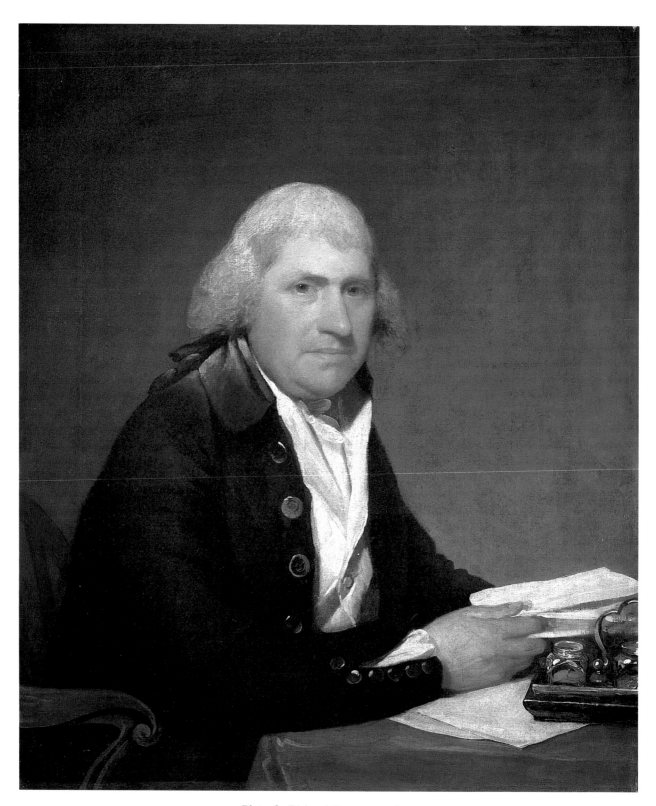

Plate 6. *Richard Yates*, 1793/94

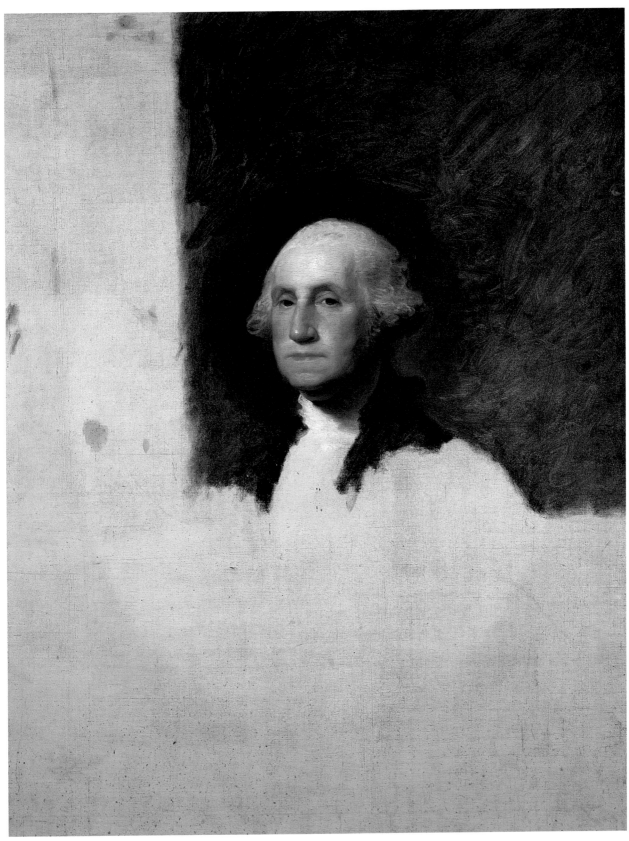

Plate 7. *George Washington* (Athenaeum Portrait), 1796

Plate 8. *Mrs. Samuel Blodget*, ca. 1798

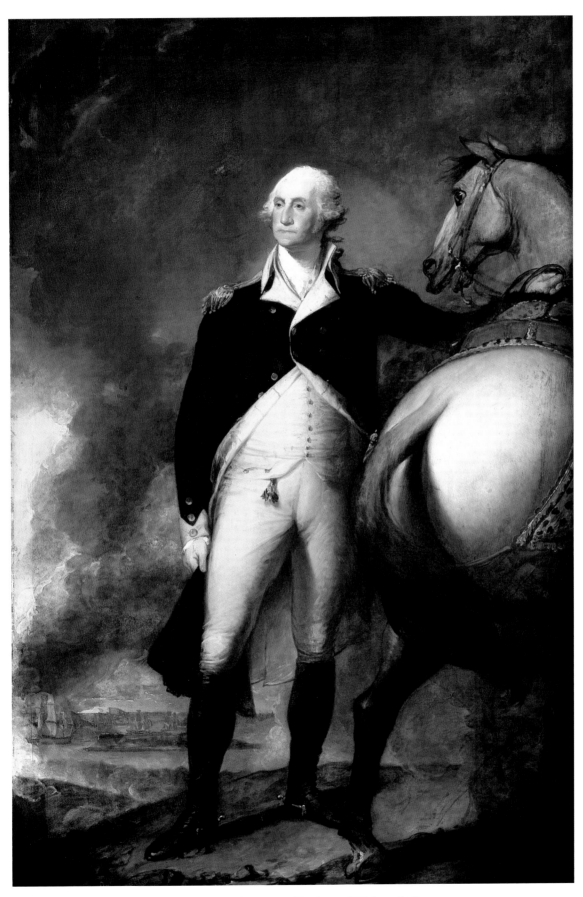

Plate 9. *Washington at Dorchester Heights,* 1806

Plate 10. *Lydia Smith*, ca. 1805

Plate 11. *Judge Stephen Jones*, ca. 1813

Plate 12. *Phebe Lord (Mrs. Thomas Cogswell Upham)*, ca. 1825

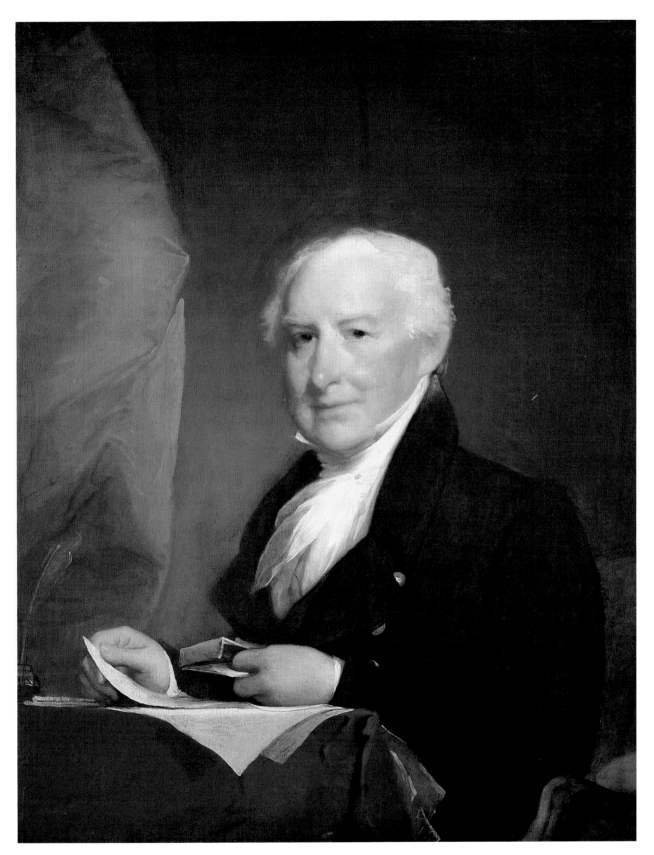

Plate 13. *William Winthrop*, ca. 1825

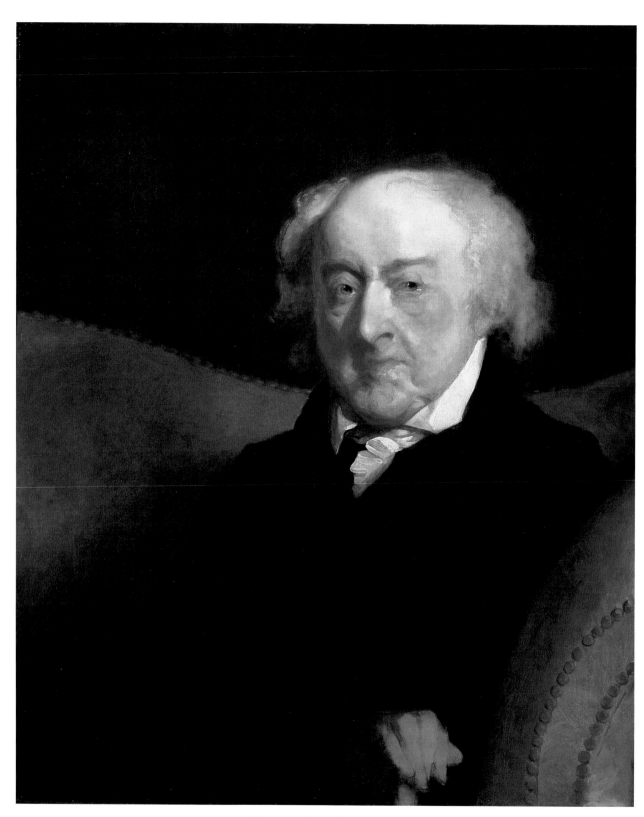

Plate 14. *John Adams, 1826*

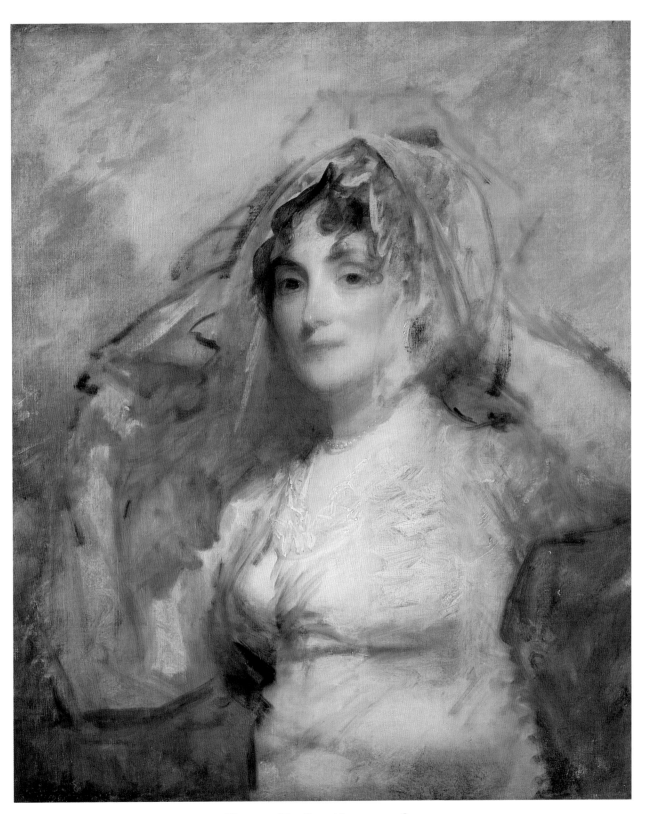

Plate 15. *Mrs. Perez Morton*, ca. 1802

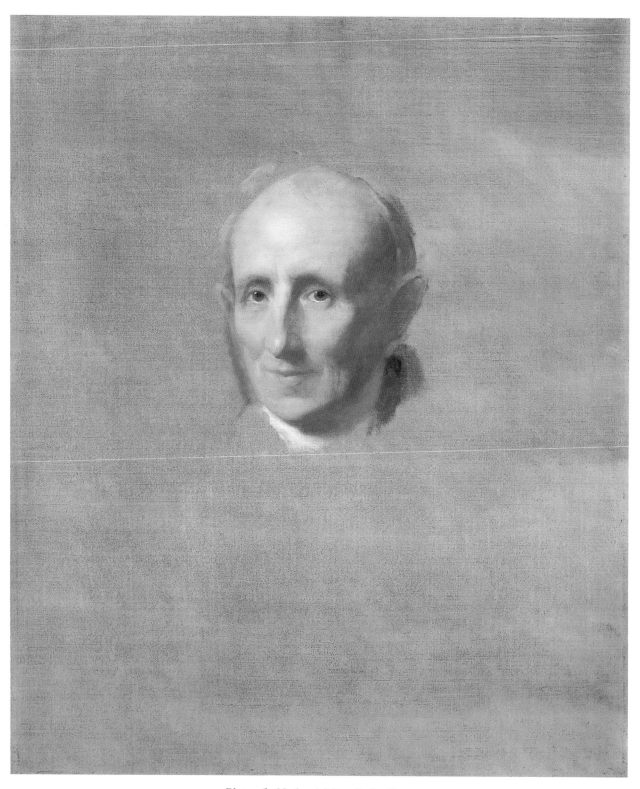

Plate 16. *Nathaniel Bowditch*, 1827

earliest subjects that Stuart painted in London, probably in 1776, and this portrait, never convincingly attributed, fits that date. At the time of the sitting, Curtis had commenced the process of publishing a piecemeal edition, by subscription, of his treatise on wildflowers, *Flora Londinensis*. A fascicle with a plate showing a foxglove, intended for the first volume, is included in the painting, which means that the portrait must have been done before the completed volume was published in 1777. Whatever the circumstances of the commission, Stuart had a connection with his subject, an apothecary by profession, in that Curtis was a member of the London Quaker community, and he lived on the same street (Gracechurch) as Stuart and two of Waterhouse's cousins who, like Waterhouse, were also Quakers.[17]

The portrait of Curtis is signed at the lower left with a signature that is now illegible. Nevertheless, what remains conforms, in broken fashion, to the artist's usual signature in cursive script—in the rare cases where it appears—namely, "G Stuart" with the initial drawn as a lowercase "G" but enlarged to the size of a capital. Stylistically the picture is convincing as by Stuart; so similar is it, in fact, to his earlier portrait of Waterhouse that a comparison is enlightening. Like that portrait, it is relatively smoothly painted and carefully defined, although the brushstrokes become more visible on the white shirt front and on the hand, which was apparently added after the table was painted. Stuart's continued interest in trompe l'oeil effects is apparent in the creases of material along the arm, the outward turning edge of the coat, and the bent corner of the illustration. The dark brown shadow on the far side of the face, as in the Waterhouse portrait, is retained with the same faint border of light at the edge, but the modeling appears to be generally more sophisticated; witness the softer highlight along the bridge of the nose and the lighter spot, indicating a change of surface, within the shadow at the far corner of the mouth. Parts of the head are less anatomically probing, less detailed than in *Benjamin Waterhouse*—for example, in the region around the near eye. Yet the irises of his eyes are modeled so as to convey a new transparency.[18]

Despite Waterhouse's efforts to find portrait commissions for his friend, including one for a full-length picture of Dr. John Coakley Lettsom, which Stuart never finished, the young artist continued to be destitute and in debt. Finally, probably in December of 1776, in a fairly emotional state and possibly ill from depression

and lack of food—for he lived mostly on crackers—Stuart wrote to Benjamin West. Having heard, undoubtedly, of West's kindness toward other American artists, he begged him for help. Saying that his hopes had been "blasted," he wanted to be able "to live & learn," he told West with excessive humility, "without being a burthen."[19]

Welcoming Stuart warmly—as he did so many other American artists—West gave him a few guineas and, after seeing his work, hired him at "half a guinea a week for paint[ing] draperies & finishing up West's portraits." He also provided him with studio space in his house and gave him further instruction in painting. Although there is no known record of his first reaction to Stuart's work, he might well have offered some of the same advice that he had written to Copley on first seeing Copley's portraits exhibited in London. What he had said then was influenced by the opinion of Sir Joshua Reynolds, now the first president of the Royal Academy, for the two artists had discussed Copley's work together. West's main criticism of Copley's *Boy with a Squirrel (Henry Pelham)* (Museum of Fine Arts, Boston) was "at first sight the picture struck the eye as being too liney, which was judgd to have arose from there being so much neetness in the lines. . . . [I]n nature every thing is round, or at least partakes the most of that forme which makes it impossible that Nature, when seen in a light and shade, can ever appear liney."[20]

Probably in response to such advice from West and others, Stuart set himself, in 1777, the task of drawing a child without depending on visible edges or outlines. The resulting small sketch, inscribed and dated on the reverse (fig. 10), was lent to Stuart's memorial exhibition of 1828, probably by Waterhouse. According to the inscription, which contains information that is condensed in the exhibition catalogue, Stuart drew the figure while he and Waterhouse were visiting Waterhouse's relative and benefactor, Dr. John Fothergill. It is a copy after one of the replicas—perhaps the 1777 version in Sèvres china—of Jean-Baptiste Pigalle's 1749 *Child with Bird Cage* (fig. 11), but the way that it is done, as an unfinished study in pencil and white chalk, so corresponds to the well-known recommendations of Leonardo da Vinci in his *Treatise on Painting* that Stuart may well have been working from Leonardo's ideas. Modeling in gradations of white to gray makes the head appear round; to suggest surrounding space, it is separated from the background not by a dividing line but, as Leonardo recommended, by sharply contrasted

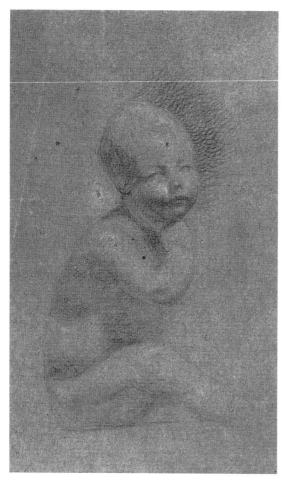

FIG. 10. *Seated Baby,* 1777

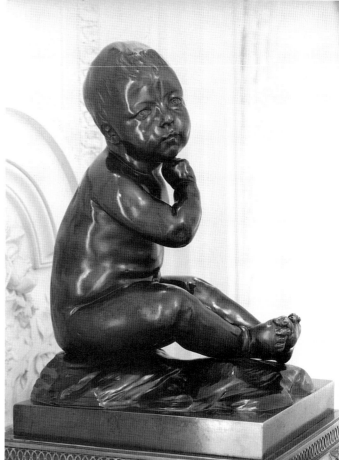

FIG. 11. Jean-Baptiste Pigalle,
Child with Bird Cage, 1749

values. Thus the pale brown color of the paper is set against a framing area of dark imbrication to establish the right edge of the face, while the shadowed left side of the head meets the middle value of the colored paper. The curve of the pencil stroke on the face conforms to the projection and recession of the original sculpted form, and, typically, Stuart's interest is predominantly in the head.[21]

As the result perhaps of studying pictures in London by the Old Masters Titian and Sir Anthony Van Dyck, Stuart rejected emphasis on line much more than West ever did; in fact, West, in the 1790s, introduced fairly pronounced outlines in his work. To clarify the contrast between them, Stuart told the Irish artist James Dowling Herbert years later a witty story about an exchange he had had with West in West's studio. Stuart had just informed his master that he would give up his short-term position as organist to focus on portrait painting.

"'Why, you can't draw?' was the response, to which Stuart replied: 'I'll paint, though.'" West's words are unlikely, but the point of the story, a difference in emphasis between the two artists, is undeniably true. Stuart did describe more explicitly, probably in 1805, what, in his opinion, chiefly distinguished the visual impact of his work from West's as "the effect of projection" without "depending merely on the accuracy of the outline."[22]

West, as an instructor, habitually gave positive criticism and much practical advice, such as how adjacent colors will affect each other or how only certain colored glazes can be used on top of certain colors but not on others without a detrimental effect. Usually he resorted more to demonstrating than explaining, for he was not a very articulate man. Yet he thought of painting as scientific, as something that could be taught by rules. One close observer, James Northcote, described him as "a learned painter, for he knew all that had been

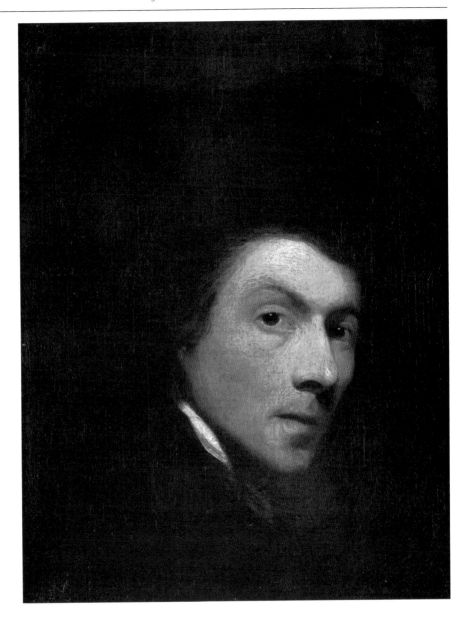

FIG. 12. *Self-Portrait*, ca. 1778

done in the art from the beginning; he was exactly what is called 'the schools' in painting, for he did everything by rule, and could give you chapter and verse for every touch he put on the canvas." Like Reynolds, he often referred, in a comparative fashion, to the Old Masters from the fifteenth through the seventeenth century, and, as if to underscore this emphasis on precedent—again like Reynolds—he had a collection of Old Master paintings that he kept on view. Fortunately for his students, he did not try to impose on them his style or his own particular ambitions as a history painter; rather, he encouraged them to follow their own bent. He saw the opposite approach as the major flaw with past schools of art: "Instead of being content to amputate

wild excrescencies [*sic*], they have pruned down the natural shoots, and distorted their natural direction, so that every plant has borne almost alike."[23]

Stuart's next known work, a self-portrait (fig. 12, pl. 2), marks what appears to be the greatest leap in his artistic career. From this point onward he discarded some of his emphasis on the minute representation of the sitter—as Reynolds exhorted the students at the Royal Academy to do—and embraced more fully the great tradition of Venetian and Flemish oil painting that was ever after a major source of inspiration to him. The story that Stuart later told Pickering about this picture makes the distinction clearer: Hurrying down a London side street, Stuart caught sight of a painting

exhibited for sale on a door. It was a portrait by the early-seventeenth-century English artist William Dobson, who was much influenced by Van Dyck but, unlike him, favored sharp contrasts in chiaroscuro and a less elegant presentation of the sitter, occasionally even with a slightly open mouth. Stuart became enthralled by the painting, and, although he could not afford anything near the price of twelve shillings, he borrowed the money and bought it. Directly afterward, he carried his new acquisition to West's painting room, where West was so charmed by it that he said he must have it. West offered twelve guineas, fifteen guineas, fifty guineas, but to no avail. "Stuart was inexorable. There is one condition, however, said Stuart, upon which I will part with the picture. I know, said he, addressing himself to Mr. West, I know your candour & goodness —I ask no equivalent for the picture, but when you tell me I can paint a portrait as good as this of Dobson's, the picture shall be yours." West quickly agreed, but added, considering Stuart's abilities, that it would take some time. Stuart "took the picture, examined it—studied it—& having no one to sit to him, painted himself. Mr. West acknowledged the excellency of the work, and obtained what he so much desired." Actually, Stuart loved to embellish the truth, particularly when by doing so he could play the role of a hero making a grand or clever gesture. Inasmuch as West did not own a Dobson portrait at the time of his death, he may well not have acquired the picture. What *is* certain, however, is that Stuart would not have claimed that a particular artist's work inspired him if it were not true.[24]

Having perhaps made his point with West, Stuart is believed to have given the self-portrait, in an unfinished state, to Waterhouse, most likely after Waterhouse returned from the University of Leyden in 1780, on his way back to Rhode Island. It must have been sometime after 1808, when Waterhouse described the painting as unfinished but as "a wonderfull fine piece, painted in broad shadow," that the completed part, the head, was cut out of the canvas, restretched, and framed. A contemporary account suggests that the picture originally showed Stuart holding a paintbrush in his right hand. When it was exhibited in 1828, a journalist described it thus: "He is represented as looking in a mirror, intently copying his own face." Probably echoing Waterhouse, this writer added that Stuart "painted it in London for Dr. Waterhouse, and it was greatly admired by Mr. West, who kept it a year or two in his own collection. . . . The mouth is relaxed, making it a pic-

FIG. 13. Benjamin West, *Self-Portrait*, ca. 1776

ture of *intense attention* in copying his own features and mind. He intentionally gave the whole, in the colouring, and in the indistinct marks of the Rubens-hat, shirt collar, and hair, the cast of an old picture." Stuart, too, commented, on seeing it years later, that he had deliberately tried to simulate an old picture, that he had "olified it," or used transparent glazes for this purpose.[25]

The self-portrait is a deliberate display of talent that does not follow a specific prototype by Dobson. Rather, it is done in the spirit of Dobson's pictures—as expressed in the glazing, the dark coloring, and the slightly open mouth. In its pose and broad-brimmed hat, it is a partial quotation from West's earlier self-portrait (fig. 13) in which the artist showed himself in a hat and pose made famous by its association with Peter Paul Rubens's self-portrait (fig. 14). By referring to this earlier use of precedent, Stuart built on his instructor's example and created a picture that, although unfinished, was deliberately more "old masterly" than West's. With much of the painting lost in shadow, the effect is also more generalized and timeless than in West's portrait. The head is painted with a cohesiveness and a new confidence to rely on mere suggestion so that instead of drawn lines or hard edges, there are soft, melting transitions in modeling; in the open expression of the face,

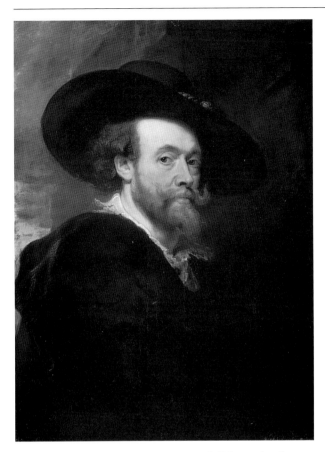

FIG. 14. Sir Peter Paul Rubens, *Self-Portrait,* 1623

there is also a new lifelike immediacy. As an artful counterpoint to the darkness surrounding it, a single streak of white indicates a neck cloth glistening in the foreground light.[26]

In using combined precedents, Stuart was following the advice of Sir Joshua Reynolds. As president of the Royal Academy, Reynolds delivered lectures on art to students and members at the annual presentation of awards, from the establishment of the academy in 1769 to 1790, when he entered semiretirement (to be succeeded two years later by West). These discourses, given each year at first and then every other year, were published, widely read, and much discussed in London art circles. One of Reynolds's themes (echoed by West) is succinctly expressed in his sixth discourse, delivered in December of 1774: "That artist who can unite in himself the excellencies of the various great painters, will approach nearer to perfection than any one of his masters." Earlier, in his second discourse (1769), he had recommended "a kind of competition" as a way of learning, "by painting a similar subject, and making a companion to any picture that you consider as a model."

But he warned against becoming the imitator of any one artist, saying in his sixth discourse: "He that follows must necessarily be behind."[27]

Stuart took care to avoid mere imitation. In a related instance of quoting, he produced a picture, tentatively called *James Ward* (fig. 15), of an unidentified boy with a dog. Signed and dated 1779, it has "J Ward" on the dog's collar, a possible clue to the identification of the sitter. As in the early seventeenth century, the boy wears his hair long and a version of the Vandyke collar—both of which were again fashionable—but the pose, with a projecting elbow, and the artificial addition of the large cloak or piece of heavy drapery are so clearly Van Dyckian that, taken as a whole, the picture would have reminded cognizant viewers immediately of Van Dyck's famous portraits. But this is a reinterpretation rather than an imitation. As if to paint a variation on the richness of his precursor's coloring, Stuart glazed the cloak with transparent pinks and blues to create an opalescent effect that is superimposed on the surface of a partially impasted white. The brushwork on the cloak is also much freer than in Van Dyck's completed pictures; and Stuart departed as well in his carefully contrived pictorial harmony, a repetition throughout the painting of muted variations on the complementary colors orange and blue.

His sharply restricted color harmony and newly pronounced brushwork were unusual but not without recent precedent. Three years after Thomas Gainsborough returned to London from Bath in 1774, he resumed his practice of entering pictures in the Royal Academy's annual exhibitions (see Gainsborough's portrait of the Honorable Anne Duncombe [fig. 16]). These paintings have the richly varied coloring associated with Van Dyck, but they also possess carefully calibrated color harmonies in delicate, evanescent hues, and an unusual quality of sketchiness in the brushwork. This new indulgence in technique was slowly beginning to regain currency. Significantly, however, both Stuart and West (as in fig. 13) allowed themselves markedly greater abandon with the brush only in secondary areas, such as drapery or a background.[28]

What Stuart might have worked on as West's assistant is open to question. He mentioned that he painted drapery for West, copied some of his likenesses, posed for several history pictures, and finished West's portraits, by which he meant presumably that he filled in the final secondary areas. With regard to history pictures, George C. Mason is the only early author to list

FIG. 15. *James Ward,* 1779

specific biblical scenes after West's designs as by Stuart, but this section of his 1879 biography does not have the authority of the quotations from Jane Stuart and is based, evidently uncritically, on the recollections and opinions of anyone who responded to his advertised requests for information. The two canvases mentioned, a full-length view of Christ and another of Moses (St. Pancras Parish Church, London), are not convincing as having been painted by Stuart. But, difficult as it is to separate Stuart's hand from West's or any other assistant's when we are not sure of the identities of all of West's students and when the painted area is formulaic drapery or even underpaint, it is safe to conclude that Stuart must have worked on minor parts of West's large history pictures. Even years later, at West's request, he contributed a small portrait of his old friend as part

of the background in West's 1787 historical piece for George III, *The Institution of the Order of the Garter* (collection of Her Majesty Queen Elizabeth II).[29]

Stuart attended Reynolds's discourses at the Royal Academy, but, even though the tuition would have been free if he had been accepted, he did not apply or become a student there. Instead of drawing, as the beginning Academy students did, from plaster casts of ancient sculpture or, as the more advanced ones did, from the nude, he preferred to paint in oils from the live models in West's studio. He was concerned enough about his knowledge of anatomy, however, to attend lectures given to medical students by the well-known anatomist Dr. William Cruikshank. While he had a painting room in West's house, he received sitters—perhaps quite a few on referral from West—and painted

FIG. 16. Thomas Gainsborough, *The Honorable Anne Duncombe, Later Countess of Radnor,* 1778

his own portraits. Eventually he himself became an instructor and reviewed the work of West's newer assistants, such as John Trumbull, who arrived from Connecticut in 1780.[30]

About this time West sat for a portrait that turned out to be one of Stuart's more experimental pictures (fig. 17). He is shown casually leaning back in a chair and looking upward over his right shoulder, a pose often used with a writer or an artist to acknowledge an external or higher source of inspiration. It was probably undertaken as a tribute to West, and possibly with the annual spring exhibition of 1781 at the Royal Academy in mind, for it appears to be the same portrait of West that Stuart exhibited there. West's picture of William Abercromby (fig. 18), shows a similar pose, al-

though less twisted and energized. Stuart's painting is more decorative in its carefully harmonized and contrasted colors and its unusually textured pigment. Concerning the latter, he raked his palette knife over thick paint to render the waistcoat embroidery and the embossed coat buttons. This new interest in paint texture is continued in the impasted dots on the jabot and the short, thick stripes across West's powdered hair. Even the visible brushwork along the open section of the coat announces that this is oil paint, rather than the illusion of a projecting fabric that Stuart would have provided earlier. The face is so thinly painted, however, that the grain of the underlying canvas is visible, making the image appear to be somewhat diaphanous. This impression is reinforced by the subtle transitions in

FIG. 17. *Benjamin West*, probably 1781

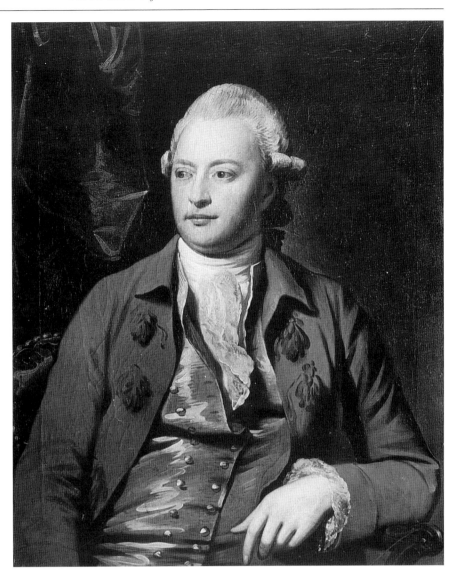

FIG. 18. Benjamin West,
William Abercromby,
ca. 1773/78

coloring and modeling, and by the fact that the features are more implied than defined. Stuart intermingled his flesh colors—from rose pink to yellowish cream and pale orange—almost imperceptively; they were rarely muddy, and so distinctive were they becoming that West spoke, at about this time, of the impossibility of trying to imitate him in this respect.[31]

Stuart had exhibited before at the Royal Academy —one portrait in 1777 and three in 1779—but these have never been identified and were not mentioned in the newspaper reviews. In contrast, when he entered his portraits of West and of Dr. John Fothergill (fig. 19) in 1781, he enjoyed highly favorable comments—the first he had received. Fothergill, Waterhouse's distinguished relative, had recently died and was, therefore,

according to the exhibition catalogue, painted from memory, probably with the help of a wax bust (destroyed) from life that had been modeled by Patience Wright. The two exhibited pictures are similar in the delicacy of the sitters' flesh and in the use of fairly obvious symbols. In the case of Fothergill—a learned and righteous Quaker—the doctor sits bolt upright, holding an open botanical text, while, behind him, the pattern on his brocaded chair culminates in a large pineapple, emblematic of his hospitality. One reviewer for the pamphlet *The Earwig* called this effort admirable, and the likeness of West won even greater praise in *St. James's Chronicle*, where the unnamed critic concluded extravagantly: "An excellent portrait. . . . I do not know a better one in the room," meaning the large exhibi-

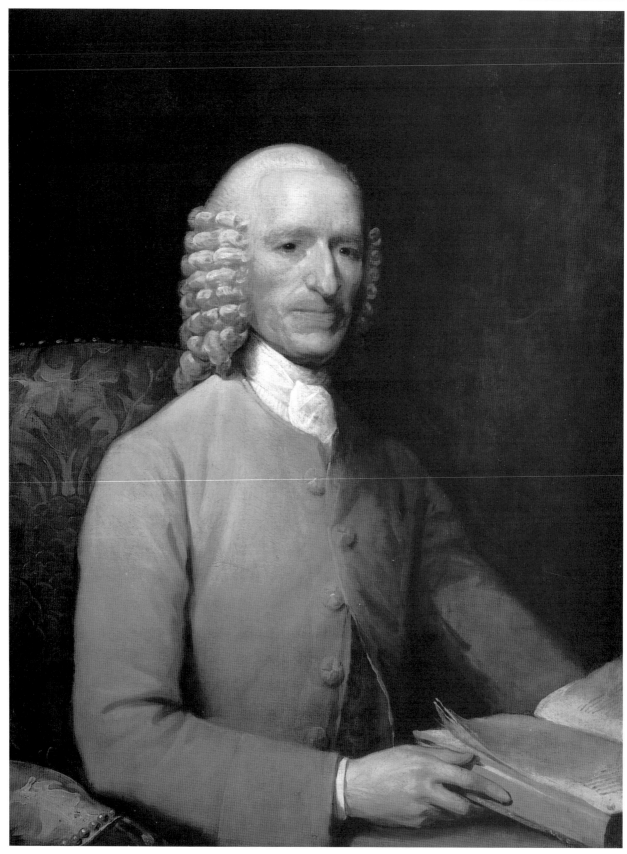

FIG. 19. *Dr. John Fothergill,* 1781

tion hall containing portraits by Reynolds and Gainsborough as well.[32]

Indeed, the portrait of West attracted such attention when exhibited at the Royal Academy that Stuart could not resist returning to the exhibition to hear the comments. Certainly the young artist stood out as a colorist. This fact became particularly apparent to West when he tried to retouch one of Stuart's copies of his own portrait of George III. He had intended to pass it off as a replica by himself, but he found that his retouching served only to spoil Stuart's beautiful flesh coloring. Deciding that the fault lay in not using the right tints, he borrowed the palette that Stuart had set, but still he could not restore the original beauty. Finally having turned the flesh into "mud," he had to give up and ask Stuart to correct it.[33]

With the self-portrait and the likeness of Benjamin West, Stuart had shown his teacher and then the London public that he could overcome the handicaps of a mostly self-taught colonial and develop his own distinctive strengths as a portraitist. His next step was to follow a well-established trend and mark his success by engaging the services of an engraver—in this case, the much-esteemed Valentine Green. In June of 1781 they published together, as a financial venture, a mezzotint after the portrait of Fothergill. Since Fothergill had an international reputation as a botanist and philanthropist as well as a local reputation as a respected physician, with one of the most lucrative practices in London, the engraving was clearly calculated to sell. It is the first of many prints that were produced, under different auspices, after Stuart's work, but it is unusual in putting the artist's own money at risk. Although we do not know the economic outcome, we can assume that the investment turned a profit; it formed a precedent that Stuart followed repeatedly thereafter with print and oil replicas of his portraits of famous sitters.

The English School

URING HIS LONDON YEARS, STUART began a major shift in direction away from his early mimeticism, which culminated in the Waterhouse likeness, toward the kind of pictorial conceptualization that we saw in his self-portrait. One of the benchmarks along the way was his conversation, perhaps in 1781, with his friend John Trumbull, whose portrait he had begun. After working at it for a week, Stuart discarded it as a failure, telling Trumbull that he "could make nothing of [his] damn'd sallow face." The need to imitate Trumbull's flesh would not have bothered Stuart in Newport, but he had become convinced that he had to create an aesthetically pleasing picture, one that conformed to a new ideal. Sir Joshua Reynolds's insistence on seeing "beauty only" clearly frustrated Stuart as a careful observer and a conscientious portraitist. The young artist, as in this instance, can be seen to have gone through a period of being torn between two competing demands: for likeness, required in a portrait, and for aesthetic satisfaction, expected in a work of art.[1]

Having attained success with his favorite format, the sitter shown to the waist, Stuart pushed himself in preparation for abandoning his apprenticeship with Benjamin West. He contributed a much more ambitious picture than previously to the Royal Academy's exhibition in 1782, which brought him a sudden boost in reputation. His full-length portrait of William Grant

(fig. 20, pl. 3) was highly unusual—probably unique among exhibited English paintings—in that it showed the subject in the act of figure skating. According to Dunlap, Grant, a Scottish gentleman, commissioned Stuart for a full-length view. The artist, who had had little practice on that scale, suggested a skating theme, ostensibly because the cold weather made skating possible, and he and Grant had discussed their mutual enjoyment of skating. That they actually left the painting room and proceeded to the Serpentine River, however, is questionable, as is Stuart's claim that he showed his expertise on the ice, while Grant had to hold the skirt of the artist's coat to maintain his balance. They could have skated on the spur of the moment, certainly, but the coattail story is too characteristic of Stuart's humorous but untrue elaborations to be convincing. Yet the connection with an actual event is worth repeating to emphasize the point that Grant is shown naturalistically, as engaged in an everyday activity, when most full-length portraits were more formal.[2]

Over thirty years later, when Stuart briefly recalled this portrait, now called *The Skater,* in a carefully recorded conversation, his description focused only on the "fine contrast of Grant in full black to the snow & grey chilly background." Although this might have reflected a later viewpoint, overall color harmony, sometimes with the addition of a sharper color as an accent, was actually a major concern of Stuart's at the time that

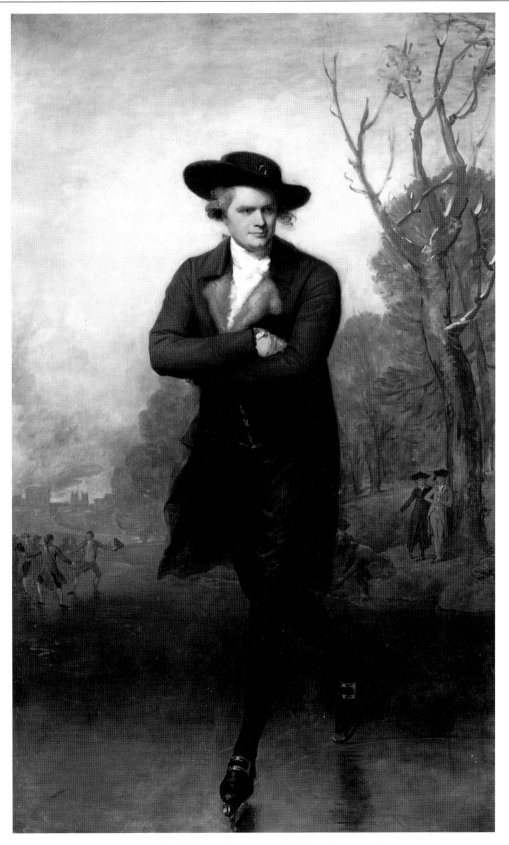

FIG. 20. *The Skater (Portrait of William Grant)*, 1782

he painted the picture. He apparently considered his subtle calibration of silvery grays, played against black, part of his achievement. "Grey chilly background" was his wording; he experienced color, probably as early as 1782, as creating feeling much the way music does.[3]

In fact, Stuart, like a number of his contemporaries, was quite interested in connections between music and color and might well have intended that *The Skater*'s overall gray tonality be evocative of tonal music. Stuart could certainly have read the 1754 English edition of Roger de Piles's *Art of Painting*, which alludes to the necessity for harmony in colors as well as in music. One of Piles's examples uses a surrounding chiaroscuro to call attention, by contrast, to an important center. Or perhaps Stuart read William Hogarth's opinion, in his 1753 *Analysis of Beauty*, that shade is like sound in that the swelling note delights the ear, and decreasing sound indicates distance. Even slightly less well-known authors, such as Francesco Algarotti and William Gilpin, linked art with music as a model for achieving harmony. Indeed, Stuart, with his particular interests, could hardly have escaped the new consciousness, since about mid-century, of the possibilities of expanding an aesthetic experience through synesthesia. Sir Isaac Newton discussed the correspondence between color and sound in his 1704 *Opticks*, which went through successive editions during the century; Londoners witnessed by 1757 a color organ that mechanically produced coordinated colors and music; and Reynolds, in his fourth discourse (1771), spoke in passing of the different musical effects of distinct and indistinct colors. Thomas Gainsborough, who like Stuart was also a musician, referred to music repeatedly in speaking of painting; Stuart probably did as well, but the evidence appears only later in his life, when his opinions on theory were recorded by aspiring younger artists.[4]

Perhaps inevitably—because, as he told Matthew Jouett, he would "dispute [with himself] rather than take the opinions of others upon trust"—Stuart arrived at his own plan for "associating" pure colors and musical chords. In 1816 he told the young South Carolinian artist John Cogdell about his idea, saying only that he had developed it "when younger," when he played "pretty much" on the piano and harpsichord. Fortunately, Cogdell dutifully recorded the theory as follows:

He took C as the centre of the Instrument—as *Sound*—there are 8 sounds & no more so there are but 8 Colours[;] for this he took the Prism thus[:] C sound

[equals] Red colour[,] & in this order they were associated

C	D	E	F	G	A	B	C
red	*orange*	*yellow*	*green*	*blue*	*purple*	*crimson*	*red*

so that C above was but a lighter shade of Red as the sound was fainter—and C [an] octave below would be a Deeper red—or red more in shade—as the tone would be lower. . . . [A]s the notes would harmonize[,] so the several tints wd. also harmonize—with his skill in the management of the Theory of [. . . ?] much might be made of the focus.

Stuart's spectrum, based like Newton's on the prism, differed in that Stuart used two values of red to make eight colors, while Newton had seven colors and eight divisions corresponding to notes. Significantly, Stuart's assignment of specific notes to colors made his scheme practical for an artist to use.[5]

Whether Stuart had developed this theory before 1782 or not, his *Skater* is quite unusual in being a tonal harmony in gray except for Grant's wrist, white shirt front, and flushed face—all of which provide the focus of the painting. When color is introduced, it is repeated in a conscious effort to create a pictorial balance. For instance, the red in Grant's flesh is echoed, in muted form, in the clothing that is part of the background scene (both left and right) and even in rough, inexplicable blotches of dull red superimposed on the gray background tree. This unnatural tree, incidentally, partly echoes the curves of Grant's posture. Muted yellows and blues seem to answer each other in minor areas. That is to say, despite the naturalness of the scene, this is a highly contrived picture, surely intended from the beginning to be an impressive entry in the Royal Academy exhibition.

As far as is known, Stuart had not exhibited a full-length picture before, so the novelty of his pose was almost certainly meant to flaunt his newly acquired skills in his first public trial. Among younger portraitists competing for attention in the press, John Opie, the supposedly self-taught genius who followed the path of Rembrandt, clearly held the lead temporarily in 1782, but Stuart was very much a contender. He had undoubtedly heard and was responding to the accusation, spread by a rival, that "he made a tolerable likeness of a face but as to the figure he could not get below the fifth button." Yet Stuart's theme, with its deliberate incorporation of surprise, must have been inspired by the

attention-getting innovation shown in the successful debuts of his American colleagues John Singleton Copley and Benjamin West. They had both departed from history-painting tradition in the interest of greater naturalism: West in the case of introducing realistic costumes, rather than the togas that Reynolds had recommended, in his *Death of General Wolfe* (fig. 8); and Copley in his portrayal of heroism in an ordinary life, with startling immediacy, in *Watson and the Shark* (1778; National Gallery of Art, Washington, D.C.). As for his display of ability, Stuart appears to have painted Grant's figure and his clothing from life, either from Grant himself or, more likely, from a substitute such as one of West's other students. The picture added to his reputation—though not apparently as much as he later suggested—and won approval in the newspapers with enthusiastic comments such as "reposed, animated and well drawn."[6]

The words used to describe *The Skater*—"reposed" and "a noble portrait . . . which produces the most powerful effect"—suggest Stuart's successful approximation of a contemporary ideal for the portrayal of character. Even in his earliest Newport portraits, he had tried to convey the dignity of the sitter—an effort supported then by theoreticians such as Jonathan Richardson and Reynolds—but the adjectives *reposed* and *noble* imply something more exalted; they recall more precisely Johann Winckelmann's admiring descriptions of ancient Greek statuary and the related concept of an inner nobility that is not one of inherited status. As one critic specified, more clearly than other reviewers, Stuart's portrait imparts a "spirited" attitude and an "appropriate" character. The sitter is presented as a thinking man who looks away from the viewer with a half smile, as if lost in thought, and as a self-possessed gentleman whose composure is contrasted with the excitement of the skaters at the left. The self-control, upright posture, and graceful movement indicate dignity; and dignity combined with intellect and serenity were taken at the time to be unmistakable signs of the noble or virtuous person.[7]

That the sitter in *The Skater* agreed to be shown in such an unusual pose as skating suggests, also, a degree of spirited eccentricity, a quality that could complete the above description by associating the sitter with that most benevolent and natural man—a man of feeling. Above all, for viewers of the period, this was a portrait about upright character—but character tempered by sensibility so that the sitter, with a meditative

awareness, became a conscious participant in the seasonal joys of nature. Sensibility, alluded to here and popular as a characteristic of heroes and heroines in novels of the period, meant the capacity to perceive, and respond to, the subtleties of both moral and natural beauty.[8]

Reactions to Stuart's exhibited work nearly always centered on the unusually strong resemblance between the picture and the sitter—Stuart's "correctness of likeness" or "identifying magic," as it was called. When Grant attended the 1782 Royal Academy exhibition, spectators, according to William Dunlap, easily recognized him as the sitter in *The Skater*. Furthermore, exhibition reviewers uniformly praised Stuart's entries that year—including portraits of the diplomat Caleb Whitefoord (Montclair Art Museum, New Jersey), the artist Dominic Serres (location unknown), and an unidentified Swedish gentleman—for strength of likeness. The last-mentioned portrait is undoubtedly that of the Swedish diplomat Christopher Springer (fig. 21), whose picture is stylistically consistent with the date of the artist's Royal Academy submissions. The critics called it "marked and masterly," and in fact, Stuart was attracted to and seems to have made a special effort with faces, such as Springer's, that were strongly "marked" with character. As if to confirm the praises of the journalists, Temple Franklin wrote to his grandfather, Benjamin Franklin, two years later, that Stuart, "who is esteemed[,] by West & everybody, the first portrait painter now living . . . is astonishing for likenesses. I heard West say 'that he *nails* the face to the canvas.'"[9]

The exhibition success of *The Skater* in 1782 enabled Stuart to leave West's establishment and set himself up as a portrait painter on his own. His clientele thereafter consisted mainly of the upper middle class, but he painted some members of the aristocracy as well, such as the duke of Manchester (location unknown) in 1783 and the duke of Northumberland (fig. 35) in 1785. Yet, despite this success, Stuart did not follow *The Skater* with a comparable tour de force. Perhaps because his portrait of Whitefoord was badly hung at the Royal Academy, he exhibited there only one year thereafter (in 1785), whereas he chose instead to contribute, in 1783, to a rival and much inferior exhibition held by the temporarily revived Incorporated Society of Artists. One factor that distanced Stuart from the Royal Academy was his seeming indifference to its exhibitions, which hurt his chances of ever being elected an associate member of that institution. Clearly he never

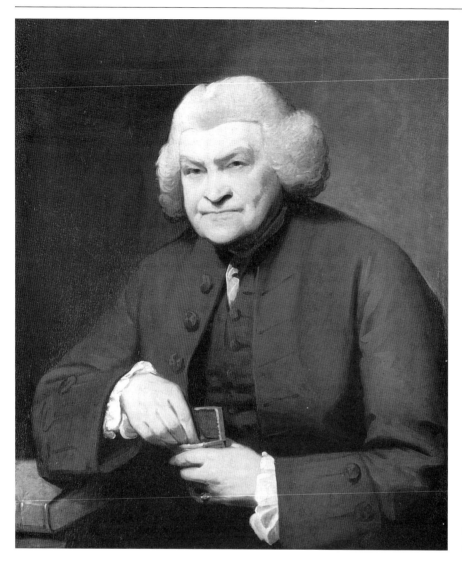

FIG. 21. *Christopher Springer,*
ca. 1782

courted an honor that helped to sell pictures.[10]

Stuart appears always to have been independent minded. He was quite capable of criticizing the work of the two most prominent artists in London, West and Reynolds, although he was fond of them both. After his separation from West, for instance, on revisiting the older artist's studio in about 1786, he saw the flaws in West's painted flesh color and felt compelled—perhaps partly because some of the major theorists agreed with him—to give improved instruction on skin coloring to West's students. In later years he increasingly refined his own portrayal of flesh, particularly with regard to the head, and he repeatedly urged students to attempt, as he did, to express the unique quality of living, human skin. As he told West's students: "Nature does not colour in streaks. Look at my hand; see how

the colours are mottled and mingled, yet all is clear as silver."[11]

According to his daughter, Stuart found "the English school" in agreement with "his own idea of art—the pursuit of nature." The English pursuit of nature was not, however, an unqualified one, as Reynolds, the leader of the English school, made clear. As a succinct expression of his creed, he placed on the Royal Academy's library ceiling the following inscription: "Theory is the Knowledge of what is truly Nature." By this statement he referred to one of the themes of his discourses—namely, that artists should portray an improved nature, a higher reality inspired by the greatest works of art from the past. Indeed, such works could teach how to actually *see* nature. Stuart did say, years later, that he had always benefited from studying the

works of Reynolds. But he also observed that there was "more poetry than truth" in Reynolds's pictures: "too much . . . imaginary beauty." Stuart's daughter was only partly right. An astute observer of the artistic scene, Anthony Pasquin, reflected in 1794 that Stuart had been the only disciple of Reynolds who had criticized the master for his "artifices."[12]

The educated public's admiration for idealized, classical sculpture inspired English artists toward greater abstraction during the 1770s and the 1780s. Reynolds played a prominent role in promoting the widespread movement by urging portraitists to distill from what they saw to arrive at a more generalized image. That the subject of a portrait should be flattered was by no means a new idea. Reynolds's contribution was to advocate the depiction of general rather than particular nature, removing blemishes and references to a particular time and place. As Stuart noted, Reynolds's own portraits often did not bear strong resemblance to their sitters. Typically they also included theatrical props, invented costuming, fanciful backgrounds, and sometimes poses that were not-so-subtle quotations from works by Old Masters. Indeed, even without quotation, their muted but rich layerings of color succeeded in reminding viewers of the appearance of centuries-old paintings.[13]

Stuart's opinions concerning Reynolds's work are especially telling with regard to the older artist's portrait of Sarah Siddons as the Tragic Muse (fig. 22). Stuart had seen the portrait of Siddons in process, during a visit to Reynolds's studio, and had expressed great enthusiasm, but he was disappointed with it in the end, perhaps because of overworked coloring. An indication of his criticism is that he asked Reynolds, regretfully, why, given that the original canvas had reached such a state of perfection, he had not used another canvas to experiment with changes. Yet Stuart seems to have been impressed with Reynolds's attempt to upgrade portraiture as a genre. Reynolds had departed from convention by painting the famous actress as a personification of an idea—and, as such, electrifyingly dignified. Part of her dignity derives from her regal pose, which was based, as was recognized at the time, on Michelangelo's prophets from the Sistine Ceiling. Closely recalling the prophet Isaiah, the pose suggests not a precise quotation that might carry special meaning but rather a loose association, serving to elevate the picture as a work reminiscent of the Old Masters.

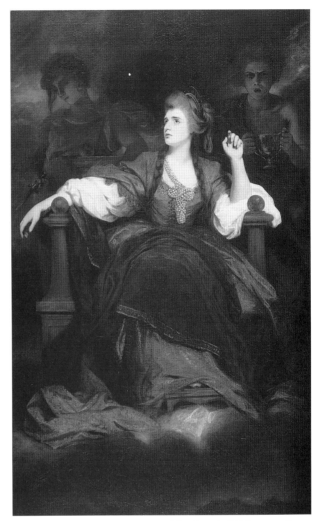

FIG. 22. Sir Joshua Reynolds, *Sarah Siddons as the Tragic Muse*, 1783

In a rather complex composition for a portrait, Siddon's companions, shrouded in darkness behind and on either side of her massive throne, extend the allegory as personifications of Pity (also based on a head from the Sistine Ceiling) and Terror. The result is a highly dramatic image in which the heroicizing content of history painting is grafted onto a full-length portrait.[14] The hybrid genre that emerged in this example and others posed a challenge to the way theoreticians had traditionally considered history painting—generally multifigured historical, allegorical, or mythological compositions—as the highest form of art, requiring the greatest use of education, imagination, and skill. Reynolds agreed with this superior ranking, but

FIG. 23. *Eleanor Gordon,* ca. 1785

he blurred the distinctions between categories by his creation of portraits that belong to the more imaginary realm of history painting. These portraits in the historical style are mentioned as a type in his fifth discourse (1772). The text states, in passing, that they must contain a mixture of the ideal and the individual, and this mixture must be consistent as an expression throughout the picture.[15]

What Stuart learned from Reynolds and the other prominent London artists is most evident in his likenesses from the mid-1780s of a young woman, Eleanor Gordon (fig. 23), and a naval hero, Captain John Gell (fig. 24). By seating the woman before a beautiful, uninhabited landscape and placing the man in a commanding pose, he conformed to gender-based portrait stereotypes that were designed to show appropriate virtues in the sitter. The woman, hatless and relatively simply dressed, holds a sheet of music; she is backed, somewhat indecisively, by an outdoor view extending to a distant mountain range and by an unfinished, indoor corner, which refers to her domesticity. These are attributes that might be found in similar depictions of contemplative women by London's most successful portrait painters: Reynolds, Thomas Gainsborough, and George Romney. Adhering to type, Gordon can be associated with nature in her procreative role, but she is presented more emphatically, with her sheet of music, as a woman of refined sensibilities. In such pictures of young women, natural physical beauty was thought to be, by association, a recommendation of character.[16]

The more ambitious picture of Gell borrows from the content of history painting and is a historical por-

FIG. 24. *Captain John Gell,* 1785

trait. It shows the uniformed captain in an appropriate heroic guise, standing on a rocky shoreline under a stormy sky and giving directions, probably to his crew, in preparation for boarding the frigate that awaits on the horizon. The emphasis, as in other such pictures, is not on convincing realism but, rather, on the dramatic general effect and the kinship between this scene and a distinguished tradition of depictions that includes Reynolds's full-length *Commodore Augustus Keppel* (National Maritime Museum, London) of about thirty years earlier. The pose, however, is closer, if taken in reverse, to another portrait of martial valor, Copley's *Hugh Montgomerie, Twelfth Earl of Eglinton* (fig. 25). As in both these precedents, Stuart clinched the connection with history painting by showing the subject engaged in heroic action rather than posing in front of it: Gell is psychologically involved as he prepares to fight the French in the East Indies.

Overall, the full-length painting of Captain Gell has the appearance of having been executed with great spontaneity. For instance, details of the head are merely suggested; the gray wig is so roughly done that blotches of Indian red, used in the flesh, appear in the wig's coloring above one ear. And the sketchiness of the gloved left hand and sword hilt contrasts markedly with the greater finishing on the near side of the figure. In striving for effects of both bravura and likeness, Stuart had aligned himself temporarily with Reynolds's well-known, slapdash manner and had produced a somewhat inconsistent, unevenly finished portrait. This ambivalence is reflected in newspaper reviews of *Captain John Gell*, written after its display in the 1785 Academy exhibition. In contrast to the seemingly universal acclaim accorded *The Skater*, one reviewer—the artist John Hoppner—admitted that the bearing of the figure may be stiff and "coldly correct," but he defended Stuart's approach by saying that this was "characteristic in a veteran officer." Another reviewer noted that, although the picture is striking, the "figure and background have a poverty about them," perhaps meaning that they are not sufficiently realized or finished. In this regard, an earlier critic, in 1783, had already warned Stuart against the pitfalls of being too facile, telling him to take care that his work "does not degenerate into slightness." Such criticism, aimed chiefly at secondary aspects of the picture, does not seem to have bothered Stuart unduly. His particular genius and his ever-changing challenge, as he well knew, lay in creating the head. This he could

FIG. 25. John Singleton Copley, *Hugh Montgomerie, Twelfth Earl of Eglinton*, 1780

do in conformity with his patrons' desires and with increasing facility.[17]

According to a surviving letter, even Reynolds, who was chiefly a portraitist, admired Stuart's ability and recommended the younger artist to some potential patrons, after having sat himself to him. Stuart's 1784 portrait of Reynolds (fig. 26) formed part of a larger commission, probably undertaken in 1782 or 1783. John Boydell, the well-known printseller who had published the famous engraving of West's *Death of General Wolfe*, commissioned Stuart to provide, for his public gallery, fifteen portraits of specified painters and engravers who had been involved in Boydell's various enterprises. Stuart fulfilled the commission over a period of about three years, and Boydell displayed the series of half-

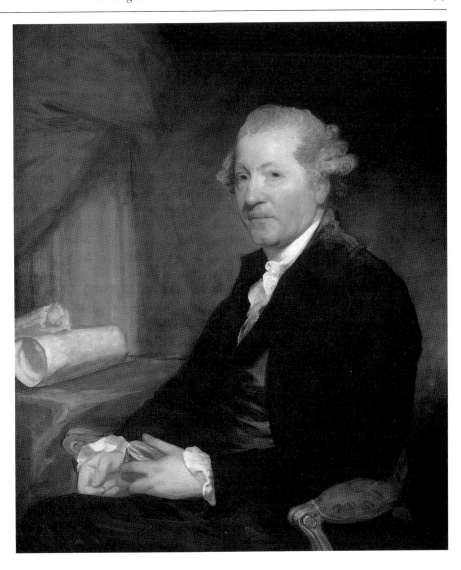

FIG. 26. *Sir Joshua Reynolds,*
1784

length likenesses in his gallery in 1786, along with Copley's *Death of Major Peirson* (The Tate Gallery, London) and some other pictures. The top of the carved frame on Copley's large history painting contained oval bust portraits by Stuart as well. They showed the engraver of Copley's picture, James Heath; Copley himself; and the artist who produced the drawing for the engraving, Josiah Boydell, who was John Boydell's nephew. The entire display served as an advertisement for Boydell as a public-spirited art patron and for the engravings after the works on view, which were available for purchase or would be forthcoming.[18]

In his half-length portraits for Boydell, Stuart used similar formats, portraying his fellow artists in relatively relaxed, natural postures and either at work or accompanied by allusions to their work so that they related to each other as members of one profession. As a whole,

these images were less dignified than the portraits of aristocrats that art patrons were accustomed to seeing at the Royal Academy exhibitions. One reviewer, recalling the Boydell exhibition, in 1804 contrasted Stuart's depictions with Sir Anthony Van Dyck's more elegant, seventeenth-century portraits of artists, deploring the lack of "elevation" and grace in Stuart's pictures, which might just as well have been of "cheesemongers or grocers." The reviewer was perhaps an artist or at least someone sensitive to the still-precarious position of artists, who had long labored to separate their profession from the taint of being any kind of trade.[19]

The portrait of Reynolds is grander than the others by Stuart and yet contains some inconsistencies that relate to that reviewer's complaint. It juxtaposes contrasting allusions that refer, on the one hand, to Reynolds's elevated position as Academy president

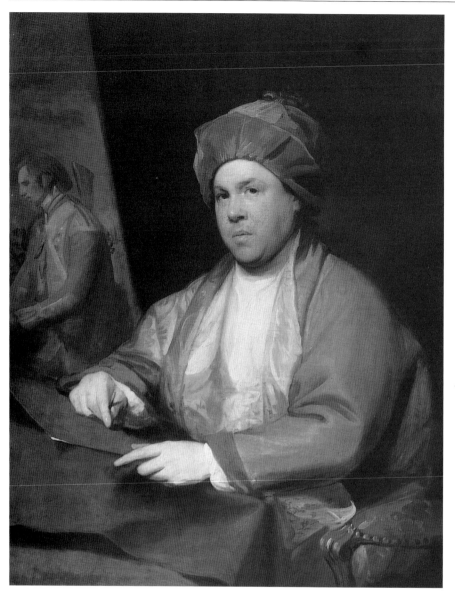

FIG. 27. *William Woollett*, 1783

and, on the other, to the gentle, unassuming manner —even self-deprecation—that was characteristic of him. With two paper scrolls on the table as emblematic of his distinguished station and accomplishments, and with the grandeur provided by a classical column and red curtain, he is shown slightly slouched and arrested in the simple act of taking a pinch of snuff, albeit from a gold snuffbox. Certainly the dual emphasis on office and humility was meant as a compliment and was probably received this way at the time by Reynolds. The snuffbox, seen earlier in Stuart's portrait of Springer (fig. 21), accompanied nearly everyone at this time, ranging from street vendors to Queen Charlotte, but it was not usually shown in portraits,

possibly because it did not serve to enhance the sitter. Its inclusion could be a witty reference not only to Reynolds (for his admirable condescension) but also to Stuart or to the two men together, for Stuart was an intemperate snuff taker.[20]

The 1804 critic singled out Stuart's inclusion of snuff taking as inappropriate and then complained about a general inexpressiveness in his "vapid countenances." Although blandness of expression was typical of portraits from the period, arising from the need to represent the sitter in a permanent aspect, there is a more telling point here. Stuart painted these portraits, all deemed strong likenesses, in a comparatively frank and documentary way without appearing to strive for a par-

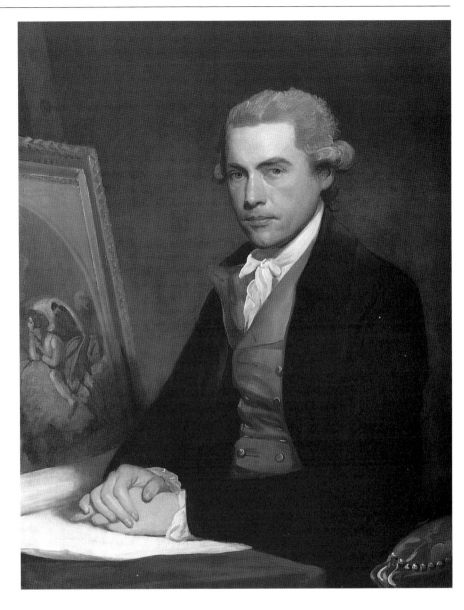

FIG. 28. *Johann Gottlieb Facius,* ca. 1784

ticular expression. He does not seem to have labored to "improve" his subject as he might have, and definitely later did, with portraits commissioned by and for the sitter. Perhaps the two best cases in point in this regard are his portraits for Boydell of the engravers William Woollett (fig. 27) and Johann Gottlieb Facius (fig. 28), whose faces are so matter-of-fact as to seem to reveal an unconscious expression or to be merely holding still. Yet the two portraits flatter by containing tributes to the skill of the engravers and the success of their collaboration with the most prominent of London's painters, West and Reynolds: Woollett is shown in the act of engraving West's *Death of General Wolfe* for Boydell; and Facius sits before his engraving, for Boydell,

of a section of Reynolds's *Nativity,* designed for a chapel window at New College, Oxford.[21]

If Stuart had had an inclination to paint facial expression as he saw it at this time, his upper-class sitters, in any case, would probably have thwarted his purpose. They would have wanted to compose themselves, exhibiting instead the fashionable blandness or patrician gravitas associated with the emotional restraint of classical statuary. Indeed, facial expression in portraiture of the 1780s had a relatively limited range. The mouth of a sitter, for instance, might be subtly differentiated —sometimes opened as in a child's laugh—but typically it incorporated a tempered smile, suggestive in differing degrees of benevolence and reserve; the eyes,

attitude, and general air were often more expressive than the mouth of a person's intelligence, energy, and public character. It was usually only in uncommissioned portraits or portraits of theatrical performers, shown in the guise of a role, that the artist could experiment, in the way that history painters could, with more complicated expressions. These involved facial distortion provoked by momentary emotion, which would be unsuitable in a portrait meant, after all, to epitomize the sitter for posterity.[22]

Stuart had just such a chance to explore greater extremes of emotional expression in a commission he received, in about 1785, for actors' portraits. The book publisher John Bell asked a group of London artists to submit small, full-length illustrations of specific contemporary actors in designated roles, to be engraved as plates in a proposed multivolume edition of Shakespeare's plays. Each engraved illustration was to show a well-known performer in the act of speaking a line from one of the plays. In the resulting publication the actors' heads in three illustrations are based on head or bust portraits by Stuart. According to the inscriptions on these engravings, Mather Brown and Johann Heinrich Ramberg, both students of West's, supplied the engraver with the drawings for the full figures. In other words, they helped Stuart, who may have been incapacitated with another depression, to fulfill his commission. Whether this coauthorship was part of the original plan or not, it is symptomatic of the fact that Stuart often lost interest in a portrait after he had completed the head, even if that head amounted to little more than a quick sketch.[23]

Stuart's oil sketch of John Henderson as Iago (fig. 29) was executed quickly, within one sitting, and just shortly before Henderson died in November of 1785. With a sidelong glance as if to suggest suspicion, Hen-

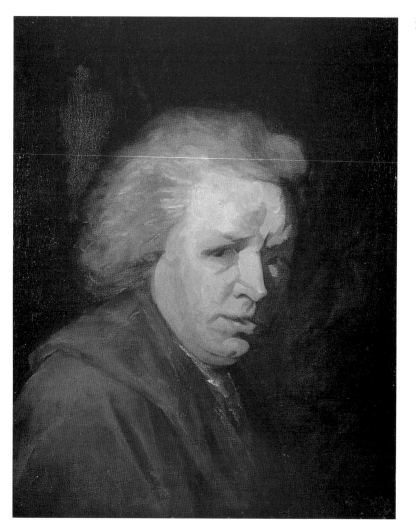

FIG. 29. *John Henderson as Iago,* 1785

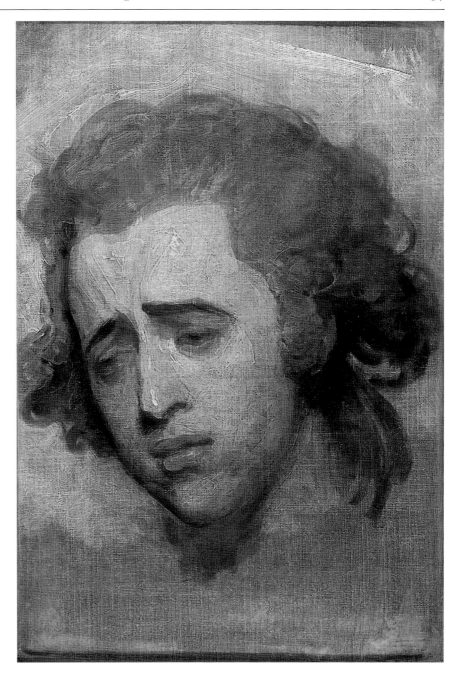

FIG. 30. *Alexander Pope as Posthumus,* 1786

derson, in his impersonation, appears in the act of telling Othello about his discovery of Desdemona's handkerchief in Cassio's possession. Ramberg modified Stuart's portrayal in the published version to make Henderson more physically attractive—less fleshy and less disheveled—and his expression more one of direct confrontation and accusation. Perhaps because Ramberg changed it so much, the engraving that Bell published with the play did not credit Stuart. In any case, Henderson died the day after its publication, and, about three months later, Bell employed another engraver to publish separately a different version of Stuart's head. This one, closer to the original but also somewhat improved in terms of physical appearance, credited Stuart as the original artist.[24]

Stuart also painted theatrical portraits of Alexander Pope as Posthumus (fig. 30) in *Cymbeline;* John Philip Kemble as Richard III (fig. 31) in *Richard III;* and Joseph George Holman as Faulconbridge (location unknown) from *King John.* All of these pictures formed the basis

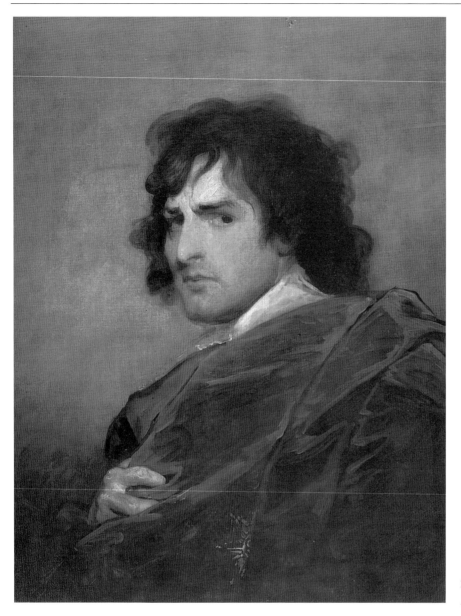

FIG. 31. *John Philip Kemble as Richard III,* 1786

for small, fanciful drawings of the actors at full length, which Brown submitted in 1786 for Bell's publication (figs. 32, 33). Stuart's freely sketched head of Pope as Posthumus, the ill-fated hero, was once lost as an unidentified and unattributed work. But the existence of Brown's copy gives the subject, and we can assign the portrait to Stuart because it is entirely consistent with the documented oil sketches of heads that Stuart supplied for this series. The image shows Posthumus reacting with great emotional pain as he receives a bloodied piece of cloth, the evidence of his beloved wife's death and his own mistaken order carried out. Unlike many history painters of the period who typically used a pattern book of diagrammed stereotypes as the ba-

sis for emotional expression, Stuart copied the specific actor's interpretation for a less mannered result. The engraved head, done from the portrait, follows the original fairly carefully, but, again, perhaps through inadvertence, Stuart's name does not appear on the engraving, the second to be published in the series. This error in identifying his labor might have caused Stuart, who could be easily offended, to snub Brown, his former student from Boston. Dunlap described the occasion: In answer to Brown's knock at his door, Stuart had his servant tell the younger artist that he was not at home even though he knew that Brown had already seen him at the window. Whether related to this incident—as it appears—or not, the last two engravings

FIG. 32. J. Thornthwaite, *Mr. Pope as Posthumus*,
after Mather Brown, 1786

FIG. 33. J. Thornthwaite, *Mr. Kemble as King Richard*,
after Mather Brown, 1786

(of Kemble and Holman) clearly and somewhat awkwardly credit Stuart for the actors' heads.[25]

Kemble, Sarah Siddons's younger brother, was just beginning his extraordinary career when he posed for Stuart, in 1786, as Richard III. He had been on the London stage during the previous three years and had so established himself as a Shakespearean actor, chiefly in tragedy, that he already rivaled Henderson, then at the summit, in reputation. In Stuart's portrayal Kemble, with furrowed brow, darkened eyes, and a five-o'clock shadow, grasps his blood-red cloak against his heart as he delivers the line: "But I am in so far in blood, that sin will pluck on sin." The slanting regard, seen also in *Henderson as Iago,* was a clearly understood ex-

pression of malignant intention. Brown made Kemble's Richard more hunched and eliminated the passionate clutching of drapery to have him wag a finger instead, so that he is less emotional and more conscious of the audience, whom he coolly addresses, in the published version.[26]

Stuart also painted Kemble as Macbeth and, reportedly, Orestes (locations for both unknown) and companion pictures of Siddons and Kemble out of role. The half-length companion pieces were commissioned in 1787 by Siddons's brother-in-law. That of the actress (fig. 34) shows her, against a stormy sky, arrested in the process of reading or rehearsing from a slender volume, undoubtedly a play. A foreground shadow gives

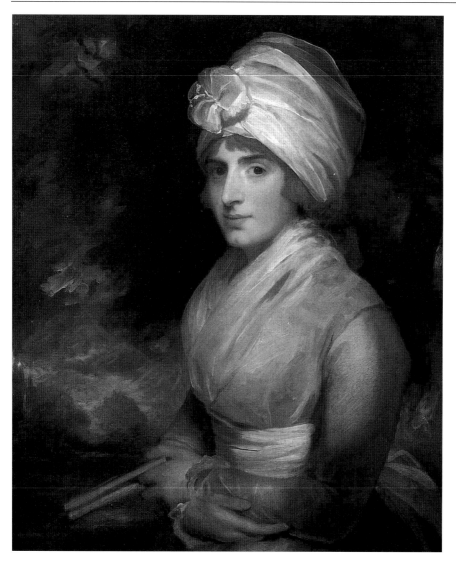

FIG. 34. *Sarah Siddons,* 1787

added depth to the picture and effectively surrounds her with darkness. She folds her arms across her waist, looking at the viewer and, at the same time, carefully marking her place in the text with one finger. Kemble's portrait (National Portrait Gallery, London) differs in that he crosses his arms energetically over his chest and stands in front of a neutral interior wall. His is a controlled space in contrast to hers, which is stereotypically linked, as in *Eleanor Gordon* (fig. 23), to wild nature. In this guise, as Siddons pauses in a thoughtful reading, she is another woman of sensibility, a counterpart to the man of feeling. The portrait caught the eye of one particular journalist who, having visited Stuart's studio, marveled that it exhibited so much "spirit and delicacy." Another critic praised Stuart's emphasis on likeness—his "uncommon similitude"—and ap-

parently preferred Stuart's portrayal to the artificiality of Reynolds's earlier personification, which had been done without a commission as an exhibition piece. This reviewer concluded: "As a portrait of a great actress it is, we think, without a rival."[27]

The dark clouded backgrounds in Stuart's portraits of Siddons and Gell (fig. 24; and undoubtedly in the 1786 missing portrait of Kemble as Macbeth, since it portrayed the storm-accompanied visit to the witches) are all references—as is Reynolds's terror-accompanied apparition *Sarah Siddons*—to a contemporary concept of the terrible sublime as defined by Edmund Burke. The very choice of some of Stuart's subjects—murderous Richard III, Macbeth with the unnatural witches, and a head of Orestes when he was pursued by furies, as it is described—is Burkean. Burke's enormously

influential 1757 treatise, *A Philosophical Enquiry into the Origin of Our Ideas of the Sublime and Beautiful,* rooted the feeling of the sublime, an aesthetic appreciation much discussed at the time, in the emotion of terror.

Burke's essay was written in response to earlier considerations of the subject. The seminal text, and the one that was to have the greatest impact later on Stuart, was a Greek treatise, *Peri Hupsous,* or *On the Sublime,* attributed to the third-century philosopher Longinus. It became best known in the English-speaking world through the Reverend William Smith's English translation of 1739, which attained a fifth edition by 1800. According to Longinus, the sublime pertained to discourse in its most lofty form and combined ideas of intense emotion, greatness of conception, and elevation of expression. Despite the continuance of Longinus's original formulation, however, the concept of the sublime acquired, from the beginning of the eighteenth century, an aesthetic connotation, as in Jonathan Richardson's definition of it as "the most excellent of what is excellent." Following this path, Burke argued that the sublime and the beautiful had become mistakenly conflated; significantly for artists, in redefining the sublime, he located it in nature and introduced visually evocative imagery in his examples of it: dark caves, raging thunderstorms, ghostly apparitions, overwhelming size, and blinding light. The attraction of the sublime, he contended, was that viewed at a safe distance, it produced a feeling of exhilaration and delight in the spectator. His imagery had such an impact on prominent artists—for instance, Reynolds and West—that frighteningly sublime subjects appeared fairly regularly in Royal Academy exhibitions by the turn of the century.[28]

Stuart, who became a good friend of Kemble's, frequented the London theaters and may well have been encouraged to continue with dramatic scenes. But his exploration of theatrical expression amounted to a relatively brief episode in a long career. The theatrical pieces, reminiscent of West's history pictures and contemporaneous public interest in Shakespearean themes, can be linked to his apprenticeship. *The Skater,* however, in its depiction of a real character made ideal, is much more indicative of the direction that Stuart was to take. As far as is known, he never returned, or was tempted to return, to the artificiality of the portrayal of actors in role.[29]

A Reputation for Likeness

As Stuart continued to experience success in London society, he responded in reserved ways to contemporary portrait preferences. He also developed, perhaps for expediency, a system of different levels of completion. One portrait might be brought to a relatively finished state and another left as a more sketchy or generalized representation of the sitter. The difference is slight, but his method is revealing about the way he seems to have thought of a portrait.

According to report, while he was in England, Stuart sometimes worked from a plaster mold taken from the sitter's face. In such instances he appears to have considered a life mask an added tool in the same way that he would often place a picture before a mirror the better to see its defects. He could also set the pose in advance by the cast, choosing the most flattering viewpoint and shortening the time required of an active sitter for the actual sittings. A London article of 1808 described the process:

Gilbert Stuart would, in all cases in which he wished to excel, have a mask taken from the face he intended to paint. By this method he thought he got more marked indication of the shapes of the bones than he could by confining himself to copying the face only. Be that as it may, certain it is that from whatever cause it arose, such were his best portraits, and we may very safely add that,

in point of distinct and characteristic resemblance, it will not be easy to find portraits by any other artist of this country that can be put before them.[1]

The subtle differences Stuart achieved with a cast could be obtained by very close observation; it is therefore almost impossible, without documentation, to divide his work according to whether or not he used a cast. One late instance is documented by a letter of 1813; another is related by Eliza Quincy, who accompanied her father on a visit to the artist's studio in 1824 for a first sitting; on her arrival, she mentioned seeing what must have been a preliminary sketch that Stuart had already done from a cast of her father's face. She wrote of Stuart: "He was gratified that Mr. Quincy, in the midst of his engagements as mayor . . . was willing to give him time for a portrait. His canvas was ready on his easel, a bold outline was sketched in chalk, and while conversing rapidly, Mr. Stuart began to put on his colors."[2] Significantly, after Stuart's death, a number of sitters' masks were found in his storage.

In the work produced in England, a convincing case can be made for the use of casts in a second version of a portrait of the duke of Northumberland. Stuart painted two portraits of the duke in the spring of 1785. The first (fig. 35) shows Northumberland as commander of the second troop of horse-grenadier guards; the second (fig. 36) has a slightly overpainted uniform,

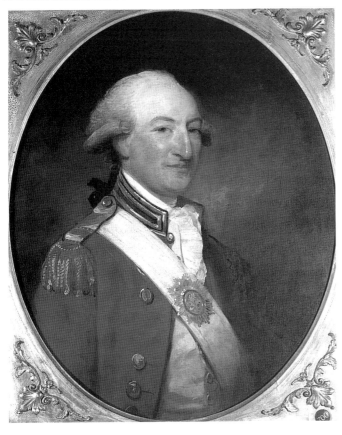

FIG. 35. *Hugh Percy, Second Duke of Northumberland,* 1785

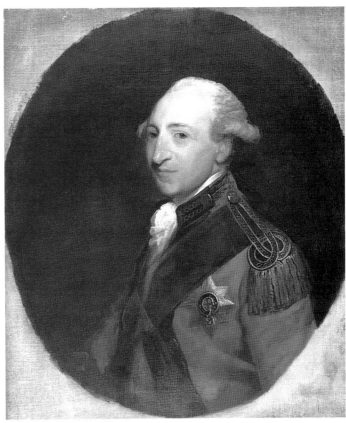

FIG. 36. *Hugh Percy, Second Duke of Northumberland,* 1785

with additions from probably 1788, indicating that he is shown after he succeeded to the dukedom and after he received the Order of the Garter, as a commander in the second lifeguards. The two heads, facing opposite directions, differ in that the first is a fairly indefinite sketch, while the second is carefully modeled in such a way that remarkably subtle transitions in surface are introduced. These concern the formation of the forehead, the eyelid folds, the bone along the nose, the cartilage at its tip, and the suggestion of a wide scar above the chin—possibly indicative of a cast having been used. The first portrait was retained by the duke, for whom Stuart also painted a sensitive portrait of a visiting Mohawk chief, Joseph Brant (fig. 37), and an ambitious group picture of the duke's children (fig. 38). According to one newspaper, Stuart received further commissions from the duke in 1787, including one for a full-length portrait of him, which may never have been executed. The second bust portrait of the duke appears to correspond to the likeness that came into the possession of one of the duke's admirers, who had it engraved in 1804.[3]

Stuart's growing prominence was such that on April 18, 1787, the London newspaper *The World* devoted an article to him titled "Stuart—the Vandyck of the Time," in which the portraits of John Philip Kemble (fig. 31), Sarah Siddons (fig. 34), Northumberland, and others are mentioned. The account is worth examining in some detail because it spells out just what was valued in his portraits: "In the most arduous and valuable achievements of portrait painting, *identity* and *duration,* Stuart takes the lead of every competitor!" That is, he is admired, as before, for strength of likeness but now also for his portrayal of the sitter in a permanent or carefully distilled aspect "independent of time and place," without the inclusion of "accident" such as might be found in a fleeting but uncharacteristic expression. Further, the writer states: "Not only skin deep, and skimming superficially over complexion and contour, Stuart dives deep—less deep only than Sir Joshua, more deep than any other pencil—Stuart dives deep into *mind!* and brings up with him a conspicuous draught of character, and characteristic thought!"[4]

With great subjectivity, art critics and knowing patrons occasionally commented, as if considering the highest criteria for excellence in a portrait, on how well a portrait showed the sitter's mind or soul. In the late eighteenth century, such references appeared with increasing frequency in newspaper reviews and seem to have been concerned chiefly with the depiction of superior, so-called mental qualities—such as "benevolence, elevation, [and] dignity"—or the sitter's "elevation of mind." Thus, for instance, to one reviewer, Sir Joshua Reynolds's portrait of Sarah Siddons showed "mind" more strikingly perhaps than any of Reynolds's earlier portraits. Instead of then remarking on a transparency of thought or emotion, the reviewer admired the "grandeur and solemnity" of the portrayal. We might expect a personification to be an exception, but the pattern of conflating the mind and soul and seeing the soul reflected in an expression of dignity is fairly consistent. For instance, an American critic, writing in 1813, observed approvingly that portraits that "exhibit *human nature dignified*" are paintings of the "*Soul* as well as *Body.*"[5]

In the same way that the painting of mind usually meant the painting of a sitter in an ideal aspect, the painting of character was another form of flattery. Stuart eventually arrived at agreement with a London reviewer (of 1784) who considered "exquisite taste" as the foundation of an ability to depict character. Perhaps the clearest theorist on the subject, and certainly one of the most influential, is Jonathan Richardson, who wrote concerning the job of a portraitist: "Every one of his people must appear . . . in good humour, but varied suitably to the raised character of the person drawn. . . . If a devil were to have his portrait made, he must be drawn as abstracted from his own evil, and stupidly good." To raise character, according to Richardson, the successful portrait painter must learn

to divest an unbred person of his rusticity, and give him something at least of a gentleman. To make one of a moderate share of good sense appear to have a competency, a wise man to be more wise, and a brave man to be more so, a modest, discreet woman to have an air something angelical . . . in such a manner as is suitable to the several characters.

In the manner of his contemporaries, Stuart spoke in typological terms when discussing character, and his work reflected the same thinking. His portrayal of character in most of his English portraits had to be condensed into a bust-length depiction, but to flatter his sitters in larger commissions, he associated his subjects, as Reynolds did, with universal types, such as that of the military hero. From Stuart's later mentions of taste, it is clear that he considered the addition of appro-

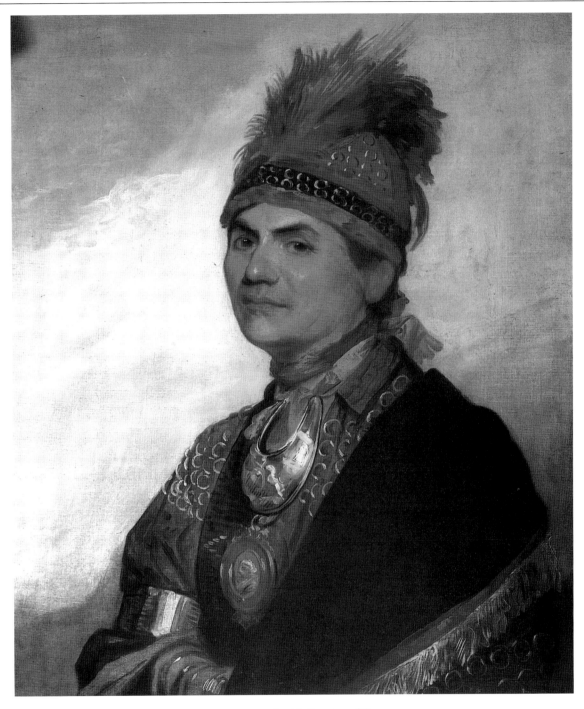

FIG. 37. *Joseph Brant,* 1786

priate character to be part of a good artist's instinctual contribution to a picture.[6]

The reviewer who likened Stuart to Sir Anthony Van Dyck had paid him one of the highest compliments possible. Van Dyck was the Old Master revered at the time perhaps most often for combining beauty with likeness and the appearance of life. Still, Stuart's reputation for "correctness" in likeness plagued him somewhat, inasmuch as not all reviewers saw his work as sufficiently elevated or flattering. He complained that the critics compared his work with that of the Old Masters—rather than with nature—so that he could fall

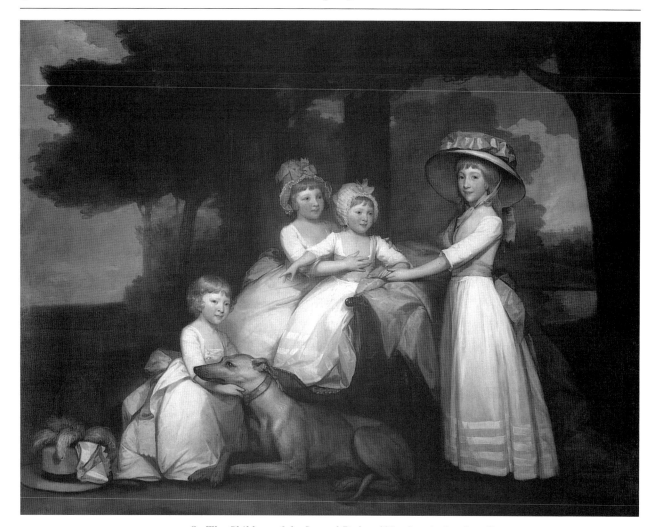

FIG. 38. *The Children of the Second Duke of Northumberland,* 1787

short depending on their preferred artists. Characteristically, he told Jouett that he finally learned how to paint dignity from life—that is, from the self-presentation of his sitters who were members of the nobility. Chiefly this meant that the sitter sat erect with a serene—sometimes aloof—self-possession, possibly even looking beyond rather than at the viewer, as in *Sir John Hort* (fig. 39). In that instance, one of a series of pictures of male friends and relatives painted for Lord Boringdon, the artist placed him, as he was now accustomed to do, on a dais in the studio so that he appears slightly above eye level, his head dramatized by the storm clouds behind.[7]

As Stuart prospered, he began to live in high style —as did quite a few of the London portrait painters— in a grand house, number three on New Burlington Street. To attain the top ranks of success, these artists had to pay court to their patrons, very much in the tradition of Van Dyck, and part of this courtship involved providing suitable surroundings that reflected the artist's aesthetic sensibility. Stuart had changed locations as his finances improved, but he now reached the epitome of success. Fortunately, one traveler from abroad who kept a detailed diary, Sophie von La Roche, visited Stuart and three painters—Reynolds, Thomas Gainsborough, and Benjamin West—as well as the "famous and wealthy engraver" Valentine Green, on September 13, 1786. Her purpose was to assess them and their work as reputedly the best artists in London, or the ones who put on the best show. She was impressed by the lavish decoration in the stately homes of all of them, "apartments hung with pictures by famous old masters, bronze and marble ornaments." Of Stuart, "a young, but respected artist, who will become an ex-

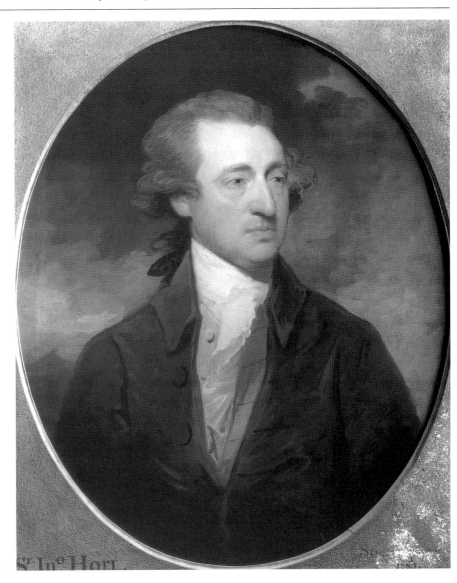

FIG. 39. *Sir John Hort,* ca. 1785

cellent portrait painter," she wrote, "he already has plenty to do [and] he, too, lives as if in the hall of the temple of the Muses, in rooms of magnificent style, fit for true genius to unfold its wings and soar." Concerning him alone, she mentioned architecture: "Fine architecture surrounds him; and it would be almost impossible for him to introduce anything niggardly or anxious into his pictures." Indeed, his drawing room had been designed by the famous architect Isaac Ware.[8]

As opposed to his student days, when he wore eccentric old clothes, Stuart adopted "extreme elegance" in his dress—and not only to assure sitters of his gentility. He had started to court Charlotte Coates. In Newport he had once sought to charm a young woman by playing his flute under her window, and he may well have tried a variation on this technique with Charlotte,

for they shared an avid interest in music. He had met her through her brother, who was a fellow student at the anatomical lessons of Dr. Cruikshank. According to Jane Stuart, Charlotte, at eighteen, was thirteen years younger, intelligent and good-looking, with a superb contralto singing voice. Stuart, on his part, was "five feet ten, with a powerful frame" and the manners of a well-bred gentleman. His face habitually assumed a melancholy expression that was reportedly as appealing to Charlotte as his dark brown hair, which she remembered as curled loosely about his neck. This wavy hair, along with his proud bearing, encouraged others to think that he resembled Charles I. As the romance blossomed, Charlotte's father, Dr. Coates from Berkshire—probably an apothecary—objected to the match. He admired Stuart's genius, but, like the other mem-

bers of her family, he was aware of his "reckless habits." By this, the family certainly meant Stuart's impetuousness and impracticality in financial matters.[9]

William Dunlap is perhaps most eloquent on Stuart's strengths and weaknesses. He and Stuart knew each other between 1784 and 1787, when Dunlap was a student with West. Remembering that period, Dunlap called Stuart "a great beau" who "lived in splendor, and was the gayest of the gay." "His colloquial powers were of the first order, and made him the delight of all who were thrown in his way." "Nature," he wrote, "had bestowed on Gilbert Stuart her choicest gifts. His mind and body were of the most powerful, and the best endowed, for active exertion or ponderous labor—for grasping the minute or the vast—for relishing the beauties of art or diving into the profundities of science." Yet, he concluded: "Of Stuart, as of some others, it may be said in the common phraseology of mankind, 'he had every sense but common sense.' He had knowledge enough to have guided an empire, and did not pilot his own frail vessel into port, even when wind and tide were with him." As a historian in his later years, Dunlap could hardly resist the chance to moralize, particularly with regard to apparent aimlessness and self-indulgence, but his final comment is a telling one: Stuart—not seeming to care about public opinion—could easily give the impression of lacking common sense.[10] In a more nuanced observation that is probably closer to the truth, another contemporary summed up Stuart as "highly honourable in his sentiments, and independent in his actions." He seems to have meant, on the negative side, that he had his own code of honor, which did not always match that of others.[11]

Despite their objections, Charlotte's family finally consented, and the couple married on May 10, 1786. Through subsequent trials, Charlotte remained devoted to Stuart, protecting him from intrusion while he was painting, sometimes kindly explaining his jokes to unenlightened visitors, and, after his death, trying to preserve his reputation. Indeed, she regarded her artist-husband with great admiration as well as affection, imbibing to the full—as Benjamin Waterhouse noted—"all those high notions of her husband's superiority to all other painters." Stuart came to use "Tom" as an affectionate nickname for his wife, and, in the same joking manner, he was fond of teasing her with straight-faced recitals of extraordinary tales. Finally the stories—usually ending in a pun or an outrageous outcome—would provoke her, as he had hoped, into objecting that they were in "very bad taste." On the whole, the two newlyweds seem to have achieved long-time marital happiness. In 1817 Stuart spoke warmly and proudly to Henry Pickering of his wife as a helpmate, evidently of invaluable service to him in her practicality. As he said, "she relieved him from all the cares of this life. He was obliged to attend to three things however—he must choose his paints, his wine & his snuff."[12]

Perhaps in celebration of his new happiness, Stuart, after his marriage, embraced the role of a generous host. Even before then he had entertained well and had been "fond of company," but he now showed off his bride in after-dinner music recitals with some of the best performers in London—concerts in which he also took part. George C. Mason says of this period in his life: "He was constantly invited out, and he delighted in return to entertain his friends at his own house." Stuart was also "a good liver," who "loved to indulge his own appetite, and to see others enjoy what was set before them." Indeed, he gave dinner parties too frequently and too lavishly. His characteristic disregard for money nearly brought him ruin after his marriage. Exceeding the extravagances of other artists, he hired a French cook, among other servants, and he would pride himself on regularly inviting as many as forty-two painters, poets, musicians, authors, and actors to dinner. Inevitably he fell into debt and had to spend some time in sponging houses (places of confinement for debtors of some means and an intermediary step toward prison). Finally, to escape his creditors, Stuart determined that he had to leave London.[13]

Contrary to speculation in the press that he had gone to France or to the United States, Stuart instead accepted an invitation from the duke of Rutland, viceroy of Ireland, to visit Dublin and paint his portrait. The duke hoped to establish a prestigious art academy in Dublin and, probably with this aim in mind, had been trying to persuade his friend Reynolds to visit. Reynolds might well have recommended Stuart, as he did a lesser artist, Christopher Pack, as a possible replacement for himself.[14]

Shortly after Stuart arrived in Dublin, apparently in mid-October of 1787, his new patron unexpectedly and suddenly died after undertaking an unusually arduous journey on horseback. Given this setback and his problems in London, Stuart, at age thirty-two, tentatively decided to set himself up as a Dublin portrait painter. The London papers—rather than their Dublin counterparts—continued to report on his progress, partly

because he returned at least twice. On these occasions, probably to avoid creditors, he gave conflicting destinations as to where he would go next. One exasperated reporter mentioned this circumstance and Stuart's boasts of his father's property in Nova Scotia, finally complaining of Stuart's "disturbed brain."[15]

According to James Dowling Herbert, an artist and writer whom Stuart befriended in Dublin, Stuart was so sought after as a portraitist in Ireland that, as Herbert put it with some artistic license: "A rage to possess some specimen of his pencil took place." From Herbert's chapter on Stuart in his 1836 book *Irish Varieties*, we know that the artist continued to be a humorous, improvident eccentric; he expressed a high opinion of his own ability; and "he assumed an independence of mind, which scarcely would be endured from any other man." For instance, he claimed that he painted "from

[his] own vision and conception" and therefore could not possibly alter a finished portrait merely to please a sitter.[16]

Stuart's portraits during his Dublin years, from 1787 to 1793, were consistent in style with his late English work. He experimented, however, with various arrangements in group pictures, as in his painting of the children of Viscount Clonmell (fig. 40), and he also, apparently for the first time, used a horizontal format with a single figure. The first known instances are his large companion portraits of Sir William Barker (fig. 41) and Lady Barker (fig. 42, pl. 4).[17] To complete the commission, Stuart seems to have visited the Barkers' estate at Kilcooley and to have made a special effort with regard to significant accessories and authentic background details. In the case of Lady Barker's picture, he related parts of the composition through echo-

FIG. 40. *Thomas and Charlotte Scott*, ca. 1789

ing arcs by including a curved chair, delicate floral needlework on a round tambour, a winding background stream, and gently rolling, distant hills. Rather than seeming to be lost in thought, as Eleanor Gordon appeared in her portrait (fig. 23), Lady Barker looks directly at the viewer, responding to that person's presence. She expresses her intelligence through her alert pose and a slightly raised eyebrow as if looking askance. Like Gordon, however, she is also joined to nature, especially in her appreciative response and her creative occupation. As a pair, the portraits of the Barkers follow well-established stereotypes—continued in Stuart's work as in that of his contemporaries—concerning the man's ability to judge (he rests his hand on a ground plan of his house) and the woman's ability to perform (she turns her tambour to show her accomplishment).[18]

A greater departure from Stuart's English work, and an unusual instance of self-expression, can be found in another Irish portrait—namely, his full-length view of George Thomas John Nugent, eighth earl of Westmeath, as a boy (fig. 43). Having painted portraits of the parents, Stuart depicted the son and heir accompanied by a large, fawning dog with "G. Stuart" printed on his collar. Clearly Stuart was irked, as Herbert noted, by the assumption of his sitters that he should flatter them and by their attempt to give him advice on how to do so. With his signature—relatively rare in itself— he must have identified his own existence consciously with that of the child-subjugated dog. According to Dunlap and a source in Jane Stuart's account, the artist spoke often of the similarity between portrait painters and kept dogs. The negative connotation is played out in the way the boy, with his ostentatious plumed hat, does not deign to touch the dog with his bare fingers.

FIG. 41. *Sir William Barker,* ca. 1790

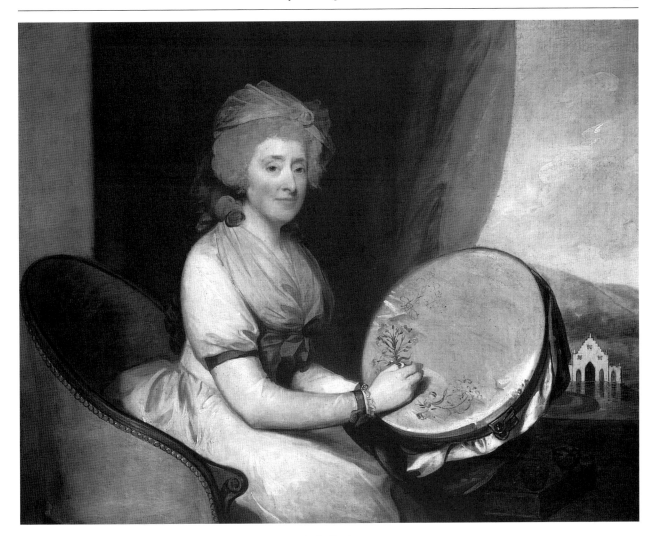

FIG. 42. *Lady Barker,* CA. 1790

Rather, he holds the dog's potentially slobbering muzzle with a handkerchief and places a ball, in a controlling gesture, on the dog's forehead. Meanwhile, the dog lifts one paw, begging his young master to throw the ball so that he can do his bidding. Despite this interpretation, the painting probably did not offend the patron, for it is concerned more with the artist's subtle self-criticism than any criticism of the boy, who is shown, after all, as an obediently clean and animal-loving child.[19]

Stuart's self-defeating whimsical streak comes through particularly clearly in Herbert's encapsulation of the older artist's Irish years. As Herbert observed: "He had all the equalizing spirit of the American,—and he looked contemptuously upon titled rank." Thus, for instance, Herbert thought that Stuart sometimes

turned down career-enhancing invitations to dinner at great houses so that he could call unexpectedly, instead, on an artist friend. In fact, Stuart preferred the company of talented individuals. Inexplicably, he also enjoyed being pursued by bailiffs—"vultures," as he called them—whom he could then outwit in what he considered clever ways. These "vultures" and his usual dinner parties continued to add to his debts. Stuart told Herbert that it cost him more to pay bailiffs—probably in bribes—to keep out of confinement than it would have if he had paid the original debt, adding that he confessed his "folly in feeling proud of such feats," meaning his keeping just ahead of arrest. From what his daughter reported as well, he seemed to enjoy occupying a central position in what he deemed a ridiculous situation. Therefore, he relished the tale of

FIG. 43. *George Thomas John Nugent, Later Eighth Earl of Westmeath,* ca. 1790

his finally submitting in 1789 to imprisonment for debt in Dublin's Marshalsea Prison, where, to his glee, he received a constant succession of prominent and serious citizens who wished to have their portraits painted. One London newspaper gushed over this circumstance that he now had "more testimonials of approbation, and more homage paid to his Genius, than any other professional man ever experienced." As Dunlap told it, Stuart received the customary half price at the first sitting, and, after accumulating a sufficient amount, paid for his release, leaving behind—in a short-lived joke—the "Irish lordships and gentry imprisoned in effigy."[20]

This demonstration of Stuart's arrogance was not an anomaly but, rather, characteristic. Herbert's amus-ing account documents other such instances, as well as Stuart's legendary impatience with criticism. For instance, he told the story of the archbishop of Dublin, who rejected a portrait of his daughter by Stuart as not sufficiently flattering. The archbishop, who had let his displeasure be known beforehand, sent a message to Stuart's upstairs painting room to ask the artist to meet him at his carriage door. Herbert, who was with Stuart, rose to depart, but the older artist stopped him: "No, you must stay and witness a novel scene." Stuart then replied to the archbishop that "he was not accustomed to attend carriages." When the archbishop answered that his gout prevented him from ascending the stairs, Stuart faked a complaint of rheumatism and offered to meet him halfway. Playacting with his foot

bound in a handkerchief, the artist prolonged the humor of the circumstance as much as possible. They did meet halfway and hobbled together to the studio. Stuart then placed the canvas on his easel and, to the archbishop's dismay, proceeded to blot out the entire picture. Ignoring the archbishop's objections, he returned his client's money. But the play was not yet over. After further protesting from the archbishop, Stuart, seemingly miraculously, removed his overpaint with turpentine. The archbishop, with great relief, agreed to receive the dried painting later that day. Bowing obsequiously, he expressed his gratitude and hobbled away. Stuart attended him halfway, then returned to his painting-room, delighting in his victory. Justifiably, the painter's daughter called him "ironical to excess." Assuming a moral stance, Stuart told Herbert that "the archbishop was arbitrary[;] therefore he was resolved not to yield to his rude and overbearing temper."[21]

Exactly when Stuart first formulated the desire to paint a portrait of George Washington, one of the most highly revered men in Ireland as well as in England and the United States, is open to question. As the artist witnessed much of the Irish parliamentary struggle for greater independence from England during his residence in the Dublin area, he was likely to have been reminded of American colonial dissension and subsequent events in which Washington emerged as the noblest of patriots and "the idol of every lover of liberty." Perhaps inspired by the situation in Ireland and the contemporaneous upheaval undertaken in the name of liberty in France, Stuart decided to return to the United States and, as he told Herbert, "make a fortune" by producing "a plurality of portraits" of Washington. Yet this intention, voiced probably in 1793, could well have been an expression of new determination to fulfill an earlier plan. Samuel Knapp, who knew Stuart many years later, claimed, with regard to the portrait of Washington, that Whigs in England wanted Stuart to go to the United States for this purpose. Certainly some of Stuart's most loyal English patrons, such as Northumberland, were members of the deeply factionalized and partially pro-American Whig party. But Stuart must have thought of such a venture himself, perhaps having heard of West's short-lived plan in 1783 to paint a series of pictures on the American Revolution and perhaps having encouraged his friend John Trumbull in his 1785 scheme to make money by painting just such a series of pictures that would then be engraved, creating a plurality of images. The London newspaper that announced in 1787 that Stuart had gone to Ireland, "[whence] it is probable he will embark for America," could well have been on the mark with regard to his ultimate ambitions. The problem was, however, that the financially troubled artist could not afford such a move.[22]

Probably one of the more extraordinary things about Stuart from the point of view of more conventionally ambitious artists—such as the history painter Mather Brown, who considered him a gifted eccentric—is that he often seems not to have cared how his portraits were finished, once he had done the head. When Stuart was in desperate financial straits, before leaving for Ireland, he pawned two unfinished canvases, both of which contained a painted head of the American peace commissioner John Jay. According to report, Trumbull eventually acquired one of these canvases and completed it for Jay as a three-quarter-length view (National Portrait Gallery, Washington, D.C.). More oddly, Stuart told Herbert that he planned to earn the money for his voyage to the United States from half-payments delivered at the first sitting, for he had no intention of completing his portraits beyond the one-sitting likeness. With characteristic inconsistency, he neglected the wishes of his sitters, who would expect finished portraits, and honored those of his creditors. He intended to repay his debts by these means before his departure. During a conversation with his young artist-friend Herbert, he rationalized his behavior as quixotic, saying: "The artists of Dublin will get employed in finishing them. You may reckon on making something handsome by it, and I shan't regret my default, when a friend is benefitted by it in the end."[23]

Originally Stuart intended to embark on a ship bound for Philadelphia, then the center of the United States government, but, learning that a traveling circus would occupy the same vessel, he and his family sailed instead for New York. After Stuart's arrival in early May of 1793, he called on John Jay, the only person he knew in New York and one of his few acquaintances who could write a letter of introduction to George Washington. Jay, whom Stuart considered a firm friend, probably introduced the artist to potential sitters; in any case, Stuart had sufficient commissions to keep him busy in New York for about a year and a half. During this period, he seems to have displayed a range in talent as if in deliberate self-advertisement.[24]

FIG. 44. *Dogs and Woodcock,* ca. 1794

The most unusual picture associated with this promotional effort is his *Dogs and Woodcock* (fig. 44), which is signed on the foreground dog's collar with "G. Stuart," followed by a shortened form of "pinxit" (almost illegible now). The subject is somewhat reminiscent of Stuart's Newport competition, which might have come to mind as he undertook what is clearly a demonstration of his skill. The painting, showing three brown-and-white spaniels in pursuit of two woodcock, one of which has escaped, conforms to a well-established tradition of picturesque, autumnal hunting scenes. Relatively small, at a little over twenty-four by twenty inches, highly decorative in coloration and exceptionally carefully painted—as in the verisimilar texture and sheen of the dogs' fur—*Dogs and Woodcock* was most likely undertaken on speculation.

Probably stimulated by local appreciation (for he was now welcomed as the finest painter in America) and by renewed contact with students of West's such as Trumbull, Stuart exerted himself, in his New York

work, to move beyond the halfhearted stage that he had reached with his unfinished Irish portraits. One London newspaper of 1790 had announced that his Irish portraits showed increased "taste" and "power," but he did not experiment or display the range in 1790 that he did three to five years later with portraits of Aaron Burr, Joseph Anthony, Margaret Izard Manigault, and Richard Yates.[25]

Aaron Burr, the United States senator from New York, appears in his bust-length portrait (fig. 45, pl. 5) under a soft spotlight that dramatizes his head and therefore himself as a thinking being. The light illuminates the red background in a fiery glow around his head, merging with an enveloping darkness that recalls the mysterious tenebrism in Stuart's early self-portrait (fig. 12, pl. 2). Like that work, this painting refers to the Old Masters, especially seventeenth-century spotlit portraits in a golden brown tonality by Rembrandt. Stuart generally preferred not to use chiaroscuro, for the effect diminished the beauty of pure color, but he did

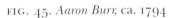

FIG. 45. *Aaron Burr,* ca. 1794

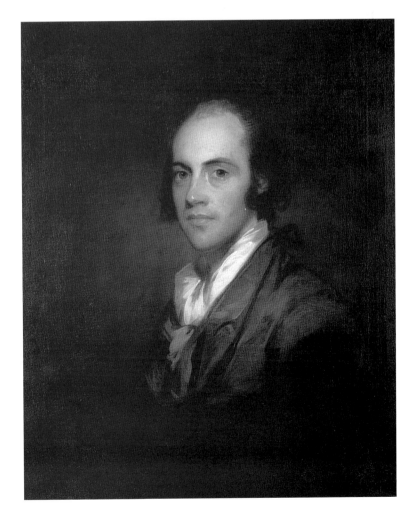

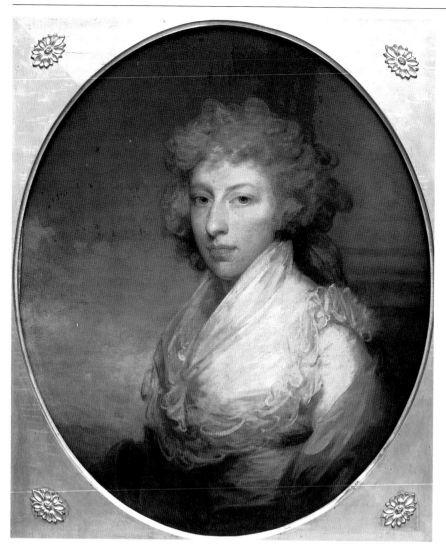

FIG. 46. *Mrs. Gabriel Manigault,*
1794

revert to this same softening surround of shadow in a later portrait—more highly keyed overall—of about 1795, of his uncle Joseph Anthony (Pennsylvania Academy of the Fine Arts, Philadelphia). In the case of Anthony, the spotlight again illuminates part of the background behind the sitter, giving added resonance to the subject. Reynolds and Allan Ramsey, among others, had used similar effects in English portraits so that there was an ongoing tradition (one that even Trumbull occasionally followed) for this somewhat disembodied pictorial type. By terminating the bust in a curved fade-out such as this, there was no awkward severing of arms at the edge of the frame, and the overall illusion had the additional benefit of resembling, flatteringly, an antique Roman bust.[26]

Stuart's portraits of two wealthy South Carolinians, Gabriel Manigault and his wife, Margaret, are particu-

larly well documented through letters and her diary. At least partly on the recommendation of Stuart's portrait of Manigault's brother, done in London in about 1785, the Manigaults commissioned portraits from the artist while visiting New York in March of 1794. Stuart's response was to create in these pictures a virtuoso display of nuanced color and visible brushwork in the stereotypically English manner, so that the likeness of Margaret (fig. 46), for instance, appeals as a very painterly performance. She and her mother admired the resemblance and proclaimed it "very like"; at the same time, she reported in her diary that Stuart was "a very entertaining well-informed man" who "had it seems a passion for old books."[27]

In contrast to these portraits, which are in different ways highly pictorial, the likeness of the prominent New York merchant and former loyalist Richard Yates

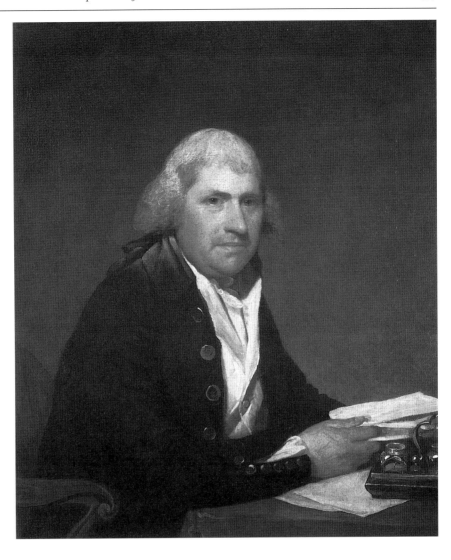

FIG. 47. *Richard Yates,* 1793/94

(fig. 47, pl. 6) is all the more notable. It might appear that the painting of the head resembles the head in Stuart's 1793 portrait of William Samuel Johnson (private collection), which Dunlap claimed to have been the first portrait that Stuart painted in New York, but there are significant differences. The portrait of Yates is more meticulously painted and conceived in a far more three-dimensional manner throughout, stylistically a surprising reversion to Copley's influence. (The companion portrait [fig. 48] of the shrewd-looking Mrs. Richard Yates, less sculptural than that of her husband, is more consistent with Stuart's late English and Irish work.)

There is a confrontational immediacy in the portrait of Richard Yates, and a sentience that hearkens back to the Waterhouse likeness (fig. 6, pl. 1). In a comparison of this work with one of Stuart's portraits for

John Boydell, such as that of Reynolds (fig. 26), what stands out as innovative is the solidity of form, the subtlety in modeling transitions and creating transparent shadows, and the purity of flesh color. This coloration and the way it appears, in the Yates portrait, to rise from beneath the sitter's cheek can be experienced unevenly in a number of Stuart's English and Irish works, but it is now part of an overall greater emphasis on living, breathing form. Unlike the Boydell pictures, the Yates portrait, like that of his wife, is probably done wholly from life. Consider the following: While the brushstrokes in Reynolds's wig suggest paint, their counterparts in Yates's portrait suggest the varied texture and sheen of powdered hair; while Reynolds's hand appears to be an anonymous glove, Yates's hand is a portrait of a particular hand with raised veins and the glowing transparency of real flesh; while

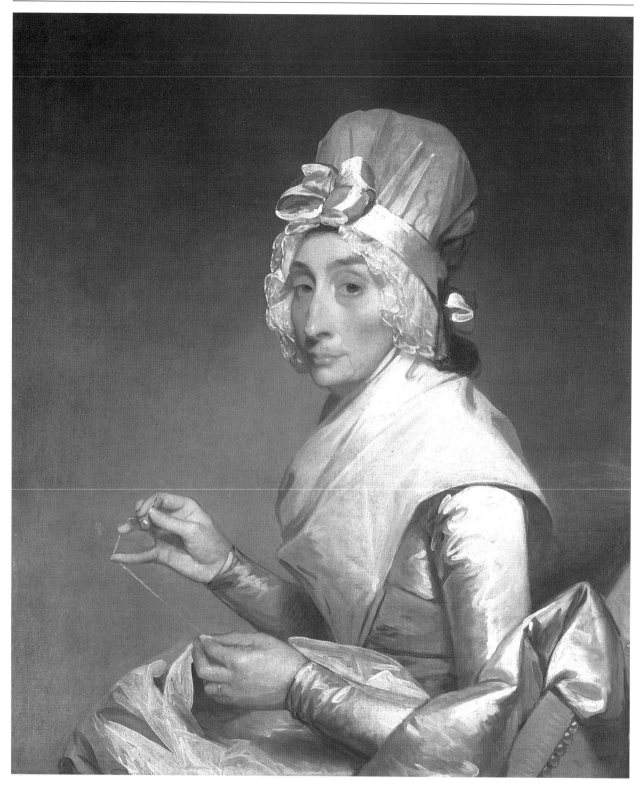

FIG. 48. *Catherine Brass Yates (Mrs. Richard Yates),* 1793/94

Reynolds's eyes are not highlighted, Yates's eyes sparkle and gleam with the liquidity of real eyes; and while the secondary areas in Reynolds's portrait are carelessly painted in Reynolds's own manner—once called "a splashing, dashing method"—the inkstand in Yates's portrait is quite carefully portrayed. Finally, along with its greater naturalism, there is in the Yates head a peculiar indistinctness of form, and yet all seems defined, which appears to result from Stuart's method of building form without relying on outline. The subject, staring and leaning forward intently with his elbows on a table, can be interpreted as a strong and even domineering man, particularly in contrast to his younger brother and business partner, Lawrence Reid Yates, whom Stuart painted as well (National Gallery of Art, Washington, D.C.). In this second portrait, closer stylistically to that of Mrs. Yates, Lawrence is shown seated in a simple Windsor chair, wearing a more flamboyant jabot than his brother's and hunched somewhat in a more lethargic, even compliant posture.

Significantly, Dunlap, who had known Stuart's London work of 1784 to 1787, was surprised when he saw the New York pictures. He wrote of the experience of seeing them: "It appeared to the writer as if he had never seen portraits before, so decidedly was form and mind conveyed to the canvas." Among the paintings he remembered were those of the Yates family. Dunlap spoke of Stuart as giving an enviable éclat and accuracy of likeness to his pictures in New York, and, indeed, his accuracy, presented with subtly enhanced coloring—more beautiful than in life—was for many highly alluring.[28] Responding to the public acclaim for his

work, Stuart remarked to a friend: "'In England my efforts were compared with those of Vandyck, Titian and other great painters—but here! They compare them to the works of the Almighty!'" Indeed, in England, even after he had left, he incurred criticism fairly consistently for adhering too closely to what he saw. For instance, an 1805 journal carried the complaint that he had shown a surprising lack of taste in painting the duke of Northumberland's nose as the awkward protuberance that it was. Yet, when he was praised, the comparison seems most frequently to have been made with Van Dyck. One British critic, writing in 1803, still mourned Stuart's departure from Great Britain "as a public loss," for "his excellence in taking a likeness was beyond comparison" and, more important, he seemed "to have copied the excellencies of Vandyke with more accuracy than any other painter of modern times."[29]

Whereas Stuart complained in London that the critics would not compare his work with nature from which he had painted, now, in New York, he appeared to welcome a quite different reaction on the part of some of his sitters. Rising to this challenge with works such as *Richard Yates* and *George Gibbs* (private collection), of about 1795—the latter painting described by one of West's late students as startlingly real, *"a living man, looking directly at you"*—Stuart returned to the impulse behind his remarks on animated flesh. When he was inspired to do so, he pursued the expression of vitality and sentience in his sitters, carrying the naturalism of John Singleton Copley's external mimeticism one step further in an attempt to include the suggestion of an inner, ephemeral life.[30]

The Portrait of Washington

IN HIS QUEST TO PAINT THE MOST SUC-cessful picture of George Washington, Stuart must certainly have been responding to the challenge presented by others who had tried to do it before; he must have been attracted to the task also because he recognized the potential in such a subject for approximating the uplifting effect of history painting. Never meant to be solely an accurate likeness of a great man, Stuart's portrait of the president—even in the earliest "Vaughan type"—epitomized Washington's character as a moral example, in the manner of a history painting. The successor to the Vaughan-type portrait, the so-called Athenaeum portrait—merely a head—brought such a response from its audience as perhaps to call into question the hierarchical categorizing of the genres in painting. In fact, the introduction of the sublime, as an exalting content, in portraiture seems to have helped to effect the merging of the categories of history and portrait that occurred in some pictures at the end of the eighteenth century. Stuart's portraits of Washington should be seen in this context. The Athenaeum version—lofty in content and suffused with didactic purpose—took Sir Joshua Reynolds's various efforts to amalgamate history and portrait painting and distilled them into one simple, powerful image. Building on the accurate portrayal of Wolfe in Benjamin West's imaginary *Death of General Wolfe* (fig. 8), Stuart located the full content of a heroic depiction in the

painting of a hero's head. By restricting and intensifying the impact of a conventionally larger picture, he created a new model for the historical portrait and, as one observer concluded, "a moral ideal in portraiture."[1]

Stuart arrived in Philadelphia probably at the end of November, delivered his letter from John Jay requesting a sitting, and began his first portrait of Washington in the "winter season," as he stated, of early 1795. There is some controversy over whether this first portrait, from life, still exists. At the core of the dispute is a certificate that Stuart signed on March 9, 1823, at the bottom of a letter of April 11, 1796, to him from George Washington. In it he says that he painted two different life portraits of Washington, specified by location, and "a third but rubbed it out." A postscript clarifies Stuart's statement: the witness for whom the certificate had been made, Timothy Williams, identified the "destroyed" portrait as the first one painted.[2]

Rembrandt Peale, an artist who knew Stuart at the time, claimed that the so-called Vaughan portrait of Washington (fig. 49), named after its first owner, was the first that Stuart painted. He maintained that it had never been destroyed and that it was the source for many replicas of the Vaughan type. In response to the certificate, which had been published in the *New York Evening Post* in 1833, Peale repeatedly insisted that his recollection was correct. Supporting Peale's remembrance, the strongest evidence that the first portrait

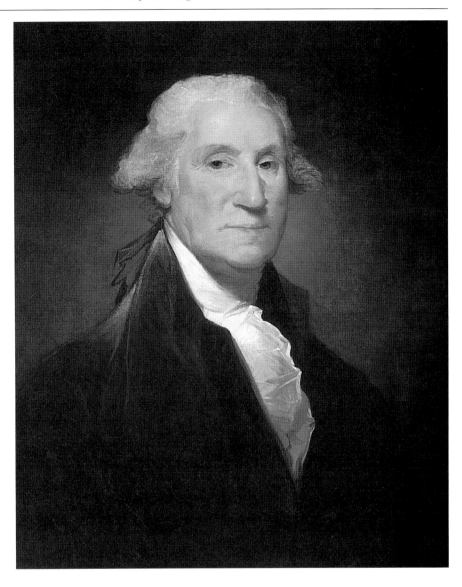

FIG. 49. *George Washington* (Vaughan Portrait), 1795

still exists and is the Vaughan portrait is the physical appearance of the picture itself. The striking difference between the Vaughan portrait and all other known versions of its type is that the Vaughan head is not much more than a drawn sketch—lightly blocked in and then penciled over in a tentative fashion. And yet the picture is completed in the background and clothing as if it were valuable as an incomplete expression in itself. One explanation that could reconcile the conflicting stories and would fit Stuart's state of mind at the time—for he reported afterward that he had felt overwhelmed by Washington's presence during the sitting and had had great difficulty in trying to capture his character—is that Stuart indeed erased, or "rubbed out," his first portrait of Washington. But, desperate to

show a result, he then repainted it, in the absence of the sitter, using the same canvas. The end product—in no way overworked but, rather, begun again with the freshness of a quick sketch—is the Vaughan portrait, painted from the one sitting and yet not from life. From all accounts, Stuart had a prodigious memory; was not bound to paint from life alone; and, knowing the commercial value of a life portrait of Washington, would not have parted with the Vaughan likeness so easily if it had been from life. He never, for instance, released the later, life-based Athenaeum portrait. It is also highly unlikely that Stuart painted a life portrait, used it for numerous replicas, and then destroyed it.[3]

What is most fascinating about the first portrait, if it is not from life (which certainly must be the case,

FIG. 50. *George Washington* (Athenaeum Portrait), 1796

inasmuch as Stuart insisted on this point on more than one occasion), is that it is then more purely the artist's own conception of Washington. That Stuart was unable to paint as he wished in Washington's presence is also telling and recalls his experience with John Trumbull's sallow skin. In other words, Stuart could go only so far in inventing when the sitter before him belied his efforts. Another important point is that Stuart had an agenda for this portrait—which is why he would have completed it as he wished—and perhaps a preconception of Washington that the president's actual appearance did not meet. Finally, Stuart's admitted dissatisfaction with the Vaughan likeness can be explained at least partly in that it was not from life and was therefore a reminder of failure. From the beginning, this picture was to express the character of an extraordinary human being, the accepted father of a newborn nation: the supreme patriot who had risked his life and accepted no pay for carrying out his duties as commander of an army; the disinterested republican who, when he could have been king, had laid down his military might before an elected government; and, in old age, the benign and authoritative head of state in a new world.[4]

Stuart obtained a second chance to paint Washington from life probably in about March of 1796, as Peale remembered. The result, purchased much later for the Boston Athenaeum, is the so-called Athenaeum portrait (fig. 50, pl. 7). Very likely at Stuart's suggestion, and perhaps prompted by his receipt of a commission from the marquis of Lansdowne for a full-length portrait of Washington, Martha Washington commissioned the Athenaeum portrait as well as a companion portrait of herself. It seems that it was understood from the beginning that a larger Lansdowne portrait (fig. 53) would be based on the Athenaeum image. On April 12, 1796, Washington sat specifically for the Lansdowne likeness, as Stuart reported, at the petition of a prominent Philadelphia socialite, Mrs. William Bingham. Her husband had witnessed the Lansdowne picture in process and then succeeded in recommissioning the work as a gift from himself and his wife to their friend the marquis. The Binghams, who knew Stuart from London and had commissioned works from him before, wanted to be certain of the quality of the Lansdowne image and to obtain a replica of it for themselves. Thus, Stuart painted two portraits of Washington from life.[5]

The Athenaeum portrait, based on several sittings from life and repeatedly promised to Mrs. Washington when finished, was deliberately retained by Stuart in an unfinished state. The Lansdowne likeness—based on the earlier picture and one life sitting—was sent overseas, where Stuart must have known it would be judged by colleagues in his profession. He had pushed himself to finish it at Bingham's urging, but the likeness he valued above all others was the Athenaeum head. Indeed, he desperately wanted to keep this original as a financial hedge and possible legacy for his family. In answer to the repeated efforts of the Washington family to retrieve the likeness after Washington's death, Stuart circulated the probable fiction that the general himself, in a private conversation, offered to let him keep the portrait. There are two slightly different accounts of this conversation, a fact that in itself suggests fabrication: either he could borrow it "at his pleasure" for copies or he could retain it forever and supply Washington with a replica in its stead.[6]

For his version of Washington, Stuart's real competition fell within a particular category. Unlike most of the artists who attempted Washington's portrait—and, with the expected financial reward in copies, there were many—Stuart was clearly inspired by the concept of a morally sublime person and the need to achieve the effect of inner sublimity in this likeness. Rarely—if at all—as the theorist Jonathan Richardson pointed out, did a portrait painter have the luck to be able to paint such a genuinely exalted character, and, given the chance, the artist had to know how to do it justice. The key text for sublimity in a portrait was ultimately that of Longinus, who had defined the sublime as an expression of elevated thought and greatness of soul. Although such a definition is ambiguous when applied to a visual image, Longinus took the important step of locating it within the human being; furthermore, his best-known English translator, William Smith, played a seminal role in concretizing this connection by suggesting portrait imagery in his introduction to Longinus's text. As others had done, he called Longinus—a self-sacrificing, long-time patriot who had struggled and died "in the cause of liberty"—the ultimate example of a sublime human being. But Smith added a description of how Longinus must have looked: "the features are graceful, the air is noble, the colouring lively." Longinus, as the sublime ideal, embodied such qualities as wisdom, virtue, bravery, and modesty; he spoke "feelingly" against tyranny and he had "a high and masculine turn of thought [which caused] him to give all possible strength and energy to his words." In

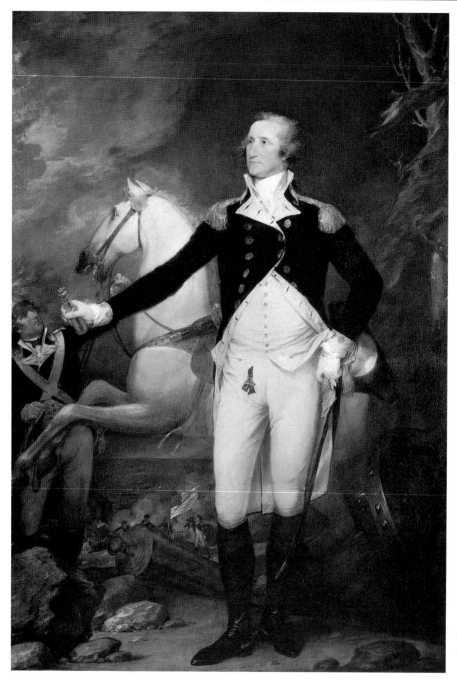

FIG. 51. John Trumbull,
*General George Washington
at Trenton,* 1792

an attempt apparently to increase Longinus's appeal, Smith even speculated about the precise religion of this third-century Greek, finally suggesting that he was a Christian and, in fact, one who had admired Saint Paul.[7]

As for Stuart's predecessors, Trumbull seems to have been the first American artist to state sublimity as his aim in painting Washington's character. The work so described, his full-length *General George Washington at* *Trenton* (fig. 51), had been commissioned by the city of Charleston, South Carolina, whose representative ultimately refused it as more theatrical than he had expected. Stuart almost certainly heard of his friend's precedent and probably also his successful substitution of a second full-length portrait, showing Washington in a recent visit to Charleston (City of Charleston, S.C.). In any case, he appears to have known the plans, concerning sublime portraits of Washington, of the Ital-

FIG. 52. Giuseppe Ceracchi, *George Washington,* 1791

ian Neoclassical sculptor Giuseppe Ceracchi, whom he must have met earlier in London. Having modeled a terra-cotta head of Washington from life in 1791 in the heroic guise of a Roman (fig. 52), Ceracchi returned from Europe to Philadelphia in the fall of 1794 in hopes of gaining a federal commission for either an equestrian statue of Washington or a grandiose monument to American liberty. Although Ceracchi was eventually to be disappointed, Stuart apparently saw him as a potentially successful competitor. Just before leaving for Philadelphia, he asked Jay for information on Ceracchi's circumstances.[8]

The concept of the sublime informs each of Stuart's first two portraits of Washington—but in markedly different ways. In the Vaughan painting the sitter is placed unusually high on the canvas, his head relieved by a fiery red background suggesting a glowing space or aureole, which cools toward the edge of the canvas. In

this respect, the picture recalls the background in the earlier likeness of Aaron Burr (fig. 45, pl. 5); in contrast to that portrait, however, Washington's face is more highly keyed throughout, from the highlighted creamy complexion of his forehead to the smudged-in ruddy coloring of his cheeks and jaw. Stuart's preferred Athenaeum head, showing the left side of the face instead of the right, is akin to the Vaughan likeness in its vibrantly colored flesh, but it is less elongated, more compact, and more massive. The gaze is also more confrontational so that the whole is suggestive of greater sagacity, intensity, and supernatural strength. In this second instance, the head is surrounded by a grayish brown halo effect created by denser painting in the unfinished background; and the lower part of the image terminates in a curved upper chest so as to allude clearly to its antique precedent, the Roman bust. There is also the faint suggestion, in the murky area behind Washington, of a flat vertical strip or a standing pillar that extends to the top of the canvas. If a pillar is indeed what was intended, then it functions as an emblematic reference to Washington's strong character or to his historic role as a founding father.

A sublime portrait is essentially concerned with the expression of power, and, to be effective, it must produce a reactive feeling of awe in the spectator. Despite his earlier attempt with the Vaughan portrait, the Athenaeum likeness is arguably Stuart's only sublime portrait in that it alone was recognized—by contemporaries such as the critic John Neal—as producing the appropriate reaction. It succeeded because it was superhumanly expressive of moral power and moral authority. In one condensed image Stuart was able to combine associations with Roman antiquity, Christianity, and—in the incompleteness of the form—even the glorious immateriality of the soul. The degree of abstraction, generally a disembodied effect, helps to take this portrait out of the realm of any ordinary image.[9]

In speaking later to an art student about the importance of a consistent overall expression, Stuart recommended the pleasing effect that can be obtained in a picture from "the idea of an adaption to an end." Surely the Athenaeum portrait (like *The Skater* [fig. 20, pl. 3]) was adapted to an end, and Washington Allston, a younger artist who knew Stuart well in Stuart's later years, seems to have understood this. Calling the likeness "sublime," he concluded that "a nobler personification of wisdom and goodness, reposing in the majesty

of a serene conscience, is not to be found on canvas." Stuart's Washington epitomized a multifaceted moral ideal that could be linked to the noblest characters of antiquity. The artist's task had clearly been to form a visual metaphor—one that would be apparent to all—for a specific, but nevertheless sublime, inner being. Although the result was widely acclaimed for uniting such effects as "the gentleman and the sage, the hero and the Christian," its exalted character also brought some criticism, such as in the complaint: "There is too much sublimity in the face." Indeed, one reviewer added: "The painter has infused into it an amplitude and grandeur that were never the attributes of Washington's *face*."[10]

Years later, Washington's step-grandson echoed a number of Stuart's contemporaries in saying that Stuart had given "all his genius" to the Athenaeum likeness. The intentionally unfinished work, as a type, gave pleasure to the eighteenth-century viewer partly because it relied on his or her complicity in using imagination for its completion. But more important in this case, the lack of finish continually reminded the viewer of the artist's interpretative participation. The Athenaeum portrait is not only a likeness but also, most deliberately, a painting stopped in process, and the connection with its creator is certainly part of its intended effect. There is much visible brushwork, or penciling, in it—an aspect that Peale thought remarkable. Although highly controlled, Stuart's unfinished brushwork separated his interpretation of Washington from the attempts of his precursors and referred to the spontaneity and ease of creation associated with inspired genius.[11]

On one level, the portrait represents creativity as a process. The unfinished background and unfinished foreground—mixing free brushwork with bare canvas—serve to flatten the entire image as a reminder of pictorial reality; while the head, by contrast, seems to project miraculously from the center as a highly three-dimensional form. As if to describe this effect, Stuart spoke later to Matthew Jouett of producing a head in such a manner that it was "forged out." In a similar way, he repeatedly discussed the realization of a visual image by increased degrees of plasticity, gradually bringing a likeness into being. He sometimes associated this experience with that of looking at oneself reflected endlessly through mirrors to become aware of a subtle difference in degree of realization. While talking with the sitter as he painted, he would establish the likeness, so much of which—he thought—depended on the

nose, and, finally, he would "awaken" the image, as Jane Stuart termed it, by completing the eyes. The Athenaeum head has been brought into existence up to a tantalizing point that relies on the viewer's imagination for the finishing touches: the eyes, for instance, lack the usual spark that is supplied by Stuart's highlights.[12]

Like many in his generation, Stuart was influenced by Johann Caspar Lavater's attempt, toward the end of the century, to codify the connection that was widely assumed to exist between a person's outward appearance and inner character. Stuart's contemporaries considered his Athenaeum head to be a remarkably strong likeness, and a morphological comparison of the head with Jean Antoine Houdon's 1785 life mask of Washington (Pierpont Morgan Library, New York)—when the mask is placed at the exact same viewing angle—supports this conclusion. Yet, in an attempt to present not just the likeness but also the essence of the president's character, Stuart made subtle adjustments in Washington's appearance. In fact, he reinforced his interpretation similarly in the case of the Vaughan portrait, which is considerably less like the life mask, and even tinkered further with this likeness in various copies before abandoning the type. He undoubtedly made these modifications at least partly because his most knowledgeable audience was Lavater educated and, whether they agreed with the specifics of Lavater's system or not, they would be especially primed to try to read character in a portrait of such a famous man.[13]

Lavater, a Swiss theologian, had his *Essays on Physiognomy* published in English in several widely read volumes over the years 1789 to 1798. These essays argue that physiognomy is a science and that a person's moral character can be identified from the bone structure of the face and the permanent lines left by habitual facial expressions. In a short discussion of portraits of Washington in the second part of his third volume, doubtless without Stuart's foreknowledge, Lavater included an engraving after the Vaughan portrait. He praised it as "the character of a great soul," for "its expression of probity, wisdom, and goodness"; but, with no regard for what Washington actually looked like, he also criticized it on the basis of character expression. Washington's features should have been made more dignified and vivacious, he maintained, to better accord with the character of a man involved in such illustrious deeds. The eyes, for instance—which in actuality were light blue—are faulted for not possessing the "heroic force" that is "inseparable from true greatness."[14]

Stuart, on his part, ridiculed the confidence of others in such rigid systems as Lavater's, but inasmuch as he prided himself on his own ability as a physiognomist, he does not seem to have considered the exercise of face reading entirely futile. Although we do not know his own theories, the language that he used in discussing Washington's appearance is decidedly Lavateresque. He told a visiting foreigner that there were features in Washington's face "totally different from what he ever observed in that of any other human being; the sockets of the eyes, for instance, are larger than what he ever met with before, and the upper part of the nose broader. All Washington's features, he observed, were indicative of the strongest and most ungovernable passions, and had he been born in the forests, it was his opinion that he would have been the fiercest man amongst the savage tribes." What Stuart focused on, terrible passion combined with even greater self-control—an "indomitable will" that was the most sublime aspect of Washington's known character—was surely what Lavater (had he known more of Washington's reputation) would have tried to find represented in the great general's face.[15]

Judging from the bone structure in the life mask, Stuart, in his Athenaeum head, actually diminished the size of the large eye sockets and the prominence of the cheekbones, which together would have made Washington more sensitive looking, even somewhat haunted. Moreover, he narrowed the tip of his nose and made it slightly more aquiline. The mouth in the painting is fuller, as contemporary comments would lead us to expect, because Washington had a set of ill-fitting false teeth when Stuart painted him. We know, as well, from historical accounts that the artist darkened Washington's eyes and enlivened his pale flesh so as to convey much greater vitality.[16]

Having arrived at his Athenaeum interpretation of Washington, Stuart must have welcomed the chance to amplify it in a full-length version for Lord Lansdowne (fig. 53). The demand for replicas on this scale could provide a lucrative business; and the added interest of the background would make this version especially suitable, as he realized, for engraving so that his income could be augmented further by the sale of reproductive prints. In his expanded interpretation, Stuart was influenced by his English patron, a wealthy art collector whom he had known in London. Lord Lansdowne was a former secretary of state who had participated in the peace negotiations at the end of the Revolution-

ary War. He was not only a former friend of the American colonies, and an admirer of Washington as a "noble example," but also a political philosopher. This last fact, especially, seems to have had some bearing on the picture's theme of benevolent governance.[17]

In the highly contrived painting, Washington is dramatized by a fictitious setting and a series of props that allude to his legacy and that of the other founding fathers. Except for its specific associations, the work is consistent with a tradition of portraiture for aristocrats and royalty. Once again, Washington is presented as a paragon of virtue and, as such, a source of national pride and inspiration. Standing ramrod straight with one hand on the sword by which he had led his country to freedom, he extends his other hand in a gesture of address that can be interpreted variously as, for instance, a greeting or even possibly a bestowal. Beneath this hand, the books below and above his writing table are significantly titled: "General Orders," "American Revolution," "Constitution & Laws of the United States," "Federalist," and "Journal of Congress." The background of classical columns and tasseled drapery is a subdued quotation, via an engraving, from a more flamboyant precedent: the late-seventeenth-century portrait of a famous preacher, Bishop Jacques Bénigne Bossuet, by the French artist Hyacinthe Rigaud (fig. 54). Like Bossuet, Washington is accompanied by a magnificently carved table and chair, but these are transformed and enriched with emblematic references to the United States in the eagles, the fasces, and the shield from the Great Seal. As also in the engraved prototype, Washington looks beyond the viewer, but with the more fixed stare—as if into the future—of a visionary. The greater use of biographical symbols and the content-charged head, suitable—it would seem—only for Washington, distinguish this portrait from its nearest precursor, Stuart's full-length portrait of the Speaker of the Irish House of Commons, *The Right Honorable John Foster* (fig. 55). In the Lansdowne portrait, the past and the future appear to be combined: the rainbow behind the columns would refer to the abatement of the storms of war and dissension; while the magnanimous gesture portends the inheritance of the future. At the time of the painting, Washington was sporadically engaged, as he had been for more than a year, in writing his farewell address to Congress and the American people. Making use of the impending retirement, Stuart portrayed Washington, according to early interpretations of the picture, in the act of ad-

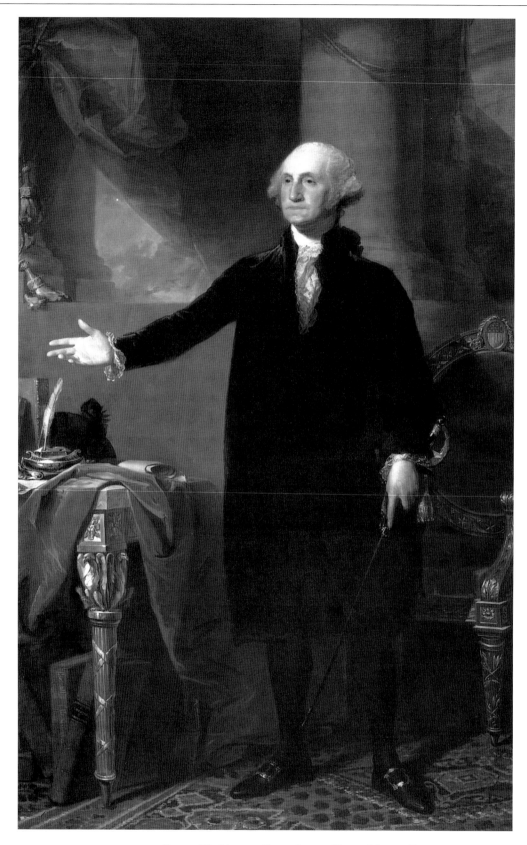

FIG. 53. *George Washington* (Lansdowne Portrait), 1796

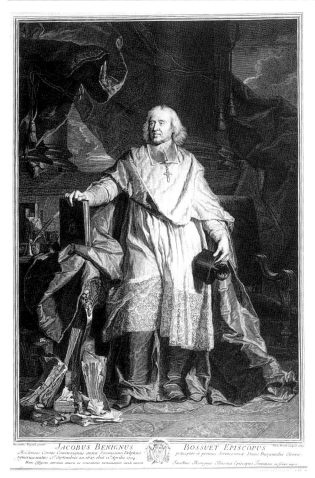

FIG. 54. Pierre-Imbert Drevet, *Bishop Bossuet,*
after Hyacinthe Rigaud, 1723

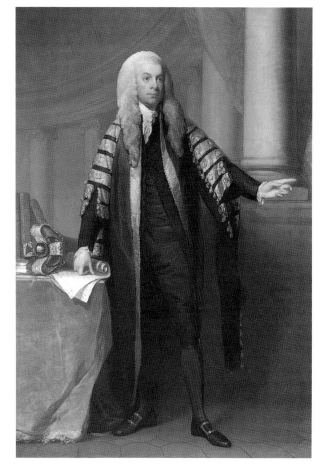

FIG. 55. *The Right Honorable John Foster,* ca. 1791

dressing Congress for the last time, in a fanciful farewell. The actual farewell address had not yet occurred and, in fact, was not given in person, so this scene, in retrospect, would have to have been the president's seventh annual message to Congress. Perhaps in recognition of this, Stuart eliminated the communicative gesture in a subsequent revision so that the image is less occasion specific.[18]

By 1817, when Henry Pickering interviewed Stuart, there were quite a few copies—some by other artists —of the Lansdowne portrait in existence; Pickering therefore felt compelled to ask the artist about the number of replicas that he had painted entirely by himself. Stuart answered that "he had made one copy of it, & that that is in the possession of Peter Jay Munroe [*sic*]." The truth of this reply seems to be borne out by the visual evidence, for Stuart used assistants in making his Lansdowne replicas, and, even in the earliest

copies, little more than the head and hands or the head alone appear to be by him. The work that later came to be known as the Munro-Lenox portrait (fig. 56)— the one to which Stuart was referring—constitutes a major revision. In this version, a less-wooden Washington assumes the graceful pose of a swordsman, his once-extended hand now lowered to the table. In a return to the Bossuet engraving, the Turkish rug is replaced by the original tessellated floor. Washington, with a slightly more elongated countenance and less massive hair, now confronts the viewer situated below him. The portrait, which must have been completed after the president's death in 1799, shows Washington as less the moral leader than the immensely dignified patriot. This picture is the one Stuart gave special recognition to as the "Mount Vernon portrait," thus seeming to update the likeness with reference to the location of Washington's retirement. It is also possible that

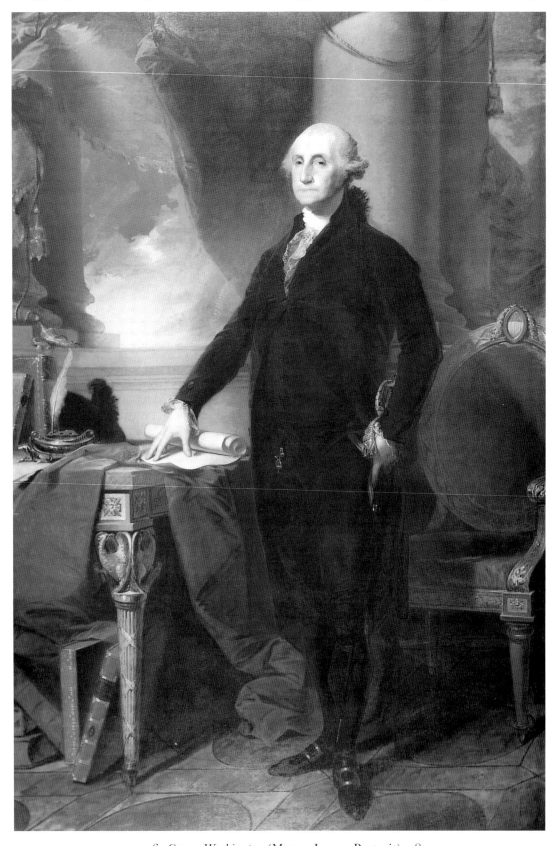

FIG. 56. *George Washington* (Munro-Lenox Portrait), 1800

he intended initially to give the picture to the Washington family at Mount Vernon, perhaps to release himself from his obligation—which had become particularly pressing with Washington's death—to deliver the Athenaeum portrait. In any case, he took the unusual step of advertising a subscription for engravings after the Mount Vernon portrait, half the sum for each print to be paid in advance to defray expenses. Although his plan did not come to fruition, the June 12, 1800, notice in *Philadelphia Aurora* becomes important because it establishes the fact that this likeness and the Munro-Lenox portrait are identical. That is, the advertisement links the present likeness with commissions from the Rhode Island and Connecticut legislatures for full-length portraits of Washington. Replicas of the Munro-Lenox painting filled those commissions.[19]

In the mention of his proposed engraving, to be executed by "an eminent artist," Stuart acknowledged with some bitterness that his Lansdowne portrait had been reproduced without his permission as a mezzotint by the English engraver James Heath. In fact, Stuart had hoped to choose the engraver and control the replication of this portrait himself so as to benefit financially from the transaction. His intentions, conveyed to Bingham, had not, however, been communicated to Lord Lansdowne. Stuart considered the Heath print an inferior work, but, having been published on January 1, 1800, just two weeks after Washington's death, it nonetheless became extremely popular in the United States as well as abroad. The Munro-Lenox picture and its projected print were clearly an attempt to rival the Lansdowne likeness and the Heath copy. When the print proposal failed, Stuart sold the Munro-Lenox portrait, via the British consul general, to a London banker. According to a Boston newspaper, "the banker wished only a half length; but by mistake it was made a full length." Surely the error was intentional. Stuart sold it for the price of a half-length because he wanted the London artists and his former patrons to see a new version that was as ambitious in scale as the Lansdowne portrait.[20]

When his attempt to rival the Heath print failed, Stuart's finances became more precarious, and the intensity of his disappointment rose so much as to be almost unbearable. His increased drinking, reported at about this time, appears to have been caused more by his frustration over the Heath print than by the monotony of the task he had set himself in producing replicas of his portraits of Washington. Even years later,

he bemoaned the fact that he and his family had not benefited from the Heath engraving.[21]

Despite these personal setbacks, Stuart's interpretations of Washington had an extraordinary impact such that he, in effect, changed the ground rules for painting portraits of the first president. The Philadelphia Peale family of painters, for instance, planned to contend with portraits that they had painted of Washington both before and after Stuart, but, from the public response, they realized that they were outmatched. To counter Stuart, Rembrandt Peale characterized him as a foreigner and criticized his portraits of Washington as deviating from the truth. Then, switching tack in defeat, he found Stuart's work "deficient in character." Subsequently he essentially imitated Stuart in an attempt to produce the ultimate portrait of Washington's *character,* albeit posthumously. With the "enthusiasm of genius"—probably somewhat in the manner of Stuart's revision of the Vaughan portrait—Peale worked for three months from his recollection, and from an amalgamation of different existing portraits, to create his intended masterpiece, a godlike Washington (with almost inevitable antique allusions) as *Patriae Pater* (fig. 57). Despite the fact that it was not a life portrait, he carried on a campaign to the end of his life to promote his "porthole" portrait of 1824 as more accurate than Stuart's more popular Athenaeum head.[22]

Stuart might have been expected to repeat his success in his subsequent commissions to paint the next four presidents of the United States, but he could not rouse himself to execute another portrait on quite the same order as the sublime portrait of Washington. In an age of considerable hero worship, when art collectors such as Thomas Jefferson purchased copies of paintings of famous men as a source of inspiration, Stuart too admired heroic character and its successful portrayal. (Not surprisingly, one of the two identified prints that he owned at his death was of the exceedingly courageous British patriot Admiral Horatio Nelson, shown with a patch over one eye and an empty shirtsleeve pinned to his chest.) Jane Stuart wrote convincingly of her father: "It is impossible for any human being to have a more exalted admiration (and I might say love) than my father had for Washington. An old friend of my father's told me he remembered that, when speaking of Washington, an exalted expression would pass over the face of the artist as he recalled the countenance and character of the great man." That is, he reacted to sublimity with the feeling prescribed by Lon-

FIG. 57. Rembrandt Peale, *George Washington* (Porthole Portrait), 1824

ginus—one of "transport," or proud identification. And he could not duplicate this feeling with Washington's successors.[23]

Stuart's appeal and his significance, according to one of his contemporaries in an account of about fifty years later, was that he gave "the expression of character to his portraits, a novelty in portrait painting in the United States more than half a century ago." Certainly his most famous creation, the Athenaeum portrait, played a large role in this estimation, exemplifying the ideal later expressed by the Royal Academician Henry Fuseli in a published lecture of 1805: The "deeper, nobler aim [concerning portraiture] is the personification of character." In the spirit of this ennobling aim, Stuart appears to have meant to be less the servant of

vanity than of virtue. He painted inspirational pictures of his sitters at their moral best. As Charles Willson Peale, Rembrandt's father, noted, Stuart was remarkable for giving all his clients a "good character," however nuanced this might be. He did not just copy exteriors but, rather, he looked for the salient strengths to emphasize in his sitter. He typically supplied a genteel air and sometimes an expression of benevolence or intelligence where it was lacking. To the suggestion of good character Stuart might add hints of passivity or energy or other qualities. Nearly always, he refrained from ostentatious show, and he did not necessarily indulge the sitter's vanity; instead, he imposed his own taste for a dignified reserve and an effect of sincerity. Since his reputation had been built on the Athenaeum

portrait, potential clients undoubtedly came to him in hopes of borrowing some of Washington's character as Stuart conceived it.[24]

What Stuart created evolved, in content, from his perception of the sitter and his own sense of propriety concerning what should be included in a portrait. Twice, in criticisms of other artists, he observed that he doubted that that person had the requisite feelings, or taste. "It takes a gentleman," he explained in an elitist echo of Reynolds and others, "to understand how to paint a gentleman." Stuart would never allow "the empiric" to corrupt the principles of good taste,[25] and he declared that an artist had to be able to *feel* character. That is to say, Stuart agreed with the well-known theorist Lord Kames, who maintained that "a taste in the fine arts goes hand in hand with a moral sense." The artist worked from nature, but, as his portraits of Washington made abundantly clear, the result was his own distillation and synthesis, his own vision and conception.[26]

Stuart conformed sufficiently to parts of the stereotype of the aesthetically and morally sensitive man to be described repeatedly by sitters as having great sensibility. Certain characteristics of the type can be cited in support of their conclusion: When Stuart learned that a young woman whose portrait he had not yet completed had just died, he burst into tears in front of her relative and could never finish the portrait; he repeatedly gave money and food, according to his daughter, to a homeless soldier and a poor musician when he was not affluent himself; he bought a slave whom he could ill afford in order to rescue him from a beating; in eccentric fashion, he had trouble keeping track of his finances and even mistakenly returned money; he disliked pretentious display; his essential nature was quietly contemplative, even melancholic; and he was strongly poetic in his responses, as when he described "the sight of old trees and rocks swept over by the raging flood" as involving an expansion of the soul. These various modes of behavior are consistent with the man of sensibility as the type developed, in complicating ways, through novels. Yet Stuart also departed from type. For instance, he was subject, as we will witness again, to periods of severe depression.[27]

The Years in Philadelphia

By the end of August of 1799, Stuart had made plans to return with his family in two months to London. But because of what he called "unthrifty habits," he seems never to have been able to save the passage fare. His intention had been to travel to Canada, where he still had relatives in Nova Scotia and where he might paint portraits of British army officers, including the duke of Kent, before going overseas to England. From this scheme, revealed to a prospective student, it is clear that Stuart hoped to revive an invitation that he had once turned down from Prince Edward, later duke of Kent (1799), stationed in Halifax. The duke had returned to Canada in 1794 from two victorious battles with the French in the West Indies, in which he had shown unusual personal valor, and (it is said) had offered to send a ship to New York for Stuart. The artist later regretted his refusal "as the most signal mistake of his whole life."[1]

Perhaps with the thought of his return to England in mind, he fumed over the circulation abroad of James Heath's engraving (from which, he believed, Heath had made a fortune) and fell into a deep depression in the spring of 1803. His quicksand financial situation —which compelled him, seemingly without gain, to churn out more and more copies of his portraits of Washington—may have contributed to his plight. Joseph Anthony, his Philadelphia uncle, lost patience with him and wrote to John Trumbull to complain of his chronically insolvent nephew's lack of self-discipline; he "never works but when compelled to it by necessity." This brings to mind reports of Stuart's lying in bed for weeks in his early London days, "waiting for the tide to lead him on to fortune." But his uncle was biased in view of a recent episode, Stuart's absolute refusal to finish his likeness of Anthony's daughter. Finally Stuart had impulsively daubed out the face to end further argument.[2]

As William Dunlap observed, Stuart, unlike many of his fellow artists, did not watch for opportunities and then carefully work to turn them to his financial advantage. Or, if he saw the opportunity, he often failed to take advantage of it. He did not have the "industry of ants" of Benjamin West and John Singleton Copley. Thus, instead of pursuing the still-possible invitation that he had received, probably in 1794, to paint a portrait of Prince Edward—and instead of returning to the audience in London that he was, in many ways, addressing in his portraits of George Washington—Stuart remained in the United States.[3]

According to Jane Stuart, her father was so overwhelmed with visitors, often including the friends of a sitter or the merely curious, that he could not carry out his professional commitments. To escape the annoyance of so much interruption, he moved from his address at Fifth and Chestnut streets in Philadelphia to a country house in nearby Germantown, where he converted a barn into a painting studio. After moving,

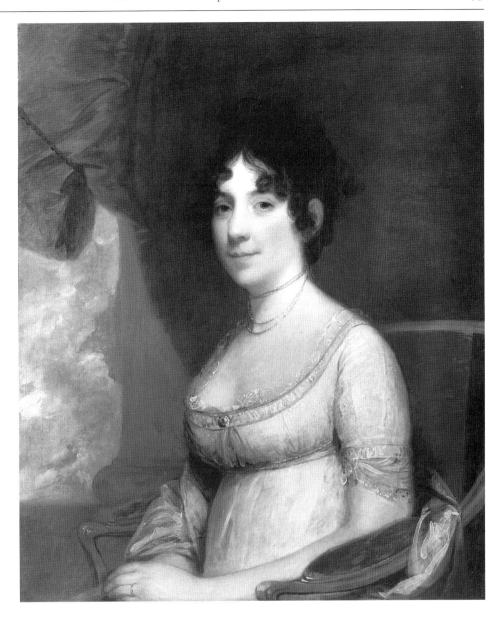

FIG. 58. *Dolley Madison*, ca. 1804

probably in the summer of 1796, Stuart produced most of his replicas of the Athenaeum and Lansdowne likenesses and continued to execute portraits of prominent and wealthy citizens.[4]

Many of his clients, in fact, were women—a patronage that departed from that of Stuart's English period, when most of his commissions came from men and were of men; as stated in an English journal of 1808, he was deemed a better painter of male than of female subjects. Some critics, such as John Neal, concluded that the portrayal of men was still Stuart's forte at the end of his life. Drawing on an 1819 visit to the artist's studio as well as a general knowledge of his work, Neal characterized Stuart's women—particularly his bemused

Dolley Madison (fig. 58)—as lacking "grace and tenderness." They were "creatures of flesh and blood, . . . somewhat too strongly individualized perhaps for female portraiture." These comments reveal the widespread belief that female portraiture, concerned necessarily with beauty, should be generalized; whereas male portraiture could be more individualized. A woman's character, moreover, was usually linked to ideas of beauty or motherhood, both expressive of virtue. The 1808 reviewer assumed that successful female portraits depend less on likeness than on "elegant taste" and other pictorial considerations. As is demonstrated in the New York painting of Margaret Manigault (fig. 46), Stuart, during his first years in the United States, could

FIG. 59. *Mrs. John Thomson Mason*, ca. 1803

easily paint a pastiche of the technical brilliance and aristocratic expression often associated with English portraiture. Despite the lack of "tenderness" in such portrayals—consistent with the cool dignity of his late English and Irish pictures—the artist was much sought after in Philadelphia, and later in Washington, D.C., as a portraitist of socially prominent ladies in the latest English fashion. His characterizations of women—compared with those by American contemporaries such as the Peales—were typically more reticent, more aloof, and more beautiful in their decorative flesh color and, occasionally, their sensuous use of paint. Generally his women looked directly out and slightly down at the

viewer, as if from an elevated dais, as in his portrait of Elizabeth Beltzhoover Mason (fig. 59). The satisfaction of one female sitter in Philadelphia might speak for many. Pleased with the harmonious use of color in her portrait and the depiction of herself in the act of putting on a glove, she remarked of Stuart's work: "They are really pictures as well as portraits."[5]

The bemused facial expression in *Dolley Madison*, suggesting a thinking sitter, brings to mind the admiration Stuart once professed for Sir Anthony Van Dyck's portraits because of "the intelligence of his heads." He himself excelled in this kind of portrayal. Yet, depending partly on his interest in the subject, he could range

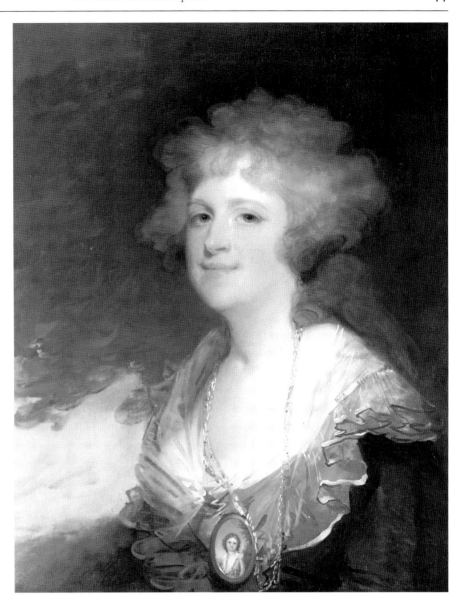

FIG. 60. *Mrs. Thomas Lea,*
ca. 1798

considerably in his suggestion of intelligence in portraits of women as well as men. For instance, he produced a relatively insubstantial and unintellectual image of Sarah Shippen Lea (fig. 60)—shown as a loving mother wearing a portrait miniature of her young son —that flattered her by glorying in the warmth of her personality and the voluptuous quality of her remarkable physical beauty, which Stuart complemented with an increased viscosity in paint. On the other hand, to suggest a mental presence and an admirable degree of sensibility, he introduced a pensiveness in his New York portrait of Aaron Burr's young daughter, Theodosia (Yale University Art Gallery, New Haven, Conn.), that, in that instance, was judged inappropriate for her age.

Carrying this pensiveness further in his portrait of Eleanor Parke Custis Lewis (fig. 61), he created a mood of deep reverie that must refer to recent family tragedies, including the loss of two of her children. Surely the depiction of mood was one way to suggest intelligence, but it was an unusual device for Stuart, who more often focused on character summation, irrespective of circumstance. Yet he used a hint of melancholy—unquestionably a fashionable expression— more than once in his portrayals of women. Another example concerns Charlotte Linzee, who died before her portrait (location unknown) was finished. Of the unfinished canvas, her sister reported: "It is like her, though with a more pensive expression & I think less

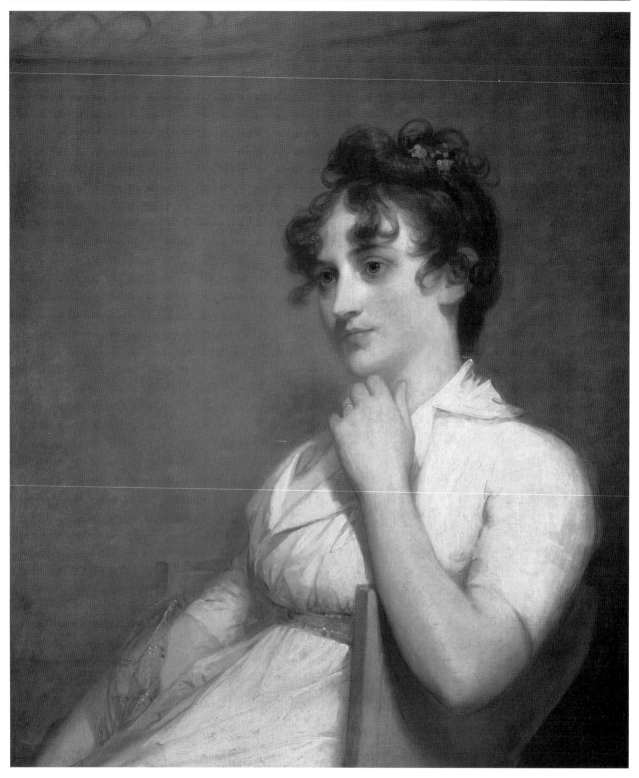

FIG. 61. *Eleanor Parke Custis Lewis (Mrs. Lawrence Lewis)*, 1804

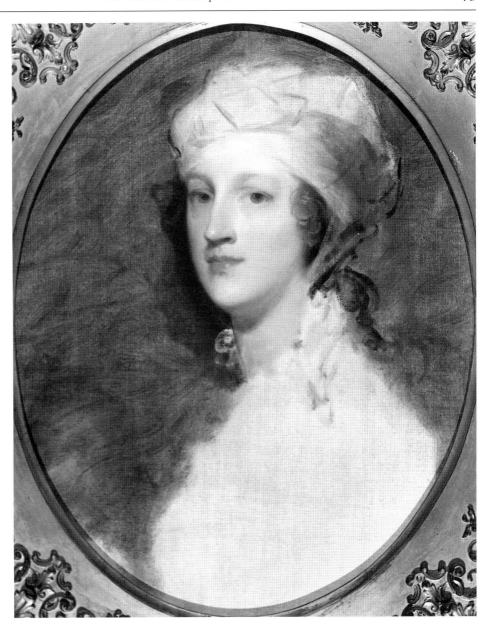

FIG. 62. *Mrs. Samuel Blodget,* ca. 1798

beautiful than she was." In his range of female types, Stuart occasionally alluded to a sweet vulnerability (in a tilted head) or interior strength (in ramrod-straight posture), but the portrait of Dolley Madison (fig. 58), which Neal so disliked, expressed more transparently than usual the lightheartedness of this intelligent sitter. However Stuart varied his response to his subject, the evocation of inner being, often in the form of an expression of either momentary or steadied-gaze interaction with the viewer, was generally characteristic of his work.[6]

One of his most admired Philadelphia pictures, at the time he painted it, was an unfinished head of Rebecca Smith Blodget (fig. 62, pl. 8), a woman known for her beauty as well as her intellect. Thomas Sully reported a general admiration for the painting as a "work of art," adding that "the drawing and conception of appearance is [*sic*] the great excellence of this portrait"; while a Blodget relative enthused over its unusual "purity" (presumably of color) and ethereal quality. Sully thought the smoothness of the skin, like "that of a child," was particularly striking. Certainly, as might be inferred from this comment, flesh color could convey messages about the sitter's health and age—and Stu-

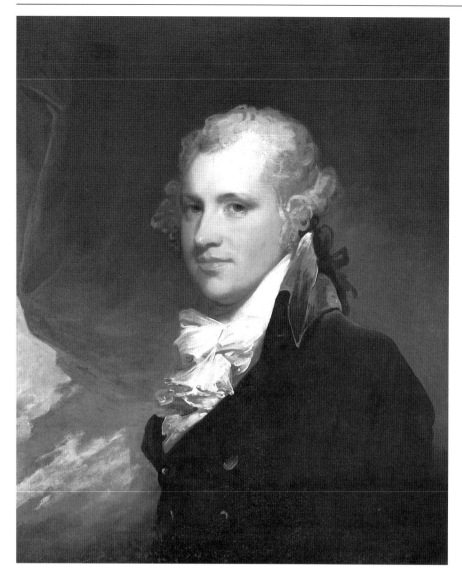

FIG. 63. *James Greenleaf,* ca. 1795

art did sometimes use color this way—but beauty and virtue were so intertwined that the unusual freshness and transparency of his skin colors (their "purity") inevitably conveyed a message of moral health and worth. Color was certainly Stuart's principal means for suggesting a moral beauty, without losing the general effect of strong resemblance.[7]

The enthusiasm of this response to Blodget's portrait, however, concerned what might be considered a sketch. Stuart had, arguably, an exquisite appreciation of the effect of vivacity in an unfinished work. Like the theorist William Gilpin, he looked, as Samuel Knapp said, for the "touches of genius" in a picture that essentially meant its completion. Most of his clients required that the portrait be conventionally finished, but

some—apparently including the admirers of this likeness—seem to have preferred the unfinished head and its association with the creativity of great masters. They may also have known that with Stuart an extended wait for a complete picture might never be rewarded.[8]

Stuart's characterizations of men in his Philadelphia years were always flattering but also subtly different, as is clear in a comparison of his portrait of the very wealthy James Greenleaf (fig. 63) with the portrait of the associate justice (later chief justice) of the Supreme Court of Pennsylvania, Edward Shippen (fig. 64). The Greenleaf portrait—quite sensuous in its dreamy eyes, soft skin, and cupid's-bow lips—is colored throughout to harmonize with and emphasize the sitter's blue eye coloring and flushed cheeks. The chief purpose here is

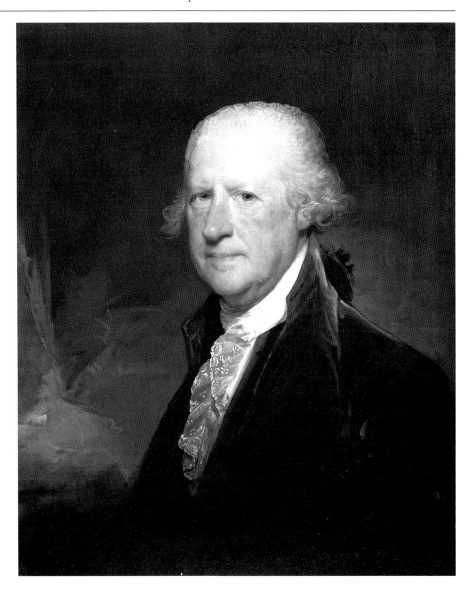

FIG. 64. *Chief Justice Edward Shippen of Pennsylvania, 1796*

surely to flatter Greenleaf's health and handsome, even pampered appearance. In the second case, as with the portraits of Washington, Stuart appears to have been interested in a more developed, more individualized, depiction of the sitter's character. The knitted brows and tightened lips are indicative of intelligence and even a discerning skepticism. One Philadelphia observer argued, understandably in this context, that Stuart "required a male head, and one, moreover, of a high intellectual order, like that of . . . Chief-Justice Shippen . . . to bring out the full power of his wonderful pencil."⁹

The Shippen likeness eventually joined Stuart's portraits of Washington as a subject for engraving. The Vaughan portrait had already been published by Johann Caspar Lavater, but in 1798 Stuart made other arrangements. Following the appearance that year of a London print after a version of the Athenaeum portrait, the Philadelphia publisher T. B. Freeman hired a newly arrived English engraver to produce prints based on both the Vaughan and Athenaeum portraits. Having met the engraver—young David Edwin—Stuart himself entered into a financial venture with Edwin to publish engravings after his portraits of public figures, and he very likely had Edwin in mind as the engraver of a print of the Munro-Lenox likeness, after the publication of Heath's print of the Lansdowne portrait in 1800. Nevertheless, the only known prints resulting from Stuart's partnership were of his portraits of Shippen and Thomas McKean (ca. 1800; private collection), chief justice of the Supreme Court of Penn-

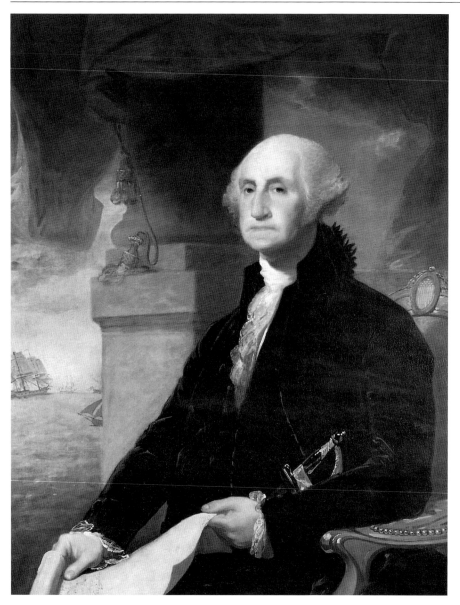

FIG. 65. *George Washington,*
1797

sylvania and later (1799) governor of the state. The
McKean engraving did not appear until 1803, with Ed-
win and Stuart cited as copublishers; the undated Ship-
pen engraving was delayed, perhaps through lack of
subscriptions, until at least 1803 or possibly 1810.[10]

McKean's bust-length likeness is distinctive in that
it is purportedly the earliest known portrait on panel
by Stuart. By May of 1800 he concluded that the sum-
mer heat in the United States could have a destructive
effect, over a period of about twenty years, on a canvas
support—particularly in a public building—and he
began to prefer using mahogany panels that would not
warp or crack. He had the panels roughened to re-
semble twilled canvas, which would be "favorable to

the sparkle of his color." The panels sometimes split
(as Jane Stuart seems to have witnessed), but he con-
tinued to use them, though less often than canvas, from
about 1800 through the 1820s.[11]

Stuart's greatest involvement with other artists in
joint ventures concerned the production of replicas,
chiefly of his portraits of Washington. Yet, as in Ireland,
he also relied occasionally on others to complete drap-
ery sections in his pictures. That he indulged in the
luxury of employing a drapery painter—particularly
in his Boston years—is clear, if from no other evidence,
than from the fact that Isaac P. Davis, a close friend in
his last twenty years, felt compelled to insist in certain
cases that he had witnessed the work done entirely by

Stuart. Significantly, Davis stopped short of claiming that Stuart never allowed the completion of a portrait by someone else. A historian who lived in Germantown and began to collect reminiscences there and in Philadelphia in 1820 stated, with only some exaggeration, that "Stuart had a great aversion to the drudgery of making drapery in his pictures, and used to employ another hand to execute them."[12]

The artist obtained help with other secondary areas as well, such as background or ornament. According to Dunlap, Stuart hired the sign painter Jeremiah Paul to letter the numerous books in the Lansdowne portrait. More important, according to the grandson of a sitter, he engaged the architect Samuel Blodget to draw (and probably paint) the surveyor's theodolite, books, and inkwell in the background of a portrait of Blodget's father-in-law, Dr. William Smith, of about 1800 (private collection). Furthermore, as Smith's grandson remembered, Blodget designed and sketched the furniture and background—undoubtedly with input from Stuart—in the Lansdowne portrait.[13]

To meet the requests for replicas of the Washington portraits, Stuart hired John Vanderlyn, who had come to him as a live-in student, in dead coloring and finishing copies—from all three prototypes—over a period of about ten months. When Vanderlyn left, probably in May of 1796, Stuart (perhaps too generously, given his later problems) allowed him to make a copy for himself of the Athenaeum portrait just as he had earlier allowed a friend, the miniaturist William Birch, to take a copy in miniature of the Vaughan portrait. With the occasional help of short-term assistants like Vanderlyn, Stuart continued to reproduce the Athenaeum head, calling the copies his $100 bills (that being what he charged for them—the same as his price for a bust portrait). He "worked mechanically and with little interest" on his copies, however, as he later told Dunlap. His daughter Jane, who was not born until 1812, heard that he painted two at a time and estimated that he probably spent two hours on each copy.[14]

One of Stuart's more interesting commissions, because it is particularly well documented, came in 1796 and 1797 from a wealthy New York merchant, William Constable, who ordered a bust-length portrait of himself ($100); a full-length copy of the Lansdowne Washington ($500); and a half-length portrait of Washington ($250; fig. 65), which he intended to give to Alexander Hamilton. The portraits of Washington were the second part of the commission, added as the result of

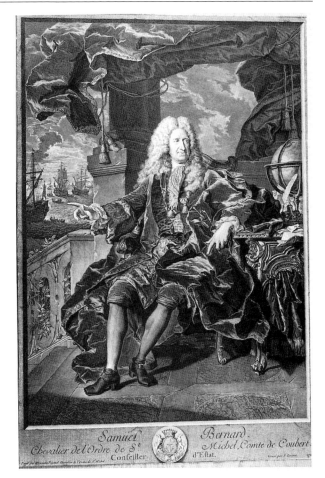

FIG. 66. Pierre-Imbert Drevet, *Samuel Bernard*, after Hyacinthe Rigaud, 1729

Constable's finding Stuart at work on the Lansdowne portrait. At Constable's urging, Stuart agreed to the unrealistic proposition (surely not carried out) that he would work on Constable's full-length picture at the same time as the Lansdowne original, for which Washington sat, so that they would both be from life. Not having received an exact price for the two pictures of Washington, Constable sent $1,000 to Stuart, through an agent, for all three portraits, and (as if to confirm Stuart's lack of participation) $150 was unexpectedly returned to him. One or more assistants certainly worked on secondary parts of both of the copies. In the case of the half-length version (fig. 65), the assistant's work is based on one or more prints, including quotations —in the column and curtain and their relation to a seascape—from Pierre-Imbert Drevet's 1729 engraving after Hyacinthe Rigaud's portrait of Samuel Bernard (fig. 66).[15]

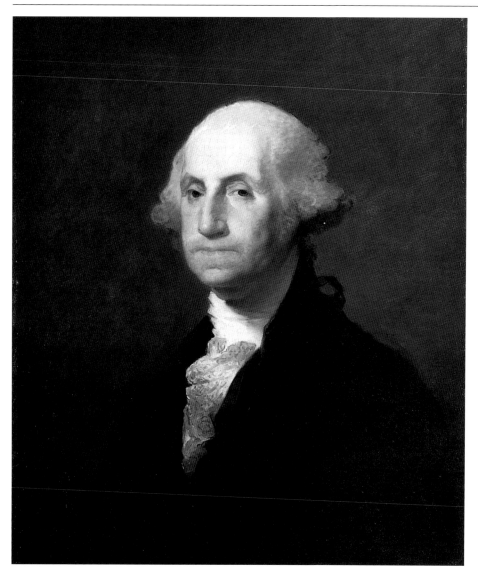

FIG. 67. *George Washington,*
1825

Many of Stuart's clients, like Constable, would or-
der a portrait of themselves and a replica of the Athe-
naeum portrait as if to provide the right associative en-
vironment for their own likeness. Given the demand
and the tediousness of copying, it was perhaps inevitable
that some of the pictures of Washington that left Stu-
art's studio were mostly by an assistant. For example—
notwithstanding the existence of Stuart's signed receipt
of August 12, 1825, for $150 in payment—his last known
copy of the Athenaeum head (fig. 67) has a strange
overall softness, almost a smudged effect in form and
color, that makes it unconvincing as by him; his hand
is possibly in evidence only in some minor touches, as
in the incongruously prominent penciling around the
tip of the nose and around the eyes. That Stuart should

retouch an assistant's copy to make it his own, as ap-
pears to be the case here, is, in fact, consistent with his
training in London and under West. The man who or-
dered the portrait, Robert Gilmor, a wealthy merchant
and art patron in Baltimore, offered to pay more for a
better-than-usual copy, but Stuart replied that there
was only one price, meaning he would not increase his
participation. Stuart, to some extent, acknowledged
his degree of involvement through his system of pric-
ing. In 1800 he charged two different prices for a whole-
length portrait of Washington, which can be interpreted
as follows: $1,000 for a framed "original"—that is, a
variation on the Lansdowne or Munro-Lenox likeness
and by himself; and $600 for a "duplicate," such as the
copies he painted of the Munro-Lenox portrait for the

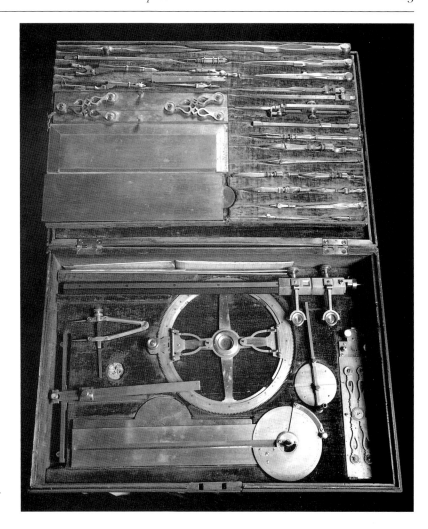

FIG. 68. Boxed set of drawing instruments, ca. 1780

state governments of Rhode Island and Connecticut, which involved an assistant. A frame, in the case of the duplicate, would cost a hundred dollars more.[16]

Stuart almost certainly traced his copies, using the most common method of transfer at the time. Once the Lansdowne portrait, for example, had been established as a prototype, he seems to have copied it in chalk on a porous and transparent piece of sized linen called a "tracing cloth"; he would then have reproduced its background in the Munro-Lenox portrait. (The backgrounds of the two works are, except for minor changes, identical.) This appears to have been the means that Stuart used throughout his copying, inasmuch as his assistant, John Penniman—a decorative painter who helped to grind his colors—used a tracing cloth in Stuart's studio, and in his presence, in 1808 to produce an outline of the Athenaeum portrait. As a further aid, Stuart owned drawing instruments (fig. 68), a boxed set given to him by the English artist Ozias Humphry

in 1784, before departing for India. Stuart must have used an ellipsograph from the set to create the ellipses on the floor in the Munro portrait. Instead of using a pantograph on the rare occasion when he needed to make a slightly reduced or enlarged copy, Stuart seems to have resorted in such instances to a scoring method and proportional dividers from this set. One witness described him as holding such an instrument when he explained that he was going to reduce the size of one of his portraits in the replica.[17]

Not much is known about Stuart's assistants, among whom were, from about 1800 to 1812, his artistically talented son, Charles, and earlier, in 1796 and 1797, possibly William Winstanley. A young Englishman with a minor talent for pictures and possibly a greater gift for showmanship, Winstanley had been painting landscapes and exhibiting a panoramic view of London—probably copied from Samuel Barker's famous original—before he met Stuart. Subsequently he produced

and sold forged replicas, most likely based on a tracing, of the Lansdowne portrait. Although Stuart did not describe him as a former student in an account of him that he later gave Dunlap, there are three pieces of supporting evidence (each admittedly slight) for his having this status: Winstanley demonstrated to an observer in 1800 that he primed his canvas with two layers of sizing and one layer of lead-colored paint just as (according to his claim) Stuart did; an architect who knew Winstanley in 1800 thought that Winstanley had "influence" with Stuart; and Winstanley—indirectly as the alleged painter of a portrait of Washington (The White House, Washington, D.C.)—was described as a pupil in a Boston obituary notice of Stuart's death. The forgeries, which Winstanley exhibited and tried to sell, infuriated Stuart, as did any attempt by Winstanley to link him to them. In one story told by Stuart, he threatened to throw the much-smaller Winstanley out of his painting-room window if he persisted in his proposal that Stuart just tap the forgeries so that Winstanley could rightly claim that the master himself had given them the final touch. Winstanley's words implied that they would share the profits. Concerning these works, the most publicized case involved the forged replica of the Lansdowne portrait at the White House, a picture that Stuart attributed to Winstanley and denied ever having painted. In one of his consistent denials, Stuart said "he did not paint it—but he had bargained for it," thus conceding that he had somehow given Winstanley the means to paint it.[18]

If it had not been for Winstanley, Stuart would never (years later) have begun his last full-length portrait of Washington and, thereby, taken up the challenge of portraying the president in his military character. To replace one of Winstanley's pirated Lansdowne copies that had been donated to the town of Boston, Stuart completed his large *Washington at Dorchester Heights* (fig. 69, pl. 9). Done, as he claimed, in nine days, the finished portrait connects Boston and General Washington in a heroic endeavor. The great hero, with his head taken from the Athenaeum likeness, is shown in his first campaign against the British, in which he was able to force the redcoats to retreat from their occupation of Boston, with the loss of remarkably few lives. In Stuart's interpretation Washington stands alone, in a moment of calm planning (all the more evident in contrast to his excited horse) as he surveys the hills of Dorchester. Behind him, the artillery smoke and distant waterfront suggest that his men are in the act of

bombarding the British, trapped below them in Boston, whence the British will flee by ship. This was Washington's first victory in the Revolutionary War, an event that had occurred thirty years before and about a year after Stuart had left Boston. In attempting the picture, Stuart must have been particularly aware of Trumbull's depiction of a similar American victory in a full-length portrait, not from life, of Washington (fig. 70) that was commissioned for the city of New York. Trumbull's painting—which Stuart could have seen—shows the great general looking slightly upward and standing in a more relaxed, less commanding position, in front of a preoccupied horse, with the British evacuating New York in the background.[19]

The problem of forgeries and the unauthorized proliferation of copies from Stuart's portraits of Washington presented formidable difficulties for the artist. Because there was no American copyright law that covered works of art, Stuart finally insisted, by May of 1800, on obtaining a signed agreement from purchasers of his portraits that gave the artist alone the right to reproduce the image. Just as authors had copyrights, he maintained that every painter "held an inherent copyright in his own works." This, however, did not stop the "pirating," as he called it, which finally led to legal action. In early March of 1801, a Philadelphia merchant involved in the China trade, John E. Sword, arranged to transport a replica of Stuart's Athenaeum portrait to Canton to be reproduced cheaply in a series of over a hundred copies, painted on glass, which were then framed and sold in Philadelphia. In purchasing the original from Stuart, however, Sword had verbally agreed that he would not have the image copied; Stuart, therefore, with the help of lawyers, argued that the grounds for action against him were breach of contract. In what appears to be the earliest American case concerning artistic copyright, the United States Circuit Court for the Eastern District of Pennsylvania decided in Stuart's favor and issued an injunction in 1802 against the sale of his image of George Washington by Sword and his associates.[20]

Naturally, with so many copies circulating and confusing rumors transmitted about which portraits were actually painted from life, Stuart's patrons began to fear that their copies of the Washington portraits were not really by him. To so many inquiries about originals from life, particularly after Washington's death in 1799, Stuart finally replied wryly: "If the General had sat for all these portraits, he could have done nothing else;

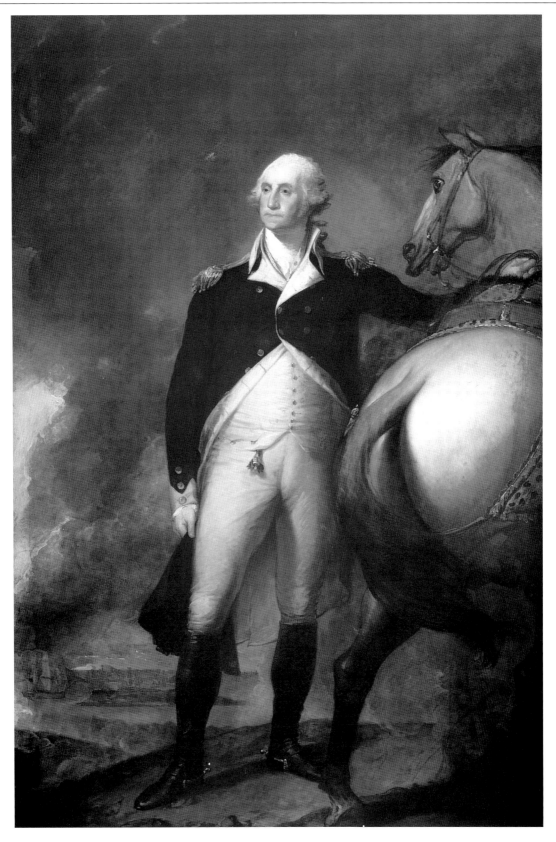

FIG. 69. *Washington at Dorchester Heights*, 1806

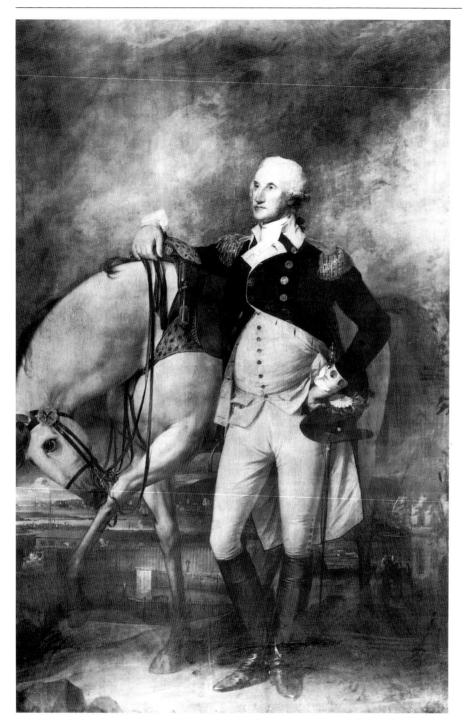

FIG. 70. John Trumbull,
*Washington at the British
Evacuation of New York*, 1790

our Independence would have been a secondary matter, or out of the question." Yet Stuart himself had encouraged some of this speculation with pleasing but false verbal assurances that certain additional works were "on the easel while Washington was sitting." This is what he had said to the buyer with regard to his Gibbs-Channing-Avery portrait (Metropolitan Museum of Art, New York) which is a reinterpretation, or arguably an improved version, of the Vaughan portrait, executed before he had the opportunity to begin the Athenaeum version. Eventually Stuart's clients began to put in special requests, such as that Washington be shown with different clothing or a different background in their copy, so that the result would be more original as a work by

Stuart and therefore more valuable as an heirloom.[21]

While his patrons thought about a commodity gain, so did Stuart in working more expeditiously than usual to finish three full-length copies of his Munro-Lenox portrait for the state governments of Rhode Island and Connecticut. He was laboring to make another payment, due March 1, 1801, on the purchase of a small farm, which he had stocked with cattle, in Pottsgrove, Pennsylvania. With characteristic foolishness, however—as in his use of crucial cash receipts for bookmarks—he had asked for no receipts for the $3,442 he had already paid toward the farm. Before the final installment was due, the recipient died, leaving no record of any transaction with Stuart—which resulted in the loss of his entire investment. Two months later, on May 6, 1801, a sheriff in Germantown attached all of Stuart's household goods and furniture—including numerous prints and paintings, about forty books on different subjects, and a gray horse with saddle and bridle—to be put up at public auction to pay a long-standing debt to an English creditor. While the artist's family moved to the home of a friend, some of his sitters scrambled to assert that his unfinished portraits had already been partially paid for and were relieved that the sale did not extend to his painting room, located in a barn near the house and perhaps next to his neighbor, a blacksmith.[22]

Possibly because of his copying business, Stuart was able to retreat from bankruptcy, but he finally became reluctant to produce any more versions of his Washington portraits. There are tales, years later, of his turning down requests for full-length copies even at a thousand dollars. His responses to such entreaties, however, could be quite contrary, as demonstrated in the following story. Cumberland Williams, a wealthy Balti-

morean, offered in about 1815 to pay any reasonable price for a "certified" copy—that is, accompanied by a signed certificate of authenticity—of the Athenaeum portrait and was refused. A friend who knew Stuart's ways then approached the artist in a second attempt. He found Stuart "in exceedingly good humor, playing on his chamber organ—his shirt sleeves and bosom frills covered with snuff." After some preliminary remarks, the friend admitted that he had been going to ask a favor that Stuart paint another copy of his Washington, but he had mentioned his intention to someone who had laughed at him and ridiculed him for attempting such a hopeless request. Stuart made the copy and said: "Now let them laugh."[23]

Just as Rembrandt Peale had once hung his life portrait of Washington above the door to his studio, Stuart, much later, tacked his Athenaeum portrait up on *his* painting-room door—unframed and casually displayed, a work designedly of consummate genius—where visitors from about 1817 to 1822 remarked on it and compared it with his current work. Possibly he put it there in 1817, after finishing a portrait of President James Monroe (Museum of American Art, Pennsylvania Academy of the Fine Arts, Philadelphia), and therefore marking his having painted the first five presidents from life; or possibly he pinned it there because, again in 1817, he had recently changed his Boston quarters to Washington Place on Fort Hill, which Washington had fortified against the British. Whatever the reason, this portrait had an impact unlike that of any of his other works: it associated Stuart with Washington for the rest of the artist's life, and there on his painting-room door, it remained a point of reference for his late portraits.[24]

Painting the Intrinsic

STUART FINALLY LEFT PHILADELPHIA in December of 1803, at first to follow the federal government. Leaving his family behind, he traveled to Washington and, in the manner of an itinerant artist, moved into a cramped, two-room habitation. The small building that he had rented had been built by the architect Benjamin Henry Latrobe to be no more than a studio. There, with the help of a man-servant who was rarely in attendance, Stuart threw himself into a burst of activity, finishing his pictures quickly, in hopes of saving his financial situation. The strain of this effort and the "marsh miasmata" of the reclaimed swampland that was Washington finally affected his health. The artist endured extended bouts with malaria, "a violent ague and fever," that brought him near death during the summer of 1804 and the spring of 1805, so debilitating him that Latrobe, who had once admired the painter's genius, eventually turned against him and began to despair of ever receiving rent. Stuart had resigned himself to itinerancy and had chosen the new capital for his first residence because he had formulated a plan, by May of 1802, as an extension of his experience with the Athenaeum likeness. He would "collect the portraits of great and eminent personages," display them in his studio, and hope to profit from a demand for copies. The artist spent about a year and a half in Washington, sending part of his income to his family, who were living in Bordentown, New Jersey.

Then, at the urging of a Massachusetts senator, he turned north, in July of 1805, to visit Boston, where he finally settled with his wife and children. As one observer wrote, Stuart had long intended the trip to Massachusetts: "He is a man of genius, and therefore does every thing differently from other people—He travels to the Southward in *his way* Northward."[1]

In both the nation's capital and Boston, Stuart's strained finances seem to have prompted him to paint pictures that are generally more formulaic than the New York and early Philadelphia paintings. The usual format for his Washington, D.C., portraits is a seated sitter turned to a three-quarter view, shown to the waist and hands, with a combined curtain-column motif to one side of the background. The use of the curtain and column, as in Dolley Madison's 1804 portrait (fig. 58) and some Philadelphia pictures, is not unlike Stuart's incorporation of Vandyke dress in his early London portrait of a young boy (fig. 15). That is, instead of referring to Washington, D.C., or to any specific interior, this motif seems to aggrandize and historicize the sitter, serving as both a baldachin and a reminder to the viewer—even in a reassuring way—of a connection between Stuart's portrait and Old Master portraits, where the motif is commonly found. Stuart seems never to have used the combination as frequently as in his Washington period. Possibly this was because of the peculiar nature of the new nation's capital, with its admix-

FIG. 71. *Counsellor John Dunn*, ca. 1798

FIG. 72. David Martin, *Jean-Jacques Rousseau,*
after Allan Ramsay, 1766

ture of foreign diplomats and first-time statesmen. As one well-connected, Belgian-born Washingtonian observed in 1805: "When Europeans are known to possess a certain rank and fortune, they enjoy greater consideration than those born here." In the midst of the insecure beginnings of a new nation, it is understandable that a rootedness in European tradition would be attractive. Certainly Stuart took advantage of his training in London, and consequently his association with European masters, to increase his popularity. In Washington, it was said: "Stuart is all the rage."[2]

Stuart's notably associative works at the turn of the century include his portrait of the Irish barrister John Dunn (fig. 71), painted in Philadelphia in the fur-trimmed gown, pose, and lighting reminiscent of Allan Ramsay's well-known likeness of the French philosopher Jean-Jacques Rousseau (fig. 72); and his medallion profile of Thomas Jefferson in an antique mode (fig. 73), painted in Washington. Dunn, a scholar who had been a member of the Irish Parliament before coming to the United States to study Native American languages, is portrayed in such a way as to recall generally the precedent of Sir Anthony Van Dyck (in the

spiky Vandyke lace cuff and hand on the breast), but the picture has a more specific connection with the 1766 portrait of Rousseau, a likeness that had become famous as a reproductive print. By linking Dunn to Rousseau, Stuart or Dunn could have meant to draw a parallel between Rousseau's initial advocacy of society in a more natural state and Dunn's admiring scrutiny of one such society in the case of the Native American. But since the fur-trimmed gown was fairly characteristic costuming in depictions of a writer or an artist, and since Stuart did not include Rousseau's signature "Armenian" hat, the Dunn portrait is probably meant to evoke association more broadly with an intellectual sensibility. In the image of Dunn, Stuart placed the hand, raised somewhat higher than in the Rousseau likeness, over the sitter's heart in a gesture that is suggestive of feeling. This hand and the bare head are bathed in a Rembrandtesque spotlight—as in the Rousseau portrait—which unites the areas of the mind and heart so as to emphasize the presence of a thinking and caring human being. In fact, the painting (associated so definitively with earlier works) is very much a picture: the light from the upper right, for instance,

FIG. 73. *Thomas Jefferson*, 1805

does not illuminate the background as it would in reality. Perhaps because Dunn was a friend—someone, in fact, who shared Stuart's interest in poetry—this portrait is more experimental and somewhat more broadly painted than usual. Tellingly, it always remained one of Stuart's few recorded favorites.[3]

The medallion profile of Jefferson was the third portrait that Stuart painted of him, the first being a commissioned work of 1800 that did not satisfy the artist. Stuart kept the first likeness in an unfinished state and probably destroyed it after obtaining another sitting, in 1805, which was evidently intended to fulfill his original commission with a different portrait. He then retained the second likeness—reportedly just a head on an unfinished canvas—in place of the first, finally sending a bust-length replica to Jefferson in 1821. Jefferson was luckier in being able to obtain the third life portrait, the small medallion in gouache and crayon on paper. It was done to Jefferson's specifications, shortly after the second portrait and apparently from that same sitting. Although it has been described as "in imitation of an antique cameo," the grisaille coloring links the head to profile-portrait coins from Hellenistic and Roman times. Jefferson, who had succeeded John Adams as president from 1801 to 1809, differed from his predecessors in being proud of his knowledge of antiquity. He had had his profile taken before, but never in

quite this classicized fashion as an idealized bust—with the cropped hair that was probably meant to recall Roman republicans such as Brutus.[4]

Stuart's sketch of Miriam Mason Sears (fig. 74) is in some ways a female counterpart to his associative portraits of Dunn and Jefferson. With her blissful smile and upward gaze—traditionally the signs of adoration—she invites association, as a newly married woman, with images of young love or, more likely (because of the direction of her glistening eyes), images of joyful, even grateful, piety. This head appears to be based on an earlier, more fully worked out half-length portrait (private collection) by Stuart in which Sears's eyes are not raised. In contrast to the more finished work, the expressive qualities of the sketch have been exaggerated, perhaps experimentally, so that it is almost a caricature. The portrait is so uncharacteristically fanciful for Stuart and so like Sir Joshua Reynolds's poetical depictions of women, as in his *Mrs. Quarrington* (fig. 75), that Stuart may well have been imitating Reynolds's precedent; quite possibly the work was not part of the original commission but, rather, was inspired by the sitter.[5]

In his half-length Boston likenesses, Stuart often discarded the pretentious column-curtain combination in favor of a simpler and more believable pilastered interior, suggesting a formal drawing room, as in his por-

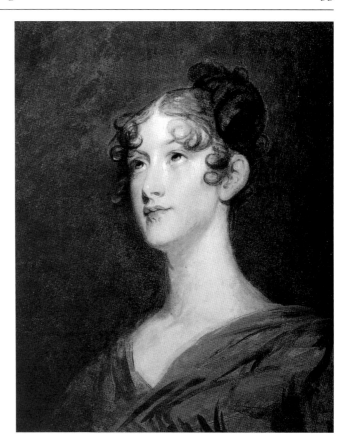

FIG. 74. *Miriam Mason (Mrs. David Sears)*, ca. 1809

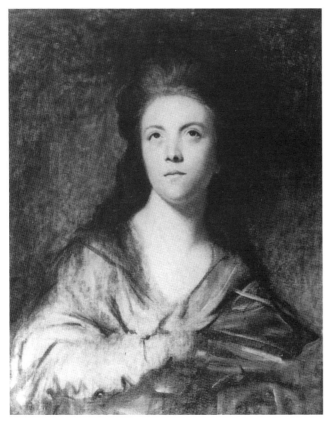

FIG. 75. Sir Joshua Reynolds, *Mrs. Quarrington*, ca. 1771

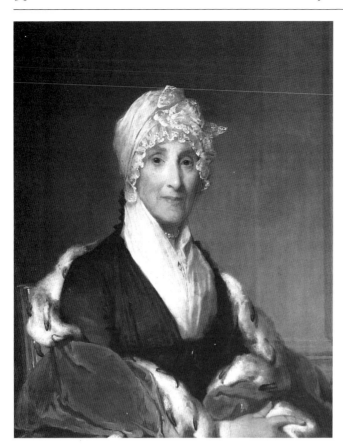

FIG. 76. *Rebecca White (Mrs. Timothy Pickering)*, 1816/18

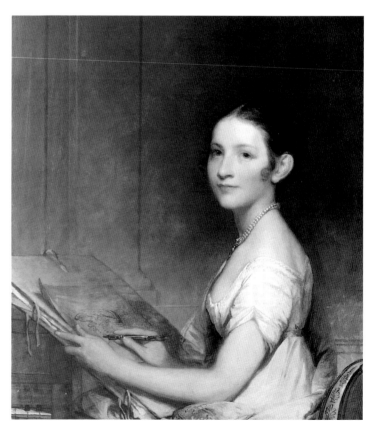

FIG. 77. *Lydia Smith*, ca. 1805

trait of Rebecca White Pickering (fig. 76) and his portrait of Lydia Smith (fig. 77, pl. 10). Many of his pictures were now just head and shoulders, but, in these larger half-length versions, the formulaic treatment of the backgrounds and poses must have reminded the viewer that Stuart's creations were conceptual, not a close mimicking of life. He, in fact, became so well known and sought after in his early Boston years that the self-quoting probably became a desideratum, a way of announcing his authorship.[6]

Despite his signature repetitiveness of design, Stuart experimented variously, during the first two decades of the nineteenth century, with his painting of flesh, in what appears to be an attempt at greater naturalism. From about 1803 to about 1810, for instance—depending on the sitter—he occasionally painted an unusually smooth, even porcelainlike skin texture reminiscent of French Neoclassical flesh in the lack of brushstroke, such as in the portrait of Hepzibah Clark Swan (fig. 78). In making this change, he began to tailor his treatment of flesh, more than before, to the individual sit-

ter so that, as he told Matthew Jouett in 1816, his painted skin texture varied. Jouett abbreviated his words as follows: "Some faces require to be finished up to the very marking with large tools. Thick skin faces of this character. In all thin and lively skins, the fitch [small brush] much used. By chopping, you shorten the flesh and give it a tenderness."[7]

While Stuart stressed the importance of a strong likeness, he continued, in Boston, to enhance the beauty of natural skin coloring. His flesh could occasionally be as highly keyed and richly colored as the glowing skin in his portrait of Samuel Alleyne Otis (fig. 79), for which Otis sat in 1811 and, according to his journal, possibly again in 1813. An effect of greater luminosity resulted from Stuart's increasing use of highlights and lighter middle tones in his modeling of flesh —a change that began at about the time of the Otis portrait, or shortly before. It is evident in his somewhat sketchy *William Orne* (fig. 80), dating from sometime between Stuart's arrival in Boston in 1805 and Orne's death in 1815; later he renewed his effort in this di-

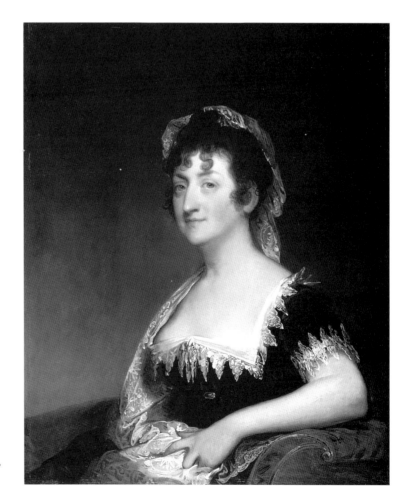

FIG. 78. *Hepzibah Clark (Mrs. James Swan)*, ca. 1806

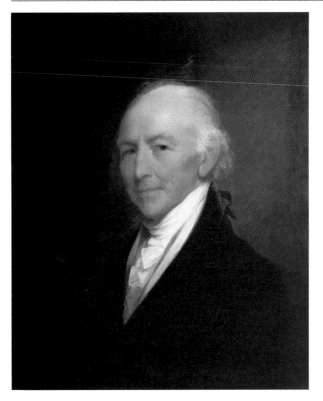

FIG. 79. *Samuel Alleyne Otis,* 1811/13

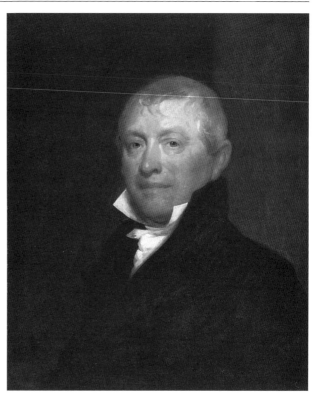

FIG. 80. *William Orne,* ca. 1805/15

rection with portraits such as those of Lydia Pickering Williams (fig. 81), Judge Egbert Benson (fig. 82), and James Monroe (fig. 83).[8]

Since the 1780s Stuart had recommended depicting human flesh with a rich, opalescent effect, but in about 1811 he seems to have been trying to transcribe more effectively the peculiar glow of living tissue—*luce di dentro,* as Washington Allston appreciatively called it. Allston had returned to the Boston art world in 1808, after an absence of seven years, having studied with Benjamin West and having traveled extensively in Europe. In Boston he spent some time with Stuart—indeed, the two men, a generation apart, became friends —and they undoubtedly discussed and possibly influenced each other concerning the painting of flesh. In fact, Allston seemed primed to paint portraits when he wrote, on his way home, that an artist can represent the soul only from life; and Stuart could have played a role in temporarily steering him in the direction of portraiture and away from history and landscape painting. The gradual progression, in Allston's few Boston portraits, toward greater plasticity and greater luminosity in the flesh, culminating with the portrait of his

mother-in-law, Lucy Ellery Channing (fig. 84), argues for Stuart's influence. The spotlit Channing portrait follows Stuart's precedent in building form through color more than line; it is also closer to life and far more subtle and sophisticated, in its suggestion of translucent flesh and secondary lights within shadows, than any portrait Allston had painted before. Like some of their contemporaries abroad (such as the German philosopher Hegel, who spoke of light as the inner and ideal element of color), Allston and Stuart both seem to have been keenly aware of the idealizing or uplifting effects of light. After the Boston interlude, Allston returned to England for a seven-year stay in 1811, as a history painter. He continued to irradiate his flesh color, but, unlike Stuart, he did so under the influence of the European Old Masters. Stuart worked more closely from life and maintained a reputation for luminous, transparent flesh.[9]

When he first arrived in Boston at age forty-nine, Stuart had enjoyed the stimulating conversation of another friend with similar interests, Benjamin Waterhouse. Significantly, Waterhouse, now a prominent physician in nearby Cambridge, found the artist, after

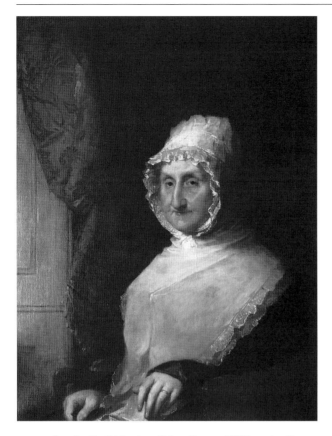

FIG. 81. *Lydia Pickering (Mrs. George Williams)*, 1824

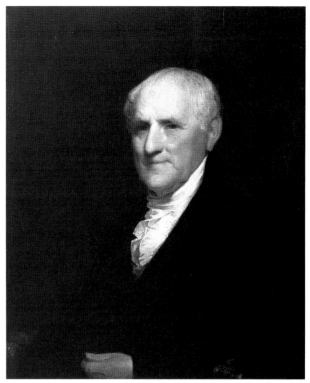

FIG. 82. *Judge Egbert Benson*, ca. 1820

the passage of over twenty-five years, considerably altered. He attributed the change to Stuart's relishing of "Irish society, particularly their conviviality," meaning feasting and especially drinking. Other chroniclers from Stuart's early years in Boston tell stories of his intemperance similar to those first heard, in about 1800, in Philadelphia. Rumors then were that he was seldom fit for business except in the morning, and such tales continued even when the artist was over sixty. Stuart could well have been an alcoholic, but it is also likely that these rumors were fueled by his erratic moods, his indolence, and the fact that his face would become flushed whenever he drank. In November of 1817 Mather Brown's aunt wrote to him in London from Boston that Stuart, "loves a chearful bottle, and does no work in the afternoon; he is very dilatory in finishing his pictures; there is no oeconomy [*sic*], of course he is said to be poor."[10]

She also mentioned the son that Stuart had lost in 1813, Charles Gilbert, whom he still mourned, as was clear to Henry Pickering when he interviewed Stuart in 1817. In fact, Stuart, by this date, had already lost

five of his twelve children, only one of whom might have died at birth. The names of the dead, other than that of Charles's younger brother, Jarvis, are not known. In a commentary that probably came by way of Jane, who was the youngest, George C. Mason wrote of Charles that his father had been so attached to him that he had used poor judgment in bringing him up. Mason's elaboration is frustratingly incomplete, but it provides some insight into Stuart's idea of a moral upbringing:

In his efforts to save him from the gay company that had been the delight of his own early life, and which had cost him so much, [Stuart] drew the cords too tight. He was too rigid in his treatment of the youth, was too exacting in his demands, and put too many restraints on his movements. The result was, when the young man came of age and began to mingle more freely with the world, he was easily led into temptation, and at the age of twenty-six he went down to the grave, the victim of many irregularities. The blow was a terrible one to Stuart who felt that he was in a great measure to blame.

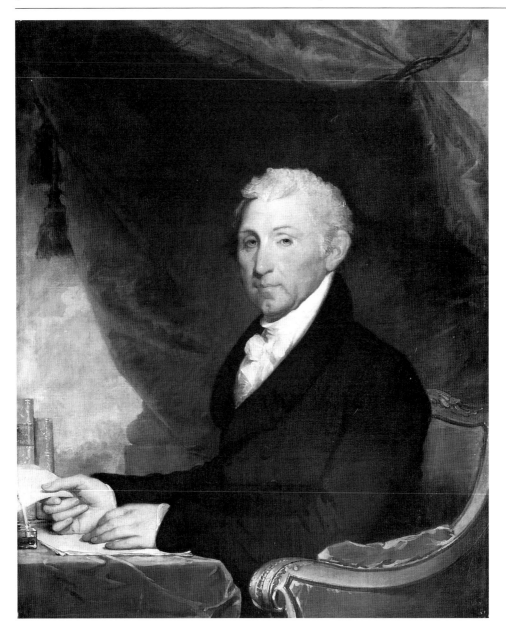

FIG. 83. *James Monroe,*
1821/22

Charles was not just dissolute; he must have known that he was dying, for he wasted away with tuberculosis. As part of Stuart's mourning process, he had made to his own design an expensive, small casket—a memento of his son—which he kept on his sitting-room table. One of Stuart's neighbors, who saw him nearly every day in about 1815 and later, described him as "impressive, magisterial-like, and deliberate." He recalled that the wife and daughters idolized Stuart; but the artist John Neagle (albeit on short acquaintance) thought that the family appeared afraid of him. Indeed, the children seem to have been in awe of their father's great

talent and—if those who survived him are any indication—to have accepted the special status of Charles and later Jane as the inheritors of his ability.[11]

The loss of Charles was not the only reason Stuart would have been depressed in 1817. Pickering recorded the following conversation in the artist's painting room in October of that year:

Mr. S. remarked, in the course of the interview, that when he first went abroad, he thought he should never attempt to paint a subject which required less canvass [*sic*] than would cover the side of a room. But you see, said he,

FIG. 84. Washington Allston, *Lucy Ellery Channing (Mrs. William Channing)*, 1811

(pointing to the portraits about the room) to what I have been reduced. I have a family—I paint for bread. I rejoined, I hope, Sir, you will long live to paint such things as these. I hope not, said he quickly—it is labour I do not like. A gentleman present remarked, I always thought that painters were perfectly happy, while engaged upon their works. As happy, dryly rejoined Mr. S., as a horse grinding bark![12]

Stuart's interest in a portrait could vary considerably. Witness, for instance, the following tale as reported in 1880 by the art historian Charles Henry Hart. In about 1813, having been commissioned to paint a portrait of a Sarah Jones Richards, Stuart was engaged in

this task when the sitter's father, Judge Stephen Jones, entered the room. "Struck with the noble and venerable presence," as Hart described it, "Stuart asked who he was, and insisted upon painting his portrait; but the old judge refused, and it was only after Stuart's repeated and earnest solicitations that the request was granted." The resulting portrait of Richards (fig. 85) is one of Stuart's more indifferent works; whereas the portrait of Jones (fig. 86, pl. 11) has the strong individuality, the singularity of being, that is characteristic of Stuart's most extended efforts. This uncommissioned work was, in fact, one of Stuart's favorite portraits and, as such, telling in terms of his aims. As others have observed, the portrait is extraordinarily "alive." Stuart's pupil Jouett,

FIG. 85. *Sarah Coffin Jones
(Mrs. John Richards),*
ca. 1813

who was with Stuart in the summer and early fall of 1816, called the picture of Jones "the most remarkable face and painting that I have ever seen."[13]

The highly colored portrait of Jones is so striking in its conveyance of a sense of solid, three-dimensional form that it brings to mind the substantiality of some of John Singleton Copley's portraits of Bostonians from the late 1760s. Indeed, after his return to Boston, Stuart repeatedly expressed admiration for Copley, and what he admired in his work is instructive. He marveled not at the flesh color but, rather, at the self-taught ability to transcribe closely the sitter's appearance. In one instance of praise, Stuart focused on a painterly passage in Copley's portrait of Epes Sargent (fig. 87) where the

subject's hand seemed to be more than just a surface; it was something volumetric and layered, containing blood within itself. "Prick that hand," observed Stuart, "and blood will spurt out!" Stuart's appreciation stemmed from his belief, expressed in 1817, that the portrait painter must take his cues from nature and develop his own distinct manner. In fact, according to Pickering, he thought Copley had been mistaken to abandon his Boston style in London.[14]

Change in Stuart's portraits is so often concerned with nuance that the larger shifts in direction do not become clear until we compare works separated by several decades. A case in point is the marked contrast between Stuart's two surviving life portraits of John Adams

FIG. 86. *Judge Stephen Jones,* ca. 1813

(figs. 88, 89), one of about 1800—completed in 1815 —and the other of 1823, the later one much more fully realized as a three-dimensional, animated form. The difference can be explained partly by a contrast in effort: the first likeness is a belatedly finished version of a one-sitting sketch and the second a prolonged attempt to document the visage of the aging former president. Yet there is more to the dissimilarity of this comparison: the first portrait is a strong likeness but relatively shallow in content (Stuart jokingly referred to it as showing Adams about to sneeze), and the second portrait has a depth that Allston, for one, found quite astounding. The discrepancy between the two pictures helps to clarify the fact that Stuart, in his late Boston work —after 1820—returned to the mimeticism of his *Richard Yates* (fig. 47, pl. 6) and modified it, becoming more involved than ever before with the introduction of a spiritual dimension.[15]

Allston concluded after Stuart's death that his friend had not been sufficiently challenged in Boston, but it is apparent that—with ailing health and fewer commissions—Stuart's sense of his own mortality sparked a burst of renewed effort in his final years. Many of his works from the 1820s characteristically convey a sense of warmth and inner being that is visible, for instance, in the portraits of Rezin Davis Shepherd (fig. 90), Phebe Lord Upham (fig. 91, pl. 12), William Phillips (fig. 92), Lydia Pickering Williams (fig. 81), and William Win-

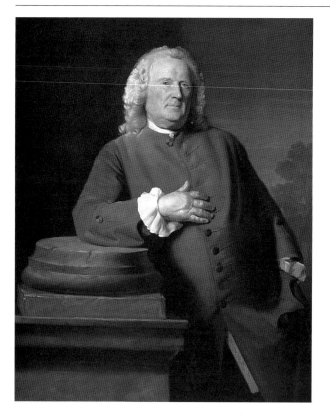

FIG. 87. John Singleton Copley, *Epes Sargent*, ca. 1760

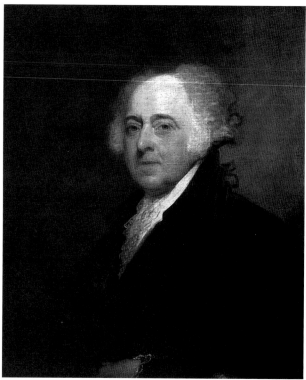

FIG. 88. *John Adams*, ca. 1800/1815

throp (fig. 93, pl. 13). As in Stuart's earlier *William Wool-lett* (fig. 27), Winthrop appears about to move, but Winthrop's skin is quite different from Woollett's; it has an extraordinary liveliness to it and a lack of fixed surface as if to suggest tenderness and actual breath-ing, an effect that contemporaries noticed in Stuart's work. Despite the tremor in Stuart's hands that in-creased markedly in 1816, he had, as his sitters observed, such control of the brush by using both hands that he could suggest with great subtlety. The sitters in this group of portraits are all more communicative and ani-mate—in the sense of animation at rest—than is Yates in his portrayal of about twenty-five years earlier. In all, there is what Stuart recommended to Jouett in 1816: "animate expression" and the effect of being, at once, both distinct and indistinct. Stuart's exact words to Jou-ett, concerning one of his own portraits, are worth quot-ing: "There is all stillness and life."[16]

This combination, a seeming contradiction in Stu-art's need to incorporate an effect of stasis even as he moved in the direction of greater animation, is so dis-tinctive, particularly in its painted manifestation, as to separate Stuart from most (if not all) of his artist con-

temporaries. His effect of stillness reflects the position of the famous Neoclassicist Johann Winckelmann, who argued, in Henry Fuseli's translation of *Reflections on the Painting and Sculpture of the Greeks,* that the more tranquil the body, the more capable it is of portraying the true nature or essential condition of the soul—as in classical sculpture—for "the true sphere of [the soul's] action is simplicity and calmness." The conjoining of the ideas of simplicity, tranquility, and soulfulness as a desideratum in portraiture helps to explain the en-thusiasm of the artist's one-time pupil Thomas Sully, who claimed, in 1832, that one of Stuart's Boston heads "was, without qualification, *the best portrait he ever saw,* and that while he was in England, he saw nothing to compare it to for excellence of coloring and simplic-ity of expression."[17]

Sully's mention of England might seem odd, but it is particularly revealing that he thought it necessary, as part of his praise, to recall his experience there, more than twenty years earlier, in 1809. In fact, the for-mer mother country continued to exert great influence as the major point of comparison in artistic matters in the United States even into the 1830s. After leaving En-

FIG. 89. *John Adams, 1823*

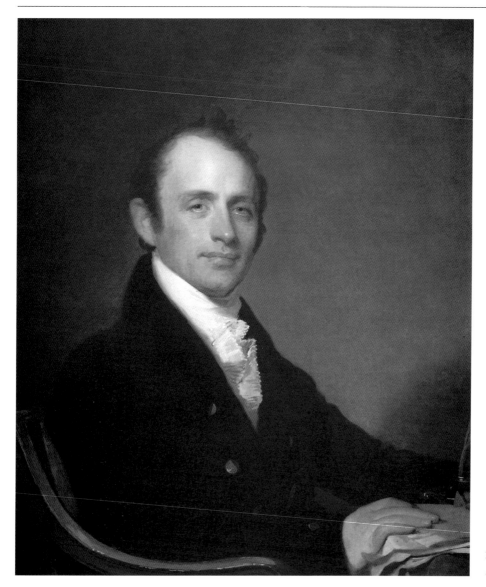

FIG. 90. *Rezin Davis Shepherd*, ca. 1825

gland, Stuart repeatedly tried to measure his work against that of the best London portraitists. He returned there from Ireland, and he made a special effort with the Lansdowne portrait (sending the original) and the Munro-Lenox portrait (sending again an original) undoubtedly because they were destined for the English capital, where his old colleagues could judge them. In the same way, in about 1820, when the much-respected Boston framemaker and picture dealer John Doggett formed an ambitious scheme to exhibit Stuart's work in London, the aging artist rose to the occasion and seems to have attempted to produce his best work.

According to plan, Doggett would purchase from Stuart a set of three-quarter-length portraits of the first

five presidents (all of whom Stuart had painted from life), the set would be displayed in Doggett's gallery, and then the pictures would be exhibited and engraved in England. In the end, despite Allston's efforts at making arrangements in London, the completed series was not exhibited there but was instead sent to Paris to be lithographed. The Doggett set included a life portrait of Adams based on a sitting in September of 1821 that Stuart had expressly requested for the series, as well as, in all likelihood, the now-finished 1805 life portrait of Jefferson that had remained in Stuart's painting room for years as a head on an unfinished three-quarter-length canvas. Perhaps because two were originals rather than replicas, Allston echoed Doggett in calling these pictures among Stuart's best works. Unfortunately,

FIG. 91. *Phebe Lord (Mrs. Thomas Cogswell Upham),* ca. 1825

the Adams and Jefferson likenesses, along with a third from the series, were destroyed in a fire at the Library of Congress in Washington in 1851; the French lithographs (figs. 94, 95) after the set—to judge from their correspondence with the surviving works—are not accurate in detail.[18]

Stuart's portraits of Adams from 1815 and 1821 were not extraordinary in the way that his last image of this president was (see fig. 89). Adams's son, John Quincy, went to Stuart in September of 1823 to commission the likeness, which would entail the artist making several trips to Quincy, Massachusetts. Stuart, at first reluctant, finally agreed "to paint a picture of affection, and of curiosity for future times." As had long been his practice, the artist kept up a conversation as he painted, in

an attempt to maintain an effect of animation in his sitter. Indeed, he was known for his brilliant conversation, usually at the dinner table but also in his painting room. Josiah Quincy, who was present, wrote of the progress of the portrait: "[Stuart] would call up different emotions in the face he was studying. He chose the best, or that which he thought most characteristic, and with the skill of genius used it to animate the picture."[19] Quincy later said of the finished work: "A faithful representation of the extreme age of the subject would have been painful in inferior hands. But Stuart caught a glimpse of the living spirit shining through the feeble and decrepit body. He saw the old man at one of those happy moments when the intelligence lights up the wasted envelope, and what he saw he fixed

FIG. 92. *William Phillips,*
1823

upon the canvas." Using similar language of the sub-
lime, Allston called the likeness one of Stuart's "tran-
sient apparitions of the soul." He described Adams as
one whose "bodily tenement seemed rather to present
the image of some dilapidated castle, than that of the
habitation of the 'unbroken mind': but not such is the
picture; called forth as from its crumbling recesses, the
living tenant is there—still ennobling the ruin, and up-
holding it, as it were by the strength of his own life."
This is not the terror-accompanied, Burkean sublime
of Reynolds's *Sarah Siddons* or the Longinian sublime
of singular moral worth, as in the Athenaeum *Washing-*

ton. Rather, it is a third sublime stemming from Longi-
nus: the sublime of an otherworldly presence.[20]

Most observers would have noted the exceptionally
strong likeness in the portrait of Adams, and probably
few would have realized that the picture is partly about
the "living" aspect of the inner tenant. As Adams's grand-
son and companion, Charles Francis Adams, observed
—well aware of Stuart's subtlety of invention—it is "in-
valuable *both* as a Painting and as a correct likeness [au-
thor's italics]." Adams, the "unbending patriot," as All-
ston called him, is here shown in two guises: first as
defiant, with his arms extended forward and crossed;

FIG. 93. *William Winthrop,*
ca. 1825

and second as frail, set against the dwarfing sofa (originally higher) and grasping loosely an old man's cane. The face, enlivened with glistening eyes—one slightly enlarged—and bathed in an exterior light from the upper right, is quite luminous and provides a sharp contrast to the surrounding darkness. This dark background, by the way, must be fictitious; Adams was reportedly painted in the parlor, then a light-colored room, at the Quincy site where this sofa still stands.[21]

In an autograph replica, slightly revised (fig. 96, pl. 14), that John Quincy Adams commissioned in 1826 after his father's death, Stuart—in the absence of the sitter—revealed more of his own interpretation. The whole image is less finished, with patches of bare canvas visible in the face, giving the impression of increased fragmentation in the painting or perhaps of greater fragility in the sitter. Yet this second version is more expressive than the original of an energy and intensity that were actually part of Adams's personality. The artist heightened the coloring in the cheeks, added a highlight to the near eye, gave more energy to the expression of the mouth, blackened the background more, and exaggerated the couch further to dramatize the head.[22]

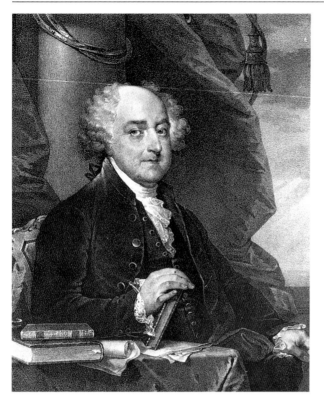

FIG. 94. Nicolas-Eustace Maurin, *John Adams,*
after Gilbert Stuart, 1825/28

FIG. 95. Nicolas-Eustace Maurin, *Thomas Jefferson,*
after Gilbert Stuart, 1825/28

The contrast between the Athenaeum portrait of Washington and the late portrait of Adams can be telling in more ways than as a contrast between a timeless personification and what is essentially a time-specific portrayal of an individual. It is time specific partly because props are used but also because the external light source is more important and more consistently (even dramatically) observed. One is an icon of strength; the other, though an image of resistance, is a vulnerable human being. The Athenaeum portrait is unquestionably the defining work of Stuart's career, but the late Adams portrait moves beyond it in the direction of finding an essence, an inwardness, and a basis for a moral subjectivity.

Allston's description of the late Adams portrait—which he must have witnessed being copied in Stuart's studio—was undeniably conditioned by his own inclination to prefer the supernatural and the sublime in subject matter. Yet Allston also knew Stuart. Although Stuart was reluctant to attend church, he believed in a spiritual afterlife and had read the Bible enough to be able to quote it. Both artists accepted humanity's divine origin, and the impetus for each to represent

this concept through luminous flesh color and (in the case of Stuart) stilled animation was almost certainly the result of a fascination with the sublime. Like Allston, Stuart would have known that Longinus spoke of the sublime as "reflected from the inward greatness of the soul" and that he remarked: "If you take away the sublime meaning, you separate as it were the soul from the body." The introduction to William Smith's Christianized translation of Longinus emphasizes the first quotation by repeating it and adding a new visual image, suggestive of luminosity: "An inward grandeur of soul is the common centre . . . whence every ray of sublimity . . . is darted out." Other writers as well—such as the devout Irishman James Usher, in an expanded second edition of his *Clio: or, A Discourse on Taste* (1769) —promoted the idea of "the unspeakable sublimity of the spirit of man"; an early-eighteenth-century serial publication that Stuart is known to have read and reread, even after 1800—Joseph Addison's *Spectator*— joins them in taking a similar position, even observing that the actual substance of "Our Maker" is "within the substance of every being."[23]

In an era that prized attempts to go beyond mere

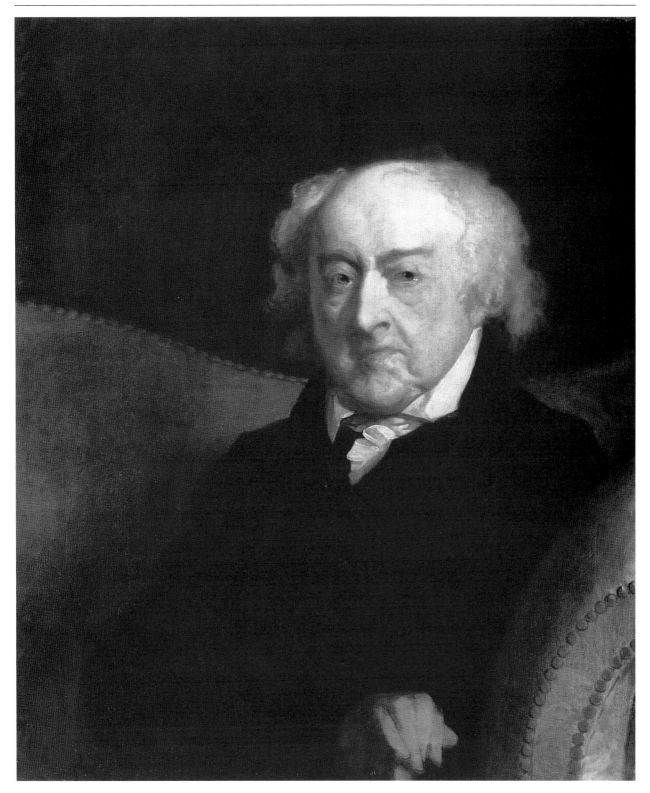

FIG. 96. *John Adams*, 1826

physical resemblance, Stuart tried to create a visual metaphor for this otherworldly connection in his painting of flesh. He copied the luminosity of real flesh and often added color more expressively than did his fellow portraitists, doing so with a purity and a vivacity that transcend nature. The transparency of his flesh is nearly always distinctive in that higher coloring, suggesting the presence of energy, seems to come from beneath the surface of the skin. Occasionally, especially from about 1815 to about 1820, Stuart even added lively, visibly broken modeling strokes that activate the surface of the face, giving "motion to the features." Flesh is, as he described it, "like no other substance under Heaven." The linkage with heaven is important and revealing in light of another comment. When he observed that his pictures had been compared to those of the Old Masters in England and jested, "but here! They compare them to the works of the Almighty!," he seems to have been defining a subtle change in his own approach as well. As those close to him knew, Stuart "had to become interested in what he did, in order to do it well," and there is evidence that he became particularly challenged during the last decade of his life. It was then that he told his daughter: "I copy the works of God."[24]

The younger artist Neagle, who knew him in his old age, elaborated on Stuart's aims: "[H]is object was to counterfeit the soul—to throw the intelligence of expression into the face of his picture—to catch the thoughts . . . the disposition, and with such elegant touches, that at a glance his copy is sufficient to afford an understanding of the mind of the original." Jane Stuart reported the opinion of another artist, essentially the same: "In general, he aimed only at the intrinsic." Stuart could easily capture characteristic expressions or "authentic hints," of an individual. But, beyond this much-praised intimation of the internal self, contemporaries such as Joseph Hopkinson found the suggestion of a spiritual presence, "immortal energies" that—in the age before Charles Darwin—"distinguish man from the brute." In a published lecture, originally delivered before the Pennsylvania Academy of the Fine Arts in 1810, Hopkinson called Stuart "perhaps unrivalled, certainly not surpassed [among American painters], in portraying the human face beaming with the soul that animates it." In making his flesh more luminous and animated, Stuart must certainly have been reacting to such a response.[25]

In fact, Stuart's praise of Copley's *Epes Sargent* (fig. 87), as mentioned above, makes sense especially in this context. Although only the comment on the hand is preserved, the overall effect of the portrait must have appealed to him. Fairly unusual in the context of Copley's Boston work, *Epes Sargent* is consistent with Stuart's aims in being not merely a likeness but also a statement of the sitter's inner strength and moral sentiment. Copley's message is conveyed through the abstracted facial expression; the strong, weathered column base; and the covering-heart gesture. In contrast, Stuart focused on engagement with the viewer in his portrait of Adams, as well as suggesting an inner spirit. His purpose being to convey "inwardness," he did not even bother to repair the unusual breaking up of Adams's face in the replica. The exterior surface of the face, and its careful description, was of far less interest to him than to Copley.[26]

Stuart's success with distilling spirit from matter is demonstrated superbly in his portrait of the poet and socialite Sarah Apthorp Morton (fig. 97, pl. 15). As the pentimenti reveal, he had begun to paint her with arms folded in front; then, inspired by her gesture of arranging a lace mantilla over her head, he whimsically changed the portrait. It now shows her at the moment of adjusting her veil, but it is left unfinished. As it is, the roughly blocked out secondary areas play up the beauty of her finely finished face; to complete the picture would have been to freeze her gesture and make the whole image less suggestive of movement; to complete it would also have detracted from the mysterious way that he combined a beautiful face and an elusive, covering veil so as to connote the transience of life. The painting is sufficient to have inspired this evocative description of it about a century later: "It is a poetic suggestion of life itself, radiant and vivacious, and passing like a breeze." Stuart kept this portrait and fulfilled his commission with another.[27]

Allusions to the ephemeral nature of human existence in several of his paintings attest that the subject held special interest for Stuart. His one known late portrait that fits this mold—a painting with some of the quality of a fancy picture because of the sitter's subordination to a theme—is *Francis Lowell Dutton*, once called *Boy with a Butterfly* (fig. 98). Here the young boy, attracted by the beauty of a passing butterfly, turns and removes his red cap—in an action similar to Morton's —to use it as a butterfly net. The opened morning glories behind him and the colorful butterflies in front (both emblems of change) refer to the transient state

FIG. 97. *Mrs. Perez Morton*, ca. 1802

FIG. 98. *Francis Lowell Dutton,* ca. 1820

of the sitter's youth and the inevitable passage of life. The morning glory—whose flowers bloom and wither within a day—reinforces the meaning of the butterfly, the more traditional emblem. Given Stuart's reputed independence and his recorded interest in flowers, we can be almost certain that this was his own choice of subject. As such, it seems to reflect his sadness over the loss of so many of his children.[28]

In their dematerialized form, the unfinished heads of Washington Allston (fig. 99) and Nathaniel Bowditch (fig. 100, pl. 16), left in Stuart's painting room at his death, are similar in content to the portraits of Morton and Dutton. Like the 1826 replica of *John Adams* (fig. 96, pl. 14), they convey the immateriality of existence not through emblem but through an associative use of style—a fragmentation of substance. Although they recall the timeless, disembodied Athenaeum head of Washington (fig. 50, pl. 7), they are more momentary, more alive (as in the highlighted, sparkling eyes), and more ethereal. By diminishing the importance of the body relative to the mind and spirit, Stuart indulged, more than before, a desire to express the interiority of a person, a desire that is rooted in the so-called age of sensibility. There is a quickening of the spirit, a suggestion of inner energy and of immediacy in both these works that often characterizes Stuart's productions between 1820 and 1828. It may well have been the transparency of such images, and their oneness with the canvas, that fostered Allston's reference to "apparitions of the soul."[29] Pickering, the poet and art lover who believed in Stuart's greatness and often visited him to record his conversation, would have appreciated his friend Allston's words. When he heard that "some injudicious friends" of Bowditch were suggesting that another artist should finish the Bowditch portrait, Pickering took it upon himself to intervene. Having saved the picture as a "fragment," he scrawled across the back of it: "Sancte inviolateque servatum sit."[30]

Stuart left many disembodied heads or unfinished pictures in his studio when he died, one of which—his *Thomas Oliver Selfridge* (fig. 101)—Jouett admired for its "wonderful fine effect" and the broad shadow under the mouth. Jane Stuart stated years later to the sitter's son, when he collected it, that this painting was one of Stuart's two favorites, along with the portrait of Dunn (fig. 71). Whether true or not, the canvas was almost certainly completed—that is, painted to the edges with black paint—by Stuart, inasmuch as Jane had the job of supplying bodies. If this is the case, then it is fur-

ther evidence that Stuart found the timeless effect of such incomplete works satisfying. They had never, as he put it—separating his mental labor from the manual labor of tradesmen—"been to the tailor's." He is surely the artist who gave the immediately surrounding background some importance by incorporating into it the skillful suggestion of a neckpiece. The sitter's head, with its relatively rich coloring, floats in front of and—from the location of the cravat—within surrounding darkness. It is part of the canvas and yet, somewhat eerily, drawn out of it, much in the manner of the portraits of Allston, Bowditch, and Morton. More than they, however, this portrait, with its arched-eyebrow expression, is a clear display of the sitter's lofty consciousness of worth.[31]

Stuart's early biographer Samuel Knapp likened him to the legendary ancient Greek painters Parrhasius and Aristeides, renowned—without surviving works—in the first instance for convincing realism and in the second for being "the first among all painters to paint the soul." Allston, for his part, compared a head by Stuart with the work of Rembrandt, Rubens, Van Dyck, and Titian, concluding that "[all four] combined could not have equalled it." These remarks evince a historical self-consciousness that is found also in Stuart's last completed work, his solemn portrait of a sixty-five-year-old surgeon's wife, Sarah Henshaw Hayward (fig. 102), signed and dated 1828.[32]

What is immediately striking about the Hayward likeness is the full-face frontal, and therefore more static, pose. The perspective is unusual for Stuart, but given his insistence on his own conception, this was unquestionably his own idea. In some sense, it is the setting up of a deliberate challenge. He had always maintained that a likeness depended chiefly on a careful transcription of the nose, but a full-face view denies the viewer even the suggestion of the nose's outline. Stuart had also taken pride in his ability to create three-dimensional projection without depending, as West did, on strong outline. In fact, his unfinished portrait of Bowditch shows him posing the problem of suggesting three-dimensional form in space with the slight handicap of a shadowed foreground. A full-face view, however—used occasionally by Sir Thomas Lawrence and Jacques-Louis David, and beginning to come into popularity—lends itself to a relatively flat treatment. Thus challenged, Stuart painted his picture, as he did in the 1820s, with great subtlety of suggestion and as if the three-dimensional image were breathed onto the

FIG. 99.
*Washington
Allston*, ca. 1820

canvas, without leaving the tracks of broken brush-strokes in the flesh. Through clever allusion, he left part of the picture to the imagination (as he was inclined to do) and included telling details such as Hayward's tilted earring on one ear, the embroidery at the edge of her turban, and the soft quality of her flesh with its melting transitions of surface: for instance, a dimple to the right of her mouth, delicate modeling along her chin, and part of a low circle at the left under her eye. To provide a suitable backdrop, Stuart used a curtained and paneled window strip to the side (probably a subtle metaphor for the curtain-column motif) as he did in a few other late works. The one slightly jarring note is the red shawl, which originally

expanded to fill the hand area. It is not really convincing as by Stuart, in that it does not harmonize well with the overall color scheme. It was probably painted or repainted, with the ringed hand, by Stuart's late assistant, his daughter Jane.[33]

During his lifetime Stuart had over twenty students, for various short periods, and he freely gave advice and help to other artists; but in his old age, he was especially sought after as a great sage in artistic matters. For instance, Allston, working on a history painting, *Belshazzar's Feast* (Detroit Institute of Arts), asked for and followed Stuart's criticism. Pickering wanted Stuart's opinion of the work of well-known French masters, finding him a learned connoisseur; he also eagerly solicited

FIG. 100. *Nathaniel Bowditch* (detail), 1827

his view on the authenticity of different European pictures in the possession of a traveling dealer. Other Bostonians brought damaged European pictures, such as one by Adriaen Ostade, to Stuart to have them restored; and James Barton Longacre, who hoped to publish an illustrated book on famous Americans, joined the artist Neagle in 1825 to sit at Stuart's feet, listening to his "rich and instructive conversation." Longacre then traveled with Isaac P. Davis and later Allston to various sites in Boston to see Stuart's portraits. Speaking of Stuart, one young sculptor confided in his diary: "His society is much courted by a few, who thank Heaven for the sake of the Arts." In sum, Charles Edwards Lester could reminisce truthfully in a book of 1846, *The Artists of America,* that the younger artists went to see Stuart's work as they would visit Italy to study the works of Old Masters.[34]

Stuart's admiring followers were most impressed by the combination of his remarkably strong resemblances and his seemingly inimitable flesh color. They could teach themselves to accomplish the one but not the other. Allston's friend John Cogdell spoke of Stuart as "the Seat of the Arts" in the United States and of his style as the "style which has bewitched all artists—and been the wonder of all who have been fortunate enough to see any paintings of this great master." Those aspirants who visited Stuart were usually warmly received—in the manner of West—and not infrequently

FIG. 101. *Thomas Oliver Selfridge*, ca. 1815

FIG. 102. *Sarah Henshaw (Mrs. Lemuel Hayward)*, 1828

given free lessons. Quite a few of them carefully recorded the master's palette colors and his way of applying flesh color, but they were frustrated in their attempts to codify the procedure. "His manner of laying in his colour can not I think be described," Cogdell wrote, "and I fear cannot be imitated." To watch Stuart at work and be told that "in examining critically the face you will be able to apply many little tints of various colors which will add to the truth of resemblance" was not enough. In his diary Cogdell listed Sully, Bass Otis, John Wesley Jarvis, and Samuel Lovett Waldo as examples of artists who had tried to imitate Stuart's color and had failed. Among others whose color benefited, as theirs did, from the attempt were Brown, John Trumbull, James Frothingham, Jouett, Neagle, Francis Alexander, and Stuart's nephew, Gilbert Stuart Newton.[35]

Despite this suggestion of intense involvement in matters of art, Stuart was not well through the 1810s and 1820s. He suffered from gout and asthma and fell periodically into such ill health that at least one sitter, by 1818, speculated that he might not live long. Allston spoke of his friend as struggling against infirmities during the decade before his death; and Neagle was surprised to learn, in the summer of 1825, that the left side of Stuart's face was partially paralyzed. Although right-handed, Stuart was much bothered by the extension of the paralysis into his left arm. Whatever the cause, Stuart died, after a stint of confinement to bed with chest pain, at age seventy-two on July 9, 1828.[36]

Twelve days after Stuart's death, Waterhouse wrote an ingratiating letter to President John Quincy Adams, recounting his attempt on Adams's behalf to obtain a full-length portrait of Adams, which had only the head completed, from Stuart's widow. Based on sittings in the fall of 1825 and later finished by Sully, the picture (Harvard University Portrait Collection, Cambridge, Mass.) had been commissioned by an Adams relative. In the letter Waterhouse seemed to acknowledge his own distance from Stuart and the much greater closeness of Allston and the art patron Isaac P. Davis as loyal friends to the artist. Aside from bemoaning the "obstinate, ungovernable, self sufficiency" of Stuart, Waterhouse generally dealt with current matters and made one remark, in passing, that is astonishing: "I called upon the widow and children, one of whom, a son of about 30 years of age, is insane, and has been several years."[37]

This last piece of information, added to the record of the artist's periodic depressions and Gilbert Stuart

Newton's later confinement in an insane asylum, strongly suggests that Stuart himself suffered from mental illness—in fact, manic-depression, a hereditary disease that was not defined until the mid-nineteenth century. What we know of Stuart is entirely consistent with the character of this syndrome—a seeming normalcy coupled with cycles of erratic mood and energy swings. The inflated self-esteem, the heightened perception, the quick anger, the forgetfulness with regard to facts, the punning and inappropriate joking, the tendency for self-blame, the unevenness of effort and vacillation in aims, and, most tragically, the inability to function in periods of despondency that might last for several months—all are characteristic symptoms of the disease. That he was ill helps to explain the long stretches of inactivity in London and Philadelphia, mentioned with disgust by Waterhouse and Joseph Anthony, and Waterhouse's remark that Stuart never had "evenness of spirits. . . . With Stuart it was either high tide or low tide." This is a classic description of the disorder.[38]

Stuart had enormous ability, and he was probably most creative when he was in a mildly manic or mixed state. Yet depression could immobilize him, and mania could cause him to produce inferior work. A probable instance of this is the amateurish lapdog in *Christian Banister and Her Son* (fig. 1), painted at a time when Stuart could draw dogs from life quite accurately, as in *The Hunter Dogs* (fig. 103), which Jane Stuart credibly claimed he completed at age fourteen. With Stuart's health unpredictable and uncontrollable—indeed, not necessarily affected by external events—his work was understandably uneven. He was probably able to adjust somewhat to his mood cycles by painting only at certain times and by using snuff, alcohol, and the exercise of long walks (which he favored) to help moderate his inclinations. He also simplified his compositions so that he could possibly complete them even when suffering from his illness. But the large number of unfinished paintings, which so many visitors reported seeing in his studio, reveals both the continuing rationale that almost anyone could finish them and his own distractibility as a manic-depressive. While his career suffered because of his illness, his manic-depression could also have had a positive effect in making him especially conscious of the animating principle within himself and others that can be found expressed in his late painting.[39]

Stuart did adjust, and, in this context, his reluctance to paint a last portrait of John Adams can be under-

FIG. 103. *The Hunter Dogs*, ca. 1769

stood. As he hesitated, he probably recalled the risky beginning of his earlier attempt to portray the second president. When the artist visited the Adams family in 1821, to begin the now-lost Doggett portrait of John Adams, Louisa Catherine Adams found him—so contrary to expectations—"a perfect lump" at the dinner table. He took snuff in huge quantities, as a stimulant, and said absolutely nothing. As she wrote later, he looked so old and dissipated (with his clothes probably disordered and dirty) that she thought his appearance not just deplorable but "disgusting." Stuart could never be sure of his mood, and he lived inevitably with the potential for sudden failure. Those who knew him said that often, inexplicably, he refused to complete a picture.[40]

In his manic state the artist was inclined to go on spending sprees, which his daughter characterized as reckless. The most obvious examples are his large-scale entertaining and his renting and elaborately furnishing the impressive New Burlington Street house. Stuart also purchased an expensive Turkish rug, at a price that shocked one patron, merely to include it in his Lansdowne picture; and, on another occasion, he impulsively bought a cow, ostensibly because it reminded him of country life. Even in his last years, when his family was quite poor, he whimsically hired a Boston ornament painter to add unnecessary decorations to his chamber organ.[41]

Stuart's mania was expressed in various other kinds of peculiar behavior. Once, for example, as part of an odd joke when visiting West's studio, Stuart appeared

wearing his stockings on top of his shoes and his waist-coat over his coat; also in London ("a little enthusiastical"), he used to shoot off a cannon in his garden whenever an engraving after a deserving painting was published; in Philadelphia, he once kicked a large piece of inferior beef from his house down the street to the responsible butcher; later, in Boston, Stuart straight-facedly told Pickering that Copley had been his pupil and that, at the age of just eleven months, he himself could draw pictures and recite the alphabet. When he was manic, as numerous people reported, he talked knowledgeably and eloquently on an astounding range of topics—he could lecture, at such times, on anything "from the Divinity to a corncob." On one occasion he launched into an impressive discourse on optics; on another he connected human anatomy ingeniously to the "economy of his shoe-tie." Waterhouse recalled that Stuart could talk animatedly "upon any topic that cast up, especially upon subjects that called forth nice discriminations, correct judgment, and rapid thought, apt phrases, ludicrous images, and [Edmund] Burke-like power of expressing them." Stuart's restlessness—evident in his sudden overnight visits to Waterhouse and possibly in his maintenance of painting rooms at two different sites when he worked in Dublin and Philadelphia—is also entirely characteristic of a manic-depressive.[42]

Many of Stuart's contemporaries were puzzled or—worse—angered by his rapid fluctuations in mood and his unpredictable onslaughts of lethargy. His family kept watch and worried at such times, perhaps even with the thought of suicide in mind. They fretted during lapses in correspondence when he traveled; for example, in 1804, two of his older children wrote, a month apart, to one of their father's friends: "My mother is very anxious" and "We are much troubled[,] not having heard from my father." Trumbull, once an old friend, reacted quite differently, growing impatient with Stuart and calling him "an enemy to himself." In a coolly detached 1803 letter to Anthony, he added: "With his talents, poverty is a crime, as it can only be the consequence of idleness." Perhaps not surprisingly, Stuart managed to alienate his self-righteous associates (including Waterhouse and Dunlap), but he found long-term sympathy in Boston with the kind art lover Davis and the benevolent Allston—Allston who had befriended another probable manic-depressive, the English poet Samuel Taylor Coleridge. Their support and that of others is revealing. To many who admired

him, Stuart's eccentricity seemed to be the very indication and natural accompaniment of genius.[43]

Paradoxically, the ideal of repose that informed Stuart's work reflected his desires and beliefs but not his own life. As he told Jouett: "Without reason to systematize & control the fervour of the immagination [*sic*], our paintings will be like our dreams when they come to be examined cooly [*sic*] and philosophically." Thus, showing the extraordinary will power (once mentioned by Waterhouse) that he exhibited in controlling his trembling hand, this artist—a man supposedly of uncontrollable passions—resisted giving expression to the seesaw reality of his existence. If he thought he had failed in his efforts at self-censorship, he would later, in a more depressed mood, destroy the portrait in question—which, in fact, often happened. Diametrically opposed to flights of fancy, Stuart's paradigm of self-control was characteristic of Greek classical art. Indeed, he once demonstrated the importance of the antique precedent in an enthusiastic outburst to Pickering, to whom he claimed that he was but the precursor: "Artists will arise in our country who (before the lapse of a century) will eclipse those of the proudest days of Greece!"[44]

Although Stuart, in his younger days in London, once half-jokingly proclaimed that "no man ever painted history if he could obtain employment in portraits," it is probably a mistake to take his bravado then as proof that throughout his life he preferred his own career to that of a history painter. Arguably the opposite was true, or, at least, it could be said that there was some ambiguity in his mind. Stuart declared that he expected to paint huge canvases—generally understood to be history pictures—when he first went to England; and several of his contemporaries reported his expressions of regret, late in life, that he had not been a history painter. What he seems to have shared with these colleagues was an admiration for a dignifying, intellectual content that drew on past art and spoke to future generations. More than this, Stuart appears, from his Athenaeum portrait, to have been drawn innately to the moral inspiration of history painting's examples of virtue. His content was that of intelligence, moral strength, and benevolence—in short, the "perfections" of the mind that the artist William Hogarth once claimed could not be represented, "beyond the appearance of common sense and placidity." In the otherworldly dimension of his luminous flesh and soulful animation, he adapted his pictorial language to an uplifting message, akin to that found in history paint-

ing. Much of his American work might be characterized as the novelist Herman Melville described a single work by Stuart in 1852: "a glorious gospel framed and hung upon the wall . . . declaring to all people, as from the Mount, that man is a noble, godlike being, full of choicest juices; made up of strength and beauty."[45]

Archibald Alison, an art theorist whom Stuart paraphrased, maintained in 1790—as Joseph Addison, William Duff, and others had before him—that the determining factor in attributing genius to an artist was the imaginative contribution in that person's painting, above and beyond the mere copying of nature. "It is . . . the Genius of the Painter," Allston wrote, "which now gives value to his compositions. . . . It is not now a simple copy which we see. . . . It is a creation of Fancy." At his best, Stuart used his imagination to produce paintings that provided moral enlargement as representations of the divinity in humankind.[46]

Responding to verses written in praise of his work, Stuart once wrote in a poem of 1803 that his aims were linked to those of a poet. The connection, which exalted portraiture by separating it from mere mimeticism, is seminal to understanding his pictures. In conversation with Jouett, Stuart also associated his degree of invention with the invention that he found in poetry, saying that it was "the same idea." To invent, as he implied at the time, meant to abstract or conceptualize what is seen by combining it with images from memory. Thus Stuart, working from his sitters, both called forth and invented ennobling or poetic qualities in their portraits. Pressed repeatedly to explain how her father achieved his stunning effects, Jane Stuart pleaded that this was impossible. Then, retreating from the task, she likened his method to the inexplicable reasoning of a great poet. She could not have provided a better summation.[47]

Notes

INTRODUCTION

1. For a general discussion of the "new moralizing fervour" and the related attempt, during this period, to ennoble "common nature" in the manner of classical art from antiquity, see Hugh Honour, *Neo-classicism* (Harmondsworth: Penguin, 1968), especially p. 18. See also the influential claim that the ultimate function of art is moral, in Sir Joshua Reynolds, *Discourses on Art,* ed. Robert R. Wark (New Haven: Yale University Press for the Paul Mellon Centre for Studies in British Art, 1981), 171. On the Athenaeum portrait as a new "moral ideal" in portraiture, see Henry T. Tuckerman, *Book of the Artists: American Artist Life, Comprising Biographical and Critical Sketches of American Artists* (1867; reprint, New York: J. F. Carr, 1966), 115.

2. The following recent statement by a scholar is so misguided as to warrant an encyclopedic rebuttal: "[Stuart] was remarkable in responding neither to the allure of history painting nor to the new intellectualism that surfaced in art at the end of the eighteenth century" (Diana Strazdes et al., *American Paintings and Sculpture to 1945 in the Carnegie Museum of Art* [New York: Hudson Hills Press in Association with the Museum, 1992], 443). On Stuart's knowledge and mental powers in general, see William Dunlap, *A History of the Rise and Progress of the Arts of Design in the United States* (1834; reprint, New York: Dover Publications, 1969), 1:171, 177, 182, 189, 191, 208, 211, 220. For Allston on Stuart as "an extraordinary man; one who would have found distinction easy in any other profession or walk of life"—a man with an original mind —see Dunlap, *History,* 1:222. His influence was summed up by John Neagle, speaking for a group of Philadelphia artists after Stuart's death: "We consider the late GILBERT STUART to have been the *Father of American Portraiture,* super-eminently endowed with genius as a painter" ("Scrap Book," vol. 1, clipping dated July 21, 1828, Historical Society of Pennsylvania, Philadelphia).

3. See Jules David Prown, "Style as Evidence," *Winterthur Portfolio* 15, no. 3 (Autumn 1980): 200–210, for a related discussion of pictorial differences in paintings by John Singleton Copley and Stuart. He argued that the obvious disparities are a partial indication of a change in cultural values between two different periods, one more materialistic—interested in impressive displays of craftsmanship—and the other more concerned with abstractions. The sensibility movement played a major, if not the most important, role in undermining the earlier materialism;

on this point, see G. J. Barker-Benfield, *The Culture of Sensibility: Sex and Society in Eighteenth-Century Britain* (Chicago: University of Chicago Press, 1992), 143, 205. See also Robert Rosenblum, *Transformation in Late Eighteenth Century Art* (Princeton: Princeton University Press, 1967), 59, for a related comment concerning the desirability, at the end of the century, of representing "abstract virtue rather than material wealth." To a greater extent than Stuart, Copley, in his American work, copied the face before him. See, for instance, the somewhat undignified facial expression in his 1769 portrait of Mrs. Isaac Smith (Elizabeth Storer; Yale University Art Gallery, New Haven, Conn.). The depiction of faces would typically be more controlled by Stuart in his American paintings of a generation later; there is much greater uniformity of expression in his work. For a discussion of the "wedge," see Samuel M. Green, *American Art: A Historical Survey* (New York: Ronald Press, 1966), 162. The quotation is from Horace Holley and is in his letter of Apr. 8, 1818, to Mary Austin Holley, Holley Papers, William L. Clements Library, University of Michigan.

4. On the related intellectual self-consciousness of the period as reflected in a pluralism of styles, see Charles Wegener, *The Discipline of Taste and Feeling* (Chicago: University of Chicago Press, 1992), 20; and William Park's period summation in *The Idea of Rococo* (Newark: University of Delaware Press, 1992), 113.

5. The Athenaeum portrait finally became the most accepted likeness of the first president of the United States and, as such, a national icon. For its status as an icon, see Egon Verheyen, "'The Most Exact Representation of the Original': Remarks on Portraits of George Washington by Gilbert Stuart and Rembrandt Peale," in *Retaining the Original: Multiple Originals, Copies, and Reproductions,* ed. Kathleen Preciado (Washington, D.C.: National Gallery of Art, 1989), 128, 137. The quotation is from Matthew H. Jouett's notes, from conversations with Stuart, in John Hill Morgan, *Gilbert Stuart and His Pupils* (New York: New-York Historical Society, 1939), 83. Allston's appreciation is in Dunlap, *History,* 1:223.

6. For "animate expression," see Jouett in Morgan, *Stuart,* 92. On the animation in Stuart's portraits expressing the presence of the soul, see Joseph Hopkinson, "Annual Discourse, Delivered before the Pennsylvania Academy of the Fine Arts, On the 13th of November, 1810," *Port Folio* 4 (Dec. 1810), supplement, 6–7. For the Romantic attitude of mind as associative, see William Vaughan, *Roman-*

ticism and Art (London: Thames and Hudson, 1994), 11.

7. The illuminated flesh and soulful aspect of Allston's portraits are evident especially in *Samuel Taylor Coleridge* (National Portrait Gallery, London) and *Benjamin West* (Boston Athenaeum), both of 1814; see also the golden light and dissolved form creating an aura of mystery in Rembrandt-inspired portraits by Rembrandt Peale, such as his self-portrait of 1828 (Detroit Institute of Fine Arts). Using visual observations and quotations from the period, David C. Huntington was the first to notice attempts among American portraitists in the early nineteenth century to portray the sitter as having a soul (see his *Art and the Excited Spirit: America in the Romantic Period*, exh. cat. [Ann Arbor: University of Michigan Museum of Art, 1972], 6–7). He cited examples by Washington Allston (*Head of a Jew*, 1817), Rembrandt Peale (*John Calhoun*, 1838), Francis Alexander (*Daniel Webster*, 1835), Hiram Powers (*Bust of Daniel Webster*, 1837?), and, less convincingly, Henry Inman (*William C. Macready*, ca. 1827), but he did not make the connection with contemporaneous concerns with the sublime in portraiture. The attempt to represent the soul crossed national boundaries and could take various forms; see, for instance, George Levitine's mention of the "frustrated striving" of Jacques Louis David's students to become "painters of the soul" ("The Influence of Lavater and Girodet's *Expression des sentiments de l'âme*," *Art Bulletin* 36, no. 1 [Mar. 1954]: 33). On Turner and Friedrich, see Vaughan, *Romanticism*, 158. The quotation is from "Portrait Painting," *Daily Evening Transcript*, May 6, 1846, 2.

8. Stuart's lack of flattery is in James Thomas Flexner, *America's Old Masters* (1939; reprint, New York: Constable, 1967), 303. See also Charles Merrill Mount, *Gilbert Stuart: A Biography* (New York: W. W. Norton, 1964), 146, for Stuart painting portraits that are "hard-hitting" in criticism of his sitters. Similar thinking seems to have influenced Richard McLanathan's comment on Stuart's Vaughan portrait of Washington: "Without his knowing it, he had created an icon" (see his *Gilbert Stuart* [New York: Harry N. Abrams in Association with National Museum of American Art, Smithsonian Institution, 1986], 83). Anne Stuart's account is in Wilkins Updike and James MacSparran, *A History of the Episcopal Church in Narragansett, Rhode Island*, ed. Rev. Daniel Goodwin (Boston: Merrymount Press, 1907), 1:604; Jane Stuart also described Trumbull's reaction in George C. Mason, *Life and Works of Gilbert Stuart* (1879; reprint, New York: B. Franklin, 1974), 64–65. They were not the only contemporaries who objected. For reviews of Dunlap that doubt some of the hearsay stories of Stuart, see "American Painters," *American Quarterly Review* 17, no. 33 (Mar. 1835): 151; and *North American Review* 41, no. 88 (July 1835): 148. On the implication of dishonesty, see Jane Stuart, "Anecdotes of Gilbert Stuart," *Scribner's Monthly* 14, no. 3 (July 1877): 379. See also Dunlap, *History*, 1:193, 210–11.

9. Dunlap did write an earlier sketch of Stuart (see his "Biographical Sketch of Gilbert Stewart [*sic*]," *Euterpeiad: An Album of Music, Poetry, and Prose*, Mar. 15, 1831, 232), but

his full biographical treatment is in his 1834 *History*. Stuart's daughter Jane began a life of her father in a series of three articles for *Scribner's Monthly* and then entrusted the task of a book-length biography to George C. Mason. Reportedly, she regretted the result (Mary E. Powel, "Miss Jane Stuart, 1812–1888: Her Grandparents and Parents," *Bulletin of the Newport Historical Society* 31 [Jan. 1920]: 13). Mason's 1879 attempt (*Stuart*, 18–19) repeats the witty-clown anecdotes in Dunlap and adds to them a similarly entertaining quotation from Stuart in J. D. Herbert's *Irish Varieties, For the Last Fifty Years: Written from Recollections* (London: W. Jay, 1836). In short, it is Dunlap's narrative that dominates all biographical references to Stuart until John Hill Morgan's "Sketch of the Life of Gilbert Stuart" in Lawrence Park, *Gilbert Stuart: An Illustrated Descriptive List of His Works* (New York: W. E. Rudge, 1926), 1:9–70; and William T. Whitley's *Gilbert Stuart* (Cambridge: Harvard University Press, 1932). The novel for children is Ilse Bischoff's *Proud Heritage: A Novel Based on the Life of Gilbert Stuart* (New York: Coward-McCann, 1949). Allston's criticism is in his letter to *New-York Mirror, A Weekly Journal, Devoted to Literature and the Fine Arts*, Oct. 24, 1835, 131.

On Stuart's thoughts and feelings, see James Thomas Flexner, *Gilbert Stuart: A Great Life in Brief* (New York: Alfred A. Knopf, 1955; reprint 1995), 22, 37, 39, 66, 75, 81, 83, 98, 114, 116, 117, 121. Flexner's biography is a revised and expanded republication of the chapter on Stuart included in his highly influential *America's Old Masters*, originally published in 1939. Certain assumptions in the book rely on novelistic stereotypes, such as "genius [having] to have its vagaries" (4); "the illicit love affairs the tempestuous Stuart must have had" (71); the presumed "troubles of his childhood from the scars left on his character" (103); and the "deep cleavage" in his nature ("gay on the surface, sad below"), reflected in the contrast between the lyrical background and the "downright" head in *The Skater* (82–83). Although the contrast within *The Skater* (see fig. 20) might be explained as fairly typical of contemporaneous portraits where the background is not from life, Flexner clearly did not want this kind of explanation but, rather, a potboiler.

The characterizations by Flexner (*Stuart*), including "too clever," are on pp. 44, 120, and 81. Although Mount (*Stuart*, 352) called Flexner's biography "frequently in error in facts and interpretation," he followed his interpretation fairly closely and continued to interweave facts, speculation, and pure falsehood. For example, for leaps into fiction concerning Stuart's thinking, see Mount, *Stuart*, 109, 150, 151, 201, 261. Mount portrayed Stuart repeatedly as a "confidence trickster" (108, 262, 265, 267, 312) and as having personality traits (74, 151, 154) that are suspiciously close to his own, as described when Mount was arrested and later convicted of stealing and attempting to sell valuable manuscripts from the Library of Congress and the National Archives. (See Victoria Churchville and Saundra Saperstein, "The Fall from Grace of an Artist, Author," *Washington Post*, Aug. 16, 1987, sec. B, 1,

5; and Ed Bruske, "Art Historian Gets Five Years in Fraud," *Washington Post*, Mar. 31, 1989, sec. A, 17). McLanathan's *Stuart* is an unfootnoted biography that is heavily dependent on Mount for facts and interpretation. In fact, the Flexner-Mount view of Stuart has been the dominant one in the second half of this century. See, for instance, Robert Hughes's treatment of the artist as a "canny" and "uneducated" trickster in his *American Visions: The Epic History of Art in America* (New York: Alfred A. Knopf, 1997), 127–30.

10. For his Englishness, see Milton W. Brown et al., *American Art: Painting, Sculpture, Architecture, Decorative Arts, Photography* (Englewood Cliffs, N.J.: Prentice-Hall, 1979; New York: Harry N. Abrams, 1979), 136, 139–40; for his Americanness, see Flexner, *Stuart*, 59, 94–95; Mount, *Stuart*, 289; and McLanathan, *Stuart*, 55. Barbara Novak also Americanized Stuart, but in a different way. Overlooking the degree to which he interpreted, she argued that he pursued a visual realism that, in its indistinctness, was more empirical than Copley's approach and even "proto-Impressionist" (see her *American Painting of the Nineteenth Century: Realism, Idealism, and the American Experience* [New York: Harper and Row, 1979], 33, 235–36). The quotation ("marvel") is from Mount, *Stuart*, 203. Similarly, in his study of Stuart's portraits of Washington, Gustavus A. Eisen found that the Vaughan portrait "possesses no trace of idealization" (see his *Portraits of Washington* [New York: R. Hamilton, 1932], 1:39).

Others have discussed these artists, as well as Charles Willson Peale and John Singleton Copley, as internationally oriented; see, for instance, Russel Blaine Nye, *The Cultural Life of the New Nation, 1776–1830* (New York: Harper, 1960), 278. For a convincing summation, closer to the period, see also the following account: "Looking back, we find the American school of painting in its first phase foreign and aristocratic in sentiment. . . . Their lineal successors are our academicians, whom fashion rules instead of the loftier feeling which animated the art of Stuart, Trumbull, and Allston" (James Jackson Jarves, *The Art-Idea* [1864; reprint, ed. Benjamin Rowland, Jr., Cambridge: Belknap Press, 1960], 202). At the end of the eighteenth century, the influential president of England's Royal Academy of Arts, we should remember, advised artists to address their work "to the people of every country and every age." See Reynolds, *Discourses*, 49.

11. For powers waning, see Whitley, *Stuart*, 207. For the opposite view, see Dunlap, *History*, 1:196, 209, 214–15, 222. This is also the opinion of Stuart's long-time friend Benjamin Waterhouse (Dunlap, *History*, 1:165). The quotation is from Elizabeth Hunter's letter of Mar. 18, 1825, to her mother, given in E. P. Richardson et al., *Gilbert Stuart: Portraitist of the Young Republic, 1755–1828*, exh. cat. (Providence: Museum of Art, Rhode Island School of Design, 1967), 106. A sculptor, John S. Cogdell, who had visited Stuart's studio in 1816 and again in 1825, wrote of his last visit: "I am as much nay more delighted with his work now than before—& his touch is so fine, delicate and natural that I am more enraptured with his work than I ever was before" (diary, vol. 4, entry for Sept. 19, 1825,

Joseph Downs Manuscript Collection, Henry Francis du Pont Winterthur Museum). Even Stuart, in the last years of his life, used to say, "If I could live and have my health, I could paint better pictures than I have ever done" (Mason, *Stuart*, 29).

12. Jouett's notes are published in Morgan, *Stuart;* the Waterhouse "Autobiography" and "Memoirs" are at the Harvard University Medical School; the diaries of Cogdell and Jonathan Mason are at the Henry Francis du Pont Winterthur Museum; the Holley report is at the University of Michigan; the G. C. Mason correspondence is at the Rhode Island Historical Society; and the Pickering "Interviews" are at the Pickering House, Salem, Massachusetts.

CHAPTER 1

1. For the story about the African slave, see the transcript of an unidentified article on Stuart in Newport's *Herald of the Times* for Feb. 7, 1839, Stuart file, Newport Historical Society, Newport, R.I.

2. See Waterhouse, "Autobiography," 10; and Waterhouse, "Memoirs," entry for Nov. 1839—both in the Francis A. Countway Library of Medicine, Harvard University Medical School, Boston.

3. See Dr. William Hunter's letter to Charles C. Bogart, July 22, 1811, papers of the American Academy of the Fine Arts, no. 17, New-York Historical Society, New York. Alexander's portrait of Dr. Hunter (Preservation Society of Newport County, Newport, R.I.) is signed and dated 1769, but Alexander was in Boston on Oct. 2, 1769, and, according to a letter, intended to leave soon. See Saunders in Richard H. Saunders and Ellen G. Miles, *American Colonial Portraits, 1700–1776*, exh. cat. (Washington, D.C.: Smithsonian Institution Press for the National Portrait Gallery, 1987), 299. Possibly Stuart's painting resembled *The Hunter Dogs* (fig. 103), a picture that Stuart painted probably in 1769 or 1770 of Dr. Hunter's two spaniels reclining under a table. For the quotations, see Waterhouse, "Autobiography," 10.

4. The chief sources of biographical information on Stuart's early life are his daughter Jane Stuart's article "The Youth of Gilbert Stuart," *Scribner's Monthly* 13, no. 5 (Mar. 1877): 640–46; and Waterhouse's remembrance in Dunlap, *History*, 1:161–95. The accounts differ slightly in that Jane Stuart claimed that her grandfather, a Jacobite, fled to Rhode Island after the defeat at Culloden; and Waterhouse said that Gilbert Stuart, Sr., was hired from Scotland by Dr. Moffatt. Waterhouse's account is probably closer to the truth, given that the elder Stuart did not arrive in America in 1746, as Jane stated, but, rather, in 1751 (see Donald Whyte, *A Dictionary of Scottish Emigrants to the U.S.A.* [Baltimore: Magna Carta Book Co., ca. 1972], 430). For Albro Anthony, see Mason, *Stuart*, 2. On the snuff shop, see William Dunlap, *Diary of William Dunlap* (New York: New-York Historical Society, 1931), 3:694.

5. For Knotchel, see Waterhouse, "Memoirs," entry for Aug. 24, 1842; Henry Pickering, "Interviews with Mr. Stuart in

1810 and 1817," entry for Oct. 29, 1817, at the Pickering House, Salem, Mass.; and Whitley, *Stuart*, 4. Following Jane Stuart ("Youth," 641), G. C. Mason (*Stuart*, 4) said that Stuart's schoolmaster at this grammar school was the Reverend George Bisset, the assistant minister at Trinity Church. Whitley, who knew of Knotchel from Waterhouse's 1805 published account of another childhood friend, argued convincingly that Stuart could have studied at the same school under both men. Stuart called it "a select Episcopal school founded . . . by some benevolent person" (Pickering, "Interviews," Oct. 29, 1817). George C. Mason mentioned the free tuition in his *Annals of Trinity Church, Newport, R.I., 1698–1821* (Newport: G. C. Mason, 1890), 28. That Stuart was given instruction by his mother is related in Mason, *Stuart*, 3, and in Jane Stuart, "Youth," 641. The quoted descriptions of Stuart are from Waterhouse in Dunlap, *History*, 1:165. On Stuart's love of music, see Dunlap, *History*, 1:168.

6. Waterhouse said that Alexander left with Stuart "after spending the summer in Rhode Island," traveling to South Carolina "and thence to Scotland" (Dunlap, *History*, 1:166). For the May 21, 1771, letter from William Aitchison in Norfolk to Charles Stuart in London, regarding Alexander, see microfilm reel M–68–2, Colonial Williamsburg File, Colonial Williamsburg, Williamsburg, Virginia. For further information on Alexander, see Pam McLellan Geddy, "Cosmo Alexander's Travels and Patrons in America," *Antiques* 112, no. 5 (Nov. 1977): 972–77; and G. L. M. Goodfellow, "Cosmo Alexander in America," *Art Quarterly* 26, no. 3 (Autumn 1963): 309–21. Dunlap (*History*, 1:169) mentioned Stuart's early familiarity with Norfolk, Virginia.

Incidentally, Charles Willson Peale, then the most prominent portrait painter in the middle colonies, remembered many years later that he had been asked to take a pupil in the 1770s and he thought that that pupil had been Stuart. Possibly the request came, at about this time, from Stuart's prosperous uncle, Joseph Anthony, whose sloop, *Peace and Plenty*, carried passengers and cargo between Philadelphia and Newport. Peale's mention of Stuart is in his unpaginated "Autobiography," pt. 1, wrapper 2, Peale-Sellers Papers, American Philosophical Society, Philadelphia. Alexander's date of death was first published in Whitley, *Stuart*, 8.

7. Jane Stuart, "Youth," 642; Anne Stuart in Updike, *History*, 1:289; Jouett in Morgan, *Stuart*, 87; Pickering, "Interviews," Oct. 29, 1817; Dunlap, *History*, 1:166, 177. Regarding matriculation, see letter to the author, June 3, 1988, from Michael S. Moss, University Archivist, University of Glasgow. See also David Daiches, *Glasgow* (London: Deutsch, 1977), 85, 90, for additional—in this case private—classes taught at the university. For Stuart's scholarly credentials when he first met him in 1780, see the opinion of the Harvard-educated Trumbull in Dunlap, *History*, 1:177. See the impression of Stuart as "well read" in Horace Holley's letter of Apr. 8, 1818, to Mary Austin Holley, in Holley, "Report." His "literary acquirements" are praised in Samuel L. Knapp, *American Biography, Form-*

ing Part VI of the Treasury of Knowledge and Library Reference (New York: Conner and Cooke, 1833), 325.

Charles Henry Hart was the first to connect Waterhouse's garbled reference to an untraceable "Sir George Chambers"—an error later copied by Jane Stuart—with Alexander's similarly named brother-in-law (see his *Browere's Life Masks of Great Americans* [New York: Doubleday and McClure, 1899], 82). Stuart may have lived at one time with Sir George Chalmers in St. Andrews Square, or at least near him; the artist mentioned repeatedly passing David Hume's house, which was also in St. Andrews Square, on his way to school in Edinburgh (see Una Pope-Hennessy, ed., *The Aristocratic Journey, Being the Outspoken Letters of Mrs. Basil Hall Written During a Fourteen Months' Sojourn in America, 1827–1828* [New York: G. P. Putnam's Sons, 1931], 94; and Peter Williamson, *Williamson's Directory for the City of Edinburgh . . . from the 25th May 1773, to 25th May 1774, Being the First Published* [1774; reprint, Edinburgh: W. Brown, 1889], 15, 35). Cosmo Alexander's will, recorded Aug. 15, 1772, does not mention Stuart but dictates that all his belongings be left to his sister, Lady Chalmers (RD 4/212/1, Scottish Record Office, Edinburgh). Stuart's father's plan is in Dunlap, *History*, 1:177; and is recorded by Anne Stuart in Updike, *History*, 254.

8. Jane Stuart is probably the closest to accurate in stating that her father did not remain in Glasgow more than two years ("Youth," 642); Jouett quoted Stuart, who often exaggerated to entertain his sitters and friends, as implying three years (Morgan, *Stuart*, 86–87); Pickering quoted Stuart as saying four years ("Interviews," Oct. 29, 1817). Jane Stuart mentioned several portraits painted in Glasgow ("Youth," 642); Whitley found a 1783 reference attributing to Stuart the claim that he had painted several portraits in Edinburgh (*Stuart*, 11). Stuart's presence in Newport is documented in John R. Bartlett, ed., *Census of the Inhabitants of the Colony of Rhode Island and Providence Plantations, 1774* (Baltimore: Genealogical Publishing, 1969), 30. For Waterhouse's comment, see Dunlap, *History*, 1:168, 167 (pp. in sequence cited).

There is considerable doubt about the survival of any early Newport portrait drawings by Stuart. One candidate is a somewhat smudged pastel drawing of a head, *Portrait of a Gentleman*, that was found without a provenance in 1921 at the Essex Institute in Salem, Massachusetts. Unfortunately, the inscription and date, "Stuart 1767," to the right of the head, could have been added later, and that fact would be nearly impossible to detect. There is no known documented work by Stuart like it, so there is little argument, at present, for assigning it to him. It is reproduced in Park, *Stuart*, 4:653.

In my discussion of Stuart's work completed before his trip to England, I include mention of all the portraits that are convincingly attributed to him with the exception of *Mrs. Aaron Lopez and Her Son Joshua* (Detroit Institute of Arts), which dates from 1773 or 1774. The painting is omitted only because it has been changed by overcleaning and cropping. Two portraits at the Redwood Library and Athenaeum in Newport—*Jacob Rodriguez Rivera*

(Mount, *Stuart,* 35; McLanathan, *Stuart,* 22) and *Abraham Redwood* (Mount, *Stuart,* 35)—appear in the most recent biographies as early works, but they are not convincing as by Stuart.

9. On Banister and his son, see Clifford K. Shipton, *Sibley's Harvard Graduates,* vol. 16 (Boston: Massachusetts Historical Society, 1972), 13–14. For more on Alexander's portrait, see Saunders in Saunders and Miles, *American Colonial Portraits,* 298–300. For another example of a long neck and sloping shoulders—almost as extreme— see a painting by Thomas Gainsborough, *The Hon. Mrs. Graham,* ca. 1775 (National Gallery of Art, Washington, D.C.). For more on the borrowing of fancy dress from prints, see Aileen Ribeiro's essay in Carrie Rebora et al., *John Singleton Copley in America,* exh. cat. (New York: Metropolitan Museum of Art, 1995), 107, 111. For an example of ermine in a portrait by Copley, see his pastel portrait of about 1771 of Mrs. Joseph Barrell (Rebora et al., *Copley,* 268). On the "hand-in" pose, see its identification with modesty in Arline Meyer, "Re-Dressing Classical Statuary: The Eighteenth-Century 'Hand-in-Waistcoat' Portrait," *Art Bulletin* 77, no. 1 (Mar. 1995): 53, and its more convincing connection with a broad notion of gentility, one that includes modesty, in Robin Simon, *The Portrait in Britain and America with a Biographical Dictionary of Portrait Painters, 1680–1914* (Oxford: Phaidon, 1987), 75.

An x-radiograph of the Banister double portrait, one of three taken for this study, exhibits the original position of the boy's arm. The spaniel, now covering it, is possibly meant to be a puppy or an English toy spaniel. Stuart seems to have struggled over this dog and to have once begun it differently, as indicated by a slightly confused area, particularly evident in a second x-radiograph, between the two figures and just above the dog.

The companion portrait of Banister (fig. 2), with stronger, even ruddy flesh coloring, is more sophisticated in the portrayal of the body. His coat, for example, casts a convincing shadow across the hand that is partially inserted into the waistcoat.

10. In Redwood's portrait, Stuart started to paint a fluted pilaster in the background, still visible in pentimenti at the upper left; he then converted it into a purplish gray curtain, possibly to convey the same elegance with more color.

11. Copley won recognition even abroad. Almost a decade earlier, in 1765 and 1767, he had sent two portraits to London to be entered, against the best of British competition, at the annual exhibition held by the Society of Artists of Great Britain, and, with much praise, he had been elected a fellow of the Society in 1766. See Rebora et al., *Copley,* 214–19, 238–40.

12. See Mather Brown's letter of Mar. 2, 1817, to Catherine and Mary Byles, Mather Brown Correspondence, Massachusetts Historical Society, Boston. Waterhouse is quoted in Dunlap, *History,* 1:169; the information was supplied for a catalogue when Waterhouse lent the portrait (see *Catalogue of an Exhibition of Portraits, Painted by the Late Gilbert Stuart, Esq.* [Boston: Eastburn, 1828], no. 161; and

Jules David Prown, *John Singleton Copley* [Cambridge: Harvard University Press for the National Gallery of Art, 1966], 1:93). Waterhouse had been apprenticed to a surgeon and is shown in the portrait with a book labeled, now almost illegibly, "——oerhaave," in reference to a famous author of medical textbooks, Hermann Boerhaave. Given that Stuart did not include a book title, he probably meant to associate Waterhouse with Boerhaave as a person and, by doing so, to compliment both his friend's intellect and his moral character. According to Samuel Johnson's 1739 essay "Life of Boerhaave," the great scientist led an exemplary life as an admired teacher and, in the face of adversity, a Christian Stoic. Johnson even likened him to Seneca and Cato (see *The Works of Samuel Johnson, LL.D., in Nine Volumes* [Oxford: Talboys and Wheeler, 1825], 6:290). This portrait has been confused with a missing second likeness, painted in London, that was described by Waterhouse in Dunlap, *History,* 1:172 (Richardson et al., *Stuart,* 42), and it has been cited unconvincingly as an English work of 1780 by Stuart (Mount, *Stuart,* 64).

13. For Copley, see Prown, *Copley,* 1:86; and Staiti in Rebora et al., *Copley,* 44–46. See Staiti also for the dwindling potential for portrait commissions as the threat of war increased (Rebora et al., *Copley,* 47). For the quotations, see Waterhouse, "Autobiography," 22–23.

14. Pickering, "Interviews," entry for Oct. 29, 1817 (quoted); and Jouett in Morgan, *Stuart,* 87. Another story of Stuart as a patriot is given without acknowledging the source, which may have been in Wilkins Updike's papers (Updike, *History,* 1:601). For Stuart's father and Nova Scotia, see A. W. H. Eaton, "Rhode Island Settlers on the French Lands in Nova Scotia in 1760 and 1761," *Americana* 10 (Jan. 1915): 41; and Whitley, *Stuart,* 13. William B. Stevens, Jr., found the record of Stuart's departure in *Newport Mercury* for Sept. 11, 1775, and Sept. 18, 1775, and published it in Richardson, *Stuart,* 11. Mount (*Stuart,* 334) wrongly concluded that Stuart visited Philadelphia before leaving for London. His evidence was the account book of Stuart's uncle, Joseph Anthony (Historical Society of Pennsylvania, Philadelphia), which mentions paying Stuart for portraits in July 1775. But had Mount been able to see the account book, he would have realized from other entries that Anthony had left Philadelphia and was visiting in Newport.

15. For more on West, see Helmut Von Erffa and Allen Staley, *The Paintings of Benjamin West* (New Haven: Yale University Press, 1986). Waterhouse ("Autobiography," 40) was struck, as were many other colonials, by the popularity of the American cause in London. He also spoke of Anthony's pride in "patronizing his ingenious nephew" and commissioning portraits from him (Dunlap, *History,* 1:167); but Samuel Miller (*A Brief Retrospect of the Eighteenth Century* [New York: T. and J. Swords, 1803], 1:411) went further, without citing a source, in saying that Anthony both patronized Stuart and "sent" him to England. For Stuart's lodging and audition, see Stuart, "Youth," 642; and Dunlap, *History,* 1:170–71. Jane Stuart ("Youth,"

643) mentioned the visits to concerts, but she was led by Dunlap's implication that the audition occurred in 1776 and stated it as a fact. As opposed to this, Herbert (*Irish Varieties,* 228–30) specifically remembered a story Stuart told that linked the audition to the time he began to work in West's studio. Whitley (*Stuart,* 74) identified the church in "Foster Lane" as St. Vedast. On Stuart's divided career preference, see Whitley, *Stuart,* 228–30; Jouett in Morgan, *Stuart,* 87; and Waterhouse in Dunlap, *History,* 1:168. John Trumbull mentioned the German flutist in Dunlap, *History,* 1:170.

16. For Stuart as strong willed, see Waterhouse, "Memoirs," entry for Mar. 5, 1839. For all other Waterhouse references, see Dunlap, *History,* 1:170, 167, 171 (pp. in sequence cited). Allston made almost an identical remark with regard to Stuart's aptitude (Dunlap, *History,* 1:222). The painting on the easel had been commissioned by Alexander Grant, a Scotsman to whom Stuart had brought letters (Dunlap, *History,* 1:170). Flexner (*Stuart,* 29) leaped to the conclusion—repeated by Mount (*Stuart,* 39) with the qualifier "probably"—that this was Sir Alexander Grant, one of Cosmo Alexander's former sitters, but Sir Alexander died in 1773 (letter of Jan. 13, 1987, to the author from George L. Campbell, Director, Old Lighthouse Museum, Stonington, Conn.).

17. Waterhouse stated that Curtis was among Stuart's early sitters, implying a date of 1776 (Dunlap, *History,* 1:172). Although the portrait is a characteristic work by Stuart, the identity of the artist has long been lost. See W. Hugh Curtis, *William Curtis, 1746–1799, Fellow of the Linnean Society, Botanist and Entomologist* (Winchester, England: Warren and Son, 1941), opp. 99, for identification of the portrait as by Joseph Wright of Derby. Sotheby's changed the attribution to "Circle of Joseph Wright of Derby" when the Royal Horticultural Society lent the painting to a Sotheby's London exhibition, *The Glory of the Garden,* in 1987 (cat. no. 121). The portrait belonged to Curtis's housemate and business partner, Dr. William Wavell, and descended to a relative of Wavell's, Col. Dene, who presented it to the society. See Curtis, *Curtis,* 19 and 23, where it is mentioned that Waterhouse's cousin and Stuart's near neighbor Nancy Freeman assisted Curtis with his book.

The Curtis portrait is probably not the first likeness that the artist painted in England. That distinction may well belong to a lost portrait of the English admiral Peter Rainier. The sitter's nephew claimed that his uncle's picture was the first when showing it to a Philadelphian who was familiar with Stuart's later work. The visiting American wrote of it: "It was a good strong likeness, but of course not in his best manner." See A. L. Elwyn's letters to Jane Stuart (Feb. 8, 1876) and to George C. Mason (Oct. 8, 1878), in "Letters Written to George Champlin Mason concerning Gilbert Stuart, 1876–1879," Rhode Island Historical Society, Providence; see also Mason, *Stuart,* 247. I was not able to trace the portrait among living (collateral) descendants of the sitter.

18. Concerning Stuart's rare signature, another instance may be the double portrait of the Malbone brothers (fig. 5), unusual in that it contains, on the sheet of paper, two overcleaned and upside-down inscriptions that might have been Stuart's monogram, followed by, on the opposite side of the page, "Newport" or "November." Whereas the modeling in the Curtis portrait seems to be more sophisticated, the Waterhouse portrait is slightly overcleaned in the shaded side of the face, so that we cannot be certain of the original appearance.

19. Dunlap, *History,* 1:172, 173; and letter from Gilbert Stuart to Benjamin West, Miscellaneous Manuscripts, New-York Historical Society. In the undated letter Stuart provided a basis for dating it: "I've just arrived at the age of 21." With regard to "blasted" hopes, it seems that Stuart thought he could teach himself, from other pictures, and be successful on his own. Stuart told Jouett that he "lived upon biscuit & music for a long time owing to the want of funds" (Morgan, *Stuart,* 87). Waterhouse claimed that he twice took Stuart "out of a sponging-house by paying the demands for which he was confined" (Dunlap, *History,* 1:172). John Trumbull remembered that when he met Stuart in 1780, the artist was still "wretchedly poor." He recalled that he once found Stuart lying in bed in a weakened state from having "eaten nothing in a week but a sea-biscuit" (Dunlap, *History,* 1:176).

Jane Stuart ("Youth," 642–43) said her father could never really forgive Waterhouse, although they remained friendly, for having known West and yet not having introduced Stuart to him. She believed that her father had gone to England solely in order to study under Benjamin West, but, from Stuart's recollections and the delay before the two met, it seems more likely that he intended to earn his living while learning, in general, from exposure to the art and artists of London.

20. Dunlap, *History,* 1:173; Jouett in Morgan, *Stuart,* 87; and Prown, *Copley,* 1:49. It has been suggested that Stuart actually lived with West, but this seems unlikely. One source of the probable error is the fact that Stuart's address, when he exhibited at the Royal Academy in 1779, appeared in the catalogue as "at Mr. West's, Newman Street," but it was not unheard of for West's students who lived elsewhere to use his address publicly. For mention of Brown and Trumbull, respectively, in this regard, see Dorinda Evans, *Mather Brown: Early American Artist in England* (Middletown, Conn.: Wesleyan University Press, 1982), 16; and Edward Basil Jupp, "Catalogues of The Royal Academy of Arts, Illustrated with Original Drawings, Autograph Letters, and Portraits," Royal Academy of Arts, London, vol. 3, the unpaginated indices to the 1784 and 1786 catalogues. Jane Stuart's belief that her father "became domesticated" with West in the summer of 1777 ("Youth," 64) is apparently based on a slightly distorted quotation from a 1779 catalogue that Henry Graves sent to her (see Mason, *Stuart,* 283); but Dunlap, who knew both Stuart and West, spoke specifically only of a "room for painting" that Stuart received "under his

master's roof" (*History,* 1:180). In a letter of June 18, 1771, West wrote to a Shrimpton Hutchinson that he objected to taking young gentlemen into his house "as students for a certain number of years" (see Guernsey Jones, ed., *Letters and Papers of John Singleton Copley and Henry Pelham, 1739–1776* [Boston: Massachusetts Historical Society, 1914], 71:118). Whitley (*Stuart,* 19) concluded that Stuart lived with West, whereas Mount (*Stuart,* 336) argued against it; but Whitley realized that there was a possible conflict, and his unpublished research for his book (Houghton Library, Harvard University, Cambridge, Mass.) can be used to support a counterargument. He found that *Kearsley's Pocket Register* for 1778 placed Stuart at 27 Villiers Street (Stuart's address in the 1777 Royal Academy exhibition catalogue), after he was supposed to have joined West.

21. For more on the connection between the sculpture and the drawing, see Dorinda Evans, "Gilbert Stuart: Two Recent Discoveries," *American Art Journal* 16, no. 3 (Summer 1984): 84–85. The most famous advocate of indistinct contours, bold shadows, and a method of shading to produce distance between the figure and the background was Leonardo da Vinci in *A Treatise on Painting,* trans. anon. (London: J. Senex, 1721), 89, 94, 110, 144, 146, 147. Stuart cited Leonardo as an authority, years later, to Matthew H. Jouett (Morgan, *Stuart,* 83). Reynolds (*Discourses,* 154) mentioned and thereby recommended the appropriate passage in Leonardo in discourse 8, delivered in 1778.

22. Herbert, *Irish Varieties,* 230; and Mason, *Stuart,* 71, quoting an 1806 reminiscence from Rembrandt Peale.

23. For West's criticism, inarticulateness, and advice, see Jouett in Morgan, *Stuart,* 84; and Allan Cunningham, *The Lives of the Most Eminent British Painters, Sculptors, and Architects* (London: J. Murray, 1830), 2:43. John Trumbull's transcription (1784) of West's comments on color is in Theodore Sizer, *The Works of Colonel John Trumbull* (New Haven: Yale University Press, 1950), 102–3. On West as "scientific," see the comments of several contemporaries in Dorinda Evans, *Benjamin West and His American Students,* exh. cat. (Washington, D.C.: Smithsonian Institution Press for the National Portrait Gallery, 1980), 22. For James Northcote's description of West, see Franziska Forster-Hahn, "The Sources of True Taste: Benjamin West's Instructions to a Young Painter for His Studies in Italy," *Journal of the Warburg and Courtauld Institutes* 30 (1967): 368n. Regarding Old Masters and West's desire not to impose his style, see Benjamin West, *A Discourse Delivered to the Students of the Royal Academy (Dec. 10, 1792) . . . To Which Is Prefixed the Speech of the President to the Royal Academicians (March 24, 1792)* (London: Thomas Cadell, 1793), 3, 11. West's fairly extensive collection of prints, drawings and paintings eventually, and possibly by this time, included works in oil by Rembrandt, Rubens, Van Dyck, Titian, Hals, Ribera, and Tintoretto, among other well-known artists (see *A Catalogue of the Truly Capital Collection of Italian, French, Flemish and Dutch Pictures Which Were Selected . . . During the Greater Part of the Last Half Century by Benjamin West, Esq., P.R.A., Deceased, the Late Venerable President of the Royal Academy,* Christie's, London, June 23–24, 1820).

24. See the third (1770) and the fourth (1771) discourses in Reynolds, *Discourses,* 50, 72; see also Pickering, "Interviews," entry for Oct. 29, 1817. For Dobson, see Malcolm Rogers, *William Dobson, 1611–46,* exh. cat. (London: National Portrait Gallery, 1983), 23. See Dunlap, *History,* 1:193n, for insights into Stuart's character.

25. Waterhouse is quoted in Charles Willson Peale's letter to Rembrandt Peale, Sept. 11, 1808, Letterbook 9, Peale-Sellers Papers, American Philosophical Society, Philadelphia; "Stuart's Gallery of Paintings," *Columbian Centinel,* Aug. 16, 1828, 1:2; and Dunlap, *History,* 1:208. Stuart was right-handed, as shown in Benjamin West's 1783 drawing *Mr. Stuart, Painting Mr. West's Portrait* (British Museum, London). The self-portrait is Stuart's only effort in this genre other than a small, unfinished oil sketch done for his wife (Metropolitan Museum of Art, New York) and a late pen-and-ink sketch that is now lost (Park, *Stuart,* 2:719–20). On the portrait as Stuart's only self-portrait, see the citation above of Charles Willson Peale's 1808 letter to Rembrandt Peale; and Pickering, "Interviews," entry for Oct. 29, 1817. The most frequent misidentification as a self-portrait has been a Stuart portrait of an unidentified man, with folded arms, at the Tate Gallery in London (frontispiece to Mount, *Stuart*). A copy of this portrait hangs at Stuart's birthplace in Saunderstown, Rhode Island.

26. Rubens's portrait was probably on public view at Buckingham House in London (Sir Oliver Millar's letter of May 16, 1978, to the author). The fact that Stuart is shown in a "Rubens-hat" is emphasized by Waterhouse (Dunlap, *History,* 1:177). A reverse inscription, now covered by relining, reads: "G. Stuart Pictor / se ipso pinxit A.D. 1778 / Aetatis suae 24 [*sic*]." Waterhouse probably added this inscription in Latin, years later, forgetting Stuart's birthdate at the time. The resemblance in Stuart's self-portrait was so strong that his student Thomas Sully observed that it was "like him to the latest period of his life" (see Sully, "Hints for Pictures, 1809–1871," 51, entry for Aug. 11, 1829, typescript, New York Public Library).

27. Reynolds, *Discourses,* 103, 107, 31, 103 (pp. in sequence cited). For more on Reynolds and the eclectic ideal, see Edgar Wind, *Hume and the Heroic Portrait: Studies in Eighteenth-Century Imagery,* ed. Jaynie Anderson (Oxford: Clarendon Press, 1986), 19–20. The larger context for Reynolds's viewpoint is discussed in Rudolf Wittkower, "Imitation, Eclecticism, and Genius," in *Aspects of the Eighteenth Century,* ed. Earl R. Wasserman (Baltimore: Johns Hopkins Press, 1965), 153–56. Reynolds's discourses were so important that Copley instructed Pelham, on Sept. 2, 1774, to buy them (Jones, *Letters,* 242). Reflecting the views of Anton Raphael Mengs, Reynolds, and others, West advised the portrait painter John Green in 1774 to "[fill his] mind with ideas from the works of the greatest ancient masters which are to be seen in England, to en-

able [him] to compose something for the Royal Academy exhibition" (Saunders and Miles, *Portraits*, 271). One of the clearest cases of West painting in competition with history is his combination of the "most excellent" parts of the Elgin marbles with figures of his own to create new compositions; in doing so, he followed, as he said, the example of Raphael and "most of the Italian artists of celebrity." "Is it not," he asked, "this combination of parts which comes the nearest to perfection in refined & ideal art?" (draft of West's letter of 1808 to Lord Elgin, MS 36, 297, fol. 33, British Library, London).

28. As Whitley (*Stuart*, 24–25) noted, the sitter is not necessarily James Ward (1769–1859), who later became an engraver and an animal painter. Reynolds, who painted some of his sitters in Vandyke dress, acknowledged in his seventh discourse (1776) that such costuming could be used to upgrade ordinary pictures by association with Van Dyck (Wark in Reynolds, *Discourses*, xxxiv). George Romney was another prominent London portrait painter, generally ranked at this time just after Reynolds and Gainsborough, whose brushwork loosened considerably during the years between 1775 and 1778. Stuart was sufficiently influenced in the long term by Gainsborough that when his student Thomas Sully first saw Gainsborough's work in 1809, he responded: "There is some resemblance to it in Stuart's manner, only that Stuart is firmer in the handling" (Sully, "Hints," 2, entry for July 21, 1809). Also inviting comparison is a portrait of Henry Herbert, first earl of Carnarvon (private collection), painted when he was Lord Porchester, because a 1795 engraving after it states that it was "painted by Gainsborough and Stuart" (see Park, *Stuart*, 1:202; Whitley, *Stuart*, 60–61; and Mount, *Stuart*, 339). Whether there is an underlying sketch by Gainsborough or not, the head, as it exists, appears to be by Stuart. The rest is not convincing as by either artist. Ellis K. Waterhouse, quoted by Mount (*Stuart*, 339) in agreement, argued plausibly that the portrait was completed by Gainsborough Dupont, the older artist's nephew.

29. On Stuart's work for West, see Dunlap, *History*, 1:174, 176, 184; and Jouett in Morgan, *Stuart*, 87. The most specific reference in these accounts is to Stuart copying West's portraits. Stuart told Dunlap that West would get a "good price" for one of Stuart's copies and then give Stuart only a guinea for it, but, nonetheless, he was grateful for the use of West's establishment and for West's instruction and support (Dunlap, *History*, 1:66). On Stuart's posing for West, see Jouett in Morgan, *Stuart*, 82; Stuart, "Youth," 644; and Mason, *Stuart*, 245. For *Christ Blessing* and *Moses Receiving the Laws*, see Mason, *Stuart*, 277. For *The Institution of the Order of the Garter*, see the 1787 account quoted by Whitley (*Stuart*, 64) from *Public Advertiser;* and Mason, *Stuart*, 277. See also Park, *Stuart*, 1:33; Mount, *Stuart*, 86, 363; and Von Erffa and Staley, *West*, 302–3, 344, where Mason's somewhat ambiguous assignment of the two biblical pictures to Stuart is followed. For examples of inaccuracies in Mason, note that he listed Mather Brown's portraits of Nathaniel Tracy

(Newburyport Public Library, Newburyport, Mass.) and William Tudor, Sr. (private collection), as by Stuart. One of the difficulties with the Moses painting is that it appears to be excerpted from a larger work (Palace of Westminster, London) by West of 1784, too late for Stuart. Stuart did copy this Moses as background for his portrait of Benjamin West (National Portrait Gallery, London) of about 1785, and his copy—in the spirit of West's original—is much more energetic than the St. Pancras version, making it unlikely that he painted the St. Pancras picture. Mount (*Stuart*, 57, 58) detected "the inimitable mark of Stuart's brush" in West's *St. Peter Denying Christ* (collection of Her Majesty Queen Elizabeth II) and five ceiling panels, showing the Graces Unveiling Nature and the Four Elements (Royal Academy of Arts, London), designed by West for Somerset House. Von Erffa and Staley (*West*, 358, 406) yielded to Mount's opinion on these paintings, partly on the basis of the St. Pancras pictures, but Stuart's mark is not "inimitable." On close inspection, there is nothing in either the ceiling or the painting that is particularly characteristic of Stuart.

30. Stuart, "Youth," 643. Stuart was never enrolled at the Royal Academy, but his daughter thought that he drew "during the evening in the life school." Whitley (*Stuart*, 20) is convincing in arguing that this was probably at West's. He cited as evidence Trumbull's story that West organized a drawing academy for them in the evenings (Dunlap, *History*, 1:176). For portrait painting in West's studio, see Dunlap, *History*, 1:180, 183, 184. For the instruction of Trumbull, see Dunlap, *History*, 1:169, 182. Stuart and West were in partnership in that Stuart would recommend West for history pictures, and West would recommend Stuart for portraits (see *St. James's Chronicle; or, British Evening Post*, May 2–4, 1782, 4). After Stuart's 1779 James Ward portrait, there is another gap in early works that can be dated precisely. His *John Park* (Museum of Fine Arts, Boston) bears an inscription on the reverse, written by the sitter's son or daughter, with a date (1780) that appears to be accurate because of the painting's style. For more information, see Thomas N. Maytham et al., *American Paintings in the Museum of Fine Arts, Boston* (Boston: Museum of Fine Arts, 1969), 1:241–42. Mount's suggestion (*Stuart*, 242) that the dog in the John Park portrait is by Trumbull is not convincing.

31. West's pose, looking upward over one shoulder, stems from the traditional way of representing the inspired evangelists as they write. For a scholarly discussion of this pose, see Mary D. Sheriff, *Fragonard: Art and Eroticism* (Chicago: University of Chicago Press, 1990), 157. The best sources for Stuart's contributions to the Royal Academy exhibitions are the exhibition catalogues that were annotated at the time by J. H. Anderdon and E. B. Jupp (Royal Academy of Arts, London) and Algernon Graves's compilation—*The Royal Academy of Arts: A Complete Dictionary of Contributors and Their Work from Its Foundation in 1769 to 1904* (London: H. Graves, 1906), 7:295–96—in which there is another attempt to identify sitters through newspaper commentary and Horace Walpole's notes. For

West's comments on the difficulty of imitating Stuart, see Dunlap, *History,* 1:178.

32. Dr. John Coakley Lettsom possessed a wax bust of Fothergill, probably from about 1773–74, by Patience Wright. An engraving after the bust (which no longer exists) appears as the frontispiece to Lettsom's *Memoirs of John Fothergill, M.D. [etc.]* (London: C. Dilly, 1786), showing a portrait that is similar to Stuart's. On the missing bust, see Charles Coleman Sellers, *Patience Wright, American Artist and Spy in George III's London* (Middletown, Conn.: Wesleyan University Press, 1976), 228–29. In the mezzotint after the portrait, engraved by Valentine Green, the text is more clearly botanical, including the illustration of a plant. The anonymously and humorously written publication *The Ear-wig; or, An Old Woman's Remarks on the Present Exhibition of Pictures of the Royal Academy* (London: G. Kearsley, 1781) does not mention the West portrait. This source and *St. James's Chronicle* are quoted in Whitley, *Stuart,* 27–28.

33. On Stuart's return to the exhibition, see Dunlap, *History,* 1:180, where the portrait of West is inaccurately called a full-length view. The story of Stuart's copy is in Dunlap, *History,* 1:178–79.

CHAPTER 2

1. See Trumbull, quoted in Dunlap, *History,* 1:177. The portrait mentioned may be the one that Stuart began just after Trumbull's release from prison (a painting that Trumbull finished), in which case it would be the picture from 1781 now owned by the Pilgrim Society in Plymouth, Massachusetts. The circumstances of the portrait are stated in John Trumbull's letter of Mar. 14, 1840, to James Thacher, James Thacher Collection, Plymouth Archives, Pilgrim Society, Plymouth, Massachusetts. Reynolds's views are expressed in notes to Charles Alphonse Du Fresnoy, *The Art of Painting,* trans. William Mason (1783; reprint, New York: Arno Press, 1969), 112. Earlier, Reynolds (*Discourses,* 171) made a similar statement in discourse 9 of 1780: "The art which we profess has beauty for its object; this it is our business to discover and to express."

2. On the novelty of the pose, see a letter and newspaper excerpt quoted in Whitley, *Stuart,* 33. See also Dunlap, *History,* 1:183. Stuart avoided painting full-length figures presumably because of the increased difficulty (see Dunlap, *History,* 1:168, 172), but his *Henrietta Elizabeth Frederica Vane* (Smith College Museum of Art, Northampton, Mass.), of about 1783, is another early instance. On Stuart's stories, see Dunlap, *History,* 1:193, 210. Stuart exaggerated the attention that this picture received and, in doing so, stressed its strength as a likeness. For example, he claimed that Grant was not only recognized but also pursued by a crowd when he attended the exhibition (Dunlap, *History,* 1:184).

3. Jouett in Morgan, *Stuart,* 87.

4. Roger de Piles, *The Art of Painting, with the Lives and Characters of Above 300 of the Most Eminent Painters,* trans. anon.

(London: Thomas Payne [1754?]), 34; William Hogarth, *The Analysis of Beauty: Written with the View of Fixing the Fluctuating Ideas of Taste* (London: William Hogarth, 1753), 97; Francesco Algarotti, *An Essay on Painting, Written in Italian,* trans. anon. (London: L. Davis and C. Reymers, 1764), 52; William Gilpin, *An Essay upon Prints: Containing Remarks upon the Principles of Picturesque Beauty* (London: J. Robson, 1768), 16, 17; and Sir Isaac Newton, *Opticks; or, A Treatise of the Reflections, Refractions, Inflections and Colours of Light* (1704; reprint, London: W. Innys, 1730), 110–11, 259.

For the color organ and also mention of synesthesia, see James T. Boulton's introduction to Edmund Burke, *A Philosophical Enquiry into the Origin of Our Ideas of the Sublime and Beautiful* (Oxford: Basil Blackwell, 1987), xxiv. On Reynolds's discourse, see Reynolds, *Discourses,* 61–62. West, too, but later than Reynolds, in a letter of about 1787, urged a student to think of harmony in color just as in music (Forster-Hahn, "Sources of True Taste," 379). For Gainsborough, see Thomas Gainsborough, *The Letters of Thomas Gainsborough,* ed. Mary Woodall (Greenwich, Conn.: New York Graphic Society, 1963; n.p.: Cupid Press, 1963), 15, 109. On the ways in which knowledge of music may have affected Gainsborough's painting, see Jack Lindsay, *Thomas Gainsborough: His Life and Art* (New York: Universe Books, 1981), 76–77. An influential painter, whom Stuart knew, connected "happy dashes," or visible penciling, with a "musical felicity" (see James Barry, *The Works of James Barry, Esq., Historical Painter* [London: T. Cadell and W. Davies, 1809], 1:389); and this same association is made in a 1785 review, where Reynolds's "penciling" is described as "well in tune" (*Morning Herald,* Apr. 28, 1785, 2). For Stuart's mention of connections between an artist and a musician, see Jouett in Morgan, *Stuart,* 82; and Pickering, "Interviews," entry for Oct. 20, 1817. See Walter Jackson Bate, *From Classic to Romantic: Premises of Taste in Eighteenth-Century England* (Cambridge: Harvard University Press, 1946), 149, for synesthesia in England as the "progeny" of British associationism.

5. Jouett in Morgan, *Stuart,* 83. See John S. Cogdell's "Diary," vol. 3, entry for Sept. 18, 1816, Joseph Downs Manuscript Collection, Henry Francis du Pont Winterthur Museum. Stuart could have been concentrating on these instruments at about the time that he played the church organ. According to Herbert, he could play on every instrument when he met West (Herbert, *Irish Varieties,* 229). See also Newton, *Opticks,* 110, fig. 4.

6. On *The Skater* as a display of ability, see Marvin Sadik's likely hypothesis that it may well be more than a coincidence that Stuart, in his first major full-length work, chose as his theme the mastery of a difficult art with aplomb (Michael Quick, Marvin Sadik, and William H. Gerdts, *American Portraiture in the Grand Manner, 1720–1920,* exh. cat. [Los Angeles: Los Angeles County Museum of Art, 1981], 22). For confirmation that the pose was Stuart's idea, see Dunlap, *History,* 1:183. For the "fifth-button" accusation, see the quotation in Whitley, *Stuart,* 33. For the linking of West, Copley, and Stuart as shifting into

greater naturalism, see Charles Coleman Sellers's review of Mount's biography of Stuart in *Pennsylvania Magazine of History and Biography* 88, no. 3 (July 1964): 374. As Whitley documented, the skating theme was apparently unprecedented at the Academy and perhaps unheard of in a large portrait (*Stuart*, 32–33). About two years later, however, Sir Henry Raeburn painted *The Rev. Robert Walker Skating* (National Gallery of Scotland, Edinburgh), his subject dressed in a nearly identical black outfit with arms crossed in the same skating pose, seen sideways. For Stuart's account of his success, see Whitley, *Stuart*, 31. The newspaper quotation is from *Morning Chronicle, and London Advertiser,* May 9, 1782, 2.

7. On *The Skater,* see a 1782 letter cited in Whitley, *Stuart,* 32–33. See also Jonathan Richardson, *The Works* (1773; reprint, Hildesheim: G. Olms, 1969), 100; Reynolds's discourse 4 (1771) in his *Discourses,* 72; and Johann Joachim Winckelmann, *Reflections on the Painting and Sculpture of the Greeks . . . ,* trans. Henry Fusseli [*sic*] (London: A. Millar, 1765), 32. For the newspaper quotation of "spirited" and "appropriate" character, see Whitley, *Stuart,* 33. See *Morning Herald and Daily Advertiser,* April 28, 1784, 2, on erect posture as the most dignified pose; and William Hazlitt, "On the Look of a Gentleman," *London Magazine* 3, no. 13 (Jan. 1821): 39, for dignity, grace, and "habitual self-possession" as the identifying characteristics of a gentleman. See also James Usher, *Clio; or, A Discourse on Taste* (1769; reprint, New York: Garland Publishing, 1970), 73: "From what I have said it appears that a sense of elegance is a sense of dignity, of virtue, and innocence united." For serenity as an expression of virtue, see Hogarth, *Analysis,* 131; and James Ward, *Conversations of James Northcote, R.A., with James Ward on Art and Artists,* ed. Ernest Fletcher (London: Methuen, 1901), 125. Intellect and virtue were also equated, as in Samuel Johnson's statement: "He who thinks reasonably must think morally" (quoted in Bate, *From Classic to Romantic,* 4–5). For dignity, gracefulness, and complacency as expressions of virtue, see also contemporary manuals on the proper deportment of a gentleman, such as Thomas Hunter, *Reflections Critical and Moral on the Letters of the Late Earl of Chesterfield* (1777; reprint, Boston: J. Boyle, 1780), 114, 120.

8. The man of feeling or sensibility—understood to be virtuous—received special promotion through the popularity of Henry Mackenzie's much-reissued novel *The Man of Feeling* (1771; reprint, New York: Garland Publishing, 1974). He is first described therein (vi) as whimsical and as "a grave, oddish kind of man." Coincidentally, both Mackenzie and Grant were Scottish lawyers. See Desmond Shawe-Taylor, *The Georgians: Eighteenth-Century Portraiture and Society* (London: Barrie and Jenkins, 1990), chap. 4, which is devoted to the painted representation of the type. The pose of Grant's upper body is the characteristic posture of an experienced skater—particularly in the guise of a dignified gentleman—and does not appear to refer to melancholia, as has been argued. For this interpretation, see William L. Pressly, "Gilbert Stuart's *The Skater:* An Essay in Romantic Melancholy," *American Art Journal* 18, no. 1 (1986): 46–50. For Grant's "wide-awake" hat and frock suit as fashionable in their black coloration (rather than indicative of melancholy), see Aileen Ribeiro, *The Art of Dress: Fashion in England and France, 1750 to 1820* (New Haven: Yale University Press, 1995), 49–50. Another interpretation of *The Skater* is that it is an allegory of Winter. For this, see Jules D. Prown, *American Painting: From Its Beginnings to the Armory Show* (Geneva: Skira, 1987), 43. The precedent in this case would have been Reynolds's full-length picture *Lady Caroline Scott as Winter* (collection of the duke of Buccleuch and Queensberry), probably exhibited in 1777, which fairly typically makes the allusion clear in the title. Stuart, however, spoke strongly later, as he probably would have then, against obscure references in portraits (Jouett in Morgan, *Stuart,* 84). Grant's legs have produced some discussion, but the conclusions—that they derive from Reynolds's *Miss Emily Pott as Thaïs* (Pressly, *"The Skater,"* 44) or from the Apollo Belvedere (Mount, *Stuart,* 70)—are not visually convincing. They do not copy either prototype, and they could more easily have been done from life, not necessarily from the sitter. For the history of the painting and what little is known about Grant, see Ellen G. Miles et al., *American Paintings of the Eighteenth Century* (Washington, D.C.: National Gallery of Art, 1995), 162–69.

9. For examples of commentary on resemblance, see *Gazetteer and New Daily Advertiser,* May 3, 1782, 3; *Morning Post and Daily Advertiser,* May 9, 1785, 3; an unidentified clipping dated July 16, 1786, in "Press Cuttings from English Newspapers on Matters of Artistic Interest, 1686–1835," vol. 1, 288, Library of the Victoria and Albert Museum, London; and an unidentified clipping dated 1789, in "Newspaper Cuttings, Fine Arts, 1731–1811," vol. 1, 58, Witt Library, Courtauld Institute of Art, London. See also Whitley, *Stuart,* 30, 53, 55; and Dunlap, *History,* 1:184. The quotations regarding the portrait of a Swede are from Whitley, *Stuart,* 31. One commentator in Whitley called it "a strong likeness," adding enigmatically: "If we are not mistaken[,] the original would not like to carry the copy of himself to Stockholm," perhaps because it shows him taking snuff. The portrait of Springer has not always been attributed to Stuart, but, stylistically, it is clearly by him. On Temple Franklin, see John Hill Morgan in Park, *Stuart,* 1:37. The rest of Franklin's letter concerning West explains "nails" as "by which he meant I believe to express, not only the resemblance of the person was perfect, but that his colouring did not change[,] a fault common to some of the first painters in this country, & particularly to Sir Joshua."

10. For the Whitefoord portrait, see *Gazetteer and New Daily Advertiser,* May 3, 1782, 3. Stuart's work exhibited with the short-lived Incorporated Society is listed in Algernon Graves, *The Society of Artists of Great Britain, 1760–1791; The Free Society of Artists, 1761–1783: A Complete Dictionary of Contributors and Their Work from the Foundation of the Societies to 1791* (1907; reprint, Bath: Kingsmead, 1969), 245. See Flexner, *Stuart,* 77, on Stuart's compromising his chances of joining the Academy.

11. On flesh color, see Piles, *Art of Painting*, 261; Hogarth, *Analysis*, 122; Gilpin, *Essay upon Prints*, 42; and especially Algarotti, *Essay*, 58–59. On the advice overheard in West's studio and its repetition, see Dunlap, *History*, 1:185. The "about 1786" date appears here, but, in Dunlap's earlier "Biographical Sketch" of Stuart for *Euterpeiad*, he gave "1784 or 1785." Stuart's comments undoubtedly reflect his awareness of the frequent criticism of West's flesh in the public press, as, for instance, in *St. James's Chronicle*, May 5, 1781, [p. 2], where it is described as "muddy."

12. Stuart, "Youth," 643. The Royal Academy's ceiling is discussed and illustrated in Nicholas Penny, ed., *Reynolds*, exh. cat. (London: Royal Academy of Arts in Association with Weidenfeld and Nicolson, 1986), 284. See Reynolds, *Discourses*, 30, 45, 113, 238–39, 278 (for the improved-nature theme) and 224 (for seeing nature). See also Reynolds's published annotations to Du Fresnoy, *Art of Painting*, 116; and Dunlap, *History*, 1:184. For the comment on "imaginary beauty," see Jouett in Morgan, *Stuart*, 87. Stuart's criticisms of Reynolds, aside from the above, appear in Dunlap, *History*, 1:217; and in Jouett in Morgan, *Stuart*, 83. In the last instance, he referred disdainfully to Reynolds's notorious use of additives, such as wax and—in this case—megilp, in an attempt to enrich his colors. Jane Stuart ("Youth," 643) mentioned her father admiring the portraits painted by George Romney "as being exceedingly beautiful and more true to nature than any others he had ever seen," presumably meaning among his English contemporaries. See Anthony Pasquin's review of a 1794 exhibition in his *Memoirs of the Royal Academicians; Being an Attempt to Improve the National Taste* (London: H. D. Symonds, 1796), 17.

13. On abstraction, see David Morgan, "The Rise and Fall of Abstraction in Eighteenth-Century Art Theory," *Eighteenth-Century Studies* 27, no. 3 (Spring 1994): 458, 460–61, where he traces the opposition of general and particular ideas from John Locke to Reynolds. See also discourse 3 (1770) in Reynolds, *Discourses*, 44–45, 50, 52. As for Reynolds's portraits not resembling sitters, see Sir Thomas Lawrence's comment in David Piper, *The English Face*, ed. Malcolm Rogers (London: National Portrait Gallery, 1992), 151. The press criticized portraits by Reynolds for "too much flattery," as in *Public Advertiser*, May 10, 1783, [p. 2]. Another version of this complaint is in John Britton, ed., *The Fine Arts of the English School* (London: Longman, Hurst, Rees, Orme, and Brown, 1812), 47: "In [Reynolds's] attempts to give character where it did not exist, he has sometimes lost likeness." On the evocation of old pictures, see M. Kirby Talley, Jr., in Penny, *Reynolds*, 55, 56, 67.

14. For an account of Stuart's visit to Reynolds's studio, see Stuart, "Youth," 643. X-radiographs of the portrait of Siddons, taken in 1994 for the Huntington Art Gallery, show her head unchanged and a lower foreground figure removed in the final painting. Stuart's suggestion, at his return visit, that Reynolds should have used another canvas implies overwork. His objection could, however, have been to the unnecessary complication of the additional foreground figure, since removed but visible in the x-radiograph. For more on *Sarah Siddons*, see David Mannings in Penny, *Reynolds*, 324–25. See also *Sarah Siddons* discussed as transcendent in Richard Wendorf, *The Elements of Life: Biography and Portrait-Painting in Stuart and Georgian England* (Oxford: Clarendon Press, 1990; New York: Oxford University Press, 1990), 245; and as having a general "nostalgic" association in Ronald Paulson, *Emblem and Expression: Meaning in English Art of the Eighteenth Century* (Cambridge: Harvard University Press, 1975), 85. For *Sarah Siddons* as a form of history painting, see Shearer West, "Thomas Lawrence's 'Half-History' Portraits and the Politics of Theatre," *Art History* 14, no. 2 (June 1991): 229.

15. Reynolds, *Discourses*, 88, 52. See Shawe-Taylor, *Georgians*, 149, for classical drapery mistakenly seen as obligatory in the type; elsewhere (p. 29) he recognized that certain portraits were considered "honorary history painting." The term *historical portrait* changed in its application as history painting changed; West's raising of a contemporary event to the status of history painting in his *Death of General Wolfe*, after all, had included contemporary portraits. During the 1780s the historical portrait most often appeared as a full-length portrait of a uniformed male flanked by a battle scene, so that the two genres were conjoined through foreground and background. In such cases, the sitter's character is portrayed in action—he is psychologically involved in the scene and is shown in an attitude of command—and the picture commemorates a specific event. (An example is given in a 1788 newspaper description using the term *historical portrait;* see Evans, *Brown*, 81.) In describing the mingling of genres Reynolds inspired, his student James Northcote said later, perhaps in the 1820s: "Portrait often runs into history, and history into portrait, without our knowing it. . . . If a portrait has force, it will do for history." Northcote is quoted in William Hazlitt, *The Complete Works of William Hazlitt*, ed. P. P. Howe (London: J. M. Dent and Sons, 1932), 2:193–94.

16. For the male and female stereotypes in *Gell* and *Gordon* as showing virtues in the sitter, see Shawe-Taylor, *Georgians*, 41, 133–34, 144. Pasquin (*Memoirs*, 44) reflected a public bias in stating that artists should acquire knowledge of "the enforcement of masculine or feminine beauty." For female beauty as indicative of virtue, see, for instance, Joseph Bartlett, *Physiognomy: A Poem* (Boston: John Russell, 1799), 14.

17. Hoppner's review is in *Morning Post and Daily Advertiser*, May 9, 1785, 3. For Stuart's coldness of expression, in general, see also the exhibition review in *Morning Post and Daily Advertiser*, May 7, 1785, 2; and the letter to exhibitors, signed "Fresnoy," in *Morning Post and Daily Advertiser*, June 3, 1785, 3. For poverty in the figure and background, see the review in *Universal Daily Register*, May 7, 1785, 2. For the dangers of being facile, see *St. James's Chronicle* for May 25–27, 1783 (Whitley, *Stuart*, 38).

18. Reynolds's recommendation of Stuart, having sat to him, is repeated in Anne Robinson's letter of Dec. 31, 1784, to her brother, Lord Grantham, in Morley Papers, vol. 1,

fol. 67v, Bedfordshire Record Office, Bedford, England. Charles Fraser reported hearsay, from probably at least twenty years later (which in light of this letter is less convincing), that Reynolds did not like Stuart's portrait of himself (Dunlap, *History*, 1:184).

19. For a list of the fifteen completed portraits, and historical praise of them as strong likenesses, see Whitley, *Stuart*, 55. Stuart said he began the Boydell series with his portraits of Reynolds and West. When he finished them he began a portrait of the history painter James Barry, but after sitting once to Stuart, Barry refused to pose further because he had discovered that he was not the first of the artists to be painted (see Pickering, "Interviews," Nov. 17, 1810). The final fifteen do not include Barry. For a reconstruction of Copley's picture frame, see Eileen Harris, "Robert Adam's Ornaments for Alderman Boydell's Picture Frames," *Furniture History: The Journal of the Furniture History Society* 26 (1990): 93–98. For the disparaging review, see *Monthly Magazine; or British Register* 17, no. 6 (July 1, 1804), 595. Boydell showed Stuart's half-length portraits again as a group as part of his Shakespeare Gallery in 1790 (see "Newspaper Cuttings, Fine Arts, 1731–1811," vol. 1, 73, Witt Library, Courtauld Institute of Art, London). They probably remained in this exhibition until it closed in 1803 (Winifred H. Friedman, *Boydell's Shakespeare Gallery* [New York: Garland Publishing, 1976], 214). On separation of art from commerce, see Shawe-Taylor, *Georgians*, 8.

20. Reynolds's four sittings with Stuart (July 23, 28, 30; Aug. 27) were recorded in the subject's pocket ledger for 1784 (Royal Academy of Arts, London). On Reynolds's unassuming manner, see Oliver Goldsmith in Britton, *Fine Arts*, 50; Pasquin, *Memoirs*, 70; and Fanny Burney in Penny, *Reynolds*, 340. For Reynolds's wish to appear this way, see Ward, *Northcote*, 85. On the range in use of the snuffbox, see Hugh McCausland, *Snuff and Snuff-Boxes* (London: Batchworth Press, 1951), 51. On condescension as a virtue, see Shawe-Taylor, *Georgians*, 71. Stuart's snuff taking is well known from Dunlap, *History*, 1:213. Susan Rather's argument that the portrait contains criticism of Reynolds and refers—curiously, by lack of reference—to his deafness is not persuasive, especially because of Reynolds's subsequent praise of Stuart. (See her "Stuart and Reynolds: A Portrait of Challenge," *Eighteenth-Century Studies* 27, no. 1 [Fall 1993], 61–84.) She also assumes jealousy on the part of both Stuart and Reynolds, which runs counter to the evidence (for commentary on Stuart as never an envious or jealous person, see Dunlap, *History*, 1:220, 223; for Stuart's statement that Reynolds was never envious, see Pickering, "Interviews," Nov. 17, 1810). Wendorf also discusses the portrait, seeing in it "a reserve, a cautiousness, even an iciness" that was characteristic of Reynolds (see his *Sir Joshua Reynolds: The Painter in Society* [Cambridge: Harvard University Press, 1996], 41). The unidentified scrolls could be general references to Reynolds's doctorate of civil law from the University of Oxford and George III's recent warrant appointing him to the position of Painter in Ordinary to the King.

21. I have reidentified the portrait of Facius, as to sitter, on the basis of an 1819 engraving after it, which was published by Boydell's successor firm, Hurst, Robinson and Co. Its previous identification, in perhaps a confused association with Boydell, was *Portrait of an Alderman*. I am indebted to David Alexander of York, England, for identifying the shown portion of the Nativity scene. An engraving by Richard Earlom of the entire window is reproduced in Penny, *Reynolds*, 32.

22. See, for instance, Philip Dormer Stanhope, Earl of Chesterfield, *The Letters of the Earl of Chesterfield to His Son*, ed. Charles Strachey, with notes by Annette Calthrop (London: Methuen, 1901), 1:353, on "a degree of seriousness in looks" as necessary for the desirable effect of dignity in an aristocrat. This advice, given in the mid-eighteenth century and published in 1771, still held true. On the decorous, blank expression, see Nadia Tscherny, "Beyond Likeness: Late Eighteenth Century British Portraiture and Origins of Romanticism" (Ph.D. diss., New York University, 1986), 35. See also Reynolds (*Discourses*, 78) on ways in which the expression of emotion distorts the beauty of a face. Alexander Cozens (*Principles of Beauty Relative to the Human Head* [London: James Dixwell, 1778]) used variations on one classical profile to show how the expression of typed character, such as the haughty or the melancholy, might be integrated with the expression of beauty, dignity, and tranquility, with the result that the profile hardly varied at all. On Stuart's striving for a tempered smile later, in his Boston work, see George G. Channing, *Early Recollections of Newport, R.I., from the Year 1793 to 1811* (Newport: A. J. Ward and Charles E. Hammett, Jr., 1868), 219.

23. For a discussion of John Bell's publication of this edition of Shakespeare's plays, see Shearer West, *The Image of the Actor: Verbal and Visual Representation in the Age of Garrick and Kemble* (London: Printer Publishers, 1991), 54.

24. For Henderson's one sitting while he was ill, see the note in the 1785 R.A. catalogue, n.p., in J. H. Anderdon's bound volume of clippings, notes, and catalogues, "Royal Academy, III, 1783–1790," British Museum, London. See also William Shakespeare, *The Dramatick Writings of Will. Shakspere; with Notes of All the Various Commentators: Printed Complete from the Best Editions of Sam. Johnson and Geo. Steevens* (London: John Bell, British Library, 1786–88), 20 vols., variously bound. The engravings after Stuart are all by J. Thornthwaite and dated: Iago, November 24, 1785; Posthumus, Feb. 28, 1786; Richard III, May 10, 1786; and Faulconbridge, June 4, 1786. For Henderson's fame in the role and the linking of Stuart's portrait to Bell's engraving, see Geoffrey Ashton, *Catalogue of Paintings at the Theatre Museum* (London: Victoria and Albert Museum in Association with the Society for Theatre Research, 1992), 19. The later engraving by Francesco Bartolozzi is dated Feb. 18, 1786.

25. Pope's portrait, along with that of Holman, entered Bell's collection of portraits, which was sold by Leigh and S. Sotheby on May 25, 1805, while Bell was still alive, the two pictures being paired in lot 258 as by Stuart (see Bur-

ton B. Fredericksen, ed., *The Index of Paintings Sold in the British Isles During the Nineteenth Century* [Santa Barbara: ABC-CLIO, ca. 1988–93], 1:709). For Brown, see Dunlap, *History*, 1:228.

26. For discussion of Kemble as Henderson's rival, see *Dictionary of National Biography*, 1967–68, vol. 10, 1261. The quotation is from act 4, scene 2. For observations on malignant eyes, see Francis Jeffrey's essay on beauty in *Encyclopaedia Britannica; or, A Dictionary of Arts, Sciences, and Miscellaneous Literature* (Edinburgh: Archibald Constable, 1817), 3:497.

27. For the portraits of Kemble and Siddons as companions, see *Times*, Oct. 24, 1787, 3. Stuart's portrait of Kemble as Macbeth, described as a "marvelously exact" head, is mentioned in *Morning Chronicle*, Feb. 16, 1786, 3:2. Whitley (*Stuart*, 53) found Stuart's *Macbeth and the Witches*, with Kemble in the role of Macbeth, in an 1802 sale of Noel Desenfans's collection. The catalogue entry says that the painting was commissioned by Kemble's friend Sir Charles Hotham. If this is correct, then Stuart did not plan to have the picture bought by Boydell as part of the Shakespeare Gallery, as Mount (*Stuart*, 110–11) stated. There seem to have been two pictures (locations unknown), one a head and the other a larger portrait that included the witches. Jane Stuart ("Youth," 644) described this larger version as a "sketch" of Macbeth meeting the witches, which Stuart often mentioned proudly. I have not been able to trace either painting.

James Boaden reported that Stuart painted a portrait of Kemble as Orestes in the scene with the furies, adding: "It is a head, and conveys the incipient madness with perfect identity of expression." (See James Boaden, *Memoirs of the Life of John Philip Kemble, Esq., Including a History of the Stage, from the Time of Garrick to the Present Period* [London: Longman, Hurst, Rees, Orme, Brown and Green, 1825], 1:23). This could be a mistaken reference to the *Richard III* portrait, but that shows Kemble wearing a partly concealed Star of the Order of the Garter. Furthermore, Boaden remembered the Orestes as belonging to Kemble's friend the Reverend C. Este, which does not fit the other provenance. Possibly Boaden saw one of the several copies after Stuart's *Richard III*, some of which do not include the detail of the badge. *Richard III* is more finished than the other heads Stuart executed for Bell, and it may not have been painted originally for him. The picture belonged to John Pybus, according to an engraving of it published on Jan. 1, 1788, by Boydell. For depictions of women and nature combined, as references to the woman's sensibility, see Shawe-Taylor, *Georgians*, 127–45. The first quotation on the portrait of Siddons is in *World*, Apr. 18, 1787, 3; the second is in *Times*, Oct. 24, 1787, 3.

28. For Burke as an influence on Stuart, see Stuart, "Youth," 643. Reynolds's *Sarah Siddons* was praised for its "sublime effect" in *Morning Post, and Daily Advertiser*, May 5, 1784, 3. On the sublime, see Richardson, *Works*, 124. See also Samuel H. Monk, *The Sublime: A Study of Critical Theories in Eighteenth-Century England* (Ann Arbor: University of

Michigan Press, 1962), 10; and Burke, *Philosophical Enquiry*, 40, 59, 82, 72, 80.

29. On Stuart's friendship with Kemble, see Herbert, *Irish Varieties*, 238.

CHAPTER 3

1. See *Monthly Magazine, or British Register* 24, no. 12 (Jan. 1, 1808): 585. Stuart's career-long use of a mirror and his recommendation of it as "one's best instructor" is reported by Jouett in Morgan, *Stuart*, 90–91. The use of a life mask may not be as unusual as it first seems. For instance, when an engraver commissioned Sir Thomas Lawrence, in 1825, to paint a portrait of a prominent lawyer as the basis for an engraving, he required Lawrence to have a life mask made to ensure accuracy. Lawrence, as the patron apparently knew, was known for flattering inaccuracy (see John Hayes, *The Portrait in British Art: Masterpieces Bought with the Help of the National Art Collections Fund*, exh. cat. [London: National Portrait Gallery, 1991], 128). See also the quotation (in Whitley, *Stuart*, 92) from Sarah Jay's letter of Nov. 15, 1794, to John Jay: Stuart delivered his picture and "insisted on my promising it should be destroyed when he presented me with a better one, which he said he certainly would if you would be so obliging as to have a mask made for him" (letter [present location unknown] from the Jay Papers, Columbia University). As in this case, Stuart could use a mask to paint additional portraits of a sitter who had once sat for him.

2. Eliza Quincy's account is in Mason, *Stuart*, 243. Jane Stuart (letter of Feb. 17, 1835, to Theophilus Parsons) apologized for having lost Stuart's 1813 cast of Chief Justice Theophilus Parsons's face, which was found among some other casts after Stuart's death (Miscellaneous Papers, Boston Public Library).

3. The duke's ledger for 1783–85 (Alnwick Castle, Northumberland) contains payments to Stuart on Apr. 22, 1785 ("in part for my picture") and on June 29, 1785 ("for the 2nd picture," which is unidentified and appears to be the second portrait). The first payment is for ten pounds and the second, presumably in full, is for twenty pounds. The duke of Northumberland, who had been adopted by the Mohawks when serving in the Revolutionary War, probably commissioned the one known portrait of Brant that is definitely by Stuart (fig. 37). Another portrait of Brant (New York State Historical Association, Cooperstown) and what is apparently a replica of this version (British Museum, London) have been mistakenly reproduced as by Stuart because of a misattribution of the New York portrait to Stuart in Park, *Stuart*, 2:746. The flesh color in these two likenesses is quite different from the duke's portrait of Brant—one reason that the works are not believable as also by Stuart. For the full-length view of the duke as in process, see *World*, June 14, 1787, 3. The admirer, Alexander Davison, had the portrait engraved by Charles Turner. The print, which shows the

addition of frontal shoulders and minor changes in the uniform, is probably based on this second bust portrait rather than a third version (for which no evidence exists).

4. *World*, Apr. 18, 1787, 3.

5. See Samuel Johnson, *A Dictionary of the English Language* (London: J. and P. Knapton, 1755), 2:n.p., for "mind" as used interchangeably with "soul." Mind is here more connected with "the intelligent power," the soul with "giving life." See Shawe-Taylor, *Georgians*, 28, for critics' claims that an artist had represented the sitter's soul, mind, or feelings in order to separate that artist's accomplishment from the mere copying of a face. For a larger perspective, see Joanna Woodall's discussion (in *Portraiture: Facing the Subject* [Manchester: Manchester University Press, 1997], 10, 16) of the increasingly dualist (mind-body) view of portraiture in the late eighteenth century. Joining others, she is persuasive in arguing that the renewed emphasis on interior status can be attributed to the rising power of the middle class. On "mental qualities" that might admirably be shown in the face, see Henry Home, Lord Kames, *Elements of Criticism* (Boston: J. White, Thomas and Andrews, W. Spotswood, D. West, W. P. Blake, E. Larkin, and J. West, 1796), 1:288. For Siddons, see *Public Advertiser*, Apr. 28, 1784, 2. See also "Review of the Third Annual Exhibition of the Columbian Society of Artists and Pennsylvania Academy," *Federal Gazette and Baltimore Daily Advertiser*, June 18, 1813, 4.

6. See *General Evening Post*, Apr. 24–27, 1784, 4. For Stuart on taste, see Dunlap, *History*, 1:199. See also Richardson, *Works*, 100. On character in Reynolds's portraits, see Robert E. Moore, "Reynolds and the Art of Characterization," in *Studies in Criticism and Aesthetics, 1660–1800: Essays in Honor of Samuel Holt Monk*, ed. Howard Anderson and John S. Shea (Minneapolis: University of Minnesota Press, 1967), 342; and Diana Donald, "'Characters and Caricatures,' The Satirical View" in Penny, *Reynolds*, 357. For a different point of view—one that is less well supported by the visual evidence—that Reynolds, in a portrait of a close friend, tried to represent divided character in other than allegorical terms, see Wendorf, *Elements*, 250, 259. Reynolds himself (*Discourses*, 790) urged a harmonious treatment of character, observing in discourse 5 that "art has its boundaries." For Stuart's thinking in typological terms with regard to portraits, see Jouett in Morgan, *Stuart*, 82; and Stuart's poem in *Port Folio*, June 18, 1803, 1. Stuart typically painted an integrated ensemble subordinated to one theme such as "nobleman."

7. On Van Dyck, see n. 4 above and Piles, *Art of Painting*, 268–69. For Stuart's likenesses as too correct, see *General Advertiser*, Apr. 13, 1786, 3. See also the article on an engraving after Stuart's missing full-length portrait of Northumberland in *Monthly Magazine, or British Register* (Feb. 1, 1805), 68, where Stuart's correctness is mentioned and the likeness criticized for depicting such a long nose: "That [Stuart] wanted taste, he has proved in this portrait." On the comparison to Old Masters, see Stuart quoted in *Monthly Magazine*, May 1, 1804, 386. Stuart's reaction is fairly close to a passage in Daniel Webb,

An Inquiry into the Beauties of Painting; and into the Merits of the Most Celebrated Painters, Ancient and Modern (London: R. and J. Dodsley, 1760), 133, which he may have read. On dignity, see Jouett in Morgan, *Stuart*, 89.

8. Stuart's London addresses are given in Graves, *Royal Academy*, 295–96; and Graves, *Society of Artists*, 245. See also Sophie von La Roche, *Sophie in London, 1786; Being the Diary of Sophie von La Roche*, trans. and ed. Clare Williams (London: J. Cape, 1933), 151, 153–54. Stuart seems never again to have lived in such luxury. As Mount (*Stuart*, 340n) found, the elevations of his drawing room, with architect identified, appear in London County Council, *Survey of London*, vol. 32: *The Parish of St. James Westminster* (London: Athlone Press for the London County Council, 1963), 2:492 and pl. 110. According to the rate books, Stuart lived there from 1784 to 1786 (Westminster City Archives Department, London). See the discussion of a courtier-artist tradition in David Andrew Brenneman, "The Critical Response to Thomas Gainsborough's Painting: A Study of the Contemporary Perception and Materiality of Gainsborough's Art" (Ph.D. diss., Brown University, 1995), 113, 115.

9. The student clothes and the flute playing are described in Dunlap, *History*, 1:175 and 169 (pp. in sequence cited). His improved clothes are described in Stuart, "Youth," 644–45. The story of her parents, how they met, and the objection to the match are in Stuart, "Youth," 644, 643 (pp. in sequence cited); the account of her mother, aside from her voice, is in Stuart, "Anecdotes," 379. The "well bred gentleman," confirming Jane's description, is from Allston's account in Dunlap, *History*, 1:222. According to John Neal, Stuart had the "bearing of one who might stand before kings." (See his *Observations on American Art: Selections from the Writings of John Neal (1793–1876)*, ed. Howard Edward Dickson [State College: Pennsylvania State College, 1943], 69.) I have not found corroboration of Jane's statement that her maternal grandfather was a "Dr. Coates of Reading," if this is interpreted as meaning that he was a physician. Consulting the London archive of the Royal College of Surgeons of England, I could not verify the statements that Mount (*Stuart*, 336) made with regard to Charlotte's father and brother as surgeons. There is no Thomas Coates listed as a member of the Royal College of Surgeons on its founding in 1800; nor is there any record of a physician with the Coates name (phonetically or otherwise) in either London or Reading and its vicinity. There was, however, an apothecary called William Coates living in Reading in 1747, and a "Mr. Coates" (also an apothecary) who lived in London in the 1780s may have been his son. See *Henry's Reading Journal; or Weekly Review*, Dec. 21, 1747, 3; and the listing in J. Johnson, ed., *The Medical Register for the Year 1783* (London: Joseph Johnson, 1783), n.p. Many apothecaries at this time practiced medicine as family doctors. For more on the subject, see W. S. C. Copeman, *The Worshipful Society of Apothecaries of London: A History, 1617–1967* (Oxford: Pergamon Press, 1967), 52.

10. Dunlap, *History*, 1:192n, 193, 162 (pp. in sequence cited).

See also Dunlap's entry on Stuart in James Herring and James B. Longacre, *The National Portrait Gallery of Distinguished Americans . . .* (Philadelphia: Henry Perkins, 1835), 1:8. On Dunlap's biased writing, see Joseph J. Ellis, *After the Revolution: Profiles of Early American Culture* (New York: Norton, 1979), 117, 125.

11. John F. Watson, *Annals of Philadelphia and Pennsylvania in the Olden Time* (Philadelphia: Whiting and Thomas, 1857), 2:65.

12. On the marriage, see Stuart, "Youth," 644; on the teasing, see her "Anecdotes," 379. According to her obituary, Charlotte was seventy-seven when she died, which agrees with Jane's account (*Newport Mercury,* Oct. 11, 1845, 3). Like my predecessors, I have not been able to find a public record of Stuart's marriage. Jane Stuart stated that her parents were married by a Reverend Springate. This could be Nathaniel Springett, the son and grandson of clerics from Bradfield, a village near Reading, in Berkshire. He received a B.A. degree from Oxford in 1751. (See Joseph Foster, *Alumni Oxonienses: The Members of the University of Oxford, 1715–1886 . . .* [Oxford: Parker, 1888], 3–4:1337.) Mount (*Stuart,* 217, 224, 245, 248), without evidence, belittled Stuart's wife as commonplace, tedious, and antagonistic. He also elaborated on their "angry years of marriage" and on an affair between the artist and one of his sitters—both claims that are undocumented. For Charlotte's protection, see Robert Gilmor's entry for July 27 in his "Memorandums Made in a Tour to the Eastern States in the Year 1797," Miscellaneous Papers, Boston Public Library; Sarah A. Cunningham's letter of Aug. 5–12, 1825, to her daughter Griselda, Morton-Cunningham-Clinch Family Papers, 1754–1903, Massachusetts Historical Society, Boston; and Dunlap, *History,* 1:219. On his wife's defense of his reputation and belief in his superiority, see Waterhouse in Andrew Oliver, *Portraits of John Quincy Adams and His Wife* (Cambridge: Belknap Press of Harvard University Press, 1970), 125–26. For "Tom," see Dunlap, *History,* 1:215. Stuart kept a journal later, in Philadelphia, in which, as a form of self-blame, he frequently noted: "Quarreled with Tom" (location of journal unknown; Dunlap, *Diary,* 3:674). On the telling of stories, see Stuart, "Anecdotes," 379. See also Pickering, "Interviews," Nov. 4, 1817.

13. The quotations are from Mason, *Stuart,* 30, except for the passage about musicians and Stuart taking part (being able to play several instruments), which is in Stuart, "Youth," 644–45. Details of the French cook and entertaining are in Herbert, *Irish Varieties,* 237. Stuart's trips to sponging houses, for debt, occurred at least three times in the late 1770s (Dunlap, *History,* 1:172) and probably intermittently in at least 1786 and 1787. Despite Sir Thomas Lawrence's mention of Stuart as having been imprisoned before leaving London (Whitley, *Stuart,* 67), Stuart does not appear in surviving London prison records (Mount, *Stuart,* 342); sponging-house records were not preserved. For a period description of sponging houses as an extortionist racket and of the related bribing of bailiffs, see Francis Place, *The Autobiography of Francis Place,* ed. Mary Thale (Cambridge: Cambridge University Press, 1972), 24–25, 31.

14. As Whitley (*Stuart,* 66–67) noted, the erroneous stories about Stuart's departure in the press, which he quoted, may have been planted by Stuart himself. Reynolds's correspondence with Rutland is in *Letters of Sir Joshua Reynolds,* ed. Frederick Whiley Hilles (Cambridge: Cambridge University Press, 1929), 151, 176. Whitley (*Stuart,* 69) also concluded that Reynolds probably arranged for Stuart's invitation to Dublin. For the duke's scheme and Pack, see Anthony Pasquin, *An Authentic History of the Professors of Painting, Sculpture, and Architecture, Who Have Practised in Ireland; Involving . . . Memoirs of the Royal Academicians* (1797; reprint, London: Cornmarket Press, 1970), 53, 55.

15. The date of Stuart's arrival is fixed approximately by Herbert (*Irish Varieties,* 227), who mentioned his attendance at an annual Saint Luke's Day celebration shortly afterward. Jane Stuart ("Youth," 645) placed his arrival about a month later, but she is less likely to be accurate in this detail. She linked it to the duke's funeral, which Stuart probably emphasized in the retelling. After Stuart's first departure, another period of speculation ensued in the London press about his whereabouts, perhaps indicating that he had returned then. See *Times,* Jan. 8, 1788, 2, for Stuart as having gone to France; a clipping dated Jan. 1788 for Stuart not having left, as expected, for America and for Stuart as having a "disturbed brain" ("Press Cuttings from English Newspapers on Matters of Artistic Interest, 1686–1835," vol. 2, 415, Library of the Victoria and Albert Museum); and *World,* Mar. 21, 1788, for Stuart as having gone from Dublin to Paris and now America. See Whitley (*Stuart,* 77) for mention of Stuart's April 1788 return to London in *World.* Stuart's father died in 1794 without a will and with such debts that the family lost their land (see the documents for an intestacy, Probate District of the County of Halifax, Law Courts, Halifax, Nova Scotia; and F. E. Crowell's scrapbook of newspaper clippings, "New Englanders in Nova Scotia," 36–37, New England Historic and Genealogical Society, Boston).

16. On Stuart in Dublin, see Herbert, *Irish Varieties,* 246, 226, 234, 233 (pp. in sequence cited). Stuart could veer strangely between arrogance and humility. See, for instance, the account of him as humble in Cogdell's "Diary," vol. 3, entry for Sept. 13, 1816. Regarding Irish politics and Gilbert Stuart, the central thesis in Hugh R. Crean's *Gilbert Stuart and the Politics of Fine Arts Patronage in Ireland, 1787–1793: A Social and Cultural Study* (Ann Arbor: University Microfilms International, 1991) is that Stuart so aligned himself with the Protestant Ascendancy that he deliberately restricted his clientele to Anglicans alone. This is not believable, particularly since Stuart let his close friendship with a devout Catholic, John Kemble, be known by publicly entertaining him in Ireland (Stuart, "Youth," 645; Mason, *Stuart,* 209). As Crean himself (*Stuart,* 247) admitted, he did not know the religion of all— and probably not even most—of Stuart's Irish sitters. Stuart, for instance, painted an unidentified jailor and his

wife (Herbert, *Irish Varieties*, 247). Clearly his patrons were determined by economic class—and necessarily so—which meant that in Ireland the Protestants would predominate. For the politics of Stuart's patrons as not interfering with his friendship with them, see the case of Thomas Jefferson in Pickering, "Interviews," Nov. 4, 1817.

17. Whitley (*Stuart*, 83) recorded a 1789 Dublin newspaper account of Stuart as excelling in his "delicacy of colouring and graceful attitudes" and as painting portraits in groups while preserving a strong resemblance.

18. Mount (*Stuart*, 345) was wrong in assuming that an eighteenth-century artist would not readily visit the estates of clients. The stereotyping seen in the Barker portraits is discussed in Ann Bermingham, "Elegant Females and Gentlemen Connoisseurs: The Commerce in Culture and Self-Image in Eighteenth-Century England," in *The Consumption of Culture, 1600–1800: Image, Object, Text*, ed. Ann Bermingham and John Brewer (London: Routledge, 1995), 489–513.

19. On flattery, see Herbert, *Irish Varieties*, 233–34; and Dunlap, *History*, 1:220–21. Regarding dogs, see Dunlap, *History*, 1:207; and Stuart, "Anecdotes," 380. Stuart's statement, undated and as given in Dunlap, concerns an increase in portrait painters: "By-and-by you will not by chance kick your foot against a dog-kennel, but out will start a portrait-painter." Jane Stuart's version has Stuart say: "Sir, there are few artists in America now, but fifty years hence you will not be able to kick a dog-kennel but out will start a portrait painter." The patron's reaction is not known; unfortunately, the family papers in the possession of the present earl of Westmeath provide no mention of Stuart (Lord Westmeath's letter to the author, Oct. 27, 1992). The picture can be considered a sensibility portrait gone amiss in that it includes the elaborate hat and protective handkerchief. For an illustration of the sensibility type, involving an immersion in nature, see Shawe-Taylor, *Georgians*, fig. 44. Pressly (*"The Skater,"* 51n) also regarded Stuart as identifying with the "fawning spaniel" in this portrait.

20. Herbert, *Irish Varieties*, 232, 237, 242–43, 245, 247. On a preference for individuals of talent, see also Samuel L. Knapp, *Lectures on American Literature, with Remarks on Some Passages of American History* (New York: Elam Bliss, 1829), 197. Stuart's disdain for superiority claimed on the basis of mere ancestry is corroborated by his choice of a quote from Thomas Overbury's *Characters*, concerning the resemblance between aristocrats and potatoes, in a later conversation with Margaret Manigault (see her diary, entry for Mar. 15, 1794, Hagley Museum and Library, Wilmington, Del.). On Irish parties, see Stuart, "Youth," 644. On the ridiculous, see her "Anecdotes," 378; and Dunlap, *History*, 1:193n, where the author also mentioned Stuart's desire to play the hero's role in the retelling of his exploits. For Marshalsea, see *Times*, Aug. 25, 1789, 2. Stuart seems to have referred to this incident when he spoke of "[painting] myself out of jail" (Herbert, *Irish Varieties*, 247). Dunlap (*History*, 1:194) gave a longer account of the incident and added the likelihood that, af-

ter enjoying the joke, he probably finished the pictures. The relevant Marshalsea Prison records were, unfortunately, destroyed in 1922, as were many records from the Public Record Office of Ireland that might have been helpful with regard to Stuart.

Concerning Stuart's indebtedness and his move from Dublin to nearby Stillorgan (Herbert, *Irish Varieties*, 243), Mount (*Stuart*, 140) suggested that he came under the "protection" of Lord Carysfort and thus moved to the part of Stillorgan that formed Carysfort's estate. His evidence consists of a "lease" of property between Carysfort and one Richard Sinclair, whom Mount considered a fictitious stand-in for Stuart or someone who "sublet to Stuart in an unrecorded transaction." The document at issue is actually not a lease but, rather, a deed terminating a mortgage (Memorial Reference Book 419, page 276, no. 273932, Registry of Deeds, King's Inn, Dublin). Since the authorities did not require that deeds of lease be registered, there was no reason, in any case, for Stuart to disguise his identity. The leap to the conclusion of protection is a wild one; Stuart could easily have lived in another part of Stillorgan. Jane Stuart ("Youth," 645) mentioned his living at Stillorgan Park, the residence of the Lord Chancellor, Lord Lifford. Either the artist leased a small dwelling on this property, or Jane, as Whitley (*Stuart*, 71) plausibly concluded, had her reference confused.

21. Herbert, *Irish Varieties*, 232–34; and Stuart, "Anecdotes," 379.

22. For Irish admiration of Washington and sympathy for Americans as "a brave and injured people," see William Spohn Baker, *Character Portraits of Washington As Delineated by Historians, Orators and Divines* (Philadelphia: R. M. Lindsay, 1887), 36. On the Irish struggle for greater independence, see T. W. Moody, F. X. Martin, and F. J. Byrne, eds., *A New History of Ireland* (Oxford: Clarendon Press, 1986), vol. 4, chap. 10. See also Herbert, *Irish Varieties*, 248. For Washington and the request of the Whigs, see Knapp, *Lectures*, 194. On Northumberland, see *Dictionary of National Biography* (1967–68), 15:866. Other prominent Whigs who commissioned portraits from Stuart included the marquis of Lansdowne and Baron Rawdon of Rawdon (both portraits [locations unknown] mentioned in *World*, Apr. 18, 1787, 3). Jonathan Mason, who knew Stuart during Stuart's Boston years, wrote a brief remembrance of the artist that gives support—although somewhat garbled—to Knapp's account. In his "Recollections of an Octogenarian" (manuscript in the possession of Peter H. Sellers, Philadelphia), he stated that Stuart returned to the United States at the suggestion of Alexander Baring and his brother to paint a portrait of Washington for William Bingham (later Alexander Baring's father-in-law). The head of the Baring Brothers banking firm, Francis Baring (Alexander's father), was a Whig politician and close friend to Lord Lansdowne, at the center of the Whig party, who later commissioned the Lansdowne portrait of Washington (fig. 53) from Stuart.

On Lansdowne, Bingham, and Baring, see Robert C.

Alberts, *The Golden Voyage: The Life and Times of William Bingham, 1752–1804* (Boston: Houghton-Mifflin, 1969), 135. On West and Trumbull, see Jules D. Prown in Helen A. Cooper, ed. *John Trumbull: The Hand and Spirit of a Painter,* exh. cat. (New Haven: Yale University Art Gallery, 1982), 29–31. See the unidentified press clipping in "Press Cuttings from English Newspapers on Matters of Artistic Interest, 1686–1835," vol. 2, 321, hand-dated "1787," Library of the Victoria and Albert Museum, London.

23. For Brown's view, see the transcript of his letter of Aug. 22, 1817, to Catherine and Mary Byles, Mather Brown Correspondence, Massachusetts Historical Society, Boston. For Trumbull's story of the pawned portraits, see Horace Holley's letter of Apr. 8, 1818, to Mary Austin Holley, in Holley, "Report." That Trumbull's completed portrait is one of these is implied by the above and also by Mason's story of the unfinished portrait's discovery, probably in 1794 (Mason, *Stuart,* 207). See also Herbert, *Irish Varieties,* 248. Stuart had been commissioned in 1783 to paint two portraits: an original for John Jay (Department of State, Washington, D.C.) and a copy (location unknown) for Jay's friend William Bingham. For mention of the commission, see John Jay's letter to Stuart of Feb. 22, 1784, Joseph Downs Manuscript Collection, Henry Francis du Pont Winterthur Museum.

24. According to Jane Stuart ("Youth," 645), her father first planned to return to England, "having made a positive engagement to do so," but then he decided to go directly to the United States. Stuart's intention, the circus, and Jay are in Pickering, "Interviews," Oct. 29, 1817. Undoubtedly France's declaration of war on England on Feb. 1, 1793, played a role in the timing of Stuart's departure. Walter G. Strickland first published the date of departure—Mar. 19, 1793—in his *Dictionary of Irish Artists* (London: Maunsel, 1913), 2:410–11. Mount (*Stuart,* 165) traced his ship's arrival on May 6, 1793.

The number of children with Stuart at this point is unknown; he eventually had twelve, about whom—with the exception of the four daughters who survived him—little can be discovered. A son, Charles Gilbert Stuart, and Jane Stuart both became artists (see Anne Stuart in Updike, *History,* 1:291). Jay's letter of introduction is in Dunlap, *History,* 1:196; and Jane Stuart, "The Stuart Portraits of Washington," *Scribner's Monthly* 12, no. 3 (July 1876), 369. Having begun his New York stay perhaps to earn money and add to his painting reputation, Stuart may have tarried further because of the yellow fever epidemic in Philadelphia during the late summer and fall of 1793; aside from being a deterrent in itself, the disease outbreak interrupted stagecoach transportation into the city (see Philadelphia's *Weekly Museum,* Oct. 26, 1793, 3).

25. The first known owner of *Dogs and Woodcock* was a New Yorker, John Q. Jones, who was born in 1803. For Jones, see Park, *Stuart,* 1:291; and *History of the Chemical Bank, 1823–1913* (New York: [Chemical Bank and Trust Company], 1913), 87. Park's date of ca. 1820 must be influenced by the owner's age, but the style is improbable for that time. The picture could be based partially on a sport-

ing print, but all attempts to locate a specific source have failed; thus the painting is arguably an entirely original work generally influenced by the genre. For Stuart's Newport competition, see chap. 1, n. 3. On Stuart's reputation and Trumbull, see Gabriel Manigault's letter of Apr. 18, 1794 (typescript on loan at Charleston Museum, S.C.; and Mount, *Stuart,* 176). The London review, titled "Shakespeare Exhibition" and hand-dated 1790, is in "Newspaper Cuttings, Fine Arts, 1731–1811," vol. 1, 73, Witt Library, Courtauld Institute of Art, London.

26. For Stuart's criticism of chiaroscuro, see Jouett in Morgan, *Stuart,* 81–82. Stuart used a similar effect in his bust portrait of Albert Gallatin (Metropolitan Museum of Art, New York), of about 1803, in which the head is spotlit, but, in this case, there is an inconsistently illuminated hand, holding a piece of paper, at the bottom of the picture. For Reynolds, see Penny, *Reynolds,* 180; for Ramsay, and for the significance of a ray of light in a portrait, see Desmond Shawe-Taylor, *Genial Company: The Theme of Genius in Eighteenth-Century British Portraiture,* exh. cat. (Nottingham, England: Nottingham University Art Gallery, 1987), 44–45, 50–52. On Trumbull, see his portrait of John Adams discussed by Oswald R. Roque in Cooper, *Trumbull,* 124.

27. On Stuart and her portrait, see Margaret Manigault's diary entries for Mar. 15, Mar. 22, and June 3, 1794, at the Hagley Museum and Library, Wilmington, Del.

28. On Johnson's portrait, see Dunlap, *History,* 1:202. To make a flesh comparison with his late Irish portraits, we might consider the somewhat similarly posed hands in the portraits of Mrs. Yates and Lady Barker. Although the hands generally resemble each other in coloring, there is noticeably more color suggested beneath the surface in Mrs. Yates's hand, and the hand also appears more individualized. On Reynolds's method, see Pasquin, *Authentic History,* 71. Dunlap's praise of Stuart (*History,* 1:195–96) is qualified by the opinion that "Stuart's portraits were incomparably better, ten, twenty, and thirty years after." In this period of stylistic self-consciousness, it is worth noting that Dunlap (*History,* 1:125) approved of an "appropriate variation of style," which he saw in West's work. Reynolds also liked the use of more than one style (see Wark in Reynolds, *Discourses,* xxxiii).

29. For Stuart's comparison, see "American Painters," *American Quarterly Review* 17, no. 33 (Mar. 1835): 177. Given that this publication was based in Philadelphia, Stuart probably made the remark there. The criticism of Northumberland's nose (cited in n. 7) appeared in a British article that was republished in *Port Folio* (May 25, 1805): 156. See also the anonymous British writer of "Remarks on the Fine Arts," *Monthly Anthology; or Magazine of Polite Literature* 1, no. 2 (Dec. 1803): 52.

30. Thomas Sully is quoted on Gibbs's portrait as alive in Dunlap, *History,* 1:215.

CHAPTER 4

1. See Shawe-Taylor, *Georgians,* 29, on portraits that qualify as "honorary history painting," especially Reynolds's *Sarah Siddons as the Tragic Muse,* and his conclusion that such pictures succeed by deserting portraiture. Stuart's effort —by this gauge, deserting history—provides a marked contrast. See also West, "'Half-History' Portraits," 246, quoting Benjamin West on Lawrence: "'Do not confound his pictures with mere portraits: painted as they are, they cease to be portraits in the ordinary sense; they rise to the dignity of history, and like similar works of Titian and Vandyke, they may be said to be painted not alone for friends and admirers in the present day, but rather for posterity.'" Martin Postle adds to this discussion a chapter devoted to ambiguity in the category of the historical portrait; see his first chapter in *Sir Joshua Reynolds: The Subject Pictures* (Cambridge: Cambridge University Press, 1995). For the "moral ideal," see Tuckerman, *Book of the Artists,* 115.

2. For Stuart's planned departure for Philadelphia in ten days, see Sarah Jay's letter to John Jay of Nov. 15, 1794, John Jay Papers, Columbia University. For "winter season," see a certificate of 1823 (National Register of Archives, Edinburgh) appended to a short note from Washington to Stuart dated Apr. 11, 1796. Concerning a sitting the next day, it reads: "In looking over my papers to find one that had the signature of Geo. Washington, I found this, asking me when he should sit for his portrait, which is now owned by Samuel Williams of London [Lansdowne portrait]. I have thought it proper it should be his especially as he owns the only original painting I ever made of Washington except one I own myself. I painted a third but rubbed it out. I now present [this to his] brother, Timo. Williams, for sd Samuel. Gt. Stuart. Boston 9th day March 1823. Attest. I. P. Davis, W. Dutton, L. Baldwin. N.B. Mr. Stuart painted in ye *winter season* his first portrait of Washington, but destroyed it. The next portrait was ye one now owned by S. Williams; the third Mr. S. now has—two only remain as above stated. T. W."

The order in which the pictures are mentioned in the above certificate, as well as the fact that the Athenaeum portrait remained unfinished, is probably the reason Jane Stuart ("Stuart Portraits," 370) mistakenly thought the Athenaeum portrait came after the Lansdowne portrait. Rembrandt Peale, in a letter of May 7 (year unknown) addressed "Dear Sir," gave the correct order and repeated it in other accounts (Robert Graham Autograph Collection, Archives of American Art, Smithsonian Institution, Washington, D.C.). The winter season must refer to 1794–95 rather than 1795–96 because Stuart made a list, dated April 20, 1795, of thirty-two men who wanted replicas of the first portrait (published in Mason, *Stuart,* 87–88; present location of MS unknown). The only counterindication to a late-winter date for the first portrait is Rembrandt Peale's memory that Washington sat to Stuart for this picture between sittings for the Peales, which appears to have been in late October of 1795 (see Peale's

advertisement, *South Carolina State Gazette,* Dec. 3, 1795, 3), but Stuart remembered that after he painted Washington "the first time, Peele [*sic;* the father] was very uneasy until the General sat to him. After some importunities, General Washington consented to sit" (Pickering, "Interviews," Oct. 29, 1817). That Washington should have to be importuned suggests a first sitting—an occasion on which Charles Willson Peale and his son Rembrandt tried to produce at least one portrait that could compete with Stuart's, and Rembrandt Peale carried on the competition with Stuart years later. After Stuart's death, Rembrandt condensed the competing sittings, in retelling the story, possibly because the competition with Stuart became so inflated in retrospect. See Rembrandt Peale's reminiscence in a letter of Mar. 16, 1846, to Charles Edwards Lester, Charles Henry Hart Collection, Archives of American Art, Smithsonian Institution, Washington, D.C. All epistolary sources for the Peale family cited in this book can be found in Lillian B. Miller, ed., *The Collected Papers of Charles Willson Peale and His Family,* National Portrait Gallery, Smithsonian Institution, Washington, D.C., Millwood, N.Y.: Kraus-Thomson Organization, 1980), microfiche.

3. This portrait was purchased by John Vaughan of Philadelphia for his father (in London), Samuel Vaughan, after whom it is named. See Rembrandt Peale's letter addressed "Dear Sir" cited in n. 2. Peale saw the original Vaughan-type portrait when it was exhibited at City Hall, Philadelphia, in 1796 (Rembrandt Peale, "Lecture on Washington and His Portraits," Charles Roberts Autograph Letters Collection, Haverford College, Haverford, Pa.). For the 1833 publication, see "Original Portraits of Washington," *Putnam's Monthly Magazine* 6, no. 34 (Oct. 1855): 346. On Stuart's difficulty, see Dunlap, *History,* 1:197–98. An x-radiograph of the Vaughan portrait shows a rather erratic aureole around the head that does not appear on the surface of the painting as it likely would if it were meant as an initial background. It also does not continue along the side of the face but, rather, stops opposite the mouth. What we are seeing could well be a thin smear of residue from a rubbing out, which in parts was probably total. The part of the aureole that is visible in the x-radiograph along the right side of Washington's face is beneath a fairly bright, brick red color that overlaps Washington's hair and continues beyond the smear to below Washington's chin. Irrespective of the oddity of this thin aureole, the Vaughan portrait is convincing as the first of its type. Although Stuart did not usually alter his work, preferring instead to rub it out and begin anew (Herbert, *Irish Varieties,* 234), the x-radiograph shows a partially changed hairline, and, when compared with the painting, it reveals further alterations on the surface. What seem to have been changed are the far eye, the upper lip, the shading under the chin, and the placement of the highlight on the tip of the nose. Perhaps the most telling revision concerns the philtral ridges of Washington's upper lip. These ridges, defining the indentation of the lip, are quite distinctive in that they are remark-

ably widely spaced. They appear in Houdon's life mask (Pierpont Morgan Library, New York), done from a mold of Washington's face, and in the x-radiograph but not in the final Vaughan portrait. An infrared reflectogram also gives evidence that the shoulders were slightly lowered. For a different opinion, see the entry on this painting in Miles et al., *American Paintings*, 201–5. Miles discounts Rembrandt Peale's comments and concludes that the Vaughan portrait is a replica because—and only because —the aureole in the x-radiograph is not indisputable evidence of a rubbing out. Such an argument disregards the strongest evidence, the uniqueness—within Stuart's known oeuvre—of the surface appearance of the painting, which has always supported its long acceptance as the first of its type. Furthermore, her observations with regard to a rubbing out do not, in fact, rule out that possibility. For Stuart's extraordinary ability to paint portraits from recollection, see Dunlap, *History*, 1:167, 212. G. C. Mason (*Stuart*, 141, 238, 244) recorded Stuart's practice of furnishing from his imagination secondary areas such as the hands and minor props; he cited also two instances, not mentioned in Dunlap, where a head was not painted from life.

4. Stuart's claim of having painted only two Washington portraits from life appeared, during Stuart's lifetime, in the following: "Stuart's Picture of Washington," *Boston Intelligencer, and Morning and Evening Advertiser*, Aug. 2, 1817, 2; Pickering, "Interviews," Oct. 29, 1817; and the 1823 certificate cited in n. 2. The newspaper account is reprinted in *New York Evening Post*, Aug. 7, 1817 (photocopy, curatorial file for Stuart's full-length *Washington*, Brooklyn Museum); and *Richmond Commercial Compiler*, Aug. 18, 1817 (transcript, archive of the Museum of Early Southern Decorative Arts, Winston-Salem, N.C.). For Stuart's dissatisfaction see Dunlap, *History*, 1:197. For Washington's reputation, see William Alfred Bryan, *George Washington in American Literature, 1775–1865* (New York: Columbia University Press, 1952), 16, 235. The approval generated abroad over Washington's rejection of power is perhaps best expressed in Trumbull's letter of Mar. 10, 1784, from London to his brother, Jonathan Trumbull: "[It] excites the astonishment and admiration of this part of the world" (John Trumbull Papers, series I, box 1, folder 4, Sterling Memorial Library, Yale University, New Haven, Conn.).

5. The Mar. 1796 date is in Rembrandt Peale's letter of Mar. 16, 1846, Charles Henry Hart Collection, Archives of American Art, Smithsonian Institution, Washington, D.C. For Martha Washington's commission, see Mason, *Stuart*, 115. Her portrait (Museum of Fine Arts, Boston; and National Portrait Gallery, Smithsonian Institution, Washington, D.C.) also remained unfinished and in Stuart's possession. The marquis of Lansdowne's name appears on Stuart's list of Apr. 20, 1795 (Mason, *Stuart*, 87–88), for one portrait of Washington. This commission might have been given earlier, in England (see chap. 3, n. 22), but Jane Stuart ("Stuart Portraits," 369) said that it was awarded on the basis of the first portrait. For verification

of the date of Apr. 12, 1796, see the letter-cum-certificate in n. 2. Although John Neagle said that the commission switched to Bingham when the Lansdowne portrait was "nearly finished," this is not very likely, because it postpones the life sitting requested by Mrs. Bingham (Dunlap, *History*, 1:203). The x-radiographs of the Lansdowne portrait reveal changes, but these are not in the head, contrary to expectation with a late life sitting. Also, a draft of a letter from Stuart to Lord Lansdowne mentions Bingham's early participation (Mason, *Stuart*, 95; present location of MS unknown). The recommissioning, as a returned favor, is discussed in an unsigned, undated letter from Lord Lansdowne's estate at Bowood Park to Benjamin Vaughan, in Benjamin Vaughan Papers, American Philosophical Society, Philadelphia. The Lansdowne head differs from the Athenaeum head principally in the changed direction of the eyes and corresponding changes in the eyelids, the slightly enlarged eye sockets, the more solemn mouth, and the increased dip in the tip of the nose. For a partial history of the controversy over which Lansdowne-type portrait is the original—the portrait that Bingham sent to Lord Lansdowne or the portrait that Bingham kept (Museum of American Art, Pennsylvania Academy of the Fine Arts, Philadelphia)—see Whitley, *Stuart*, 195–99. The PAFA version has most recently been published as the original (McLanathan, *Stuart*, 99), the main argument being that it alone is signed and dated "G. Stuart 1796."

Since leaving Stuart's painting room in 1796, the two portraits have been brought together twice: at the Centennial Exposition, Philadelphia, in 1876; and at the National Portrait Gallery, Smithsonian Institution, Washington, D.C., in October of 1974. In the latter comparison —which was made side by side—it was clear to the then-director of the gallery, Marvin Sadik, and a number of curators and conservators present, including myself, that the portrait sent to Lord Lansdowne (herein called the Lansdowne portrait) was the original. Aside from being the more altered version, it is much closer to the Athenaeum head in its sketchiness, the figure is less stiff and more elegantly proportioned, and the rug pattern is more accurately in perspective. There is also stronger modeling in the chin as if, in this version, the artist was working from life. The PAFA version must have been signed and dated to distinguish it from other copies, given that Stuart planned to use it as the source for replicas (see Robert Gilmor, "Memorandums Made in a Tour to the Eastern States in the Year 1797," 10–13, Miscellaneous Papers, Boston Public Library). Jane Stuart ("Stuart Portraits," 372) quoted Elizabeth Parke Custis's mention of attending many of the sittings that Washington had with Stuart and seeing the likeness of Washington "grow under [her] father's pencil." She undoubtedly meant the Athenaeum portrait. Rembrandt Peale claimed that the Lansdowne portrait was based on the Athenaeum portrait with one additional life sitting (see his letter of May 7, Robert Graham Autograph Collection, Archives of American Art, Smithsonian Institution, Washington, D.C.). On visual evidence, this appears to be the case.

6. On pushing to finish the Lansdowne portrait, see Stuart, "Stuart Portraits," 369. The two stories on keeping the portrait are in Dunlap, *History,* 1:198; and Stuart, "Stuart Portraits," 370. The Washington family's attempts to obtain it are mentioned in William Thornton's letter of Jan. 6, 1800, to William Winstanley, Thornton Papers, Library of Congress. Stuart's intention to keep it as a legacy is in Dunlap, *History,* 1:199.

7. Richardson, *Works,* 99–100, 102. For Washington's character as truly sublime, in Longinian terms, see Richard Payne Knight, *An Analytical Inquiry into the Principles of Taste* (London: T. Payne and J. White, 1805), 383. See also Cassius Longinus, *Longinus on the Sublime: The Peri Hupsous in Translations by Nicolas Boileau-Despréaux (1674) and William Smith (1739),* ed. W. B. Johnson (Delmar, N.Y.: Scholars' Facsimiles and Reprints, 1975), section with Smith's translation, xviii, xvii, ix, xix, xxvi, xxxiv, xxxi, xxv, xxiii, xxiv, xxviii (pp. in sequence cited). Alexander Pope was the first to call Longinus an example of the sublime (quoted on the Smith title page).

8. For Trumbull on his own portrait as sublime, see Cooper, *Trumbull,* 120; see also John Hill Morgan and Mantle Fielding, *The Life Portraits of Washington and Their Replicas* (Lancaster, Pa.: Lancaster Press, ca. 1931), 169. Regarding Ceracchi, see Sarah Jay's letter to John Jay of Aug. 2, 1794 (John Jay Papers, Columbia University, New York), in which she reminded her husband of his promise to Stuart, presumably to write a letter to Washington, and then asked where Ceracchi resided. In a now-missing letter of Nov. 15, 1794, from Mrs. Jay to her husband, she said of Stuart: "He informed me that Ceracchi and his family are come out to reside at Philadelphia, and have actually been there three months" (quoted in a letter of Aug. 23, 1878, from John Jay, in "Letters to G. C. Mason"). For other details about Ceracchi, to whom Jay sat for a bust in 1792, see Ulysse Desportes, "Giuseppe Ceracchi in America and His Busts of George Washington," *Art Quarterly* 26, no. 2 (Summer 1963): 142, 146, 149, 160. Desportes now considers the terra-cotta at Nantes to be the 1791 original (Nov. 3, 1997, conversation with the author).

Using the language of the sublime, at least one critic singled out Ceracchi and Stuart for alone creating "god-like" representations of Washington, "a god-like man" ("Stuart vs Rembrandt Peale," *New York American,* Sept. 11, 1824, 2). Dunlap ("Biographical Sketch") also paired the two artists, claiming that one had produced the best painting and the other the best sculpture of Washington, Ceracchi's being better even than Houdon's life mask. Horatio Greenough's colossal sculpture of George Washington (National Museum of American Art, Smithsonian Institution, Washington, D.C.), from 1832–41, is a late example of the morally sublime, consistent with these earlier works.

9. For a historical perspective on eighteenth-century practices—namely, prioritizing the head and the use of the Roman portrait bust—see Marcia Pointon, *Hanging the Head: Portraiture and Social Formation in Eighteenth-Century England* (New Haven: Yale University Press, 1993), 6–7.

See also Neal, *Observations,* 2. The associations are in Tuckerman, *Book of the Artists,* 8. The effect of strength in the Athenaeum portrait comes partly from the leonine appearance of the extended hair and thick neck. On the association of these characteristics with power, see Thomas Cowper, "Observations Respecting the History of Physiognomy," *European Magazine* 19:2 (Feb. 1791), 124.

10. For adapting, see Jouett in Morgan, *Stuart,* 92. For Allston, see Dunlap, *History,* 1:221. For a related discussion of Reynolds's *Sarah Siddons* as linking the particular with the universal, see Moore, "Reynolds," 353. For Washington identified with "the greatest heroes of antiquity," whom he surpasses in "virtue and exemplary moderation," see William P. Carey's sketch of Washington published in Dublin's *Miscellanist* in 1789 and reprinted in a Philadelphia journal of the same year; and for Washington as often compared with the Roman patriot Cincinnatus, see Jean Pierre Brissot de Warville, quoted in 1791 (both in Baker, *Character Portraits,* 36, 39). Longinus connected sublimity with the great authors and heroes of antiquity through himself as well as his references (*Longinus on the Sublime,* section with Smith's translation, 37, 86). For reference to "gentleman," etc., see Tuckerman, *Book of the Artists,* 8; and for "too much sublimity" and grandeur, see Neal, *Observations,* 2.

11. For genius, see George Washington Parke Custis, *Recollections and Private Memoirs of Washington, by His Adopted Son, George Washington Parke Custis* (Philadelphia: William Flint, 1859), 521. For the observer's pleasure, see Reynolds, *Discourses,* 259; and Eric Rothstein, "'Ideal Presence' and the 'Non Finito' in Eighteenth-Century Aesthetics," *Eighteenth-Century Studies* 9, no. 3 (Spring 1976): 308. For brushwork, see Peale's letter of Dec. 27, 1834, to William Dunlap, reprinted in Rembrandt Peale, "Washington Portraits: Letters of Rembrandt Peale," *Magazine of American History* 5, no. 2 (Aug. 1880): 130; and Peale's privately printed pamphlet *Portrait of Washington,* n.p., n.d., 6, in John Neagle's "Collection of Writings on Art," vol. 1, Philadelphia Museum of Art. For more on contemporary discussion of brushwork and the inspired genius, see Sheriff, *Fragonard,* 138–41, 143.

12. For mirrors and focus, see Jouett in Morgan, *Stuart,* 81, 84; Herbert, *Irish Varieties,* 230–31; Dunlap, *History,* 1:216; Dunlap, *Diary,* 3:699; and Thomas Sully's "Memoirs of the Professional Life of Thomas Sully Dedicated to His Brother Artists, Philadelphia, November 1851," [118], Joseph Downs Manuscript Collection, Henry Francis du Pont Winterthur Museum. Another observer offered a different version: "[Stuart] endeavours in the first sitting to give the appearance of the person at 20 yards distant and in each succeeding sitting to advance it in effect nearer until it be completed at 2 yards distance" (O. Dickinson, "Remarks on Painting," section for 1809, 2, Joseph Downs Manuscript Collection, Henry Francis du Pont Winterthur Museum). This procedure resembles Gainsborough's allowance of more light into the room as he proceeded (see David Mannings, "At the Portrait Painter's: How the Painters of the Eighteenth Century Conducted

Their Studios and Sittings," *History Today* 27, no. 5 [May 1977]: 283). On the nose and conversation, see Dunlap, *History,* 1:212; and Mason, *Stuart,* 140–41. For Jane Stuart, see Mason, *Stuart,* 37.

13. For adjustments, see Peale's "Washington Portraits," 130.

14. For Lavater's comments and the Vaughan engraving, dated Nov. 2, 1796, see Johann Caspar Lavater, *Essays on Physiognomy, Designed to Promote the Knowledge and the Love of Mankind . . . ,* trans. Henry Hunter (London: John Murray, ca. 1792), vol. 3, pt. 2, 435 and pl. opposite.

15. On Stuart's lack of confidence in others' detection of character, see Stuart, "Anecdotes," 378; and on Stuart's belief in Lavater "or at least in the leading principles of physiognomy," see Neal, *Observations,* 73. For Stuart's praise of himself as a physiognomist and his mention of God's "legible hand" in the readable signs of character, see Herbert, *Irish Varieties,* 245. For Stuart's description of Washington, see Isaac Weld, Jr., *Travels through the States of North America and the Provinces of Upper and Lower Canada During the Years 1795, 1796 and 1797* (1807; reprint, New York: A. M. Kelley, 1970), 1:105. In 1817 Stuart made similar observations to John Neal, speaking of Washington's "large features and stately bearing, and of the signs he saw, in the massive jaw, the wide nostrils, and large eye-sockets, that he was a man of almost ungovernable passions and indomitable will" (Neal, *Observations,* 72). Self-denial concerning the emotions is an ideal that appears in Lavater's well-known, admiring description of Socrates (Lavater, *Essays on Physiognomy,* 1:166, 167, 169–70), which Weld (*Travels,* 106) recalled in his recital of Stuart's account. Self-denial concerning worldly rewards, as in Washington's surrender of military power after victory, is an aspect of the sublime that appears in Longinus (*Longinus on the Sublime,* section with Smith's translation, 14).

16. On Washington's teeth, see Mason, *Stuart,* 118–20; Stuart's making his flesh "too fair and florid" is mentioned in Rembrandt Peale's "Washington Portraits," 130. Stuart's darkening the eyes, claiming that "in a hundred years they will have faded to the right color," is in [George Washington Parke Custis], "Portraits of Washington: Being an Appendix to the Custis Recollections and Private Memoirs," *Home Journal* 1 (Dec. 15, 1855), 3:5.

17. Stuart had painted the marquis of Lansdowne's portrait in England (*World,* Apr. 18, 1787, 3). The marquis's involvement in the peace negotiations is in *Dictionary of National Biography* (London: Oxford University Press, 1967–68), 15:1009. For the marquis's admiration, see Bingham's letter to Rufus King of Nov. 29, 1796, in the Rufus King Papers, bound in "American Political Letters, 1796–1799," vol. 41, New-York Historical Society, New York; for the quote, see Lord Lansdowne's letter of Mar. 5, 1797, to Bingham in Charles Henry Hart, "Stuart's Lansdowne Portrait of Washington," *Harper's New Monthly Magazine* 93, no. 555 (Aug. 1896): 382.

18. See, for instance, the portrait's kinship in pose with Titian's portrait of Philip II (Museo del Prado, Madrid) in Marianna Duncan Jenkins, *The State Portrait: Its Origin and Evolution* ([New York]: College Art Association of America in Conjunction with *Art Bulletin,* 1947), fig. 22. Given that the Bossuet portrait (Musée du Louvre, Paris) was in France, the engraving had to have been the source. Charles Henry Hart first recognized this connection (Park, *Stuart,* 1:50). For two different claims over who posed for the figure of Washington in the Lansdowne portrait, see Mason, *Stuart,* 92. A third claim (also p. 92), that it was the Vicomte de Noailles, appears to concern the Munro-Lenox portrait of Washington. On the role of Noailles, whom Stuart also painted in a smaller full-length portrait in 1798 (Metropolitan Museum of Art, New York), see John K. Howat, "'A Young Man Impatient to Distinguish Himself,' The Vicomte de Noailles as Portrayed by Gilbert Stuart," *Metropolitan Museum of Art Bulletin* 29 (Mar. 1971): 338. Concerning Foster, from the engraving after it, it seems that the portrait is slightly cropped, especially at the top (Park, *Stuart,* 1:328–29), and would have been closer originally to the size of Stuart's related full-length portrait of the Lord Chancellor of Ireland, *John, Lord Fitzgibbon,* of 1790 (Cleveland Museum of Art). Lord Shaftesbury, in his influential *Characteristicks,* advised just such a combination of past and future as may well be in Stuart's Lansdowne portrait; see Wind, *Hume,* 23. Regarding the farewell address, see Janet Podell and Steven Anzovin, *Speeches of the American Presidents* (New York: H. W. Wilson, 1988), 13. Gardiner Baker gave one of the earliest published interpretations in advertising his replica of the Lansdowne portrait, providing the meaning of the rainbow and stating that Washington was represented "addressing Congress for the last time before his retirement" (*Time Piece,* Feb. 7, 1798, quoted in Whitley, *Stuart,* 107–8). In an article on the painting's arrival in England, Washington is described as "addressing the Hall of Assembly. The point of time is that when he recommended inviolable union of interests between America and Great Britain" (*Oracle, Public Advertiser,* May 15, 1797, 2). This is a somewhat misinformed reference to Washington's defense of the Jay Treaty in his seventh annual address on Dec. 8, 1795 (see Podell and Anzovin, *Speeches,* 10). Washington is also interpreted as speaking "in the character of a senator" in "Whole Length Portrait of General Washington," *Port Folio* (Dec. 19, 1801): 405.

19. For discussion of painted replicas, see Pickering, "Interviews," Nov. 10, 1817. The position of Washington's hand, with the fingertips on a piece of paper, recalls the pose of Francis Malbone in Stuart's early double portrait of Malbone and his brother (fig. 5) and, more closely, the pose in Reynolds's 1784 portrait of the powerful politician Charles James Fox, a likeness that became well known through a popular engraving (reproduced in Penny, *Reynolds,* 307); while Fox's hand is relaxed, however, and seen from above, Washington's is stiffened with energy. Mount (*Stuart,* 228–30, 233) connected the missing Mount Vernon portrait with the Munro-Lenox likeness. Morgan quoted the advertisement in *Philadelphia Aurora* in Park, *Stuart,* 1:50–51n. It was repeated in Baltimore, Norfolk, and Charleston newspapers within about a

month (archive of the Museum of Early Southern Decorative Arts, Winston-Salem, N.C.). The crucial statement is: "Gilbert Stuart, having been appointed by the legislatures of Massachusetts and Rhode-Island to prepare *full length portraits* of the late Gen. Washington, takes this mode to apprize [*sic*] the citizens of the United States, of his intention to publish engravings of General Washington *from the Mount-Vernon portrait.*" No ownership, either future or present, is specified for the portrait. The undated draft of a letter to Lord Lansdowne provides further information in that Stuart claimed to have "issued proposals for a superior engraving, from a portrait [of Washington] intended to be fixed at Mount Vernon" (Mason, *Stuart,* 96). The commission said to be from the Massachusetts legislature was possibly a confused reference to Connecticut, because copies went only to the State Houses in Providence and Newport, Rhode Island, and Hartford, Connecticut.

20. Park, *Stuart,* 1:50–51n. Custis (*Recollections,* 522) stated that the well-known English engraver William Sharp had, at Stuart's instructions, already taken initial steps to produce an engraving from the Lansdowne portrait when an engraving by James Heath appeared. Stuart once showed Custis the "copperplate prepared in England for him by the celebrated Sharpe [*sic*]." Although retired, Sharp had "consented to execute a farewell engraving of Stuart's Washington." Jane Stuart ("Stuart Portraits," 370) also mentioned Sharp as the intended engraver. Reportedly the arrangement with Sharp was made through Benjamin West. See William Bingham's letter (quoted in Whitley, *Stuart,* 101), saying that Stuart had asked West to engage an engraver but that Lord Lansdowne did not know this. On the popularity of the Heath engraving, see Wendy C. Wick, *George Washington, an American Icon: The Eighteenth-Century Graphic Portraits,* exh. cat. (Washington, D.C.: National Portrait Gallery, Smithsonian Institution, 1982), 60. The sale to a London banker and the eventual purchase by Peter Jay Munro is in "Stuart's Picture of Washington," *Boston Intelligencer,* Aug. 2, 1817, 2. The Heath engraving extends the Lansdowne picture somewhat at the edges, as if the print were done from the picture unframed. The original tacking edges of this portrait are cut off, but portions remain on the left side (note in registrar's file, National Portrait Gallery, Washington, D.C.).

21. Stuart's bitterness over the pirated print was well known. See, for instance, Stuart, "Stuart Portraits," 369, 369n; and, for Stuart's description of the injury done him, the draft of his letter to Lord Lansdowne (Mason, *Stuart,* 95–96). On drinking, see Israel Whelen's letter of Aug. 6, 1800, to Oliver Wolcott, Jr., Papers of Oliver Wolcott, Jr., vol. 15, no. 108, Connecticut Historical Society, Hartford.

22. For Stuart's flesh coloring as Irish and his portraits as inaccurate, see Rembrandt Peale's "Lecture on Washington and His Portraits," 20–22, Charles Roberts Autograph Letters Collection, Magill Library, Haverford College, Haverford, Pennsylvania. For the Bingham version of the Lansdowne portrait as resembling "a little old French marquis more than Washington," see Rembrandt Peale quoted in Dunlap, *History,* 1:205. Dunlap first identified Peale only as an academy president; he was actually vice-president of a short-lived academy called the Society of Artists of the United States (part of the Pennsylvania Academy of the Fine Arts in Philadelphia) in 1811—the presumed time of the reminiscence—and later president of the American Academy of Fine Arts in New York. For "deficient in character," see [Rembrandt Peale], "To the Editors of the American," *New York American* (Sept. 7, 1824): 2. For "enthusiasm of genius" as a period expression, see "Stuart vs Rembrandt Peale," *New York American* (Sept. 11, 1824): 2. On Peale's portrait, see Lillian B. Miller et al., *In Pursuit of Fame: Rembrandt Peale, 1778–1860,* exh. cat. (Washington, D.C.: [Seattle] University of Washington Press for National Portrait Gallery, 1992), 144. See also Verheyen, "Most Exact Representation," 127–39.

Concerning the competition for the best portrait of Washington, Stuart observed in his later years that "Houdon's bust came first, and my head of him next," Houdon's likeness having been based on a mask taken before Washington acquired his cumbersome false teeth (Stuart, "Stuart Portraits," 370). In fact, Stuart was so intrigued by Houdon's likeness that he made a small pencil copy (Museum of Fine Arts, Boston) for himself of one of Houdon's casts from the life mask. Presumably done years after Washington's death, while Stuart lived in Boston, the drawing shows a profile view—which was Lavater's preferred perspective for physiognomical interpretation—although Stuart had not painted this view. The original drawing is no more than a continuously traced silhouette—as if done from a shadow—which Stuart then went over with a darker pencil, adapting the likeness evidently to Washington as he knew him. A raking light makes visible the artist's additions: interior details and a more expressive outline, perhaps to compensate for the fact that a mask is taken from a face at rest. When compared with his first profile and the actual bust (Mount Vernon), it is clear that Stuart's changes exaggerate an arch in Washington's forehead, the indentation between his eyes, a bump at the base of his nose, the slight downturn in the tip of the nose, the heaviness of the eyelids, the saddened expression of the mouth, and the slight projection of a second chin. Stuart also extended the sideburns forward. He did not, however, modify the chin so as to suggest the later presence of false teeth. This change, in the interest of greater realism, would destroy Washington's natural profile and the potential for accurate physiognomical analysis. In a discussion of Gotthard Heidegger's death mask (full face and profile)—which shows a head similar to Washington's—Lavater (*Essays on Physiognomy,* 1:260–62) suggested, by extrapolation, that the changes Stuart made in the upper part of Washington's profile are expressive of greater wisdom. Yet Lavater was inconsistent in his interpretations, and Stuart undeniably had his own ideas. Lavater even admitted, "It is undoubtedly possible, even easy, for the physiognomist to be mistaken" (1:271).

23. On Jefferson, see Susan R. Stein, *The Worlds of Thomas Jefferson at Monticello* (New York: H. N. Abrams in Association with the Thomas Jefferson Memorial Foundation, 1993), 33. Jane Stuart is the source of information on Nelson and the Nelson print, "which was the first American engraving of Nelson" and therefore the 1805 Boston print after William Beechey's portrait (Powel, "Jane Stuart," 12–13). The other identified print was of Benjamin West ("Inventory of the Estate of Gilbert Stuart," docket no. 28699, Supreme Judicial Court, Archives and Records Preservation, New Court House, Boston). On Stuart's affection for Washington, see Stuart, "Stuart Portraits," 371. For the effect of the sublime as a feeling of "transport," see Longinus, *Longinus on the Sublime*, section with Smith's translation, 3. See also the discussion of proud identification as the appropriately Longinian reaction, in Steven Knapp, *Personification and the Sublime: Milton to Coleridge* (Cambridge: Harvard University Press, 1985), 68–69.

24. On Stuart's significance, see Custis, *Recollections*, 521. Neal (*Observations*, 4) corroborated this, saying Stuart "developes [*sic*] character like a magician." For Fuseli's influence on Stuart, see Stuart, "Youth," 643. See also Eudo C. Mason, *The Mind of Henry Fuseli: Selections from His Writings With an Introductory Study* (London: Routledge and Paul, 1951), 284. To be "the servant not of Vanity but Virtue" was the expressed wish of Stuart's friend Trumbull in a letter of Jan. 18, 1785, John Trumbull Papers, series I, box 1, folder 5, Sterling Memorial Library, Yale University, New Haven, Conn. Stuart—who, according to Jouett, loved Trumbull (Morgan, *Stuart*, 90)—seems to have shared the general high-mindedness of purpose that was endemic in the circle of Benjamin West. To a friend, for instance, Stuart spoke of what he had tried "all my painting life . . . to avoid—vanity and bad taste" (Dunlap, *History*, 1:218). Related to this, see Pasquin, *Memoirs*, 48, for one of many examples of incitements to artists of the late eighteenth century to have an uplifting effect on society. For good character, see C. W. Peale's letter to Rembrandt Peale of Aug. 23, 1823, Letterbook 17, Peale-Sellers Papers, American Philosophical Society, Philadelphia. One reviewer wrote: "We have seen many of Stuart's pictures where the *living* originals did not seem overburthened with sense, and in no instance have we seen his portraits wanting in dignity of expression" ("Review of the Third Annual Exhibition," *Federal Gazette and Baltimore Daily Advertiser*, June 18, 1813, 2). The son of one sitter confided that his father had sat to Stuart with great reluctance, adding: "How an artist could contrive under such circumstances to take a likeness that expresses so much good nature, I cannot imagine" (1814 diary quoted in Park, *Stuart*, 2:738). Knapp (*American Biography*, 325) observed that Stuart sometimes "threw a ray of his own genius into a countenance in which nature had given no indication that she had stolen the fire from heaven to light it up." On Stuart's looking for strengths in the sitter, see Jouett in Morgan, *Stuart*, 83. Despite such complimentary treatment, Stuart refused to flatter in other circumstances—specifically, when it seemed tasteless. For

examples, see Herbert, *Irish Varieties*, 234; and Mason, *Stuart*, 59, 274. See also Jane Stuart in Mason, *Stuart*, 56–57, for Stuart's dislike of an artificial effect in the sitter's cosmetics or costume. His rejection of artifice reflects the fashion shift toward greater sincerity that succeeded the influence of Lord Chesterfield and is apparent in such conduct books as Hunter's *Reflections* (6, 10, 48). Instead of Chesterfield's recommended mask of integrity, Hunter trumpeted the genuine article as displayed in the lives of such ancient role models as Plato and Seneca. Using chiefly literary sources, Lionel Trilling traced an increase in sincerity in European and American society, beginning in about 1770 and continuing through the nineteenth century; see his *Sincerity and Authenticity* (Cambridge: Harvard University Press, 1972).

25. For Stuart's criticism of a potential copyist as not having the "requisite feelings," see Dunlap, *History*, 1:199. On a different occasion, he made a similar criticism of another artist, saying: "It takes a gentleman . . ." (diary entry transcribed in Jonathan Mason, Jr., "Recollections of a Septuagenarian," 2:26, Joseph Downs Manuscript Collection, Henry Francis du Pont Winterthur Museum). That a good portrait painter must think as a gentleman was a much promoted idea that appears also in Richardson, *Works*, 12. For more on this concept in Reynolds's *Discourses*, see Wendorf, *Reynolds*, 25–26. The reference to "the empiric" is in a clipping dated July 21, 1828, in John Neagle, "Scrap Book," vol. 1, Historical Society of Pennsylvania, Philadelphia. See also Wark in Reynolds, *Discourses*, 191.

26. For the necessity to "feel character," see the diary transcription in Mason, "Diary," 2:26. See also Kames, *Elements of Criticism*, 1:14; Lord Kames was not unique in expressing this view, but he was often associated with the idea. On the popularity of American editions, during this period, of Kames's *Elements of Criticism*, see James Engell, *The Creative Imagination: Enlightenment to Romanticism* (Cambridge: Harvard University Press, 1981), 190. "Vision" is mentioned in Herbert, *Irish Varieties*, 234. Stuart's use of the word *feeling* is reminiscent of the cult of sensibility. See the discussion of the philosopher David Hume's pronouncement—"Morality is more properly felt than judged of"—in Louis I. Bredvold, *The Natural History of Sensibility* (Detroit: Wayne State University Press, 1962), 23.

27. For "great sensibility," see Mrs. Cary quoted in 1819 in Park, *Stuart*, 1:205; and Horace Holley's letter to Mary A. Holley, Apr. 8, 1818, in Holley, "Report." The anecdotes are from: Mason, *Stuart*, 213; Virginia C. Miller's letter of Nov. 7, 1878, in "Letters to G. C. Mason"; Stuart, "Anecdotes," 376; Mason, *Stuart*, 47; Jonathan Mason in Mason, *Stuart*, 30 ("He never put any value on money"); William Constable's letter to John Vaughan, July 25, 1797, "William Constable's Letter Book of Aug. 1795 to June 1799," photocopy, curatorial file on Stuart's portrait of Washington, Brooklyn Museum, Brooklyn, N.Y.; Stuart, "Youth," 646; Neagle in Dunlap, *History*, 1:215, 218; and Jouett in Morgan, *Stuart*, 92. For characteristics of the type, see Mackenzie, *Man of Feeling*, 9,

37–38, 258; and Barker-Benfield, *Culture of Sensibility*, 68, 220, 248, 281. Stuart's response to a "raging flood" shows his appreciation of the sublime in nature. On the imagery as sublime, see, for instance, Hugh Blair, *Lectures on Rhetoric and Belles Lettres* (1819; reprint, Delmar, N.Y.: Scholars' Facsimiles and Reprints, 1993), 30. Stuart's description and reaction possibly reflect a recollection of the words of James Thomson in his well-known poem on winter from "The Seasons" of 1726; see *The Seasons, and, The Castle of Indolence*, ed. James Sambrook (Oxford: Clarendon Press, 1972), 131–32.

CHAPTER 5

1. For Stuart's plans, see the letter from Abraham G. D. Tuthill of Aug. 26, 1799, to Col. Sylvester Dering, Dering Letter Book (typescript), Shelter Island Historical Society, Shelter Island, New York. For his invitation and mistake, see Stuart, "Youth," 645. In 1798 the duke became commander-in-chief of the British army in North America (see David Duff, *Edward of Kent: The Life Story of Queen Victoria's Father* [London: S. Paul, 1938], 130, 133, 147, 152). "Unthrifty" is in "Stuart's Washington," *Boston Evening Transcript*, Sept. 24, 1852, 1.

2. On Heath's making a fortune, see Stuart, "Stuart Portraits," 373. For Anthony, see his letter of "the spring of 1803" quoted in Charles Henry Hart, "Gilbert Stuart's Portraits of Men," *Century Magazine* 76, no. 6 (Oct. 1908): 95. Stuart in London is in Dunlap, *History*, 1:167. For Anthony's daughter's "striking" portrait, see the diary entry for June 10, 1802, in Thomas P. Cope, *Philadelphia Merchant: The Diary of Thomas P. Cope, 1800–1851*, ed. Eliza Cope Harrison (South Bend, Ind.: Gateway Editions, 1978), 124.

3. Dunlap's comment is in Herring and Longacre, *National Portrait Gallery*, vol. 1, section on Stuart, 8. The ant reference is in Dunlap, *History*, 1:167.

4. On the move to Germantown, see Stuart, "Stuart Portraits," 370. For evidence of where the Washington portraits were painted, see Washington's letter quoted in Mason, *Stuart*, 88–89; and William R. Smith's letter of Nov. 24, 1858, to John A. McAllister, Historical Society of Pennsylvania, Philadelphia. For a time Stuart retained a painting room in Philadelphia, possibly for the convenience of some sitters, after he moved to Germantown (Mason, *Stuart*, 141). He had had the same arrangement when he lived in the vicinity of Dublin, at Stillorgan (Herbert, *Irish Varieties*, 243).

5. See *Monthly Magazine* 24 (Jan. 1, 1808) 12:585; and Neal, *Observations*, 30, 69. One of the most frank period acceptances of the inferior status of a woman occurs in the Honorable E—— S——, *The Deportment of a Married Life* (London: Printed for Mr. Hodges, 1790), 191. For the reaction of period feminists against just such infantilizing of the woman as demonstrated by Neal, see Barker-Benfield, *Culture of Sensibility*, 348–49. As attitudes shifted gradually some writers referred—in, for instance, Jeffrey's

1817 entry on beauty in the fifth edition of *Encyclopaedia Britannica*, 3:497—to female beauty as insipid if nothing of the mind was expressed on the face. On the expectation that the man should be more carefully delineated, see Andrew Wilton, *The Swagger Portrait: Grand Manner Portraiture in Britain from Van Dyck to Augustus John, 1630–1930*, exh. cat. (London: Tate Gallery, 1992), 39. For an English criticism of a lack of warmth in Stuart's pictures, see *Morning Post*, May 7, 1785, 2; and June 3, 1785, 3. Dunlap (*History*, 1:214) did not agree that Stuart's portraits of women were inferior to his portraits of men. For Stuart's popularity as a painter, see Charles Willson Peale's letter of May 8, 1805, to Rembrandt Peale, Letterbook 6, Peale-Sellers Papers, American Philosophical Society, Philadelphia. Regarding "pictures," see Lady Liston's letter of Oct. 8, 1800, to James Jackson, Sir Robert Liston Papers, National Library of Scotland, Edinburgh.

6. For Van Dyck, see Dunlap, *History*, 1:217. For Burr's opinion of his daughter's portrait as having "a pensive, sentimental air, that of a love-sick maid," see Milton Lomask, *Aaron Burr*, vol. 2: *The Years from Princeton to Vice President, 1756–1805* (New York: Farrar, Straus and Giroux, 1979), 196. The portrait of Theodosia is so heavily restored as to obscure the original effect. For the woman of sensibility, see Mackenzie, *Man of Feeling*, 19–20, 22. For tragic aspects of Lewis's life, see Miles et al., *American Paintings*, 238. For melancholy as fashionable, see Bredvold, *Natural History*, 59. Regarding the Linzee portrait, see Sarah A. Cunningham's letter of Aug. 5–12, 1825, to her daughter, Griselda, in the Morton-Cunningham-Clinch Family Papers, 1754–1903, Massachusetts Historical Society, Boston.

7. See Sully's "Hints," 107 (undated entry), New York Public Library. For the relative, see Mason, *Stuart*, 143. For the moral message in flesh color, see, for example, Webb, *Inquiry*, 73. See also Michael Anthony Philip Shortland, "The Body in Question: Some Perceptions, Problems and Perspectives of the Body in Relation to Character, c. 1750–1850" (Ph.D. diss., University of Leeds, 1984), 1:45. For Stuart, see his reference to health and disposition when discussing flesh color with Jouett—for instance, "the rosy bloom of health & joy" (Morgan, *Stuart*, 91). For moral beauty as represented through health, see Robert E. Norton, *The Beautiful Soul: Aesthetic Morality in the Eighteenth Century* (Ithaca, N.Y.: Cornell University Press, 1995), 204. Most of Norton's book is relevant in that he discusses the Enlightenment belief that a good soul somehow leaves a beautiful imprint (never quite defined) on a person's bodily appearance.

8. For a "speaking vivacity" lost by overworking a portrait, see Waterhouse's opinion, probably reflective of Stuart's, in his "Memoirs," entry for July 22, 1838. For touches, see Knapp, *American Biography*, 197; and William Gilpin, *Observations Relative Chiefly to Picturesque Beauty, Made in the Year 1772, on Several Parts of England; Particularly the Mountains, and Lakes of Cumberland, and Westmoreland . . .* (London: R. Blamire, 1786), 2:11: "[Such touches] excite the imagination; and lead it to form half the picture

itself." On Stuart's reputation for not finishing, see Catherine Byles's letter to Mather Brown, Apr. 30, 1817, "Mary and Catherine Byles Letterbook, 1808–18," Massachusetts Historical Society, Boston.

9. Quoted in Mason, *Stuart,* 143.

10. Wick, *George Washington,* 60, 62. The 1798 London engraving, by William Nutter, is from one of Stuart's earliest versions with a saw-toothed queue ribbon. On the engravings of Shippen and McKean, see Dunlap, *History,* 1:206; and Mantle Fielding, *Catalogue of the Engraved Work of David Edwin* (Philadelphia: M. Fielding, 1905), 25, 37. Although the Shippen oil portrait was finished in 1796, the sitter having so stated to his daughter on Jan. 30 of that year, its date has traditionally been given mistakenly as 1803 because of the inscription, stating the sitter's age as seventy-four, on the undated engraving. The sitter's given age indicates that the engraving probably dates from 1803; but the portrait could also have been engraved posthumously, with the wrong age, sometime before it was reproduced in an 1810 edition of *Port Folio.* See Park, *Stuart,* 2:686.

11. On the portrait of McKean as the earliest on panel, see Park, *Stuart,* 2:516. On Stuart's use of panels, see a letter of May 17, 1800, from Oliver Wolcott, Jr., to John Trumbull, Papers of Oliver Wolcott, Jr., vol. 11, no. 48, Connecticut Historical Society, Hartford. The reason for roughening the panels is in Stuart, "Anecdotes," 381. On panel splitting, see Jane Stuart in Mason, *Stuart,* 59.

12. On Davis, regarding the Gibbs-Coolidge set of portraits of the first five presidents, see Mason, *Stuart,* 111–12. Stuart's own painting of drapery could be "slovenly" (Dunlap, *History,* 1:218), as in his portrait of Chief Justice John Jay (National Gallery of Art, Washington, D.C.). Jay's son, Peter Augustus Jay, complained about the painting of the robe in this portrait in a letter of July 8, 1808, to his father (John Jay Papers, Columbia University). Despite such sloppiness (involving the inferior painting of one arm, undoubtedly by Stuart), in a number of his portraits, there is arguably a distinction between Stuart's participation and that of another, inferior hand. Some early examples probably resulted from Stuart's habit of procrastination and his relatively sudden departures from London and later Dublin: for instance, the full-length portrait, ca. 1785–87, of Admiral Lord St. Vincent (Viscount St. Vincent, Jersey) as a captain appears, from a sharp photograph, to have a head by Stuart, but the rest —particularly the outlined body with the inferior drawing of the right hand and hat—is questionable. If Stuart abandoned the portrait, this may have been the cause of Lord St. Vincent's complaint, in 1805, that Stuart had "behaved most ungratefully to him" (quoted in Joseph Farington, *The Diary of Joseph Farington,* ed. Kenneth Garlick and Angus Macintyre [New Haven: Yale University Press for the Paul Mellon Centre for Studies in British Art, 1982], 7:2544). In Ireland many of Stuart's portraits were finished by others, after leaving his studio (Herbert, *Irish Varieties,* 226, 248). In the United States he seems to have used an assistant most in his Philadelphia replicas and during the late Boston years. Generally, his reliance on an assistant—aside from the help of his children, Charles and then Jane—appears to have been sporadic. For instance, he could not complete the body in his portrait of a Reverend Jarvis (who was unable to sit for this part) because, as Mrs. Jarvis reported to her husband, "Stuart has no gown & no one there who could sit for you" (letter of July 31, 1817, from Mrs. Samuel Farmer Jarvis to her husband, Papers of the Reverend Samuel Farmer Jarvis, Records of the Cathedral Church of St. Paul, Archives of the Episcopal Diocese of Massachusetts, Boston). For the Germantown historian, see Watson, *Annals,* 2:64; and Dumas Malone, *Dictionary of American Biography* (New York: Scribner, 1964), 10:546, on Watson.

13. Dunlap told the story of Thomas Sully writing to Stuart in 1814 to suggest that they paint in conjunction, with Sully providing backgrounds. Stuart did not answer the letter, but a few years later, when Sully was in Boston, Stuart made the same proposal to him (*Diary,* 3:702; and *History,* 1:132). For Paul, see Dunlap, *History,* 1:417. For Blodget, see William R. Smith's letter of Nov. 24, 1858, to John A. McAllister, Historical Society of Pennsylvania, Philadelphia. Judging from the awkward perspectives and the pentimenti in the Smith portrait—showing that there was once a compass on the table and no paper overlapping the table edge—it seems that Blodget painted the accessories, and Stuart probably altered his work. Stuart most likely painted the background in the Lansdowne portrait, guided by Blodget's sketch with its partial transcription of the Bossuet engraving. It was probably Stuart who added the rug (Mason, *Stuart,* 99–100).

14. Vanderlyn first became Stuart's live-in student briefly in New York, before he ran out of money, and was then sponsored as Stuart's pupil in Philadelphia by Aaron Burr. At Stuart's suggestion, Vanderlyn later left him to study in Europe. On Vanderlyn, see William T. Oedel, "John Vanderlyn: French Neoclassicism and the Search for an American Art" (Ph.D. diss., University of Delaware, 1981), 31, 34–35, 39. See also the transcript of Birch's "Autobiography," p. 37, Historical Society of Pennsylvania, Philadelphia; Mason, *Stuart,* 106, 141; Dunlap, *History,* 1:199; and Stuart, "Stuart Portraits," 370.

15. See the memorandum of Constable's daughter, Mrs. H. B. Pierrepont, the excerpt from Constable's letter book, and the receipt signed by Stuart (in which the portraits are specified and Hamilton mentioned) in the "Pierrepont Family Papers Relating to Gilbert Stuart's Portrait of George Washington," Library Collection, Brooklyn Museum. Constable's portrait is at the Metropolitan Museum of Art, New York, and his Lansdowne copy is at the Brooklyn Museum. The connection between background details in the half-length portrait of Washington and the Drevet engraving was made anonymously in the curatorial file of the New York Public Library. These quotations and the amateurish chair back are not convincing as by Stuart.

16. For surviving documentation on the Gilmor portrait, see Edward S. King, "Stuart's Last Portrait of Washington: Its

History and Technique," *Journal of the Walters Art Gallery* 9 (1946): 84. For Stuart's training, see Dunlap, *History*, 1:178. On the prices, see the letter of May 17, 1800, from Oliver Wolcott, Jr., to John Trumbull, concerning the Munro-Lenox copy for the Connecticut State House, Papers of Oliver Wolcott, Jr., vol. 11, no. 48, Connecticut Historical Society, Hartford. This copy of the Athenaeum Washington arouses suspicion also because Jane Stuart was working closely with her father at the time, and he spoke of her as the best copyist of his work (see the anonymous notice in New York's *Evening Post*, Apr. 25, 1833, 2). Stuart provided two copies of the Munro-Lenox portrait for the state government of Rhode Island (State House, Providence, and Colony House, Newport). While the Providence version is very close to the Munro-Lenox copy in the State House at Hartford, Connecticut, the Newport version is quite different and—partly as the result of overcleaning and a bad restoration in 1905—shows little evidence of Stuart's participation. His abbreviated signature, recorded by Park (*Stuart*, 2:859) among others, is no longer present on the table leg. As for other mentions of Stuart's prices: see Dunlap, *History*, 1:188, for Stuart's prices equal to any of his London competitors except Reynolds and Gainsborough; the unidentified newspaper clipping, dated 1784, in a 1784 R.A. exhibition catalogue, for Stuart raising his price from twenty-five guineas to thirty so that he matched Romney's price and charged ten guineas less than Gainsborough (J. H. Anderdon, "Royal Academy, III, 1783–1790," British Museum, London); Farington, *Diary*, 1:207, entry for July 1, 1794, for Stuart's prices being lower in New York than they had been in London but his expenses also being proportionally lower; and Eliza Susan Quincy's letter of Sept. 21, 1878, for Stuart's late Boston prices as "moderate" ("Letters to G. C. Mason").

17. On the tracing cloth, see Morgan, *Stuart*, 34. For Penniman, see Mason, *Stuart*, 46. David Humphreys's letter of Dec. 1, 1807, to Ozias Humphry is in "Original Correspondence of Ozias Humphry, R.A.," vol. 6 (1803–7), Royal Academy of Arts, London. See Henry Sargent's account of Stuart holding a small instrument, proportional dividers, in Dunlap, *History*, 2:1, 61. Stuart's brass instruments and magazine case were made, as they are inscribed, by George Adams the Elder, in London. When Stuart's children tried to sell the instruments after his death, they referred to them as mathematical instruments, which indeed they are (Harriet Fay's letter of Oct. 4, 1831, to Dr. George C. Shattuck, Massachusetts Historical Society, Boston). Eventually relatives of Charles Willson Peale bought the complete set from Stuart's widow.

18. On Winstanley, see J. Hall Pleasants, "Four Late Eighteenth Century Anglo-American Landscape Painters," *Proceedings of the American Antiquarian Society* 52, pt. 2 (1943): 301–20; and Dunlap, *History*, 1:200. The 1800 references are in "Diary of Mrs. William Thornton," *Records of the Columbia Historical Society* 10, no. 165 (1907), entry for July 10, 1800; and the draft of a letter of Jan. 6, 1800, from William Thornton to William Winstanley, Wil-

liam Thornton Papers, Library of Congress. For the obituary, see "The Late Gilbert Steuart [*sic*]," *New York Mirror and Ladies' Literary Gazette* (Aug. 2, 1828): 30 (reprinted from *Boston Evening Gazette*). See Dunlap, *History*, 1:200 and 202, for the window story and the tale, also from Stuart, of Winstanley switching one of his own copies of the Lansdowne portrait for a replica that had come from Stuart. The incident occurred in the spring of 1800, when Winstanley was placed in charge of packing and shipping the replica from (probably) New York to the White House in Washington. The replica (present location unknown) had belonged to Gardiner Baker, a museum owner, of New York. Jane Stuart ("Stuart Portraits," 372) repeated the account. Stuart's quote is in Anna Maria Thornton's letter of Aug. 24, 1802, to Dolley Madison, Dolley Madison Papers, Alderman Library, University of Virginia, Charlottesville.

19. See Dunlap, *History*, 1:200–201, for the "nine-days" reference and the story, from Stuart, of Winstanley offering one of his Lansdowne copies as security for a loan of $500 from a Boston merchant. Winstanley then disappeared, and the merchant, thinking—as he had been told—that he had a genuine work by Stuart, donated it to the town of Boston. The picture, hung in Faneuil Hall, was ridiculed as a forgery, so the merchant applied to Stuart to paint a genuine full-length version for $600 to replace it, which Stuart did. Later Stuart "retouched," as he said, a small full-length copy of this portrait, done by an assistant, and gave it to Isaac P. Davis with an accompanying letter of gift that is seemingly misdated as January "1801"—possibly to be read "1807." The small copy has been mistakenly called the original sketch for the larger picture (Park, *Stuart*, 2:861; Morgan and Fielding, *Life Portraits*, 270; and Eisen, *Portraits*, 1:129). G. C. Mason (*Stuart*, 105) mentioned the letter, which is reproduced with the painting in Eisen, *Portraits*, vol. 1, pls. 10, 11. On the fortification of Dorchester Heights and its consequences, see Douglas Southall Freeman, *George Washington: A Biography* (New York: Scribner, 1951), vol. 4, chap. 2.

20. The insistence on a contract stating Stuart's "privilege [*sic*] of copyright and publishing prints" is in Israel Whelen's letter of Aug. 6, 1800, to Oliver Wolcott, Jr., Papers of Oliver Wolcott, Jr., vol. 15, no. 108, Connecticut Historical Society, Hartford. Stuart's opinion is in Dunlap, *History*, 1:199. For a cursory discussion of the case and full quotations from what survives—the bill of equity and the writ of injunction—see E. P. Richardson, "China Trade Portraits of Washington After Stuart," *Pennsylvania Magazine of History and Biography* 94, no. 1 (Jan. 1970): 95–100. G. C. Mason (*Stuart*, 114, 139) gave the similar story of [Peter] Blight, another merchant involved in the China trade. Inasmuch as there is no record of a law case involving Blight, this is undoubtedly the Sword case, Blight being included as one of his "associates." See Stewart [*sic*] v. Swords [*sic*], case no. 1, May Session, 1802, United States Circuit Court for the Eastern District of Pennsylvania, Records of the District Courts of the United States, Record

Group 21, National Archives—Mid-Atlantic Region, Philadelphia (copies from this file are at the Historical Society of Pennsylvania, Philadelphia). There is no reference to precedent in the bill of equity, which suggests that this case is the first of its kind. For the rarity of the case, see, for instance, John D. Gordan III, "Morse v. Reid: The First Reported Federal Copyright Case," *Law and History Review* 10, no. 1 (Spring 1992): 21–41, on the first known federal copyright case [1798], which concerned books, protected by law. The first copyright law concerning prints was passed by Congress on Apr. 29, 1802, and it is under this law that Stuart copyrighted his engraving of McKean and seems to have intended to work with Edwin. Heath had his engraving of the Lansdowne portrait copyrighted in England and then took advantage of the 1802 copyright law in the United States to obtain an American copyright as well (see Copyright Office, *Copyright Enactments: Laws Passed in the United States Since 1783 Relating to Copyright* [Washington, D.C.: U.S. Government Printing Office, 1963], 25; and E. McSherry Fowble, *Two Centuries of Prints in America, 1680–1880: A Selective Catalogue of the Winterthur Museum Collection* [Charlottesville: University Press of Virginia for the Henry Francis du Pont Winterthur Museum, 1987], no. 203). Stuart's problem with the circulation of inferior engravings concerned his other portraits as well; see, for instance, Horatio Gates's letter of Dec. 22, 1796, to Ebenezer Stevens, allowing the engraver Cornelius Tiebout to copy Stuart's portrait of Gates (photocopy, University of Virginia, Alderman Library, Charlottesville).

21. On fears about authenticity, see, for example, the report of Benjamin Henry Latrobe and William Stephen Jacobs of May 6, 1803, concerning a copy of the Athenaeum portrait that the American Philosophical Society was considering buying from Stuart: "Report of the Committee to Whom Was Referred the Consideration . . . of a Portrait of General (George) Washington, Painted by Gilbert Stuart," American Philosophical Society, Philadelphia. For Stuart's reply, see Stuart, "Stuart Portraits," 370. For the Gibbs-Channing-Avery portrait, see Mason, *Stuart,* 90; and Elizabeth Bryant Johnston, *Original Portraits of Washington, Including Statues, Monuments, and Medals* (Boston: J. R. Osgood, 1882), 93. Of the many authors who have considered the difficult question of the authenticity of extant versions of Stuart's Washington portraits, the best appears to have been John Hill Morgan, who gave his views in Morgan and Fielding, *Life Portraits.* On the heirloom issue, see Christopher Hughes's letter of Dec. 21, 1825, to Harrison Gray Otis, Harrison Gray Otis Papers, 1821–26, Massachusetts Historical Society, Boston.

22. See Stuart's letter of Feb. 16, 1801, addressed "Sir," regarding the portrait for the state of Connecticut and the payment due for the farm, Simon Gratz Collection, Historical Society of Pennsylvania, Philadelphia. On the farm, see Dunlap, *History,* 1:209; Mason, *Stuart,* 46–47; and Stuart, "Stuart Portraits," 373. Jane Stuart, along with Mason, said that Stuart had stocked the farm with an imported Durham breed. Dunlap located the farm "near Pottsville," while Herring and Longacre (*National Portrait*

Gallery, 1:6) said it was "at Pottsgrove." See *Aurora General Advertiser,* May 8, 1801, 3; Mason, *Stuart,* 47; and Thomas Boylston Adams's letter of May 31, 1801, in Andrew Oliver, *Portraits of John and Abigail Adams* (Cambridge: Belknap Press of Harvard University Press, 1967), 133. Adams—more accurate than Mason—mentioned the English creditor and added: "How soon he may be served with similar process, for debts contracted here, is more than I can answer." In fact, Stuart had already been sued in an amiable action case concerning a grocer's unpaid bill in December of 1800, in which, as in the Sword case, Stuart was represented by the lawyer Alexander James Dallas, one of his sitters and later U.S. Secretary of the Treasury. On Dec. 15, 1800, this case was referred to a panel of arbitrators, but the file on the case does not appear to have survived (see Robertson v. Stewart [*sic*], case no. 346, Common Pleas Docket, December Term, 1800, p. 362, Department of Records, City Hall, Philadelphia). According to Cornelius William Stafford's *Philadelphia Directory for 1800* ([Philadelphia]: Cornelius W. Stafford, 1800), the only Philadelphian with the plaintiff's name—James Robertson—was a grocer. Stuart was known for spending money lavishly on fine food and drink (see Watson, *Annals,* 2:65; and Mason, *Stuart,* 30).

23. See Mason, *Stuart,* 29; and Mason, "Diary," 2:24–25.

24. On Peale, see Carol Eaton Hevner in Miller et al., *In Pursuit of Fame,* 249. On the Athenaeum portrait, see "Stuart's Washington," *Daily Evening Transcript,* Sept. 24, 1852, 1, where the claim is made that the portrait was unrolled to show a visitor in about 1815; the letter of July 31, 1817, from Mrs. Samuel Farmer Jarvis to her husband, Papers of the Reverend Samuel Farmer Jarvis, Records of the Cathedral Church of St. Paul, Archives of the Episcopal Diocese of Massachusetts, Boston, indicating that the portrait was on display in the studio; and Dunlap, *History,* 1:197, where the portrait is said to have been on Stuart's studio door in 1822. At least one visitor thought that Stuart's painting room at Fort Hill was "in the house that was Washington's headquarters during the Revolution" (see George W. Bond's letter of Aug. 2, 1878, to G. C. Mason, "Letters to G. C. Mason"). On Stuart's association with Washington, see Stuart's obituary in Philadelphia's *Aurora and Pennsylvania Gazette,* July 16, 1828, 2.

CHAPTER 6

1. For Stuart's approximate arrival date, see Benjamin H. Latrobe's letter of Dec. 13, 1803, quoted in Talbot Hamlin, *Benjamin Henry Latrobe* (New York: Oxford University Press, 1955), 315. His quarters in Washington, the "marsh miasmata," his fever, his risk of dying, and Latrobe's fear of loss of rent are discussed in Latrobe's letters: Sept. 26, 1803, to John Lenthall; Mar. 12, 1805, to John Vaughan; Mar. 13, 1805, to Stuart; and Oct. 3, 1811, to a Mr. De Lormerie (see *The Correspondence and Miscellaneous Papers of Benjamin Henry Latrobe,* ed. John C. Van Horne and Lee W. Formwalt [New Haven: Yale University Press for the

Maryland Historical Society, 1984–86], 1:326; 2:24–27; 3:154n). Stuart's 1802 plan is given in his statement as a complainant in the circuit-court records for Stewart [*sic*] v. Swords [*sic*] (see Richardson, "China Trade Portraits," 96). For the sake of further commissions, Stuart traveled to Baltimore from Washington (Whitley, *Stuart,* 122). On his finishing pictures quickly, his workload, and a painting trip to a Maryland estate, see Margaret Law Callcott, *Mistress of Riversdale: The Plantation Letters of Rosalie Stier Calvert, 1795–1821* (Baltimore: Johns Hopkins University Press, 1991), 80, 120n. Stuart's letter of May 15, 1804, to Edward Stow, reports payments sent to the artist's family in Bordentown, New Jersey. The missing middle portion of this letter is quoted in Whitley, *Stuart,* 116–17; the beginning and ending of what must be the same letter, seamed together as one and bearing the same date, belong to Joseph Rubinfine, American Historical Autographs, West Palm Beach, Florida. Photostats from the original copies of both Whitley's and Rubinfine's excerpts, with a small section missing, are filed together as if parts of one letter, at the Massachusetts Historical Society in Boston. Mount (*Stuart,* 253–54), not noticing the seaming and rejecting the coincidence of date, treated the excerpts, probably mistakenly, as two letters. He assumed, without evidence, from the first excerpt, that Stuart was maligning his wife, and, from the shortness of the second excerpt, that Stuart was indifferent to the trouble Stow had taken on his behalf. The artist's invitation to visit Boston is mentioned in John Trumbull, *Autobiography, Reminiscences and Letters by John Trumbull from 1756 to 1841* (New York: Wiley and Putnam, 1841; New Haven: B. L. Hamlen, 1841), 244–45. Stuart's arrival in Boston was announced as a visit in *Columbian Centinel,* July 31, 1805 (Whitley, *Stuart,* 126). His Boston addresses are given in Dunlap, *History,* 1:208; augmented by Park, *Stuart,* 1:59. The observer's remark is in a copy of a letter of May 1804, from an unidentified friend to Anna P. Cutts, Cutts Collection of the James and Dolley Madison Papers, microfilm reel 14326, Manuscript Division, Library of Congress.

2. On Washington society, see Rosalie E. Calvert's letter of Aug. 8, 1805, in Callcott, *Mistress of Riversdale,* 124. Regarding insecure beginnings, see, as an example, the praise of a copy of Stuart's Lansdowne portrait on exhibition in New York: "Foreigners of the first taste have rapturously pronounced it 'the masterpiece of painting!'" (*Federal Gazette and Baltimore Daily Advertiser,* Feb. 27, 1798, 3; quoted from *New-York Gazette*). Stuart's popularity is mentioned in a letter of May 7, 1804, to Anna P. Cutts from an unidentified friend, Cutts Collection of the James and Dolley Madison Papers, University of Chicago, microfilm reel 14326, Library of Congress. For more on the deliberate use of association in works of the period, see Wark in Reynolds, *Discourses,* xxvi.

3. On Dunn, see Park, *Stuart,* 1:294; and Miles et al., *American Paintings,* 216–18. On Ramsay's portrait and its type, see Shawe-Taylor, *Genial Company,* 50, 58. For similar dress as connected with writers and artists, see Penny, *Reynolds,*

248; and Ribeiro, *Art of Dress,* 3–4. For Dunn's admiration for Indian society, his adoption by a Miami chief, and his attempt to write poetry in an Indian language, see his "Notices Relative to Some of the Native Tribes of North America," in *Transactions of the Royal Irish Academy* (Dublin: Printed for the Academy by George Bonham, 1803), 9:101, 102, 105n, 107, 132, 133, 134n. On the gesture of friendship, see Zirka Zaremba Filipczak in Arthur K. Wheelock, Jr., et al., *Anthony Van Dyck* (New York: H. N. Abrams, 1990), 62; see also Cesare Ripa, *Baroque and Rococo Pictorial Imagery: The 1758–60 Hertel Edition of Ripa's "Iconologia,"* trans. Edward A. Maser (New York: Dover, 1971), 43, 52. Stuart's interest in poetry is clear from a poem he wrote to acknowledge the verses he had received, praising his artistic ability, from one of his sitters, the published poet Sarah Apthorp Morton. Both poems, flattering to Stuart and perhaps with his approval, were published in *Port Folio,* June 18, 1803, 3:25. Dunn, friend to both the artist and Morton, may have played a role in having the poems published. On Dunn's portrait as a favorite, see Mason, *Stuart,* 176; and letters from Martin Brimmer (Aug. 8, 1878) and Thomas O. Selfridge (Oct. 22, 1878) in "Letters to G. C. Mason." Dunn's friendship is mentioned in Stuart, "Stuart Portraits," 371. This portrait apparently belonged to Dunn; another version (Museum of Fine Arts, Boston), probably second—with the position of the hand changed to grasp the collar, and some light added behind the head—belonged to Dunn's friends Sarah Apthorp Morton and Perez Morton. The effect of both changes is to add to the suggestion of spatial depth. Stuart retained an unfinished, initial sketch of the head (private collection), which he used in giving instruction to his pupils and which Jane Stuart inherited. For documentation of the latter, with Jane Stuart's annotated bill of sale, see the catalogue of the Percy A. Rockefeller sale, Parke-Bernet Galleries, New York, Nov. 20, 1947, no. 32, ill.

4. For quotations from Jefferson's correspondence regarding the sittings and Stuart's preference for the second likeness, see Stein, *Monticello,* 141. In Stuart's announcement (June 12, 1800) of a subscription for an engraving after the Munro-Lenox portrait of Washington, he mentioned that he also intended to have his portraits of Adams and Jefferson engraved (Park, *Stuart,* 1:50–51n). No engravings are known for any of these portraits. On Dec. 22, 1803, Stuart received half payment from Samuel Smith for a portrait of Jefferson to be delivered in six weeks. Smith never received the first life portrait, contrary to what Mount (*Stuart,* 263, 370) contended; this commission for a replica of the first portrait was never fulfilled (receipt and Christopher Hughes's letter of Dec. 21, 1825, to H. G. Otis, Harrison Gray Otis Papers, 1821–26, Massachusetts Historical Society, Boston). Stuart probably traveled to Washington specifically to paint a second portrait of Jefferson and one of Madison, as Mason (*Stuart,* 107) stated. James Bowdoin's 1805 commission to Stuart for half-length portraits of Jefferson and Madison undoubtedly prompted the second sitting (see Bowdoin's letter of Mar. 25, 1805, to H. Dearborn, Bowdoin Collection,

Bowdoin College Library, Brunswick, Maine). On the Bowdoin portraits, see Marvin S. Sadik, *Colonial and Federal Portraits at Bowdoin College* (Brunswick: Bowdoin College Museum of Art, 1966), 155–66. Both Mount (*Stuart*, 290, 370) and David Meschutt argued that the second life portrait was sold to Madison in 1806 and is the version now at Colonial Williamsburg (see Meschutt, "Gilbert Stuart's Portraits of Thomas Jefferson," *American Art Journal* 13, no. 1 [Winter 1981]: 12–13). Jefferson knew of the Madison version, however, having probably seen it, and called it a replica (Meschutt, "Portraits," 12). Furthermore, there is evidence that the second life portrait remained with Stuart after 1806. Pickering ("Interviews," Nov. 4, 1817) saw a "head" of Jefferson at Stuart's studio in 1817 and related that Stuart had spoken of it as an original, saying that it had been executed at one sitting. In 1818 Henry Dearborn, having visited Stuart, wrote to Jefferson of Stuart's unfinished portrait (Stein, *Monticello*, 139); in 1820 Dearborn mentioned that Stuart still had "[the] one" portrait of Jefferson (Meschutt, "Portraits," 7). This head that Stuart retained cannot be the missing 1800 life portrait because the replicas that he painted, after 1817, are of the 1805 type with Jefferson's parted hair conforming to its appearance in 1805. For evidence, compare the Gibbs-Coolidge portrait, now at the National Gallery of Art, Washington, D.C., and Nicolas Maurin's lithograph (fig. 95) after the now-destroyed Doggett portrait with the illustrations in Alfred L. Bush, *The Life Portraits of Thomas Jefferson* (Charlottesville: Thomas Jefferson Memorial Foundation, 1987). The question remains as to whether Stuart finally sent the 1805 life portrait or an 1821 replica of this portrait to Jefferson in 1821. The so-called Edgehill portrait that Jefferson received is a bust-length version on panel (Thomas Jefferson Memorial Foundation, Charlottesville, Va.; and National Portrait Gallery, Washington, D.C.). It is problematic as the original because the head is outlined in the manner Stuart used for replicas, and the portrait's style is more consistent with a date of 1821 than of 1805. Furthermore, Pickering described a relatively large-sized picture that, in the context of Stuart's work, implies a canvas support. Pickering ("Interviews," Nov. 4, 1817) called the portrait of Jefferson a "fine likeness" and said: "It is intended to be a *three-quarters* [about forty by thirty-two inches; Pickering included drawings to illustrate Stuart's sizes]. For this size, his price is $300." Dearborn later relayed Stuart's request that Jefferson let him know whether he wanted the original as "a common portrait [bust] or one of half the length of the Body, the former at $100 [which Jefferson had already paid], the latter $300" (letter from Dearborn to Jefferson, Mar. 3, 1820, Jefferson Papers, Library of Congress). The reply, switching pictures and saying that Jefferson would be happy with the bust-length portrait of 1800, rather than a half-length view, means that Jefferson remembered that the second life portrait, because of its size, had to be a half-length version; his answer seems to have spawned the bust replica that he received (letter from Jefferson to Dearborn, Mar. 26, 1820,

Jefferson Papers, Library of Congress). The Gibbs-Coolidge replica of the 1805 portrait, from about 1815–17, is also a traced bust on panel, which leaves two possibilities: that the 1805 original that Pickering saw is missing or, more likely, that it was completed as the half-length portrait of Jefferson, on canvas and about forty by thirty-two inches, that John Doggett obtained from Stuart probably just after the 1821 replica was sent to Jefferson. The Doggett portrait was destroyed in a fire at the Library of Congress in 1851. The cameo reference is in Mason, *Stuart*, 207. Jefferson's pride in his knowledge of the Romans is evident from a story in Pickering, "Interviews," Nov. 4, 1817. For a discussion of the antique-coin portrait as a type, see Shawe-Taylor, *Genial Company*, 53–57.

5. For adoration in the Sears portrait, see, for instance, Jennifer Montagu, *The Expression of the Passions: The Origin and Influence of Charles Le Brun's Conférence sur l'expression générale et particulière* (New Haven: Yale University Press, 1994), ill. 103, 104. For an image of the second portrait, see Park, *Stuart*, 4:454. The dating is based on Mason (*Stuart*, 253), who mistakenly recorded that the sketch (on panel) was cut out of its original canvas. The later overpaint that appears on the neck, drapery, and background of the sketch in Park's illustration (*Stuart*, 4:455) has since been removed, but the portrait still has the appearance of having been completed by another hand from the head down, particularly in the painting of the flesh. According to family tradition, Miriam Sears wanted her relatively short neck to appear longer. This wish may well have conditioned the setting of both poses. Martin Postle (*Reynolds*, 13–17) discusses Reynolds's use of the "uplifted" expression as a repeated type until the mid-1780s. Although Stuart painted portraits of Sears and her husband twice each, none of the portraits seems to have been intended as a companion piece. The sketch did belong to Miriam Sears, but, if it had been commissioned, we would expect it to have depended on separate sittings and to differ more from the finished, larger picture (which appears to show a younger woman) that Stuart did of her. Possibly, therefore, it is a fanciful copy, even a gift, from Stuart, who was a friend of the sitter's parents and had moved to Boston from Washington because of their urging (Mason, *Stuart*, 28). The story of cutting the head out could speak to the relationship between the two pictures.

6. As her son recorded (Pickering, "Interviews," Oct. 29, 1817; Nov. 4, 1817; Nov. 10, 1817), Rebecca Pickering sat four times to Stuart, who invented her ermine-edged cloak. Portraits such as hers and Miss Smith's usually required four sittings of probably about an hour. A simpler portrait might necessitate only three sittings. (For notes on Stuart's procedure in 1809, see Dickinson, "Remarks on Painting," 4, Joseph Downs Manuscript Collection, Henry Francis du Pont Winterthur Museum.) Yet Stuart could take much longer. One sitter complained of sitting daily for nearly two weeks and then having Stuart suddenly change his mind and want to begin again with another pose (Mason, "Diary," 2:23). Stuart, like many of

his contemporaries, did not usually sign his pictures, apparently considering it unnecessary because, as he said, "I mark them all over" (Dunlap, *History,* 1:218).

7. For a French prototype, see contemporary portraits by Jacques-Louis David, such as *Napoleon Crossing the Alps* of 1800 (Musée National, Versailles). See also Jouett in Morgan, *Stuart,* 86.

8. For Stuart's fanciful flesh color, see Jouett in Morgan, *Stuart,* 83. An example of a sitter's successful protest against the unrealistically high facial coloring in his portrait, the result of five sittings in 1823, can be found in the Salisbury family papers (see Forbes, "Family Portraits," 18). Horace Holley (letter of Apr. 18, 1818, in Holley, "Report") observed that "Stewart generally makes the color of the cheeks too brilliant, especially in the portraits of men, as in that of general Washington." Despite such reports, and perhaps chiefly with female subjects, Stuart could occasionally paint quite pale flesh, as in the portrait of Louisa Catherine Adams of ca. 1825 (The White House, Washington, D.C.), which the sitter thought, in its coloring and solemn expression, spoke too truthfully of inner suffering (see Oliver, *John Quincy Adams,* 85). The relevant quotations from Otis's journal are in Miles et al., *American Paintings,* 253. For more on the Orne, Benson, and Monroe portraits, see, respectively, Maytham et al., *Museum of Fine Arts,* 1:249; New-York Historical Society, *Catalogue of American Portraits in the New-York Historical Society* (New Haven: Yale University Press, 1974), 1:70–71; and John Caldwell et al., *American Paintings in the Metropolitan Museum of Art* (New York: The Metropolitan Museum of Art in Association with Princeton University Press, 1994), 194–95. G. C. Mason (*Stuart,* 278) recorded, from family hearsay, that Mrs. Williams had her portrait painted at age eighty-eight, which would give the portrait a date of 1824, the year of her death. The Monroe portrait is a replica, based on an 1817 life portrait (Museum of American Art, Pennsylvania Academy of the Fine Arts, Philadelphia), that does not have the same highlighting of the flesh.

9. For *luce di dentro,* a phrase borrowed from Titian, see William H. Gerdts and Theodore E. Stebbins, Jr., *"A Man of Genius": The Art of Washington Allston (1779–1843),* exh. cat. (Boston: Museum of Fine Arts, 1979), 32. Somewhat in support of his own coloring, Stuart thought that Titian's flesh colors had become blended and mellowed with time and were originally more distinct (Dunlap, *History,* 1:217). Allston said that he saw Stuart often both before and after his 1811–18 trip to Europe and "learned much from him" (Dunlap, *History,* 1:221). In a discussion of the two artists, Tuckerman (*Book of the Artists,* 112) separated them convincingly, concluding that Allston was inspired by "ideality" and Stuart by "sense" or acuteness of perception. A comparison of portraits by them of the same man, the Reverend William Ellery Channing, is quite telling. Stuart's portrait (The Fine Arts Museums of San Francisco), from probably about 1805, shows him, in his clerical bands, as the rather happy intellectual that

he reputedly was. Allston's portrait of 1811 (Museum of Fine Arts, Boston) presents him as more frail and serious, looking outward in a soulful stare. In contrast to Stuart, Allston attempted to paint the sitter's spiritual identity more than his individual personality. See Elizabeth Palmer Peabody, *Reminiscences of Rev. William Ellery Channing, D.D.* (Boston: Roberts Brothers, 1880), 342, for Allston thinking his own portrait too "gloomy" and for Channing's happy disposition. See also the Channing family's dislike of Stuart's portrait as "wanting in refined expression," in William Henry Channing, *Memoir of William Ellery Channing with Extracts from His Correspondence and Manuscripts* (London: J. Chapman, 1848), 3:493. Allston's mention of painting the soul is in the copy of his letter of Apr. 23, 1808, to John Vanderlyn, Dana Family Papers, Massachusetts Historical Society, Boston. For Hegel, see his *Aesthetics: Lectures on Fine Arts,* trans. T. M. Knox (Oxford: Clarendon Press, 1975), 2:810. On Stuart's reputation for painting flesh in 1827, see the quotation in Whitley, *Stuart,* 207. Unfortunately, Allston's correspondence is mostly missing from the crucial years when he met Stuart and was most interested in portraits.

10. For Waterhouse, see Dunlap, *History,* 1:219. On Stuart's intemperance, see Israel Whelen's letter of Aug. 6, 1800, to Oliver Wolcott, Jr., Papers of Oliver Wolcott, Jr., vol. 15, no. 108, Connecticut Historical Society, Hartford; and the copy of the letter of Nov. 18, 1817, to Mather Brown in "Mary and Catherine Byles Letterbook, 1808–18," 461, Massachusetts Historical Society, Boston. Stuart, who was a connoisseur of wines, bought wine, brandy, and gin by the cask in his Germantown days and later, in 1819, preferred to drink East Indian Madeira (Watson, *Annals,* 2:65; Neal, *Observations,* 69, 71). The reddening of his face is in Watson, *Annals,* 2:65.

11. From Anne Stuart's account (below) and the census records, Stuart appears to have had five sons and seven daughters. See Ronald Vern Jackson, ed., *Pennsylvania 1800 Census Index* (Salt Lake City: Accelerated Indexing Systems, 1972), vol. 2; Ronald Vern Jackson, *Massachusetts 1810 Census Index* (Salt Lake City: Accelerated Indexing Systems, 1981); and Ronald Vern Jackson et al., *Massachusetts 1820 Census Index* (Salt Lake City: Accelerated Indexing Systems, 1976). In 1800 and in 1810, Stuart's mother was living with him. Servants were counted in 1800, at which time Stuart had three. Since Jane is not listed in the 1820 census as under age ten, she seems to have been born before the 1812 date given by Powel ("Jane Stuart," 3) and not verified elsewhere. Her birth was not recorded (Registry Archives, City Hall, Boston). See Pickering, "Interviews," Nov. 10, 1817, for having heard of the son's dissipation and for Stuart's praise of his son's genius as a mathematician and an artist. The number of children and an appreciation of Charles as a landscapist is given by Anne Stuart in Updike, *History,* 1:291. See also Mason, *Stuart,* 47–48. For Charles's death from consumption, see Charles G. Stewart [*sic*] in "Boston Deaths, 1801–1848, N–S," Registry Archives, City Hall, Boston.

The observations of Stuart's neighbor are in "Stuart's Washington," *Daily Evening Transcript*, Sept. 24, 1852, 1. Neagle's comment is in Dunlap, *History*, 1:215.

12. See Pickering, "Interviews," Oct. 4, 1817. Stuart's linkage of the activity of a portrait painter with the activity of a mill horse is not unique; see, for instance, Sir Thomas Lawrence's complaint, in 1801, that portrait painting was a "dry mill-horse business" (Shawe-Taylor, *Georgians*, 7).

13. For Hart's anecdote, see Park, *Stuart*, 1:446. The date of the Jones portrait, which Jouett saw in Stuart's possession in 1816, must be 1813 or earlier, given that James Frothingham saw it before Stuart's son Charles died (Dunlap, *History*, 2:215). For *Jones* as a favorite portrait, see Jouett in Morgan, *Stuart*, 89.

14. Stuart criticized Copley's flesh color (see Dunlap, *History*, 1:217), but he also spoke highly of his work repeatedly (see, for instance, Dunlap, *History*, 1:125; Mason, *Stuart*, 164, 244; and Pickering, "Interviews," Nov. 17, 1810, and Oct. 4, 1817). For the quoted remark on Copley's portrait, see S. G. W. Benjamin, *Art in America: A Critical and Historical Sketch* (New York: Harper and Brothers, 1880), 20.

15. See John Adams's letter of Mar. 3, 1804, to F. A. van der Kemp ("Letters of John Adams, 1781–1825," 37, Historical Society of Pennsylvania, Philadelphia), in which he mentioned Stuart's first portrait of him, commissioned by the Massachusetts House of Representatives, as having been no more than a "first sketch." John Quincy Adams recalled that Stuart's first portrait (sketch) of his father had been "painted" in 1799, but the precise date can be considered uncertain inasmuch as the picture is a companion piece to one of Mrs. Adams, for which there exists a receipt of payment dated May 20, 1800. In 1815 Abigail Adams recorded her husband's second sitting for the completion of this first likeness (Oliver, *John and Abigail*, 169n, 132n, 140 [pp. in sequence cited]). For the comment on sneezing of ca. 1800, see Mason, *Stuart*, 142. The resulting portrait, with highlighting typical of Stuart's 1815 work, can still be interpreted as suggestive of sneezing. Oliver's argument (*John and Abigail*, 140–41) that two portraits were produced, one in 1798 and one in 1815, is unconvincing partly because his candidate for the earlier portrait is not persuasive. For Allston on the last life portrait, see Dunlap, *History*, 1:223. Concerning mimeticism, see Cogdell's "Diary," vol. 4, entry for Sept. 22, 1825. In comparing Stuart's portraits from studio visits of 1817 and 1825, Cogdell was struck by the superiority of the later work, finding a greater refinement of touch and a greater naturalism in 1825.

16. On the lack of challenge, see Allston in Whitley, *Stuart*, 223. For Stuart's sense of his own mortality stimulating him to greater effort, see Mary T. Peabody's letter of Jan. 27, 1825, to Rawlins Pickman, Horace Mann Papers, 2:1822–82, Massachusetts Historical Society, Boston. For Stuart's portraits as breathing, see Knapp, *American Biography*, 325; and "Original Portraits of Washington," *Putnam's Monthly Magazine* 6, no. 34 (Oct. 1855): 346. Jane Stuart mentioned the same effect, a momentary quality:

"We can almost fancy that he has given motion to the features" (Mason, *Stuart*, 37). The sensation of motion in the features would have been desirable as suggestive of sensibility; see Sir Charles Bell, *Essays on the Anatomy of Expression in Painting* (London: Longman, Hurst, Rees, and Orme, 1806), 102. On the tremor in his hands, see Dunlap, *History*, 1:87; and "Stuart's Washington," *Daily Evening Transcript*, Sept. 24, 1852, 1, where a neighbor noted that "though he could paint well enough, he wrote with difficulty." For Stuart's advice, see Jouett in Morgan, *Stuart*, 92, 84 (pp. in sequence cited).

17. See Winckelmann, *Reflections*, 32. For Sully, see John Neagle's Notebook No. 3, "Hints for a Painter with Regard to His Method of Study, etc.," entry for Sept. 23, 1832, American Philosophical Society, Philadelphia.

18. London artists such as Sir Thomas Lawrence were, in fact, quite interested in seeing Stuart's work. See, for instance, Farington, *Diary*, 3:858; Dunlap, *History*, 1:205–6; and Jonathan Mason's letter of July 16, 1878, in "Letters to G. C. Mason." On Doggett's plan, see Washington Allston, *The Correspondence of Washington Allston*, ed. Nathalia Wright (Lexington: University Press of Kentucky, 1993), 202–3. For the 1828 lithographs, done by Nicolas Maurin, see Mabel M. Swan, "The 'American Kings,'" *Antiques* 19, no. 4 (Apr. 1931): 278–81. The surviving likenesses from the set are of Madison (Mead Art Museum, Amherst College, Amherst, Mass.) and Monroe (Metropolitan Museum of Art, New York).

Stuart had earlier, between 1815 and 1817, filled a commission (from Colonel George Gibbs of Rhode Island) for a set of bust-length replicas of his pictures of the presidents (National Gallery of Art, Washington, D.C.). For this set, Stuart apparently based his likenesses on the following five portraits: the Athenaeum head of Washington (fig. 50, pl. 7) in his possession; the life portrait of Adams of ca. 1800 (fig. 88) that he retained; the Jefferson portrait that Pickering saw; his revision of his *Madison* (Colonial Williamsburg, Williamsburg, Va.) at Bowdoin College, Brunswick, Maine, which he copied (Sadik, *Portraits*, 159–60; Miles et al., *American Paintings*, 266); and his July 1817 life portrait of Monroe (Museum of American Art, Pennsylvania Academy of the Fine Arts, Philadelphia). The Gibbs-Coolidge series may have been intended originally as a set of four, Monroe's portrait, which is different in background, being added later and differentiated to separate him as the current president. This series and the Doggett set cannot have been planned or painted concurrently, contrary to a recent opinion (Miles et al., *American Paintings*, 266). Having released his life portrait of Monroe to the sitter, Stuart had to borrow back the Gibbs replica in 1821 as the basis for the Doggett replica (see Stuart's letter to Gibbs of May 19, 1821, Papers of Oliver Wolcott, Jr., vol. 48, no. 103, Connecticut Historical Society, Hartford). He had finally delivered the likeness of Adams of ca. 1800, in December of 1815, but he was able to convince Adams to sit again in 1821 for the Doggett portrait (see Miles et al., *Ameri-*

can Paintings, 212n; and Oliver, *John and Abigail,* 161). According to *Boston Daily Advertiser,* Doggett had received his pictures and could announce their exhibition on June 20, 1822 (Sadik, *Portraits,* 160). For the Jefferson portrait and the lithographs, see n. 4 of this chapter. For Allston, see his letter to Charles Robert Leslie of Feb. 7, 1823, in Allston, *Correspondence,* 202.

19. On the Adams commission, see *Memoirs of John Quincy Adams, Comprising Portions of His Diary from 1795 to 1848,* ed. Charles Francis Adams (Philadelphia: J. B. Lippincott, 1875), 6:175–76. On brilliant conversation, see Louisa Adams in Oliver, *John and Abigail,* 161. Indeed, his conversation was such that Daniel Webster is said to have visited him often for the pleasure of talking (Stuart, "Anecdotes," 377). Josiah Quincy is quoted in his *Figures of the Past* (Boston: Little, Brown, 1926), 71.

20. See Quincy, *Figures,* 71; and Allston in Dunlap, *History,* 1:223.

21. On likeness, see the strong resemblance to J. H. I. Browere's plaster bust of Adams (New York State Historical Association, Cooperstown), done two years later from a life mask. The bust shows a more embittered and withdrawn face. See Charles Francis Adams's diary entry for Aug. 27, 1829, quoted in Oliver, *John and Abigail,* 191; and Allston's quote in Dunlap, *History,* 1:223. Charles Francis Adams paid to have the whitewashed parlor walls at the Adams homestead in Quincy stripped of paint in 1851, revealing—probably for the first time—the dark mahogany that is seen today (Apr. 1851 entry in his financial journal, Massachusetts Historical Society, Boston; microfilm copy at the Adams National Historic Site, Quincy, Mass.).

22. For "intensity of feeling" as characteristic of Adams, see Peter Shaw, *The Character of John Adams* (Chapel Hill: University of North Carolina Press, 1976), 317.

23. For Allston, see Gerdts and Stebbins, *Allston,* 11. On Stuart's belief, see his mention of death as the phenomenon of being "taken to the bosom of God" in Sarah A. Cunningham's letter of Aug. 5, 1825, to her daughter Griselda, Morton-Cunningham-Clinch Family Papers, 1754–1903, Massachusetts Historical Society, Boston. See also Jouett in Morgan, *Stuart,* 83; Knapp, *American Biography,* 326; Mason, *Stuart,* 59; Dunlap, *History,* 1:209; and Stuart, "Anecdotes," 377. On Longinus, see *Longinus on the Sublime,* section with Smith's translation, 18, 32, xviii, xxxiii [pp. in sequence cited]. See also Usher, *Clio,* 246.

 On reading *Spectator,* see Dunlap, *History,* 1:199. For Addison, see *Spectator,* vol. 8, no. 565; quoted in Joseph Addison, *The Addisonian Miscellany, Being a Selection of Valuable Pieces from . . . the Spectator, Tatler, and Guardian to Which is Prefixed the Life of Joseph Addison, Esq.* (Boston: Bumstead, 1801), 289.

24. Regarding this luminosity, a New York journalist could characterize Stuart's recent work in 1827 as "his late, powerful, and brilliant, glowing heads" (Whitley, *Stuart,* 207). The reference to "motion" is Jane Stuart's (Mason, *Stuart,* 37). Stuart's *General Amasa Davis* (Detroit Institute of Arts), from about 1820, is an example of such en-livening of the face. For Stuart on flesh, see Jouett in Morgan, *Stuart,* 83. The "works of the Almighty" reference is in "American Painters," *American Quarterly Review* 17, no. 33 (Mar. 1835): 177. On the problem of interest, see Mason, *Stuart,* 143. The "works of God" quotation is from Jane Stuart (Mason, *Stuart,* 38). Stuart made a similar comment, although in a half-joking context, when his portrait of Daniel Webster was criticized as too handsome: "God made him so," he replied (see Sarah A. Cunningham's letter of Aug. 5, 1825, to her daughter Griselda, Morton-Cunningham-Clinch Family Papers, 1754–1903, Massachusetts Historical Society, Boston). Allston showed his kinship with Stuart when, years later, he wrote: "Who can look into the human eye, and doubt of an influence not of the body?" (See *Lectures on Art and Poems (1850) and Monaldi (1841) by Washington Allston,* ed. Nathalia Wright [Gainesville, Fla.: Scholars' Facsimiles and Reprints, 1967], 113.)

25. For Neagle, see his eulogy in the newspaper clipping of July 21, 1828, in his "Scrap Book," vol. 1, Historical Society of Pennsylvania, Philadelphia. See also Stuart, "Anecdotes," 380. For commentary on "authentic hints," see Tuckerman, *Book of the Artists,* 112. The "immortal energies" are mentioned in "American Painters," *American Quarterly Review* 17, no. 33 (Mar. 1835): 177. See also Hopkinson, "Annual Discourse," *Port Folio* 4 (Dec. 1810), supplement, 6–7. The way Stuart's sitters thought is voiced, for instance, by an elderly Mrs. Peabody: In an undated letter of probably 1809, she wrote of sitting to Stuart and feeling apprehensive about her looks, but she remained optimistic that the portrait would express her benevolence and her sentiments, which she hoped would "illumine [her] countenance" (Park, *Stuart,* 2:579). Another sitter, William Ellery Channing, expressed disappointment in 1835 that in the several portraits of himself, including Stuart's, "so little benevolence has beamed from the features" (Channing, *Memoir,* 494).

26. For the column as possibly derived from its appearance as an emblem in traditional illustrations of Samson or the personification of Force, see Rebora et al., *Copley,* 187 (the author interprets this portrait as concerned with worldliness). For inwardness, see Neal, *Observations,* 73.

27. See the quotation from a 1915 *Bulletin of the Worcester Art Museum* in Park, *Stuart,* 2:535. Morton, following a respected tradition, wrote a poem in praise of Stuart's talent after having sat to him. This poem and an answering one by Stuart were published together in Philadelphia in *Port Folio* for June 18, 1803. In his response, Stuart gallantly paid tribute to Morton's beauty and acknowledged the superiority of poetry, especially great poetry such as Homer's, to his own painting. He may have been infatuated with Morton while he wrote the poem, but these two exercises are not convincing as the sole evidence of a love affair between the authors, as Mount (*Stuart,* 248) claimed. For evidence to the contrary, see the bemused and indifferent description of Stuart in a letter of Aug. 5, 1825, from Sarah A. Cunningham (Sarah Morton's later married name) to her daughter Griselda, Morton-

28. Stuart made reference to the transitoriness of temporal experience in other works as well: the effect of breathing is recalled, for instance, in the portrait of William Winthrop (fig. 93, pl. 13). For the butterfly title, see G. A. Bethune's letter of Aug. 5, 1878, in "Letters to G. C. Mason." The date is based on Dutton's probable age, he having been born in 1812. For a discussion of the butterfly motif and its meaning, see Wendorf, *Elements,* 182–83, 297–98. On the morning glory, see Alice M. Coats, *Flowers and Their Histories* (New York: McGraw-Hill, 1968), 59. For Stuart's independence, see Eliza Susan Quincy's letter of Sept. 21, 1878, in "Letters to G. C. Mason." On Stuart and flowers, see Herbert, *Irish Varieties,* 244. Stuart also used emblems of mortality—this time in reference to war—in his full-length *Louis-Marie, Vicomte de Noailles* of 1798 (Metropolitan Museum of Art, New York), which includes a horse's skull and a snake as memento mori.

29. The Bowditch portrait, reduced in size after Stuart's death, can be dated to a commission of Jan. 3, 1827 (see Henry J. Bowditch's letter of Sept. 2, 1878, in "Letters to G. C. Mason." The Allston portrait is less precisely dated. Although assigned to 1828 by Park (*Stuart,* 1:98), it may date from about 1818 (after Allston's return to Boston) or 1820, given that Edmund Dwight commissioned it along with a portrait of Daniel Webster, traditionally thought to date from 1817 (Hood Museum of Art, Dartmouth College, Hanover, N.H.), and later a portrait of Edward Everett (Harvard University Portrait Collection, Cambridge, Mass.). Everett recalled his as dating from 1820 (Park, *Stuart,* 1:316). Concerning Dwight's commission, see Mary Eliot Parkman's letter of Oct. 12 [1877?], in "Letters to G. C. Mason." On the connection between the rejection of corporeality and the "delicate sensations of the age of sensibility," see Roy Porter, "Bodies of Thought: Thoughts about the Body in Eighteenth-Century England," in *Interpretation and Cultural History,* ed. Joan H. Pittock and Andrew Wear (Basingstoke: Macmillan, 1991), 91–92. For "apparitions," see Dunlap, *History,* 1:223.

30. Mason, *Stuart,* 149 (meaning, "Let it be preserved holy and inviolate").

31. On Selfridge (1775–1816), see Jouett in Morgan, *Stuart,* 87. For Selfridge's portrait as a favorite, see the letter of his son, Thomas O. Selfridge, dated Oct. 22, 1878, in "Letters to G. C. Mason." The son spoke of the resemblance as perfect, his father and Stuart as "friendly," and the portrait as dating from 1814 or 1815. Without knowledge of this letter, the authors of a recent book mistook the son (1804–1902) for the sitter and mistakenly dated the portrait ca. 1826 (Carol Troyen et al., *American Paintings in the Museum of Fine Arts, Boston: An Illustrated Summary Catalogue* [Boston: Museum of Fine Arts, 1997],

263). Park (*Stuart,* 2:673–74) also confused the father and son. Selfridge was indeed proud and, as an attorney and a Federalist, became involved in a well-publicized duel when his ethical conduct and political motives were questioned (note in curatorial files, Museum of Fine Arts, Boston). Regarding Jane, see, for example, Samuel F. Jarvis's letter of Sept. 9, 1878, where it is said that she painted the robe, hands, and background in a portrait that Stuart had refused to finish because of a criticism (Park, *Stuart,* 2:673–74). Mary E. Powel ("Jane Stuart," 12) mentioned Jane's bodies and backgrounds, including a seascape. For the tailor reference, see Horace Holley's letter of Apr. 8, 1818, in Holley, "Report." Regarding tradesmen, it is clear that Stuart strove to maintain the status of a gentleman and very much wanted to separate his work from association with that of mere physical labor. See Jouett in Morgan, *Stuart,* 91; and Jane Stuart in Mason, *Stuart,* 38. The confirming evidence in Dunlap (*History,* 1:218) is particularly memorable: when a portrait was returned to Stuart because the painting of the cravat made the muslin appear to be too coarse, he threatened to return the picture with a piece of the finest muslin glued to the offensive part. Stuart delighted in witty suggestion of form. See, for instance, his portrait of John Bill Ricketts (National Gallery of Art, Washington, D.C.) in which the head of a horse is adumbrated in the background.

32. On the Greeks, see Knapp, *American Biography,* 328; and Pliny the Elder, *The Elder Pliny's Chapters on the History of Art,* trans. K. Jex-Blake (Chicago: Argonaut, 1968), 111, 133. For Allston, see Dunlap, *History,* 1:214. Years later, Allston rephrased his remark, adding that it seemed to him that Van Dyck and Stuart "looked at Nature with the same eyes" (*New-York Mirror, A Weekly Journal, Devoted to Literature and the Fine Arts,* Oct. 24, 1835, 131). On Hayward's portrait as the artist's final work, see the 1828 catalogue quoted in Mason, *Stuart,* 197. Dunlap (*History,* 1:209) mentioned an unfinished picture of John Quincy Adams as his last. This portrait (Harvard University Portrait Collection, Cambridge, Mass.), dating from 1825 and intended to be a full-length view, was completed below the head by Thomas Sully. See Oliver, *John Quincy Adams,* 123–25.

33. On the importance of the nose, see Dunlap, *History,* 1:218. For projection, see Mason, *Stuart,* 71.

34. For Stuart's students—not all of whom are known—see Morgan, *Stuart.* On his kindness to artists, see Dunlap, *History,* 1:223. His local status is evident as well in the role he played in the approval of a design, in the 1820s, for a Bunker Hill monument (see Whitley, *Stuart,* 186). In 1826 the English art critic John Neal quoted Allston on respect for Stuart's artistic judgment: "'Stuart's word in the art is law and from his decision there is no appeal,' [to which Neal added] and so say all the good painters of America" (see Whitley, *Stuart,* 205). Stuart suggested changes in the perspective of Allston's painting and advised that Daniel's open right hand be changed to a clenched fist, more expressive of emotion (see David Bje-

[At top of left column, continuation of note 27:]

Cunningham-Clinch Family Papers, 1754–1903, Massachusetts Historical Society, Boston. Morton wrote that he was "as eccentric, as dirty [especially with snuff and paint], & as entertaining as ever." The rest of the letter, recounting their conversation, suggests that she did not know him well.

lajac, *Millennial Desire and the Apocalyptic Vision of Washington Allston* [Washington, D.C.: Smithsonian Institution Press, 1988], 115, 142). See also Pickering, "Interviews," Aug. 19, 1817; and James Barton Longacre's diary, entries for July 21, 23, 24, and 29, 1825, Longacre Family Papers, microfilm reel 1083, Archives of American Art, Washington, D.C. For the sculptor, see Cogdell's "Diary," vol. 4, entry for Sept. 19, 1825. See also C. Edwards Lester, *The Artists of America: A Series of Biographical Sketches of American Artists* (New York: Baker and Scribner, 1846), 131.

35. See Cogdell's "Diary," vol. 3, entries for Sept. 18 and 15, 1816. Stuart gave paid instruction, but he also gave free lessons to, among others, Rembrandt Peale (Mason, *Stuart,* 72) and Lewis Peckham. In 1810, although he was strapped for money, he refused to take pay from Peckham—an artist, musician, and soldier from Newport. He gave him canvas and paints and said he would teach him for as long as he wished. Others attested to Stuart's kindness as a teacher, and Peckham confirmed this in saying that he felt "somewhat surprised in finding a man who appears to be so anxious for my improvement" (see Wilbur D. Peat, *Pioneer Painters of Indiana* [Indianapolis: Art Association of Indianapolis, 1954], 15). For the last quotes from Cogdell, see his "Diary," vol. 3, entry for Sept. 13, 1816. For "many little tints," see Dickinson, "Remarks on Painting," section for 1809, 5, Joseph Downs Manuscript Collection, Henry Francis du Pont Winterthur Museum, Winterthur, Del.

36. For gout and infirmities, see Dunlap, *History,* 1:208, 222. For asthma, see the quotation in Park, *Stuart,* 1:205. On life expectancy, see Horace Holley's letter of Apr. 8, 1818, in Holley, "Report." On paralysis, see Dunlap, *History,* 1:216; and Mason, *Stuart,* 29 (describing death also).

37. The letter of July 21, 1828, from Waterhouse to John Quincy Adams is quoted in Oliver, *John Quincy Adams,* 125–26.

38. Stuart's nephew on his sister's side, Gilbert Stuart Newton, was confined to a "mad-house" in 1834 (Dunlap, *Diary,* 3:778). Mary E. Powel ("Jane Stuart," 15) reported that Stuart's daughter Emma Stebbins "had been long an invalid under medical care in Providence" and that Stuart's daughter Anne, whom she knew, seemed depressed. Her unpublished notes go further in actually stating that Emma was insane (Stuart File, Newport Historical Society, Newport, R.I.). Very possibly she lived at a psychiatric hospital that opened in Providence in 1847; this cannot be confirmed, however, because the hospital prohibits outside access to records of former patients (letter to the author of Nov. 10, 1997, from Ann G. Beardsley, Director of Information Management, Butler Hospital, Providence). The unidentified insane son is mentioned again in Jane's obituary; she helped to support him as well as the rest of the family through her painting career after her father's death (*Newport Mercury,* May 8, 1888, Newport Obituary File, Newport Historical Society, Newport, R.I.). On the history of manic-depression, see George Winokur, Paula J. Clayton, and Theodore Reich, *Manic Depressive Illness* (St. Louis: C. V. Mosby, 1969), 2. See also Kay R. Jamison, *Touched with Fire: Manic-Depressive Illness and the Artistic Temperament* (New York: Free Press, 1993; Toronto: Maxwell Macmillan Canada, 1993; New York: Maxwell Macmillan International, 1993), 13, 265, 27, 18, 126, 262 (pp. in sequence cited). For insanity and manic-depression often occurring in the same families, see Jamison, *Touched with Fire,* 194. For Waterhouse, see Dunlap, *History,* 1:167; and for Anthony, see Hart, "Stuart's Portraits of Men," 95.

39. An instance in which Stuart's illness may have prevented him from working is mentioned in Mason, *Stuart,* 238. Stuart had been commissioned by Thomas H. Perkins to furnish a likeness of his brother, James, who was well acquainted with the artist. The "hours given to sittings had been passed in conversation," however, so that when James suddenly died of pneumonia and his brother called to retrieve the portrait that he expected to be "nearly finished," he found only a sketch on Stuart's easel. Weeks later, Stuart finished the portrait (private collection), which the family affirmed as a perfect likeness, done from memory and, most likely, from a cast. In fact, Stuart must have been using casts all along, chiefly because of his illness, though the reason would not have been known to the general public.

 On the picture of Dr. William Hunter's two dogs lying under a table, see Stuart, "Youth," 641; and Mason, *Stuart,* 5–6. On Stuart's unevenness, as noticed by his contemporaries, see Dunlap, *History,* 1:214. For a routine of walking, see Dunlap, *History,* 1:213. For a studio filled with unfinished paintings, see, for instance, Cogdell's "Diary," vol. 3, entry for Sept. 13, 1816, and vol. 4, entry for Sept. 19, 1825. On the distractibility of a manic-depressive and the need to simplify creative work, see D. Jablow Hershman and Julian Lieb, *The Key to Genius: Manic Depression and the Creative Life* (Buffalo, N.Y.: Prometheus Books, 1988), 183, 181 (pp. in sequence cited).

40. See Louisa Adams in Oliver, *John and Abigail,* 161–62; and Mason, *Stuart,* 30. Stuart would also refuse to begin a portrait. See Dunlap, *History,* 1:167–68.

41. For "reckless extravagance," see Stuart, "Youth," 645. This agrees with the artist's earlier reputation as a spendthrift, mentioned in *The Times* of London, Jan. 8, 1788, 2. Stuart probably rented rather than bought the New Burlington Street house, which was described, in the poor-rate records, as "empty"—presumably meaning unfurnished—before Stuart moved in (see the poor-rate records for St. James's, Piccadilly, for 1784 [D105], at the Westminster City Archives, London). The rug is in Mason, *Stuart,* 99–100; the cow is in Stuart, "Anecdotes," 378; the organ is in Nathan Negus's "Memorandum Book," entry for Jan. 3, 1820, microfilm reel no. 611, Archives of American Art, Smithsonian Institution, Washington, D.C.

42. The stockings episode is in Dunlap, *History,* 1:193n. For the cannon story, see Whitley, *Stuart,* 61–62. The inferior-beef incident is in Watson, *Annals,* 2:65. For Pickering, see his "Interviews," Oct. 4 and Dec. 8, 1817; admittedly, there could be a kernel of truth in what Stuart told

Pickering. The corncob reference is in Dunlap, *Diary,* 3:692. See also Dunlap, *History,* 1:182, 189, 191, 219. On the painting rooms, see chap. 5, n. 4.

43. Suicide might seem to be an exaggeration, but Stuart could become severely depressed, and he spoke at least once of a dead person as fortunate in not having to contend with the "troubles and vexations of this miserable world" (Sarah A. Cunningham's letter of Aug. 5–12, 1825, to her daughter Griselda, Morton-Cunningham-Clinch Family Papers, 1754–1903, Massachusetts Historical Society, Boston). The letters from Stuart's children—Charles and Elizabeth—are to Edward Stow, a merchant and broker who became bankrupt in 1802. Although the letters cannot be located, evidence of their having existed can be found in Park, *Stuart,* 1:56; and they are partially quoted in Theodore Bolton's review of Whitley's book on Stuart in *New England Quarterly* 5, no. 4 (Oct. 1932): 839. Theodore Sizer, Trumbull's biographer, sent a copy of Trumbull's letter (location unknown) to Mount (quoted in Mount, *Stuart,* 241, 352). On genius and Stuart's eccentricity, see Dunlap, *History,* 1:171, 210; a copy of a letter of May 1804, from an unidentified friend to Anna P. Cutts, Cutts Collection of the James and Dolley Madison Papers, microfilm reel 14326, Manuscript Division, Library of Congress; Cogdell's "Diary," vol. 3, entry for Sept. 13, 1816; and Mason, "Diary," 2:21.

The connection that was once made between genius and eccentricity is now often posited between genius and manic-depression. See Hershman and Lieb, *Key to Genius,* 12: "Manic-depression is almost, but not absolutely, essential in genius."

44. See Jouett in Morgan, *Stuart,* 82. On the need to control imagination as a neoclassical stance, see Irène Simon, *Neo-classical Criticism, 1660–1800* (Columbia: University of South Carolina Press, 1971), 20–21. On strong will, see Waterhouse, "Memoirs," entry for Mar. 5, 1839. For uncontrollable passions, see Dunlap, *History,* 1:195. Stuart was well aware of the potential for self-expression in painting. For instance, he considered "spirited touches" expressive of an artist's "impetuous disposition" (Dunlap, *History,* 1:217). On destruction of pictures, see Eliza Susan Quincy's letter of Sept. 9, 1878, in "Letters to G. C. Mason." See also Pickering, "Interviews," entry for Dec. 8, 1817.

45. Stuart's quoted statement is in Dunlap, *History,* 1:185. See Pickering, "Interviews," entry for Oct. 4, 1817; and "Stuart's Washington," *Boston Evening Transcript,* Sept. 24, 1852, 1. According to Knapp (*American Biography,* 326), Stuart "always contended that a regard should be had to the moral as well as physical, in making a just portrait of a man." This brings to mind the dismissive criticism, made by Reynolds's friend Samuel Johnson,

of palace portraits that, "however excellent, neither imply the owner's virtue, nor excite it" (James Northcote, *The Life of Sir Joshua Reynolds* [London: Henry Colburn, 1819], 1:240); also Reynolds's praise of "what excites ideas of grandeur, or raises and dignifies humanity; or, in the words of a late poet [Oliver Goldsmith], which makes the beholder *learn to venerate himself as man*" (*Discourses,* 130). Relevant also is the poet William Wordsworth's explanation: "'What I should myself most value in my attempts [is] the spirituality with which I have endeavoured to invest the material Universe, and the moral relation under which I have wished to exhibit its most ordinary appearances'" (Engell, *Creative Imagination,* 275). See also Hogarth, *Analysis,* 131; and Melville, *Pierre, or The Ambiguities,* ed. Hershel Parker (New York: Harper Collins, 1995), 44. Melville's opinion is not confined to that of a later generation; Knapp (*American Biography,* 325) had described Stuart in 1829 as standing "at the head of his profession as a painter of *the human face divine.*" ("Human face divine" is a quotation from John Milton's *Paradise Lost,* III, 44.)

46. For a paraphrase of Alison, see Jouett in Morgan, *Stuart,* 92; and see Alison quoted and elaborated in Walter John Hipple, Jr., *The Beautiful, the Sublime, and the Picturesque in Eighteenth-Century British Aesthetic Theory* (Carbondale: Southern Illinois University Press, 1957), 169. On genius, see Archibald Alison, *Essays on the Nature and Principles of Taste* (Edinburgh: F. C. and J. Rivington, 1811), 2:128. See also Addison's emphasis on inventive genius in Wittkower, "Imitation," 157; William Duff, *An Essay on Original Genius, and Its Various Modes of Exertion in Philosophy and the Fine Arts,* ed. John L. Mahoney (1767; reprint, Gainesville, Fla.: Scholars' Facsimiles and Reprints, 1964), vii, 6, 190; and Penelope Murray's discussion of the development of this concept of genius in *Genius: The History of an Idea* (Oxford: B. Blackwell, 1989), 3.

47. See Stuart's poem in *Port Folio* 3, no. 25 (June 18, 1803): 1; and Jouett on invention in Morgan, *Stuart,* 92. Stuart's recommendation to combine materials, or remembered visual images, as the stimulus to invention is jotted down almost incoherently, by Jouett, but it sufficiently resembles the clearer discussions of invention in Reynolds (*Discourses,* 27) and Duff (*Essay,* 6–7) to be the same. For art that addresses the mind rather than the eye, and the linkage of this activity with poetry, see Reynolds, *Discourses,* 50, 234. Through a connection with poetry, Reynolds (*Discourses,* 50, 57) sought to elevate painting to the rank of a liberal art rather than a mechanical trade. On the history of the joining of the "sister arts," see Rensselaer W. Lee, "Ut Pictura Poesis: The Humanistic Theory of Painting," *Art Bulletin* 22, no. 4 (Dec. 1940): 197–269. See Jane Stuart in Mason, *Stuart,* 36.

Abbreviations

Cogdell, "Diary"
Cogdell, John S. "Diary." Vols. 1 and 3. Joseph Downs Manuscript Collection, Henry Francis du Pont Winterthur Museum, Winterthur, Del.

Holley, "Report"
Holley, Horace. Letter to Mary Austin Holley, April 8, 1818. Holley Papers, William L. Clements Library, University of Michigan, Ann Arbor.

"Letters to G. C. Mason"
"Letters Written to George Champlin Mason Concerning Gilbert Stuart, 1876–1879." Rhode Island Historical Society, Providence.

Mason, "Diary"
Mason, Jonathan, Jr. "Recollections of a Septuagenarian." Vol. 2. Joseph Downs Manuscript Collection, Henry Francis du Pont Winterthur Museum, Winterthur, Del.

Pickering
Pickering, Henry. "Interviews with Mr. Stuart in 1810 and 1817." Manuscript at Pickering House, Salem, Mass.

Waterhouse, "Autobiography"
Waterhouse, Benjamin. "Autobiography." Benjamin Waterhouse Papers, Francis A. Countway Library of Medicine, Harvard University Medical School, Boston.

Waterhouse, "Memoirs"
Waterhouse, Benjamin. "Memoirs." Benjamin Waterhouse Papers, Francis A. Countway Library of Medicine, Harvard University Medical School, Boston.

Selected Bibliography

PRIMARY SOURCES

Manuscript Collections

ANN ARBOR, MICHIGAN
University of Michigan, William L. Clements Library, Holley
Papers

BEDFORD, BEDFORDSHIRE, ENGLAND
Bedfordshire Record Office, Morley Papers

BOSTON, MASSACHUSETTS
Boston Public Library, Miscellaneous papers
City Hall, Registry Archives
Episcopal Diocese of Massachusetts, Records of the Cathedral Church of St. Paul, Jarvis Papers
Harvard University Medical School, Francis A. Countway Library of Medicine, Waterhouse Papers
Massachusetts Historical Society
 Adams Papers
 Brown-Byles Papers
 Dana Papers
 Mann Papers
 Morton-Cunningham-Clinch Papers
 Otis Papers
 Shattuck Papers
New Court House, Archives and Records Preservation, Supreme Judicial Court, Inventory of the Estate of Gilbert Stuart
New England Historic and Genealogical Society, Miscellaneous papers

BROOKLYN, NEW YORK
Brooklyn Museum Library Collection, Pierrepont Family Papers

BRUNSWICK, MAINE
Bowdoin College Library, Bowdoin Collection

CAMBRIDGE, MASSACHUSETTS
Harvard University, Houghton Library, Whitley Papers

CHARLESTON, SOUTH CAROLINA
Charleston Museum, Manigault Papers Typescript (loan)

CHARLOTTESVILLE, VIRGINIA
University of Virginia, Alderman Library

Dolley Madison Papers
Stevens Papers

DUBLIN, IRELAND
King's Inn, Registry of Deeds, Memorial Reference Books

EDINBURGH, SCOTLAND
National Library of Scotland, Liston Papers
National Register of Archives, Miscellaneous manuscripts
Scottish Record Office, Probate Records

HALIFAX, NOVA SCOTIA
Law Courts, Probate District of the County of Halifax

HARTFORD, CONNECTICUT
Connecticut Historical Society, Wolcott Papers

HAVERFORD, PENNSYLVANIA
Haverford College, Magill Library, Roberts Autograph Letters Collection

LONDON, ENGLAND
British Library, Miscellaneous manuscripts
British Museum, Anderdon Collection of annotated Royal Academy catalogues
Courtauld Institute of Art, Witt Library (*see* London, *under Newspapers and Journals*)
Royal Academy of Arts
 Humphry Correspondence
 Jupp Collection of annotated and extra-illustrated Royal Academy catalogues
Victoria and Albert Museum, Library (*see* London, *under Newspapers and Journals*)
Westminster City Archives, Rate Books

NEW HAVEN, CONNECTICUT
Yale University, Sterling Memorial Library, Trumbull Papers

NEWPORT, RHODE ISLAND
Newport Historical Society, Miscellaneous files

NEW YORK, NEW YORK
Columbia University, Jay Papers
New-York Historical Society
 King Papers
 Miscellaneous manuscripts
 Papers of the American Academy of the Fine Arts

New York Public Library, Miscellaneous papers

PHILADELPHIA, PENNSYLVANIA
American Philosophical Society
 Latrobe-Jacobs Report
 Neagle Notebooks
 Charles Willson Peale Papers
 Vaughan Papers
City Hall, Department of Records, Common Pleas Docket
Historical Society of Pennsylvania
 Anthony Account Book
 Birch Autobiography
 Gratz Collection
 Miscellaneous papers
 Neagle Scrap Book, vol. 1
National Archives—Mid-Atlantic Region, United States Circuit Court for the Eastern District of Pennsylvania, Record Group 21
Philadelphia Museum of Art, Bound Pamphlets from the library of John Neagle, vol. 1
Peter H. Sellers, Mason Manuscript

PLYMOUTH, MASSACHUSETTS
Pilgrim Society, Plymouth Archives, Thacher Collection

PROVIDENCE, RHODE ISLAND
Rhode Island Historical Society, G. C. Mason correspondence on Stuart

QUINCY, MASSACHUSETTS
Adams National Historic Site, C. F. Adams Journal

SALEM, MASSACHUSETTS
Pickering House, Pickering Interviews with Stuart

SHELTER ISLAND, NEW YORK
Shelter Island Historical Society, Dering Letter Book (typescript)

WASHINGTON, D.C.
Library of Congress
 Jefferson Papers
 Madison Papers
 Thornton Papers
Smithsonian Institution, Archives of American Art
 Graham Autograph Collection
 Hart Collection
 Longacre Family Papers
 Negus Papers

WILLIAMSBURG, VIRGINIA
Colonial Williamsburg, Colonial Williamsburg File

WILMINGTON, DELAWARE
Hagley Museum and Library, Manigault Diary

WINSTON-SALEM, NORTH CAROLINA
Museum of Early Southern Decorative Arts (Archive)

WINTERTHUR, DELAWARE
Henry Francis du Pont Winterthur Museum Library, Joseph Downs Manuscript Collection
 Cogdell Diary
 Mason Diary
 Sully Memoirs
 Miscellaneous papers

Newspapers and Journals

BALTIMORE
Federal Gazette & Baltimore Daily Advertiser, 1798, 1813

BOSTON
Boston Intelligencer, and Morning and Evening Advertiser, 1817
Columbian Centinel, 1828
Daily Evening Transcript, 1846, 1852
The Monthly Anthology; or Magazine of Polite Literature, 1803
The North American Review, 1835

CHARLESTON
South Carolina State Gazette, 1795

LONDON
Monthly Magazine, or British Register, 1804, 1805, 1808
"Newspaper Cuttings, Fine Arts, 1731–1811" (Courtauld Institute of Art, Witt Library)
"Press Cuttings from English Newspapers on Matters of Artistic Interest, 1686–1835," vols. 1 and 2 (Victoria and Albert Museum, Library)
The Gazetteer and New Daily Advertiser, 1782
The General Advertiser, 1786
The General Evening Post, 1784
The Morning Chronicle, and London Advertiser, 1782, 1786
The Morning Herald and Daily Advertiser, 1784
The Morning Post, and Daily Advertiser, 1784, 1785
The Oracle, Public Advertiser, 1797
The Public Advertiser, 1783, 1784
St. James's Chronicle, 1781
St. James's Chronicle; or, British Evening Post, 1782
The Times, 1787, 1788, 1789
The Universal Daily Register, 1785
The World, 1787

NEWPORT
The Newport Mercury, 1845

NEW YORK
Evening Post, 1833
New York American, 1824
New-York Mirror and Ladies' Literary Gazette, 1828
New-York Mirror, A Weekly Journal, Devoted to Literature and the Fine Arts, 1835
Putnam's Monthly Magazine, 1855
The Home Journal, 1855

PHILADELPHIA
American Quarterly Review, 1835
Aurora and Pennsylvania Gazette, 1828
Aurora General Advertiser, 1801
The Port Folio, 1801, 1803, 1805, 1810
Weekly Museum, 1793

READING, ENGLAND
Henry's Reading Journal; or Weekly Review, 1747

SECONDARY SOURCES

Adams, John Quincy. *Memoirs of John Quincy Adams, Comprising Portions of His Diary from 1795 to 1848.* Ed. Charles Francis Adams. 12 vols. Philadelphia: J. B. Lippincott, 1874–77.

Addison, Joseph. *The Addisonian Miscellany, Being a Selection of Valuable Pieces from . . . the Spectator, Tatler, and Guardian to Which is Prefixed the Life of Joseph Addison, Esq.* Boston: Bumstead, 1801.

Alberts, Robert C. *The Golden Voyage: The Life and Times of William Bingham, 1752–1804.* Boston: Houghton-Mifflin, 1969.

Algarotti, Francesco. *An Essay on Painting, Written in Italian.* Trans. anon. London: L. Davis and C. Reymers, 1764.

Alison, Archibald. *Essays on the Nature and Principles of Taste.* 2 vols. Edinburgh: F. C. and J. Rivington, 1811.

Allston, Washington. *Lectures on Art and Poems (1850) and Monaldi (1841) by Washington Allston.* Ed. Nathalia Wright. Gainesville, Fla.: Scholars' Facsimiles and Reprints, 1967.

———. *The Correspondence of Washington Allston.* Ed. Nathalia Wright. Lexington: University Press of Kentucky, 1993.

Ashton, Geoffrey. *Catalogue of Paintings at the Theatre Museum.* London: Victoria and Albert Museum in Association with the Society for Theatre Research, 1992.

Baker, William Spohn. *Character Portraits of Washington as Delineated by Historians, Orators and Divines.* Philadelphia: R. M. Lindsay, 1887.

Barker-Benfield, G. J. *The Culture of Sensibility: Sex and Society in Eighteenth-Century Britain.* Chicago: University of Chicago Press, 1992.

Barry, James. *The Works of James Barry, Esq., Historical Painter.* 2 vols. London: T. Cadell and W. Davies, 1809.

Bartlett, John R., ed. *Census of the Inhabitants of the Colony of Rhode Island and Providence Plantations, 1774.* Baltimore: Genealogical Publishing, 1969.

Bartlett, Joseph. *Physiognomy, A Poem.* Boston: John Russell, 1799.

Bate, Walter Jackson. *From Classic to Romantic: Premises of Taste in Eighteenth-Century England.* Cambridge: Harvard University Press, 1946.

Bell, Sir Charles. *Essays on the Anatomy of Expression in Painting.* London: Longman, Hurst, Rees, and Orme, 1806.

Benjamin, S. G. W. *Art in America: A Critical and Historical Sketch.* New York: Harper and Brothers, 1880.

Bermingham, Ann. "Elegant Females and Gentlemen Connoisseurs: The Commerce in Culture and Self-Image in Eighteenth-Century England." In *The Consumption of Culture 1600–1800: Image, Object, Text,* ed. Ann Bermingham and John Brewer. London: Routledge, 1995.

Bischoff, Ilse. *Proud Heritage: A Novel Based on the Life of Gilbert Stuart.* New York: Coward-McCann, 1949.

Bjelajac, David. *Millennial Desire and the Apocalyptic Vision of Washington Allston.* Washington, D.C.: Smithsonian Institution Press, 1988.

Blair, Hugh. *Lectures on Rhetoric and Belles Lettres.* 1819. Reprint, Delmar, N.Y.: Scholars' Facsimiles and Reprints, 1993.

Boaden, James. *Memoirs of the Life of John Philip Kemble, Esq., Including a History of the Stage, from the Time of Garrick to the Present Period.* 2 vols. London: Longman, Hurst, Rees, Orme, Brown, and Green, 1825.

Bolton, Theodore. "Book Reviews." *New England Quarterly* 5, no. 4 (Oct. 1932): 837–39.

Bredvold, Louis I. *The Natural History of Sensibility.* Detroit: Wayne State University Press, 1962.

Brenneman, David Andrew. "The Critical Response to Thomas Gainsborough's Painting: A Study of the Contemporary Perception and Materiality of Gainsborough's Art." Ph.D. diss., Brown University, 1995.

Britton, John, ed. *The Fine Arts of the English School.* London: Longman, Hurst, Rees, Orme, and Brown, 1812.

Brown, Milton W., et al. *American Art: Painting, Sculpture, Architecture, Decorative Arts, Photography.* Englewood Cliffs, N.J.: Prentice-Hall, 1979; New York: Harry N. Abrams, 1979.

Bryan, William Alfred. *George Washington in American Literature, 1775–1865.* New York: Columbia University Press, 1952.

Burke, Edmund. *A Philosophical Enquiry into the Origin of Our Ideas of the Sublime and Beautiful.* Ed. James T. Boulton. Oxford: Basil Blackwell, 1987.

Bush, Alfred L. *The Life Portraits of Thomas Jefferson.* Charlottesville: Thomas Jefferson Memorial Foundation, 1987.

Caldwell, John, et al. *American Paintings in the Metropolitan Museum of Art.* 3 vols. New York: Metropolitan Museum of Art in Association with Princeton University Press, 1994.

Callcott, Margaret Law. *Mistress of Riversdale: The Plantation Letters of Rosalie Stier Calvert, 1795–1821.* Baltimore: Johns Hopkins University Press, 1991.

Catalogue of an Exhibition of Portraits, Painted by the Late Gilbert Stuart, Esq. Boston: Eastburn, 1828.

A Catalogue of the Truly Capital Collection of Italian, French, Flemish and Dutch Pictures Which Were Selected . . . During the Greater Part of the Last Half Century By Benjamin West, Esq., P.R.A., Deceased, the Late Venerable President of the Royal Academy. Christie's, London, June 23–24, 1820.

Channing, George G. *Early Recollections of Newport, R.I., from the Year 1793 to 1811.* Newport: A. J. Ward and Charles E. Hammett, Jr., 1868.

Channing, William Henry. *Memoir of William Ellery Channing with Extracts from His Correspondence and Manuscripts.* 3 vols. London: J. Chapman, 1848.

Chesterfield, Philip Dormer Stanhope, Earl of. *The Letters of the Earl of Chesterfield to His Son.* Ed. Charles Strachey, with notes by Annette Calthrop. 2 vols. London: Methuen, 1901.

Coats, Alice M. *Flowers and Their Histories.* New York: McGraw-Hill, 1968.

Cooper, Helen A., ed. *John Trumbull: The Hand and Spirit of a Painter.* Exh. cat. New Haven: Yale University Art Gallery, 1982.

Cope, Thomas P. *Philadelphia Merchant: The Diary of Thomas P. Cope, 1800–1851.* Ed. Eliza Cope Harrison. South Bend, Ind.: Gateway Editions, 1978.

Copeman, W. S. C. *The Worshipful Society of Apothecaries of London: A History, 1617–1967.* Oxford: Pergamon Press, 1967.

Copyright Office. *Copyright Enactments: Laws Passed in the United States Since 1783 Relating to Copyright.* Washington, D.C.: U.S. Government Printing Office, 1963.

Cowper, Thomas. "Observations Respecting the History of Physiognomy." *European Magazine* 19, no. 2 (Feb. 1791): 122–26.

Cozens, Alexander. *Principles of Beauty Relative to the Human Head.* London: James Dixwell, 1778.

Crean, Hugh R. *Gilbert Stuart and the Politics of Fine Arts Patronage in Ireland, 1787–1793: A Social and Cultural Study.* Ann Arbor: University Microfilms International, 1991.

Cunningham, Allan. *The Lives of the Most Eminent British Painters, Sculptors, and Architects.* 6 vols. in 3. London: J. Murray, 1830–39.

Curtis, W. Hugh. *William Curtis, 1746–1799, Fellow of the Linnean Society, Botanist and Entomologist.* Winchester, England: Warren and Son, 1941.

Custis, George Washington Parke. *Recollections and Private Memoirs of Washington, by His Adopted Son, George Washington Parke Custis.* Philadelphia: William Flint, 1859.

Daiches, David. *Glasgow.* London: Deutsch, 1977.

DeLorme, Eleanor Pearson. "Gilbert Stuart: Portrait of an Artist." *Winterthur Portfolio* 14, no. 4 (Winter 1979): 339–60.

Desportes, Ulysse. "Giuseppe Ceracchi in America and His Busts of George Washington." *Art Quarterly* 26, no. 2 (Summer 1963): 140–79.

Dictionary of National Biography. 21 vols. Oxford: Oxford University Press, 1967–68.

Duff, David. *Edward of Kent: The Life Story of Queen Victoria's Father.* London: S. Paul, 1938.

Duff, William. *An Essay on Original Genius, and Its Various Modes of Exertion in Philosophy and the Fine Arts.* Ed. John L. Mahoney. 1767. Reprint, Gainesville, Fla.: Scholars' Facsimiles and Reprints, 1964.

Du Fresnoy, Charles Alphonse. *The Art of Painting.* Trans. William Mason. 1783. Reprint, New York: Arno Press, 1969.

[Dunlap, William]. "Biographical Sketch of Gilbert Stewart [*sic*]." *Euterpeiad: An Album of Music, Poetry, and Prose,* Mar. 15, 1831, 232.

———. *A History of the Rise and Progress of the Arts of Design in the United States.* 1834. Reprint (2 vols. in 3), New York: Dover Publications, 1969.

———. *Diary of William Dunlap.* 3 vols. New York: New-York Historical Society, 1931.

Dunn, John. "Notices Relative to Some of the Native Tribes of North America." In *The Transactions of the Royal Irish Academy.* Vol. 9. Dublin: George Bonham, 1803.

E—— S——, the Honorable. *The Deportment of a Married Life.* London: Printed for Mr. Hodges, 1790.

The Ear-wig; or, An Old Woman's Remarks on the Present Exhibition of Pictures of the Royal Academy. London: G. Kearsley, 1781.

Eaton, A. W. H. "Rhode Island Settlers on the French Lands in Nova Scotia in 1760 and 1761." *Americana* 10 (Jan. 1915), 1–43.

Eisen, Gustavus A. *Portraits of Washington.* 3 vols. New York: R. Hamilton, 1932.

Ellis, Joseph J. *After the Revolution: Profiles of Early American Culture.* New York: Norton, 1979.

Engell, James. *The Creative Imagination: Enlightenment to Romanticism.* Cambridge: Harvard University Press, 1981.

Evans, Dorinda. *Benjamin West and His American Students.* Exh. cat. Washington, D.C.: Smithsonian Institution Press for the National Portrait Gallery, 1980.

———. *Mather Brown: Early American Artist in England.* Middletown, Conn.: Wesleyan University Press, 1982.

———. "Gilbert Stuart: Two Recent Discoveries." *American Art Journal* 16, no. 3 (Summer 1984): 84–89.

Farington, Joseph. *The Diary of Joseph Farington.* Ed. Kenneth Garlick and Angus Macintyre. 16 vols. New Haven: Yale University Press for the Paul Mellon Centre for Studies in British Art, 1978–84.

Fielding, Mantle. *Catalogue of the Engraved Work of David Edwin.* Philadelphia: M. Fielding, 1905.

Flexner, James Thomas. *Gilbert Stuart: A Great Life in Brief.* 1955. Reprinted as *On Desperate Seas: A Biography of Gilbert Stuart,* New York: Alfred A. Knopf, 1995.

———. *America's Old Masters.* 1939. Reprint, New York: Constable, 1967.

Forbes, Harriette M. "Some Salisbury Family Portraits." *Old-Time New England* 21, no. 1 (July 1930): 3–18.

Forster-Hahn, Franziska. "The Sources of True Taste: Benjamin West's Instructions to a Young Painter for His Studies in Italy." *Journal of the Warburg and Courtauld Institutes* 30 (1967): 367–82.

Foster, Joseph. *Alumni Oxonienses: The Members of the University of Oxford, 1715–1886 . . .* 4 vols. Oxford: Parker, 1887–88.

Fowble, E. McSherry. *Two Centuries of Prints in America, 1680–1880: A Selective Catalogue of the Winterthur Museum Collection.* Charlottesville: University Press of Virginia for the Henry Francis du Pont Winterthur Museum, 1987.

Fredericksen, Burton B., ed. *The Index of Paintings Sold in the British Isles During the Nineteenth Century.* 3 vols. in 5. Santa Barbara, Calif.: ABC–CLIO, ca. 1988–93.

Freeman, Douglas Southall. *George Washington: A Biography.* 7 vols. New York: Scribner, 1948–[57].

Friedman, Winifred H. *Boydell's Shakespeare Gallery.* New York: Garland Publishing, 1976.

Gainsborough, Thomas. *The Letters of Thomas Gainsborough.* Ed. Mary Woodall. Greenwich, Conn.: New York Graphic Society, 1963; n.p.: Cupid Press, 1963.

Geddy, Pam McLellan. "Cosmo Alexander's Travels and Patrons in America." *Antiques* 112, no. 5 (Nov. 1977): 972–77.

Gerdts, William H., and Theodore E. Stebbins, Jr. *"A Man of Genius": The Art of Washington Allston (1779–1843).* Exh. cat. Boston: Museum of Fine Arts, 1979.

Gilpin, William. *An Essay upon Prints: Containing Remarks upon the Principles of Picturesque Beauty.* London: J. Robson, 1768.

————. *Observations Relative Chiefly to Picturesque Beauty, Made in the Year 1772, on Several Parts of England; Particularly the Mountains, and Lakes of Cumberland, and Westmoreland . . .* 2 vols. London: R. Blamire, 1786.

Goodfellow, G. L. M. "Cosmo Alexander in America." *Art Quarterly* 26, no. 3 (Autumn 1963): 309–21.

Gordan, John D., III. "Morse v. Reid: The First Reported Federal Copyright Case." *Law and History Review* 10, no. 1 (Spring 1992): 21–41.

Graham, John. *Lavater's Essays on Physiognomy: A Study in the History of Ideas.* Bern: Peter Lang, 1979.

Graves, Algernon. *The Royal Academy of Arts: A Complete Dictionary of Contributors and Their Work from Its Foundation in 1769 to 1904.* 8 vols. London: Henry Graves, 1905–6.

————. *The Society of Artists of Great Britain, 1760–1791; The Free Society of Artists, 1761–1783: A Complete Dictionary of Contributors and Their Work from the Foundation of the Societies to 1791.* 1907. Reprint, Bath: Kingsmead Reprints, 1969.

Green, Samuel M. *American Art: A Historical Survey.* New York: Ronald Press, 1966.

Hamlin, Talbot. *Benjamin Henry Latrobe.* New York: Oxford University Press, 1955.

Harris, Eileen. "Robert Adam's Ornaments for Alderman Boydell's Picture Frames." *Furniture History: The Journal of the Furniture History Society* 26 (1990): 93–98.

Hart, Charles Henry. "Stuart's Lansdowne Portrait of Washington." *Harper's New Monthly Magazine* 93, no. 555 (Aug. 1896): 378–86.

————. *Browere's Life Masks of Great Americans.* New York: Doubleday and McClure, 1899.

————. "Gilbert Stuart's Portraits of Men." *Century Magazine* 76, no. 6 (Oct. 1908): 95.

Hayes, John. *The Portrait in British Art: Masterpieces Bought with the Help of the National Art Collections Fund.* Exh. cat. London: National Portrait Gallery, 1991.

Hazlitt, William. "On the Look of a Gentleman." *London Magazine* 3, no. 13 (Jan. 1821): 39.

————. *The Complete Works of William Hazlitt.* Ed. P. P. Howe. 21 vols. London: J. M. Dent and Sons, 1930–34.

Hegel, Georg Wilhelm Friedrich. *Aesthetics: Lectures on Fine Art.* Trans. T. M. Knox. 2 vols. Oxford: Clarendon Press, 1975.

Herbert, J. D. *Irish Varieties, For the Last Fifty Years: Written from Recollections.* London: W. Jay, 1836.

Herring, James, and James B. Longacre. *The National Portrait Gallery of Distinguished Americans . . .* 4 vols. Philadelphia: Henry Perkins, 1830–35.

Hershman, D. Jablow, and Julian Lieb. *The Key to Genius: Manic Depression and the Creative Life.* Buffalo, N.Y.: Prometheus Books, 1988.

Hipple, Walter John, Jr. *The Beautiful, the Sublime, and the Picturesque in Eighteenth-Century British Aesthetic Theory.* Carbondale: Southern Illinois University Press, 1957.

History of the Chemical Bank, 1823–1913. New York: [Chemical Bank and Trust Company], 1913.

Hogarth, William. *The Analysis of Beauty: Written with the View of Fixing the Fluctuating Ideas of Taste.* London: William Hogarth, 1753.

Honour, Hugh. *Neo-classicism.* Harmondsworth: Penguin, 1968.

Howat, John K. "'A Young Man Impatient to Distinguish Himself,' The Vicomte de Noailles as Portrayed by Gilbert Stuart." *Metropolitan Museum of Art Bulletin* 29 (Mar. 1971): 327–40.

Hughes, Robert. *American Visions: The Epic History of Art in America.* New York: Alfred A. Knopf, 1997.

Hunter, Thomas. *Reflections Critical and Moral on the Letters of the Late Earl of Chesterfield.* 1776/77. Reprint, Boston: J. Boyle, 1780.

Huntington, David C. *Art and the Excited Spirit: America in the Romantic Period.* Exh. cat. Ann Arbor: University of Michigan Museum of Art, 1972.

Jackson, Ronald Vern. *Massachusetts 1810 Census Index.* Salt Lake City: Accelerated Indexing Systems, 1981.

————. *Pennsylvania 1800 Census Index.* 2 vols. Salt Lake City: Accelerated Indexing Systems, 1972.

Jackson, Ronald Vern, et al. *Massachusetts 1820 Census Index.* Salt Lake City: Accelerated Indexing Systems, 1976.

Jamison, Kay R. *Touched With Fire: Manic-Depressive Illness and the Artistic Temperament.* New York: Free Press, 1993; Toronto: Maxwell Macmillan Canada, 1993; New York: Maxwell Macmillan International, 1993.

Jarves, James Jackson. *The Art-Idea.* 1864. Reprint, ed. Benjamin Rowland, Jr., Cambridge: Belknap Press, 1960.

Jeffrey, Francis. "Beauty." In *Encyclopaedia Britannica; or, A Dictionary of Arts, Sciences, and Miscellaneous Literature.* 20 vols. Edinburgh: Archibald Constable, 1815–.

Jenkins, Marianna Duncan. *The State Portrait: Its Origin and Evolution.* [New York]: College Art Association of America in Conjunction with *Art Bulletin,* 1947.

Johnson, J., ed. *The Medical Register for the Year 1783.* London: Joseph Johnson, 1783.

Johnson, Samuel. *A Dictionary of the English Language.* 2 vols. London: J. and P. Knapton, 1755.

————. *The Works of Samuel Johnson, LL.D., in Nine Volumes.* 9 vols. Oxford: Talboys and Wheeler, 1825.

Johnston, Elizabeth Bryant. *Original Portraits of Washington, Including Statues, Monuments, and Medals.* Boston: J. R. Osgood, 1882.

Jones, Guernsey, ed. *Letters and Papers of John Singleton Copley and Henry Pelham, 1739–1776.* Vol. 71. Boston: Massachusetts Historical Society, 1914.

Jouett, M. H. *See* Morgan, John Hill

Kames, Henry Home, Lord. *Elements of Criticism.* 2 vols. Boston: J. White, Thomas and Andrews, W. Spotswood, D. West, W. P. Blake, E. Larkin, and J. West, 1796.

King, Edward S. "Stuart's Last Portrait of Washington: Its History and Technique." *Journal of the Walters Art Gallery* 9 (1946): 81–96.

Knapp, Samuel L. *Lectures on American Literature, with Remarks on Some Passages of American History.* New York: Elam Bliss, 1829.

———. *American Biography, Forming Part VI of the Treasury of Knowledge and Library Reference*. New York: Conner and Cooke, 1833.

Knapp, Steven. *Personification and the Sublime: Milton to Coleridge*. Cambridge: Harvard University Press, 1985.

Knight, Richard Payne. *An Analytical Inquiry into the Principles of Taste*. London: T. Payne and J. White, 1805.

Latrobe, Benjamin H. *The Correspondence and Miscellaneous Papers of Benjamin Henry Latrobe*. Ed. John C. Van Horne and Lee W. Formwalt. 3 vols. New Haven: Yale University Press for the Maryland Historical Society, 1984–86.

Lavater, Johann Caspar. *Essays on Physiognomy, Designed to Promote the Knowledge and the Love of Mankind . . .* Trans. Henry Hunter. 3 vols. in 5. London: John Murray, [ca. 1792].

Lee, Rensselaer W. "Ut Pictura Poesis: The Humanistic Theory of Painting." *Art Bulletin* 22, no. 4 (Dec. 1940): 197–269.

Leonardo da Vinci. *A Treatise on Painting*. Trans. anon. London: J. Senex, 1721.

Lester, C. Edwards. *The Artists of America: A Series of Biographical Sketches of American Artists*. New York: Baker and Scribner, 1846.

Lettsom, John Coakley. *Memoirs of John Fothergill, M.D., [etc.]*. London: C. Dilly, 1786.

Levitine, George. "The Influence of Lavater and Girodet's *Expression des sentiments de l'âme*." *Art Bulletin* 36, no. 1 (Mar. 1954): 33–44.

Lindsay, Jack. *Thomas Gainsborough: His Life and Art*. New York: Universe Books, 1981.

Lomask, Milton. *Aaron Burr*. 2 vols. New York: Farrar, Straus and Giroux, 1979–82.

London County Council. *Survey of London*, vol. 32: *The Parish of St. James Westminster*. 2 parts. London: Athlone Press for the London County Council, 1963.

Longinus, Cassius. *Longinus on the Sublime: The Peri Hupsous in Translations by Nicolas Boileau-Despréaux (1674) and William Smith (1739)*. Ed. W. B. Johnson. Delmar, N.Y.: Scholars' Facsimiles and Reprints, 1975.

McCausland, Hugh. *Snuff and Snuff-Boxes*. London: Batchworth Press, 1951.

Mackenzie, Henry. *The Man of Feeling*. 1771. Reprint, New York: Garland Publishing, 1974.

McLanathan, Richard. *Gilbert Stuart*. New York: Abrams in Association with National Museum of American Art, Smithsonian Institution, 1986.

Malone, Dumas. *Dictionary of American Biography*. 11 vols. New York: C. Scribner's Sons, 1958–64.

Mannings, David. "At the Portrait Painter's: How the Painters of the Eighteenth Century Conducted Their Studios and Sittings." *History Today* 27, no. 5 (May 1977): 279–87.

Mason, Eudo C. *The Mind of Henry Fuseli: Selections from His Writings With an Introductory Study*. London: Routledge and Kegan Paul, 1951.

Mason, George C. *Life and Works of Gilbert Stuart*. 1879. Reprint, New York: B. Franklin, 1974.

———. *Annals of Trinity Church, Newport, R.I., 1698–1821*. Newport: G. C. Mason, 1890.

Maytham, Thomas N., et al. *American Paintings in the Museum of Fine Arts, Boston*. 2 vols. Boston: New York Graphic Society, 1969.

Melville, Herman. *Pierre, or The Ambiguities*. Ed. Hershel Parker. New York: Harper Collins, 1995.

Meschutt, David. "Gilbert Stuart's Portraits of Thomas Jefferson." *American Art Journal* 13, no. 1 (Winter 1981): 2–16.

Meyer, Arline. "Re-Dressing Classical Statuary: The Eighteenth-Century 'Hand-in-Waistcoat' Portrait." *Art Bulletin* 77, no. 1 (Mar. 1995): 45–63.

Miles, Ellen G., et al. *American Paintings of the Eighteenth Century*. Washington, D.C.: National Gallery of Art, 1995.

Miller, Lillian B., ed. *The Collected Papers of Charles Willson Peale and His Family*. National Portrait Gallery, Smithsonian Institution, Washington, D.C.; Millwood, N.Y.: Kraus-Thomson Organization, 1980. Microfiche.

Miller, Lillian B., et al. *In Pursuit of Fame: Rembrandt Peale, 1778–1860*. Exh. cat. Washington, D.C., and Seattle: University of Washington Press for the National Portrait Gallery, 1992.

Miller, Samuel. *A Brief Retrospect of the Eighteenth Century*. 2 vols. New York: T. and J. Swords, 1803.

Monk, Samuel H. *The Sublime: A Study of Critical Theories in Eighteenth-Century England*. Ann Arbor: University of Michigan Press, 1962.

Montagu, Jennifer. *The Expression of the Passions: The Origin and Influence of Charles Le Brun's Conférence sur l'expression générale et particulière*. New Haven: Yale University Press, 1994.

Moody, T. W., F. X. Martin, and F. J. Byrne, eds. *A New History of Ireland*. Vols. 2–6, 9. Oxford: Clarendon Press, 1976–96.

Moore, Robert E. "Reynolds and the Art of Characterization." In *Studies in Criticism and Aesthetics, 1660–1800: Essays in Honor of Samuel Holt Monk*, ed. Howard Anderson and John S. Shea. Minneapolis: University of Minnesota Press, 1967.

Morgan, David. "The Rise and Fall of Abstraction in Eighteenth-Century Art Theory." *Eighteenth-Century Studies* 27, no. 3 (Spring 1994): 449–78.

Morgan, John Hill. *Gilbert Stuart and His Pupils [including notes by M. H. Jouett]*. New York: New-York Historical Society, 1939.

Morgan, John Hill, and Mantle Fielding. *The Life Portraits of Washington and Their Replicas*. Lancaster, Pa.: Lancaster Press, ca. 1931.

Mount, Charles Merrill. *Gilbert Stuart: A Biography*. New York: W. W. Norton, 1964.

———. "Gilbert Stuart in Washington: With a Catalogue of His Portraits Painted between December 1803 and July 1805." In *Records—Columbia Historical Society of Washington, D.C.*, ed. Francis Coleman Rosenberger. Vol. 48. Washington, D.C.: Columbia Historical Society, 1973.

———. "The Irish Career of Gilbert Stuart." *Quarterly Bulletin of the Irish Georgian Society* 6, no. 1 (Jan.–Mar. 1963): 6–27.

Murray, Penelope. *Genius: The History of an Idea*. Oxford: B. Blackwell, 1989.

Neal, John. *Observations on American Art: Selections from the Writings of John Neal (1793–1876)*. Ed. Howard Edward Dickson. State College: Pennsylvania State College, 1943.

Newton, Sir Isaac. *Opticks; or, A Treatise of the Reflections, Refractions, Inflections, and Colours of Light.* London: W. Innys, 1730.

New-York Historical Society, *Catalogue of American Portraits in the New-York Historical Society.* 2 vols. New Haven: Yale University Press, 1974.

Northcote, James. *The Life of Sir Joshua Reynolds.* 2 vols. London: Henry Colburn, 1819.

Norton, Robert E. *The Beautiful Soul: Aesthetic Morality in the Eighteenth Century.* Ithaca, N.Y.: Cornell University Press, 1995.

Novak, Barbara. *American Painting of the Nineteenth Century: Realism, Idealism, and the American Experience.* New York: Harper and Row, 1979.

Nye, Russel Blaine. *The Cultural Life of the New Nation, 1776–1830.* New York: Harper, 1960.

Oedel, William T. "John Vanderlyn: French Neoclassicism and the Search for an American Art." Ph.D. diss., University of Delaware, 1981.

Oliver, Andrew. *Portraits of John and Abigail Adams.* Cambridge: Belknap Press of Harvard University Press, 1967.

———. *Portraits of John Quincy Adams and His Wife.* Cambridge: Belknap Press of Harvard University Press, 1970.

Park, Lawrence. *Gilbert Stuart: An Illustrated Descriptive List of His Works.* 4 vols. New York: W. E. Rudge, 1926.

Park, William. *The Idea of Rococo.* Newark: University of Delaware Press, 1992.

Pasquin, Anthony. *Memoirs of the Royal Academicians; Being an Attempt to Improve the National Taste.* London: H. D. Symonds, 1796.

———. *An Authentic History of the Professors of Painting, Sculpture, and Architecture, Who Have Practised in Ireland; Involving . . . Memoirs of the Royal Academicians.* 1797. Reprint, London: Cornmarket Press, 1970.

Paulson, Ronald. *Emblem and Expression: Meaning in English Art of the Eighteenth Century.* Cambridge: Harvard University Press, 1975.

Peabody, Elizabeth Palmer. *Reminiscences of Rev. William Ellery Channing, D.D.* Boston: Roberts Brothers, 1880.

Peale, Rembrandt. "Washington Portraits: Letters of Rembrandt Peale." *Magazine of American History* 5, no. 2 (Aug. 1880): 129–34.

———. *Portrait of Washington.* Private printing. N.p., n.d.

Peat, Wilbur D. *Pioneer Painters of Indiana.* Indianapolis: Art Association of Indianapolis, 1954.

Penny, Nicholas, ed. *Reynolds.* Exh. cat. London: Royal Academy of Arts in Association with Weidenfeld and Nicolson, 1986.

Piles, Roger de. *The Art of Painting, with the Lives and Characters of Above 300 of the Most Eminent Painters.* Trans. anon. London: Thomas Payne, [1754?].

Piper, David. *The English Face.* Ed. Malcolm Rogers. London: National Portrait Gallery, 1992.

Place, Francis. *The Autobiography of Francis Place.* Ed. Mary Thale. Cambridge: Cambridge University Press, 1972.

Pleasants, J. Hall. "Four Late Eighteenth Century Anglo-American Landscape Painters." *Proceedings of the American Antiquarian Society* 52, pt. 2 (1943): 187–324.

Pliny the Elder. *The Elder Pliny's Chapters on the History of Art.* Trans. K. Jex-Blake. Chicago: Argonaut, 1968.

Podell, Janet, and Steven Anzovin. *Speeches of the American Presidents.* New York: H. W. Wilson, 1988.

Pointon, Marcia. *Hanging the Head: Portraiture and Social Formation in Eighteenth-Century England.* New Haven: Yale University Press, 1993.

Pope-Hennessy, Una, ed. *The Aristocratic Journey, Being the Outspoken Letters of Mrs. Basil Hall Written During a Fourteen Months' Sojourn in America, 1827–1828.* New York: G. P. Putnam's Sons, 1931.

Porter, Roy. "Bodies of Thought: Thoughts about the Body in Eighteenth-Century England." In *Interpretation and Cultural History,* ed. Joan H. Pittock and Andrew Wear. Basingstoke: Macmillan, 1991.

———. "Making Faces: Physiognomy and Fashion in Eighteenth-Century England." *Etudes Anglaises* 38, no. 4 (Oct.–Dec. 1985): 385–96.

Postle, Martin. *Sir Joshua Reynolds: The Subject Pictures.* Cambridge: Cambridge University Press, 1995.

Powel, Mary E. "Miss Jane Stuart, 1812–1888: Her Grandparents and Parents." *Bulletin of the Newport Historical Society* 31 (Jan. 1920): 1–16.

Pressly, William L. "Gilbert Stuart's *The Skater:* An Essay in Romantic Melancholy." *American Art Journal* 18, no. 1 (1986): 43–51.

Prown, Jules David. *John Singleton Copley.* 2 vols. Cambridge: Harvard University Press for the National Gallery of Art, 1966.

———. "Style as Evidence." *Winterthur Portfolio* 15, no. 3 (Autumn 1980): 197–210.

———. *American Painting: From Its Beginnings to the Armory Show.* Geneva: Skira, 1987.

Quick, Michael, Marvin Sadik, and William H. Gerdts. *American Portraiture in the Grand Manner: 1720–1920.* Exh. cat. Los Angeles: Los Angeles County Museum of Art, 1981.

Quincy, Josiah. *Figures of the Past.* Boston: Little, Brown, 1926.

Rather, Susan. "Stuart and Reynolds: A Portrait of Challenge." *Eighteenth-Century Studies* 27, no. 1 (Fall 1993): 61–84.

Rebora, Carrie, et al. *John Singleton Copley in America.* Exh. cat. New York: Metropolitan Museum of Art, 1995.

Reynolds, Sir Joshua. *Discourses on Art.* Ed. Robert R. Wark. New Haven: Yale University Press for the Paul Mellon Centre for Studies in British Art, 1981.

———. *Letters of Sir Joshua Reynolds.* Ed. Frederick Whiley Hilles. Cambridge: Cambridge University Press, 1929.

Ribeiro, Aileen. *The Art of Dress: Fashion in England and France, 1750 to 1820.* New Haven: Yale University Press, 1995.

Richardson, E. P. "China Trade Portraits of Washington After Stuart." *Pennsylvania Magazine of History and Biography* 94, no. 1 (Jan. 1970): 95–100.

Richardson, E. P., et al. *Gilbert Stuart, Portraitist of the Young Republic, 1755–1828.* Exh. cat. Providence: Museum of Art, Rhode Island School of Design, 1967.

Richardson, Jonathan. *The Works.* 1773. Reprint, Hildesheim: G. Olms, 1969.

Ripa, Cesare. *Baroque and Rococo Pictorial Imagery: The 1758–60 Hertel Edition of Ripa's "Iconologia."* Trans. Edward A. Maser. New York: Dover, 1971.

Roche, Sophie von La. *Sophie in London, 1786; Being the Diary of Sophie von La Roche.* Trans. and ed. Claire Williams. London: J. Cape, 1933.

Rogers, Malcolm. *William Dobson, 1611–46.* Exh. cat. London: National Portrait Gallery, 1983.

Rosenblum, Robert. *Transformation in Late Eighteenth Century Art.* Princeton: Princeton University Press, 1967.

Rothstein, Eric. "'Ideal Presence' and the 'Non Finito' in Eighteenth-Century Aesthetics." *Eighteenth-Century Studies* 9, no. 3 (Spring 1976): 307–32.

Sadik, Marvin S. *Colonial and Federal Portraits at Bowdoin College.* Brunswick: Bowdoin College Museum of Art, 1966.

Saunders, Richard H., and Ellen G. Miles. *American Colonial Portraits, 1700–1776.* Exh. cat. Washington, D.C.: Smithsonian Institution Press for the National Portrait Gallery, 1987.

Sellers, Charles Coleman. "Review of *Gilbert Stuart: A Biography* by Charles Merrill Mount." *Pennsylvania Magazine of History and Biography* 88, no. 3 (July 1964): 373–74.

———. *Patience Wright, American Artist and Spy in George III's London.* Middletown, Conn.: Wesleyan University Press, 1976.

Shakespeare, William. *The Dramatick Writings of Will. Shakspere: With Notes of All the Various Commentators: Printed Complete from the Best Editions of Sam. Johnson and Geo. Steevens.* 20 vols. London: John Bell, British Library, 1786–88.

Shaw, Peter. *The Character of John Adams.* Chapel Hill: University of North Carolina Press, 1976.

Shawe-Taylor, Desmond. *Genial Company: The Theme of Genius in Eighteenth-Century British Portraiture.* Exh. cat. Nottingham: Nottingham University Art Gallery, 1987.

———. *The Georgians: Eighteenth-Century Portraiture and Society.* London: Barrie and Jenkins, 1990.

Sheriff, Mary D. *Fragonard: Art and Eroticism.* Chicago: University of Chicago Press, 1990.

Shipton, Clifford K. *Sibley's Harvard Graduates.* Vol. 16. Boston: Massachusetts Historical Society, 1972.

Shortland, Michael Anthony Philip. "The Body in Question: Some Perceptions, Problems and Perspectives of the Body in Relation to Character, c. 1750–1850." 2 vols. Ph.D. diss., University of Leeds, 1984.

Simon, Irène. *Neo-classical Criticism, 1660–1800.* Columbia: University of South Carolina Press, 1971.

Simon, Robin. *The Portrait in Britain and America with a Biographical Dictionary of Portrait Painters, 1680–1914.* Oxford: Phaidon, 1987.

Sizer, Theodore. *The Works of Colonel John Trumbull.* New Haven: Yale University Press, 1950.

Stafford, Cornelius William. *Philadelphia Directory for 1800.* [Philadelphia]: Cornelius W. Stafford, 1800.

Stein, Susan R. *The Worlds of Thomas Jefferson at Monticello.* New York: H. N. Abrams in Association with the Thomas Jefferson Memorial Foundation, 1993.

Strazdes, Diana, et al. *American Paintings and Sculpture to 1945 in the Carnegie Museum of Art.* New York: Hudson Hills Press in Association with the Museum, 1992.

Strickland, Walter G. *Dictionary of Irish Artists.* 2 vols. London: Maunsel, 1913.

Stuart, Jane. "The Stuart Portraits of Washington." *Scribner's Monthly: An Illustrated Magazine for the People* 12, no. 3 (July 1876): 367–74.

———. "The Youth of Gilbert Stuart." *Scribner's Monthly* 13, no. 5 (Mar. 1877): 640–46.

———. "Anecdotes of Gilbert Stuart." *Scribner's Monthly* 14, no. 3 (July 1877): 376–82.

Swan, Mabel M. "The 'American Kings.'" *Antiques* 19, no. 4 (Apr. 1931): 278–81.

Thomson, James. *The Seasons, and, The Castle of Indolence.* Ed. James Sambrook. Oxford: Clarendon Press, 1972.

Thornton, Mrs. William. "Diary of Mrs. William Thornton." *Records of the Columbia Historical Society* 10, no. 165 (1907): 89–226.

Trilling, Lionel. *Sincerity and Authenticity.* Cambridge: Harvard University Press, 1972.

Troyen, Carol, et al. *American Paintings in the Museum of Fine Arts, Boston: An Illustrated Summary Catalogue.* Boston: Museum of Fine Arts, 1997.

Trumbull, John. *Autobiography, Reminiscences and Letters by John Trumbull from 1756 to 1841.* New York: Wiley and Putnam, 1841; New Haven: B. L. Hamlen, 1841.

Tscherny, Nadia. "Beyond Likeness: Late Eighteenth Century British Portraiture and Origins of Romanticism." Ph.D. diss., New York University, 1986.

Tuckerman, Henry T. *Book of the Artists: American Artist Life, Comprising Biographical and Critical Sketches of American Artists.* 1867. Reprint, New York: J. F. Carr, 1966.

Updike, Wilkins, and James MacSparran. *A History of the Episcopal Church in Narragansett, Rhode Island.* Ed. Rev. Daniel Goodwin. 3 vols. Boston: Merrymount Press, 1907.

Usher, James. *Clio; or, A Discourse on Taste* 1769. Reprint, New York: Garland Publishing, 1970.

Vaughan, William. *Romanticism and Art.* London: Thames and Hudson, 1994.

Verheyen, Egon. "'The Most Exact Representation of the Original': Remarks on Portraits of George Washington by Gilbert Stuart and Rembrandt Peale." In *Retaining the Original: Multiple Originals, Copies, and Reproductions,* ed. Kathleen Preciado. Washington, D.C.: National Gallery of Art, 1989.

Von Erffa, Helmut, and Allen Staley. *The Paintings of Benjamin West.* New Haven: Yale University Press, 1986.

Ward, James. *Conversations of James Northcote, R.A., with James Ward on Art and Artists.* Ed. Ernest Fletcher. London: Methuen, 1901.

Watson, John F. *Annals of Philadelphia and Pennsylvania in the Olden Time.* 2 vols. Philadelphia: Whiting and Thomas, 1857.

Webb, Daniel. *An Inquiry into the Beauties of Painting; and into the Merits of the Most Celebrated Painters, Ancient and Modern.* London: R. and J. Dodsley, 1760.

Wegener, Charles. *The Discipline of Taste and Feeling.* Chicago: University of Chicago Press, 1992.

Weld, Isaac, Jr. *Travels through the States of North America and the Provinces of Upper and Lower Canada During the Years 1795, 1796 & 1797.* 2 vols. 1807. Reprint, New York: A. M. Kelley, 1970.

Wendorf, Richard. *Sir Joshua Reynolds: The Painter in Society.* Cambridge: Harvard University Press, 1996.

———. *The Elements of Life: Biography and Portrait-Painting in Stuart and Georgian England.* Oxford: Clarendon Press, 1990; New York: Oxford University Press, 1990.

West, Benjamin. *A Discourse Delivered to the Students of the Royal Academy (Dec. 10, 1792) . . . To Which Is Prefixed the Speech of the President to the Royal Academicians (March 24, 1792).* London: Thomas Cadell, 1793.

West, Shearer. "Thomas Lawrence's 'Half-History' Portraits and the Politics of Theatre." *Art History* 14, no. 2 (June 1991): 225–49.

———. *The Image of the Actor: Verbal and Visual Representation in the Age of Garrick and Kemble.* London: Printer Publishers, 1991.

Wheelock, Arthur K., Jr., et al. *Anthony Van Dyck.* New York: H. N. Abrams, 1990.

Whitley, William T. *Gilbert Stuart.* Cambridge: Harvard University Press, 1932.

Whyte, Donald. *A Dictionary of Scottish Emigrants to the U.S.A.* Baltimore: Magna Carta Book Co., ca. 1972.

Wick, Wendy C. *George Washington, an American Icon: The Eighteenth-Century Graphic Portraits.* Exh. cat. Washington, D.C.: National Portrait Gallery, 1982.

Williamson, Peter. *Williamson's Directory for the City of Edinburgh . . . from the 25th May 1773, to 25th May 1774, Being the First Published.* 1774. Reprint, Edinburgh: W. Brown, 1889.

Wilton, Andrew. *The Swagger Portrait: Grand Manner Portraiture in Britain from Van Dyck to Augustus John, 1630–1930.* Exh. cat. London: Tate Gallery, 1992.

Winckelmann, Johann Joachim. *Reflections on the Painting and Sculpture of the Greeks. . . .* Trans. Henry Fusseli [*sic*]. London: A. Millar, 1765.

Wind, Edgar. *Hume and the Heroic Portrait: Studies in Eighteenth-Century Imagery.* Ed. Jaynie Anderson. Oxford: Clarendon Press, 1986.

Winokur, George, Paula J. Clayton, and Theodore Reich. *Manic Depressive Illness.* St. Louis: C. V. Mosby, 1969.

Wittkower, Rudolph. "Imitation, Eclecticism, and Genius." In *Aspects of the Eighteenth Century.* Ed. Earl R. Wasserman. Baltimore: Johns Hopkins Press, 1965.

Woodall, Joanna, ed. *Portraiture: Facing the Subject.* Manchester: Manchester University Press, 1997.